# Jackson Pollock

*Ellen G. Landau*

Harry N. Abrams, Inc., Publishers

EDITOR: Phyllis Freeman
DESIGNER: Mark La Riviere
PHOTO EDITOR: Jennifer Bright

The Library of Congress has cataloged the Abrams edition as follows:

Landau, Ellen G.
     Jackson Pollock / Ellen G. Landau.
     p. 288 cm.
     Bibliography: p.
     Includes index.
     ISBN 0-8109-3702-6 (cloth) / 0-8109-9245-0 (paperback)
     1. Pollock, Jackson, 1912-1956—Criticism and interpretation.
     2. Abstract expressionism—United States.   I. Title.
     ND237.P73L36        1989
     759.13—dc19                                          89-241

Original clothbound edition published in 1989 by Harry N. Abrams, Inc.

Printed and bound in China
10 9 8 7 6 5 4 3 2 1

FRONTISPIECE: Pollock painting *Autumn Rhythm*, 1950. Photographs by Hans Namuth.

Harry N. Abrams, Inc.
100 Fifth Avenue
New York, N.Y. 10011
www.abramsbooks.com

Abrams is a subsidiary of
LA MARTINIÈRE
GROUPE

*For Howard, Jay, and Julie*

# Contents

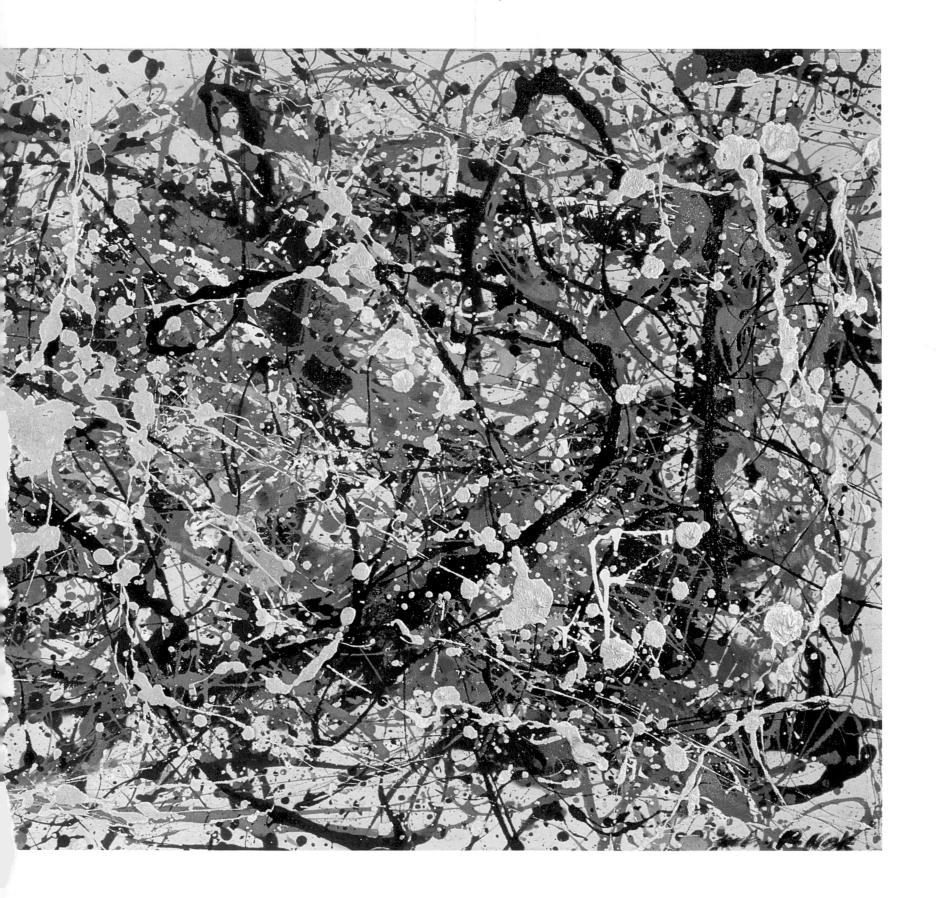

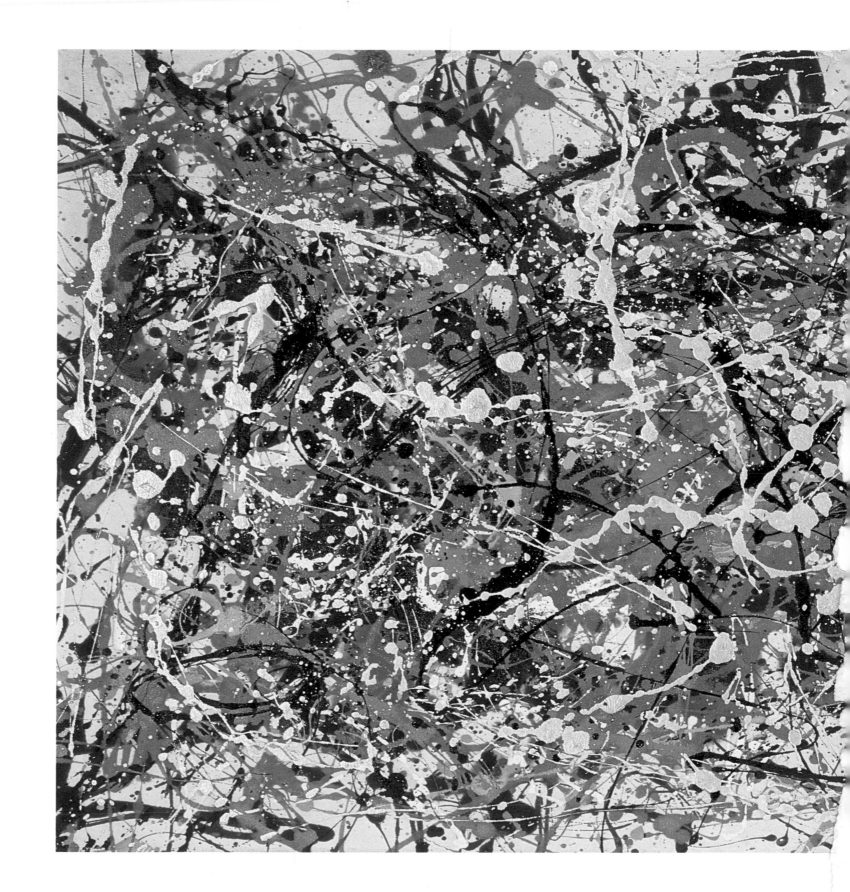

Number 8, 1949. *1949*

# The Wild One

We say that the . . . genius is always ahead of his time. True, but only because he's so thoroughly *of* his time.
—Henry Miller, Preface to *The Subterraneans*, by Jack Kerouac, 1959

If Pollock had not existed, surely *Time-Life* would have invented him.
—Nigel Gosling, *The Observer*, 1973

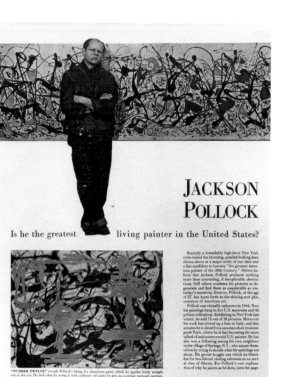

JACKSON POLLOCK

Is he the greatest      living painter in the United States?

Recently a formidably high-brow New York critic hailed the brooding, pointed-looking man shown above as a major artist of our time and a fine candidate to become "the greatest American painter of the 20th Century." Others believe that Jackson Pollock produces nothing more than interesting, if inexplicable, demonstrations. Still others condemn his pictures as degenerate and find them as unpalatable as yesterday's macaroni. Even so, Pollock, at the age of 37, has burst forth as the shining new phenomenon of American art.

Pollock was virtually unknown in 1944. Now his paintings hang in five U.S. museums and 40 private collections. Exhibiting in New York last winter, he sold 12 out of 18 pictures. Moreover his work has stirred up a fuss in Italy, and this autumn he is slated for a one-man show in avant-garde Paris, where he is fast becoming the most talked-of and controversial U.S. painter. He has also won a following among his own neighbors in the village of Springs, N.Y., who amuse themselves by trying to decide what his paintings are about. His grocer bought one which he identifies for bewildered visiting salesmen as an aerial view of Siberia. For Pollock's own explanation of why he paints as he does, turn the page.

"NUMBER TWELVE" reveals Pollock's liking for aluminum paint, which he applies freely straight out of the can. He feels that by using it with ordinary oil paint he gets an exciting textural contrast.

*Page in* Life *magazine, August 8, 1949.* © *1949, 1977 by Time, Inc. Photograph of Pollock* © *Arnold Newman*

"Is he the greatest living painter in the United States?" This query, used as the headline for a 1949 feature in *Life* magazine aimed at introducing the American public to a relatively unknown artist named Jackson Pollock, has often been invoked as a starting point for discussion of Pollock's controversial career. Although the judgment expressed in the question was based on a remark made by a respected art critic, Clement Greenberg, most readers probably thought *Life*'s editors were being facetious. That a painter who made his pictures by flinging pigment from cans of store-bought commercial paint at unstretched canvas rolled out flat on the floor could possibly be considered the best this country could produce was an idea that, in 1949, must have seemed absurd. The Luce Corporation's other weekly, *Time*, later coining the witty, but sarcastic epithet "Jack the Dripper," would help accelerate the young artist's notoriety; indeed, Jackson Pollock's name became widely known in the United States by the late fifties, and by people for whom new trends in painting were otherwise of little or no interest.[1]

The Jackson Pollock story has been explored and exploited frequently in the three decades that have passed since his premature death at forty-four in an auto crash on Long Island. Greenberg, his foremost champion, once characterized Pollock as "a kind of demiurgic genius," and in the years to come this estimation was to increasingly take on the authority of a confirmed fact. B. H. Friedman, the first to attempt a biography of Pollock, recounted his own firsthand observation of this phenomenon, describing evenings at downtown New York's Cedar Bar, where frequently younger artists would surround Jackson Pollock, "trying, trying, trying to touch him for luck." The sculptor Tony Smith, another friend of Jackson Pollock's, remarked in an interview that he had strongly disagreed when he overheard someone say at Pollock's funeral that the tragically dead artist was "just like the rest of us." Smith remembers thinking that this "just wasn't true," because Jackson had "more of the hero about him and everyone knew it."[2]

Some of the elements that have come to comprise Pollock's heroic persona were evident in the earliest reviews of his work. Words like "violent," "savage," "romantic,"

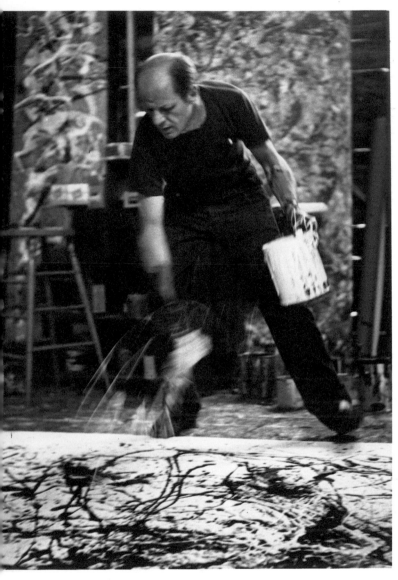

*Pollock at work, 1950*

"undisciplined," and "explosive" were repeatedly used in the 1940s in critiques on the art pages dealing with his first shows. Even *The New York Times*, in 1949, praised the young artist's "ravaging aggressive virility."[3] Many critics and reporters presented Pollock as a modern-day mixture of the daring of Prometheus and the energy and superhuman strength of Hercules (with more than a dash of the innocence of the Noble Savage). The merit of his sometimes incomprehensible paintings lay in the clear evidence they displayed of search and struggle. *Newsweek* once pointedly quoted a comment Pollock had made long before in a letter to his father, "I'll never be satisfied until I'm able to mould a mountain of stone with the aid of a jack hammer to fit my will."[4]

To anyone who knew him in the 1920s and '30s, the notion that Jackson Pollock would achieve fame, both as an artist and a "culture hero," would have seemed most unlikely. Intensely self-conscious, the young Jack Pollock was described by his friends and family as childish, troubled, and insecure, restive and driven, and he seems never to have outgrown these traits. One of his later acquaintances remembered being in awe of Pollock's desperation, characterizing him as a man who always appeared to be looking into a hard-driving rain.[5] *Life*'s obituary in 1956 quoted the observation of Betty Parsons, a former dealer of his, that Jackson was born with "too big an engine inside."

In 1941, one of the five Pollock brothers, Sanford, wrote to another family member about their youngest sibling. (Paul Jackson, born January 28, 1912, was the last child produced by the marriage of Stella May McClure and LeRoy Pollock.) Sande listed Jack's deep-rooted personality problems, which included irresponsibility, overintensity, manic depression, and self-destructiveness, all of which were exacerbated by his excessive drinking.[6] The painter Lee Krasner, who married Jackson Pollock in 1945, later described fourteen years of life with him as a succession of crises: at one moment, he could be beautiful and gentle; in the next, he became either explosively angry or totally bottled up.[7]

Diagnosed by various Jungian therapists as pathologically introverted, with a low tolerance for frustration, Pollock resembled the protagonist of a favorite Herman Melville novel, *Billy Budd*.[8] Apparently taking after his father—described by Jackson's brother Charles as a "sensitive, . . . easily hurt, . . . inward and withdrawn" man—as a teenager, Jackson Pollock perceptively defined his problem personality when he wrote in a family letter, "People have always frightened and bored me consequently I have been within my own shell."[9] In the ensuing years, through his art, Pollock was to find a way to express vehemently, and sometimes even lyrically, the feelings he was never eloquent enough to delineate in words. He somehow managed to convert his antisocial personality (Greenberg called him a "Gothic") into a positive impetus to creativity. James Johnson Sweeney was one of the first to recognize this, and Sweeney most likely provided Jackson with further impetus to follow his inclinations when he wrote that the young artist's emphasis on "the fury of animal nature" constituted "his personal poetry and his strength."[10]

Born in Cody, Wyoming, and reared in Arizona and California, Jackson Pollock delighted in reminding those around him of his roots. Snapshots from the family's archives that date back to the late 1920s (when Jackson had helped his father on a surveying job along the north rim of the Grand Canyon) show a handsome boy in cowboy getup. One picture even shows him shooting his gun off a mesa. In 1930, however, Pollock moved east to join

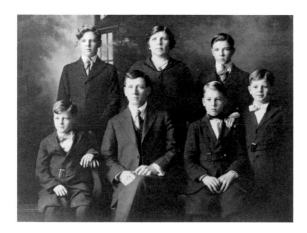

*The Pollock family, 1917*

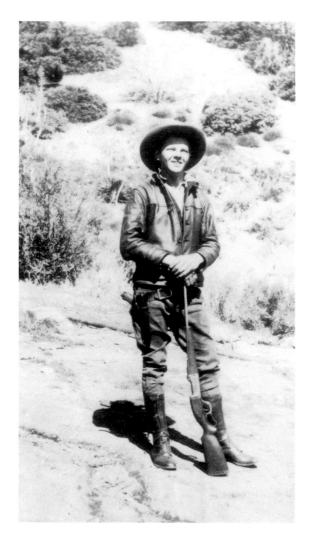

*Pollock in Southern California, c. 1927–28*

several of his brothers at New York's Art Students League, and he was never to return permanently to the western locales where he had grown up. About ten years later, when asked if he preferred the East or West, Pollock did not hesitate to answer that "living is keener, more demanding, more intense and expansive" where he was now; he added that the artistically stimulating influences were much more interesting and rewarding in New York. At the same time, he remarked that he still had "a definite feeling for the West."[11]

Apparently, this nostalgia never dissipated, and especially during the last decade of his life, Pollock often donned his pointed boots and seemed ever more to relish acting the cowboy; friends remember that sometimes he even sat like one on his haunches, walked like one, and his occasional "busting up" of the Cedar Bar reminded many onlookers of an outlaw in a frontier saloon.[12] Perhaps Pollock, who really was shrewder than generally given credit for, adopted this pose to create a legitimate context for his taciturn and restless personality. Aloof, a loner with an aura of melancholy, uneasy in society, frequently drunk, rash and impulsive but always faithful to his own convictions, his fate controlled by destiny—these have been cited by cowboy historian Rita Parks as characteristics commonly used to typify the legendary American heroes of the Old West.[13] As *Life* pointed out, a similar restlessness had been forced upon Jackson Pollock as a child, since his father had had trouble holding down a job, and his ambitious mother—a "real pioneer"—encouraged the family's moves in search of a better life.[14] According to his wife, Jackson was quiet, because he didn't believe in talking, he believed in doing; the origins of his taciturnity were explained by his brother Charles: Jackson didn't waste words because the family he had been raised in "didn't need much talk."[15]

In a 1950 interview with the Pollocks, which appeared in *The New Yorker* magazine's "Talk of the Town" section, Lee Krasner invoked her husband's background as a way of explicating the expansiveness of his newest large paintings. "Jackson's work is so full of the West. . . . That's what makes it so American," she said to the unidentified interviewer, who was actually their East Hampton neighbor, Berton Roueché. This observation, Roueché noted, Pollock himself "confirmed with a reflective scowl."[16] Subsequent writers have had a field day with the Western metaphor, to the ludicrous point where Pollock's artistic achievements have been likened to the cowboy sport of bronco busting; as the "Billy the Kid of the Manhattan art world," reporters have presented him "twirling lariats of color in wide open spaces" in order to create "vistas of writhing paint trails." Thomas Hess, one of the first to analyze this turn of events, commented that it had begun to sound in too many reviews as if Pollock had just ridden out of the old frontier, not with guns afire but with "anecdotes blazing." Reporters implied that, as Pollock rode (not on horseback, but in his frequently photographed depression-vintage Ford Model A), exactly like the bigger-than-life American folk hero Pecos Bill, "the light of wide prairies shone through his eyes and tornadoes screeched over his shoulder." Either implicitly or explicitly as a result of these analogies, Jackson Pollock came to exemplify for modern times the cowboy's attitude of ultimate honesty; Hess explained this as based on the fact that he seemed to be living his own life "from the inside out," cowboy style.[17]

Jackson Pollock's reputation for stubborn independence was to prove a key component in defining the parameters of his myth. Postwar America was so homogenized,

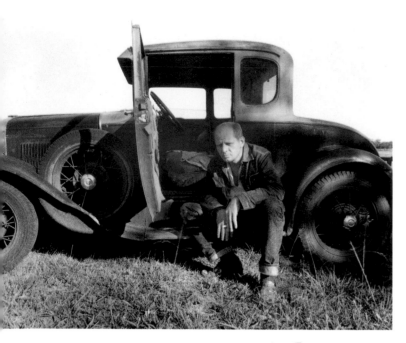

*Pollock on the runningboard of his Model-A Ford, 1952*

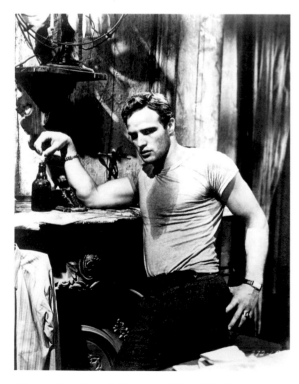

*Marlon Brando in* A Streetcar Named Desire, *1951*

bureaucratized, and "buttoned down" that many people felt easily lost in a "lonely crowd." As iconoclastic night-club comic Lenny Bruce liked to point out, to be a man in the fifties meant you had to "sell out." Since a significant portion of the population chafed under these conditions, it is not surprising that movies with frontier themes became very popular in that decade. In films like *Shane, High Noon, 3:10 to Yuma,* and other adult westerns, the hero riding off into the sunset in many ways more accurately exemplified not the nineteenth century winning of the West, but the contemporary dilemma. These characters were cheered on by viewers because, without regard for acceptance by society, they made their own decisions. It would soon become apparent that Jackson Pollock—described by fellow Abstract Expressionist Franz Kline as a "lone shepherd dog running outside the world"[18]— was a *real* version of the Hollywood and Madison Avenue he-men being created and marketed in response to current audience demand.[19] Thus it was that the media, always hot on the trail of new trends, began to emphasize the cowboy in Pollock.

A self-help book published in 1956, Robert Lindner's *Must You Conform?*, became a best seller because it reassured its readers that the instinct for rebellion was actually a healthy and normal one, if put to productive rather than negative use. As described in a number of film histories that include the immediate postwar era, male audiences of the fifties—ranging from disaffected youngsters to repressed adults—enthusiastically responded not only to the seditious protagonists of westerns, but also to a new breed of modern "rebel heroes" portrayed by actors like Montgomery Clift, Paul Newman, Marlon Brando, and James Dean.[20] These characters usually combined animal vitality, sexuality, and a certain emotional fragility with their insubordination (the same personality mix ascribed by friends and family to Jackson Pollock).

Nigel Gosling, writing from London in 1973, astutely observed that it should not at all be surprising that Pollock had been produced by the same country that originated the style of acting practiced by these stars. Gosling has not been the only writer to notice that many intuited a correspondence between Pollock and the "method" actors. In fact, photographs and descriptions of him used by the media in the fifties sometimes seem to have been deliberately chosen to duplicate treatment of the rebel hero film stars. *Time* magazine zeroed in on this parallel, reporting, "It was never simple for Pollock. Friends saw him, a cigarette smoldering on his lip, emerge from his studio limp as a dish rag," making it sound as though the artist had just completed an emotion-draining session at the Actors Studio, where these film stars trained.[21]

Many of Jackson Pollock's published and private statements prove that his thinking directly correlated with the basic premises of the acting style so inextricably a hallmark of his era. For example, in an interview he gave in 1944 to the journal *Arts & Architecture,* he noted (about the European Surrealists), "I am particularly impressed with their concept of the source of art being the unconscious." In *Possibilities* magazine, whose sole issue was published in the winter of 1947/48, Pollock described his total absorption when he worked: "When I am *in* my painting, I'm not aware of what I'm doing." His paintings, Pollock said, had a life of their own; his role was to let it come through. Another of the Abstract Expressionists, Willem de Kooning, remembers that Pollock, comparing the way each approached his canvas, taunted, "*You* know more, *I* feel more," and in an interview in the early fifties, Pollock defined painting as "a state of being."[22]

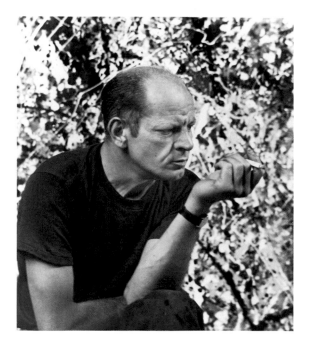

*Pollock, 1950*

All these statements clearly elucidate Jackson Pollock's instinctive understanding of the wellsprings of his creativity. And, it is fascinating to discover how, in many significant ways, Pollock's ideas converge with the tenets of the Stanislavsky acting method, developed in Russia and taught in the United States by theater coaches Lee Strasberg, Stella Adler, and Harold Clurman. The resemblance of their methodology to Pollock's mature creative process, which emerged independently in 1946–47—at virtually the same time as the Actors Studio opened in New York—is uncanny. Noted coaches at the Studio encouraged participants to delve deep into their psyches and to use their own bodies and feelings spontaneously and forcefully in a quest for inner truth. Described by Clurman as "a fanatic on the subject of emotion," Strasberg, in particular, directed his students to try to live their roles and to actually *become* the characters they intended to portray.

Undoubtedly, the two most famous and powerful method performances to emerge out of these principles were Marlon Brando's in *A Streetcar Named Desire* in 1951, and James Dean's film role four years later as Jim Stark in *Rebel Without a Cause*. Both of these were to provide ready-made opportunities for analogy with Pollock, but the *Streetcar* connection was most direct: through her friend and fellow artist Fritz Bultman, Lee Krasner had met Tennessee Williams—the author of this Pulitzer-prizewinning play—before she knew Pollock; and later, she, Pollock, and Williams spent time together with the Bultmans in Provincetown, Massachusetts. Krasner's reminiscence of their sojourn in New England from June through August of 1944 is quoted at length in B. H. Friedman's book, where she concluded by remembering that, "Tennessee . . . used to ride to our place on his bicycle. It was a good summer." Tennessee Williams, in his own memoirs, noted Pollock's "sturdy" build and boisterous, drunken behavior during those months in Provincetown.[23] Williams made Stanley Kowalski, the protagonist of *Streetcar* (which he wrote in 1947), similarly primitive and passionate, an atavistic brute whose instantaneously eruptible feelings were more intensely conveyed physically than verbally. Brando's electrifying performance in this role had a strong impact on America, to the point where, a few years after Elia Kazan's brilliant movie version, Robert Brustein incisively analyzed in *Commentary* magazine the appearance—which he attributed to Kowalski—of a new "hero" on the American scene, a counterculture figure whose primary attribute was the expression of "feeling without words."[24]

Many of the symptoms of Jackson Pollock's obvious and deeply rooted personality problems were made manifest in behavior patterns closely akin to those Williams gave to Stanley Kowalski, and Brustein's description of the proliferating hero type modeled after the character in Williams's play could have captioned any of the 1950s photographs of Pollock. According to Brustein, the newly admired role model for the era's youth was of medium height and of lower-class birth (although Pollock gave the impression of being big, as his wife noted, he was really not). On his face was always a surly and discontented expression, with eyes peering out under beetling brows. Contorted in a perpetual slouch—rather than standing up tall and straight—the new hero of the fifties never smiled, but stared steadily. This was a person whose outer demeanor bespoke not the confidence of standard hero figures of the past, but an inner life of anguish and torment.

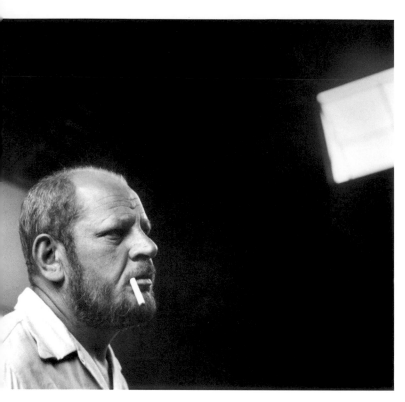

*Pollock in a photograph in* Time *magazine, December 19, 1955*

Tennessee Williams once characterized Jackson Pollock as a "dark" man;[25] according to his first psychiatrist, Pollock was more than just introverted and shy, he was totally nonverbal.[26] Many other friends and acquaintances have recalled that Jackson would frequently try to overcompensate for this inadequacy by making his physical presence felt more strongly, and some have noted that, on occasion, he comported himself with more than a touch of theatricality. He made most of his points in a tactile way (the same approach he took to painting), and apparently even sometimes wondered aloud what it would be like to be an actor.[27] By the late forties, Pollock was attacking his canvases in an extremely dramatic fashion, and he liked to compare his process of moving in and out and around his flat paintings to the approach of a matador stalking a bull in the arena. Based on a conversation the two men had during which he had used precisely these words, Pollock always believed that he was Harold Rosenberg's inspiration for the latter's redefinition of Abstract Expressionism as "Action Painting." In a 1952 article published in *Art News*, Rosenberg explained that the canvas had begun to function for many artists not as "a space in which to reproduce, re-design, analyze or 'express' an object, actual or imagined," but as "an arena in which to act." Most important to those who followed this procedure was not the development of subject or style, but the "role" they played while creating.[28]

Although Rosenberg later claimed that the artist described in his text was a composite of several people (including de Kooning and Kline), based on his extreme ability to release his impulses and his feelings and to make his psychic and physical "energies visible" in the process of painting, Jackson Pollock appears to have been the original impetus for the designation "Action Painter." Given Pollock's puzzled, vulnerable looks, in addition to the way he used his hands (which were, in Krasner's words, "fantastic and powerful"), his method of painting in "sustained paroxysms of passion" (as characterized by Ivan Karp in 1956, in *The Village Voice*), and his obvious intense self-absorption and fascination with violence, it should not seem surprising that all of these characteristics would combine to mark Pollock in many people's minds as a kind of soul mate to Stanley Kowalski (whose unruliness and animality were widely interpreted—according to Brustein—as "a mask for true profundity").

That Tennessee Williams may have, at least in part, modeled Kowalski on Pollock is not beyond the realm of possibility. (He may have—perhaps unconsciously—combined aspects of Pollock's personality with the more obvious characteristics of his friend Pancho Rodríguez y González, generally considered to be the main prototype for Stanley.)[29] As Gosling observed, the actual facts of the artist's life—"the big, hard-swearing, hard-drinking, lovable, handsome and magnetic young man slowly going down into middle-age like a warship with all guns firing"—sound a lot like the plot outline for a 1950s script.[30] In fact, Williams definitely used both Pollock and Krasner somewhat later, in 1969, as prototypes for Miriam and Mark Conley, the main characters of another play, *In the Bar of a Tokyo Hotel*. The verbal sparring of this battling couple, a domineering wife at odds with her drunken and dissolute painter husband, remarkably (and unflatteringly) duplicates the interpersonal dynamics of the latter stages of the Pollocks' marriage. At one point, Williams (whose own relationship with Jackson and Lee, although casual, was sometimes stormy) had one of the other players summarize, "Mark is mad . . . a man raging in the dark. . . . He's

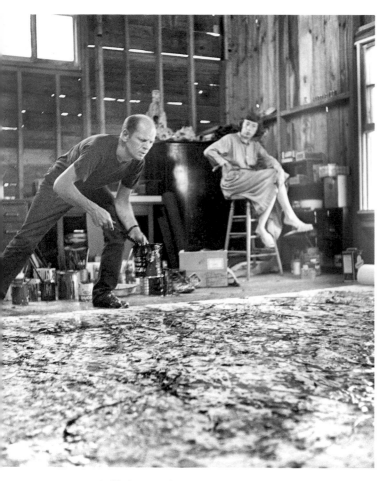

*Pollock at work, 1950*

gone through drip, fling, sopped, stained, saturated, scraped, ripped, cut, skeins of, mounds of heroically enduring color."[31] Nevertheless, in his memoirs, Williams was to praise Pollock for the creation of "moments of intensely perceptive being." Jackson Pollock, the playwright remarked in 1972, "could paint ecstasy as it could not be written."[32]

Stanley Kowalski, not the more obviously Pollock-derived character of Mark Conley, remains the metaphor most frequently invoked by Jackson's friends to describe his behavior. For instance, the painter/writer Robert Motherwell, one of the first to recognize Pollock's talent in print, has repeatedly compared the instinctive intelligence, fiery explosiveness, and uncontrollable neuroses that he remembers the real Pollock shared with the traits of the fictional Stanley. Several comments made by the sculptor George Segal in 1967 during an artists' symposium on Pollock's influence are often quoted. Although he never met the older artist, Segal noted that in his student days at New York University everyone was talking about Pollock: "They told me he was violent, deep, inarticulate, he drank too much, was passionate, revolutionary, put HIMSELF in his paintings." Segal distinctly recalled that this word portrait immediately conjured up for him "Marlon Brando's brooding, pouting profile looking down while Stella ripped his tee-shirt." Unwittingly echoing Brustein's article, Segal also remarked that, "Pollock's creased forehead in his photographs intrigued me. He had the agonized look of a man wrestling with himself in a game of unnameable but very high stakes."[33]

Thus, Pollock's Kowalskian behavior and visage were apparently obvious not just to those who knew him. In fact, it seems to have led the fifties press to conjure up further Brando analogies, providing those who perused the supermarket magazine racks with a context they could more readily understand for what *Life* termed a "baffling" new phenomenon. Indeed, in early 1956, *Time*'s critic found that not only Pollock, but the other Abstract Expressionists as well, could be sensationalized in the eyes of the magazine's middle-class readership by imputing to them the amoral and offensive characteristics of one of the era's most widely publicized social ills: the havoc wreaked on society by marauding bands of juvenile delinquents. It was as the leader of such a group, the Black Rebels motorcycle gang, that Brando had made a hit in his most recent film, *The Wild One*, and it was in the 1956 article in *Time* that picked up the film title that Pollock was branded as an equally violent slasher of traditional values. In the *Time* review, Pollock and the others were described as "hell-bent"; *The New York Times* similarly portrayed his paintings as "haphazard, lawless and chaotic."[34]

Perhaps the explicit ridicule of "Jack the Dripper" in *Time*'s "The Wild Ones" article was an attempt to counteract any positive reader sentiment that might have accrued from the magazine's grudging acknowledgment the year before that Jackson Pollock could no longer be dismissed as a mere curiosity. Titling a 1955 art review "The Champ," *Time* had most likely aimed at evoking yet another Brando performance—as the "has-been" boxer Terry Malloy in a different Kazan film, *On the Waterfront*. As Malloy, Brando laments in his big scene that he "coulda been a contender," but now was just a bum. Unlike Malloy, however, it had to be admitted that Pollock had somehow become a force to be reckoned with: *Time*'s critic, in fact, described the artist as "shuffling into the ring" at Manhattan's Janis Gallery, where his friends recognized him as "the bush-bearded heavyweight champion of Abstract Expressionism."

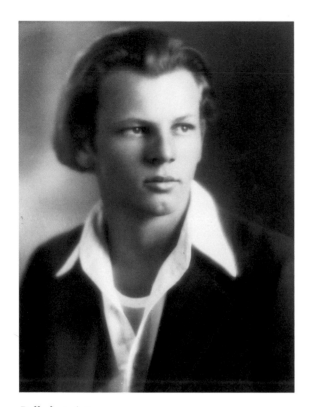

*Pollock at sixteen*

As yet unremarked in the literature on Pollock's popular image is the fact that, in addition to the artistic parallels between Pollock and Brando, there were—especially in the late forties and early fifties—a number of telling similarities in their personal lives as well. The unconventional and insecure behavior of each may have seemed coincidental at that time; it is now known that both men's problems stemmed in large part from difficult childhood relationships with their mothers.[35] One of the actor's friends recalls that Brando (very much like Pollock) was so volatile and unpredictable—off-screen as well as in the movies—that, although he never played the part, he reminded many who knew him of Dr. Jekyll, the sensitive physician whose brutish alter ego was known as Mr. Hyde. According to this source, quoted in Morella and Epstein's unauthorized Brando biography, in the late forties, at the height of Brando's career, there often seemed to be "two Marlons fighting for supremacy." Anyone reading over the countless interviews with colleagues and family on the subject of Jackson Pollock would find identical descriptions of his personality at that same time. As Motherwell has noted, the emotionally suppressed Pollock drank (as did Jekyll) to "kill the censor in his brain."[36]

An equally popular characterization of Jackson Pollock stems from a cultural linkage with another product of the Actors Studio, Lee Strasberg's greatest method protégé, James Dean; Pollock has often been designated (after the title of Dean's most famous movie) a "rebel without a cause."[37] In many significant ways, the artist's life truly did anticipate some of the themes of that 1955 film, based on case studies by Robert Lindner concerning the mixed-up and rebellious kids of the post–World War II decade. As a teenager after the First World War, Jackson Pollock was considered a troublemaker in his high school in Los Angeles; he, too, wore long hair and unconventional clothes, and he was expelled several times after clashes with authorities. When he was seventeen, Jackson complained in a letter to his older brother Charles that "this so called happy part of one's life youth to me is a bit of damnable hell," lamenting that if only he could "come to some conclusion about my self and life perhaps there [*sic*] i could see something to work for." Continuing to express thoughts that would later be echoed by Dean as Jim Stark, Pollock wrote, "the more i read and the more i think i am thinking the darker things become."[38]

Like both Brando and Pollock, James Dean also became famous off-screen as well as on for his unpredictable behavior, moody intensity and seemingly cultivated attitude of irresponsibility, and he was portrayed as a loner, inwardly preoccupied. Dean's artistic strength was touted in the fan magazines as stemming from his incessant process of self-analysis; in fact, Dean's goal in becoming an actor was represented by *Life* as "a courageous attempt to find out where he belonged."[39] Furthermore, in the parts he played with a great deal of physicality, Dean simultaneously personified and inverted the Method style, for all agreed that Dean, no matter what his character's name, "pretty much played himself." Foreshadowing Jackson Pollock in an eerie and uncanny way, just after the completion of his third film, *Giant*, Dean was killed speeding at the wheel of his car.

It soon became fashionable in certain circles to rationalize Dean's fate; many believed it was much better to live a brief, "uncompromising" life than to be stifled in the materialistic atmosphere of Main Street, U.S.A. In two widely read articles that appeared in *Esquire* magazine and *The New York Times*, the poet John Clellon Holmes elucidated this philosophy

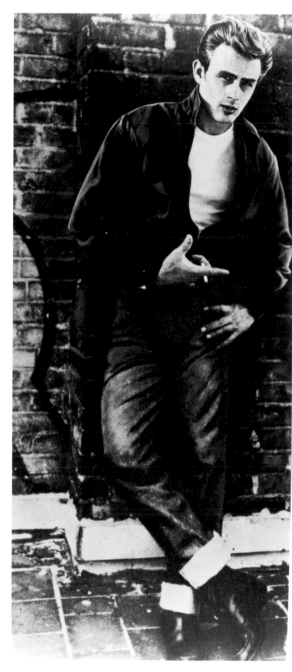

*James Dean on the set of* Rebel Without a Cause, *1955*

*Pollock, East Hampton,* 1950

*James Dean in* East of Eden, *1955*

increasingly shared by a large urban intellectual subculture, hyped extensively in the press as the "Beat Generation." Countering the many negative connotations of the term, Holmes defined "Beat" as rawness, a state of being directly pushed up against the wall of one's own consciousness. In the quintessential counterculture novel of the McCarthy decade *On the Road*, Jack Kerouac expanded on this theme, taking a moral position diametrically opposed to the one represented by *The Man in the Gray Flannel Suit*.

To many "squares," Abstract Expressionism quickly came to be seen as an artistic manifestation of the perceived subversiveness of the Beat attitude, and most of the Beats—as well as many of the artists—did not disagree. According to Holmes, the Beats believed that the only valid art consisted of statements that "cried out" for expression because of their unalterable truth to the sayer. These statements—perhaps not typically artistic or poetic—should burst out of their creator "in a flood," finding their own unique form in the process. Only such statements were "worth saying in the first place."[40] The particular similarity of this credo not only to Dean's style of acting, but also to what Pollock was doing seemed obvious. The Beat association was reinforced even further by stories making the rounds in the early fifties recounting the painter's increasingly contentious behavior, as well as published photos showing him newly hirsute.

Although poetry, not painting, was the form in which the Beat point of view was most cogently articulated at that time, since many of the movement's writers also "hung out" at the Cedar Bar, there were numerous direct opportunities for the Abstract Expressionists and their avant-garde counterparts in the literary world to meet and interact. Robert Creeley was one of the so-called Beat poets who met Jackson Pollock as part of the downtown New York scene. Creeley was so taken with the artist's stress on the generative role of process that he admits to a conscious attempt to adapt this point of view in his writing. Charles Henry Olson also found Pollock's reliance on body movements to create significant form impressive, so much so, in fact, that Olson set out to modify for poetry Pollock's creation of linear configurations based on his own locomotion. Stimulated by what he saw Pollock was doing, Olson proceeded to build his "projective verses" on the pattern of his own breathing. In Olson's spontaneously produced versification, as in Pollock's late forties and early fifties poured works, the expanse of each page was treated in an all-over fashion.[41] In like manner, Allen Ginsberg began to omit demarcations of the beginning and end in his poems, and Kerouac's uncorrected, stream-of-consciousness prose seems to have developed out of a related context.

After his own car crash (about a year after Dean's), the raw directness of Jackson Pollock's totally unpreconceived recording of his unconscious was not only eulogized in lyrics by Mike McClure published in *Evergreen Review*,[42] it was publicly hailed in an essay by Kenneth Rexroth, who finally said what many had believed to be true, that Pollock's life (death), and works were the essence of Beat. Rexroth officially added the artist to a growing list in the radical press of heroes "suicided" by contemporary American society.[43] A verse by Dylan Thomas, a sax solo by Charlie Parker, a painting by Jackson Pollock—all of these works by the movement's martyrs were applauded as "pure confabulations" whose simple existence constituted their best and only reason for being. (Since Krasner reported that Pollock often played recordings by Thomas and Parker as background while he worked, their parallel canonization by Rexroth seems more than fitting.)

In the years since his death, many hypotheses have been put forth to try to explain the unprecedented imprint of Jackson Pollock on American society. In addition to being lauded for stubbornly maintaining an individual stance in an increasingly homogeneous world, Pollock has been posthumously congratulated as well for what some have perceived as a grand existential gesture made in the face of atomic threat. And, most prominently, over and over again, Jackson Pollock has been credited with having virtually singlehandedly brought about the long-awaited aesthetic triumph of America over the centuries-old hegemony of Europe.

Some have concluded that the magnitude of Jackson Pollock's importance is in large measure due to the fact that no framework existed previously for his kind of energy.[44] But that is true—if at all—only in a very narrow art-historical sense, for the matrix into which Pollock's accomplishments fit is so much more complex and wide reaching. A tense, insecure, explosive man, embodying none of the traditional hero's traits, Jackson Pollock became an American hero nevertheless, and he has proved, moreover, to be a role model with tenacious staying power. Politics, artistic styles, social issues, all of these keep changing, but the example set by Pollock has managed to retain an extraordinary relevance; indeed, as the years have gone by, and newer and newer trends have developed, the extent of Pollock's impact is continually being reassessed and upgraded.

Hardly any expert today would disagree with the judgment that, whether or not he could be considered America's greatest painter, Jackson Pollock has certainly been the most influential artist ever produced by this country. But, while he was alive, some reviewers—unsympathetic in the extreme—accused Pollock of running a wrecking enterprise. His work, they complained, ruthlessly shattered the accepted conventions of picture making. Looking back, we can see that these critics were really not wrong in what they were saying; what they could not know, however, was just how profoundly Pollock's challenge to tradition was to change the course of art.

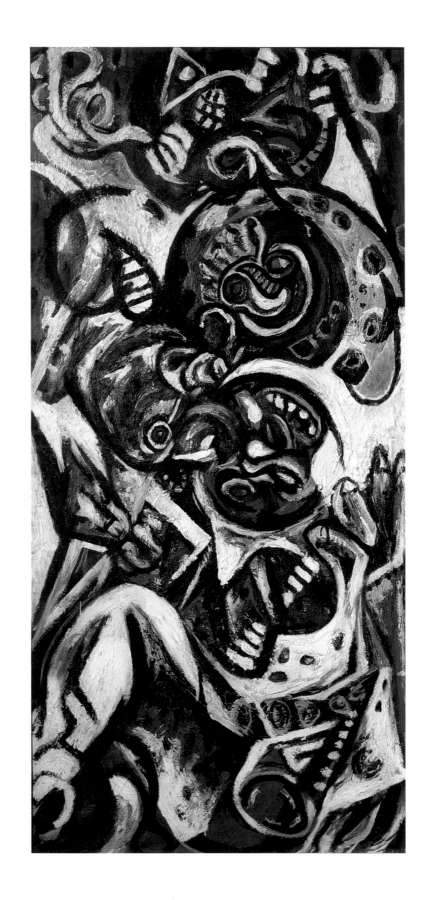

Birth. *c. 1938–41*

# Birth

If he had not been an artist, in one way or another
Jack would have thrown his life away.
—Charles Pollock

When, acting on an impulse, she first visited Jackson Pollock's studio in November 1941, Lee Krasner was amazed. Asked later to describe the incident, Krasner always emphasized her utter stupefaction at what she saw there: "What did I think? I was overwhelmed, bowled over, that's all. I saw all those marvelous paintings. I felt as if the floor was sinking when I saw those paintings. How could there be a painter like that that I didn't know about?"[1] Among the works Krasner viewed on that day was a vertical canvas entitled *Birth*, which Pollock intended to submit to an upcoming group show, "French and American Painting," scheduled that winter. This exhibition was being planned to highlight young unknowns; Krasner had been asked to show as well, which precipitated her uninvited call at Pollock's apartment on Eighth Street.

Years later Lee Krasner recalled that, on first viewing, what struck her so forcefully about Jackson Pollock's paintings was that their focus was completely different from that of the works she was used to seeing on the easels of her friends: in his canvases she saw the unmistakable presence of what she termed "very contemporary thinking." *Birth*, for instance, looked nothing like the typical American Scene or Social Realist subjects at that time found everywhere in art schools and studios in New York; nor was it an imitation of the innovations of the School of Paris, the current trend among the more advanced artists around town. Painted in dissonant, garish colors counterpointed by heavy black outlines and areas done in dazzling white, the composition of *Birth* seemed to be charged with energy. In it, three heads, or rather masks—recognizable as such because of their savagery and flatness—surmounted a bent-legged lower torso distinctly sexualized with both male and female shapes. Circularity was played off against angularity everywhere in the crowded and disjunctive composition, thickly and obsessively painted by Pollock directly from the tube and then worked not only with brush bristles, but also with the other end of his tool, the stick.

Although she could make some connections with the more expressionist works of Picasso and probably recognized Pollock's motifs as related to the currently popular Mexican muralists, *Birth*, taken in its entirety, seemed to Krasner like nothing she had ever seen

*Thomas Hart Benton, c. 1937*

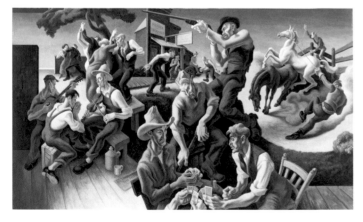

*Thomas Hart Benton.* Arts of the West. *1932*

before. As she got to know its maker better in the ensuing weeks and months, she found, to her surprise, that he could not articulate the background leading to the radicality his images powerfully conveyed. In fact, when Pollock talked at all to Krasner about his ideas and influences, he spoke of Thomas Hart Benton, an artist denigrated in the forties by most painters in New York with aspirations to the avant-garde. When she learned that he had been Pollock's mentor, Krasner's wonderment increased.

Jackson Pollock had actually come to New York from California in the fall of 1930, with the express idea of studying with Thomas Hart Benton at the Art Students League, where his brother Charles was already in attendance.[2] As Benton was shortly to become one of the most celebrated—and controversial—artists of the depression decade, this turned out to be an important decision. By 1941, however, Regionalism or American Scene painting, the movement with which Benton's name (in addition to Grant Wood's and John Steuart Curry's) had become synonymous, like the social and political characteristics of the post-crash years to which its tenets were so closely allied, was clearly on the wane. Regionalism—an unashamedly sentimentalized, illustrational protest against European modernism—had never been in the forefront of aesthetic innovation. Now, current events, as well as a growing distaste for the style on the part of many young painters, were rendering the precepts that had formed Pollock's artistic education obsolete. Nevertheless, as late as 1937, he had still been trying, albeit not very successfully, to fit into the Regionalist mold. A number of events in his personal life between 1937 and 1941, however, resulted in his abandoning this frustrating attempt and taking on, instead, the new direction represented in *Birth*.

Jackson Pollock's personality was apparently a combination of confusion and single-mindedness; even as a mixed-up teenager he knew that, for him, "being a[n] artist is life its self"[3] (although, at that time, he thought he would be a sculptor, not a painter). A difficult adolescent, he found school "boresome," declining to participate much except for his classes in art. Luckily, he found encouragement in the direction he chose from his brothers, especially the eldest, Charles (who had begun his own training for an art career in 1922); from a group of like-minded friends who included Reuben Kadish, Manuel Tolegian, Jules Langsner, and Philip Goldstein (later changed to Guston); and from one of his teachers at Manual Arts High School in Los Angeles, Frederick John de St. Vrain Schwankovsky. Schwankovsky, who had been educated in the East at the Pennsylvania Academy of the Fine Arts and the Art Students League, exposed those in his classes to the work of such European modernists as Cézanne and Matisse. More important, he (in his own words) encouraged his students to "meet" themselves, to expand their consciousness and develop their ego in whatever individual directions *they* wanted to take. To this end, "Schwanny" introduced Pollock and his other favorite pupils to the ideas of the Theosophical Society, taking them to camp meetings at Ojai, California, where his good friend the Theosophical philosopher Jiddu Krishnamurti spoke further about the attainment of true happiness through self-discovery.[4] Pollock later recalled being mesmerized by Krishnamurti's encouragement to believe that everyone has the strength and power within himself to "speak with his own authority." This led immediately to Pollock's taking on an "arty" pseudonym, "Hugo,"[5] and taking part in protests at school (against ROTC, emphasis on athletics, and the like), but its repercussions were to be much more significant over time. Pollock continued to speak about Krishnamurti to his wife and

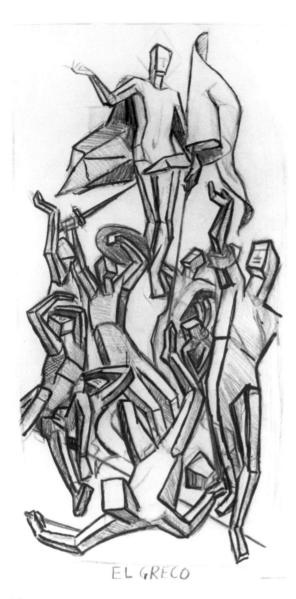

EL GRECO

*Thomas Hart Benton.* Study After El Greco. *n.d.*

others in later life, and in certain very important ways (perhaps due to the fact that his childhood experience included no formal religious training), many of the Theosophical doctrines he learned as a youth were to continue to guide his beliefs.

In January of 1930, at the beginning of the year Pollock was to move East without finishing high school, he was still, for the most part, pessimistic about his future progress. At that time, Jackson wrote to Charles, "altho i feel i will make an artist of some kind i have n[e]ver proven to myself nor any body else that i have it in me." Pollock knew he lacked the facility in art of friends like Philip Guston. Everything seemed to come hard for him and he frequently expressed doubts about his talent; even though he was visiting museums with Schwankovsky, and reading the art magazines his brother recommended, these experiences had not improved his abilities. One particularly interesting statement with reference to his future development was obviously written to New York in great misery and frustration. Jackson complained bitterly in that same letter to Charles, "my drawing i will tell you frankly is rotten it seems to lack freedom and rhythem [*sic*] it is cold and lifeless. it isn't worth the postage to send it."[6]

Thus, Jackson Pollock, still teen-aged, persuaded by Charles and another brother, Frank to come to New York with them instead of wasting more time in high school, arrived at the Art Students League serious and intense about art, but basically uninformed, undereducated, and with his mind still in "an unsettled state."[7] His fellow students in the Benton class were amazed at how this callow young Westerner could alternate so radically between a sweet, shy diffidence and aggressively challenging, quarrelsome tough-guy behavior (usually depending on if or how much he would drink). Some remember his attempts to appear cultured—which everyone could see through—that seemed an odd counterpoint to his otherwise "country-boy" behavior. The latter persona was encouraged by Benton, who, coming from Missouri, looked with contempt on Easterners as effete. Benton cultivated special friendships with his students from the West and Midwest, the locales he glorified in his work. A small man, Benton at that time was also a heavy drinker and he liked to affect a gruff and feisty pose. He quickly became a surrogate father for Pollock, whose own dad was depressed over his business failures and apparently thought little of his youngest son. Many recall how flattered Jackson was that Benton and his young wife, Rita, paid him so much attention.[8]

Earlier in Thomas Hart Benton's life, he had been involved in both radical artistic and political (i.e., Marxist) ideology, but by the time Jackson Pollock came to study with him, the older painter—now believing that art should stem from its own immediate social and cultural background—had broken with his former "borrowed" interests in favor of a more "virile and honest" emphasis on depicting American life.[9] Although his subjects were American, Benton's style was derived from the High Renaissance, Mannerist, and Baroque masters he admired, particularly Michelangelo, El Greco, Tintoretto, and Rubens. Despite the fact that Benton claimed that the "turmoil" of his rhythmic sequences was meant to symbolize the turmoil of America in his day ("its restlessness, psychological forces, nostalgia and yearnings"), the organization of his works was strongly indebted to European examples. But for a student such as Pollock who desired to learn how to achieve rhythmical composition, Benton was the ideal mentor, for his Regionalism was so clearly an extension of his admiration for these earlier styles of painting. Moreover, critics sympathetic to his style lauded Benton for his "full-

bodied muscularity," a comment that—significantly for Pollock—referred both to the figures his teacher drew *and* to the way that he drew them. Energy, bold vitality, and expressiveness exuded from Benton's most successful works, among which were a number of important mural commissions on which Pollock was able to watch him at work. In his memoirs, Benton later described his approach to this type of painting: "a mural is for me a kind of emotional spree. The very thought of the large spaces puts me in an exalted state of mind, strings up my energies. . . . A certain kind of thoughtless freedom comes over me. I don't give a damn about anything. Once on the wall, I paint with downright sensual pleasure."[10] Certainly Pollock must have been impressed with the excitement of this approach.

Thomas Hart Benton believed in and taught the ideas of the aesthetician John Dewey, who, in a series of lectures on the philosophy of art given at Harvard University in 1932, proposed that the nature of an artist's experience was ultimately of greater importance than the work he produced; the true meaning of art, to Dewey, derived from the sensations and responses of the process of creativity. This too must have had an impact on Jackson Pollock, especially coming so close on the heels of a similar, although more generalized emphasis in the preachings of Krishnamurti. That these ideas were internalized by Pollock is evident from his own later statements, many of which stress the role of the art experience. Benton claimed to be opposed to what he called the "ivory-tower" notion of process—rather than theme—as the major formative element in a pictorial composition, but this antimodernist posture was belied somewhat by his adaptation of Dewey's ideas and his essentially kinesthetic approach to painting. Although his works did not come out looking like those of the modern schools because of their continued emphasis on anecdotal subject matter, Benton did later admit that French Cubism, although he denied its validity for American painting, had possibly suggested some of his directions.

One of Pollock's fellow classmates at the Art Students League, Axel Horn, has described those who enrolled in Benton's classes as compartmentalized individuals, with a "similar need to break down the total complex problem of creating a work of art into its smaller components"—which was, in fact, Benton's teaching philosophy.[11] Benton had elaborated his rules for a wider audience in the late 1920s, when he had published a series of articles on "The Mechanics of Form Organization" in a popular periodical, *The Arts*. In these essays, Benton explained how to attain compositional equilibrium and rhythmic balance (the latter by repetition of similar factors in a dynamic sequence at alternating intervals), and how to organize a work from the edges inward or outward from the center. He analyzed ways to achieve a sense of volume or fullness, through superimposition or an exploitation of the inherent convexities and concavities of warm and cool color. "Muscular shift and countershift as visible external phenomena," should become, he said, "a specific compositional determinant."[12] The mechanical values of many Old Master paintings ranging from Signorelli to Rubens, Benton believed, were traceable to "an extension of muscular action patterns" and he strove, in his own work, to update this approach for the twentieth century. Whether Jackson ever actually read these articles is not known. (They did go into the clipping collections of his friend Reuben Kadish and his brother Charles.) That he was at least familiar with their diagrams is evident from looking at Pollock's sketchbooks, in which he tried his hand at Benton's formulas. As late as 1937–38, Pollock included in the corner of one drawing a rendering of Benton's arrangement of volumes in and around a central axis in space.

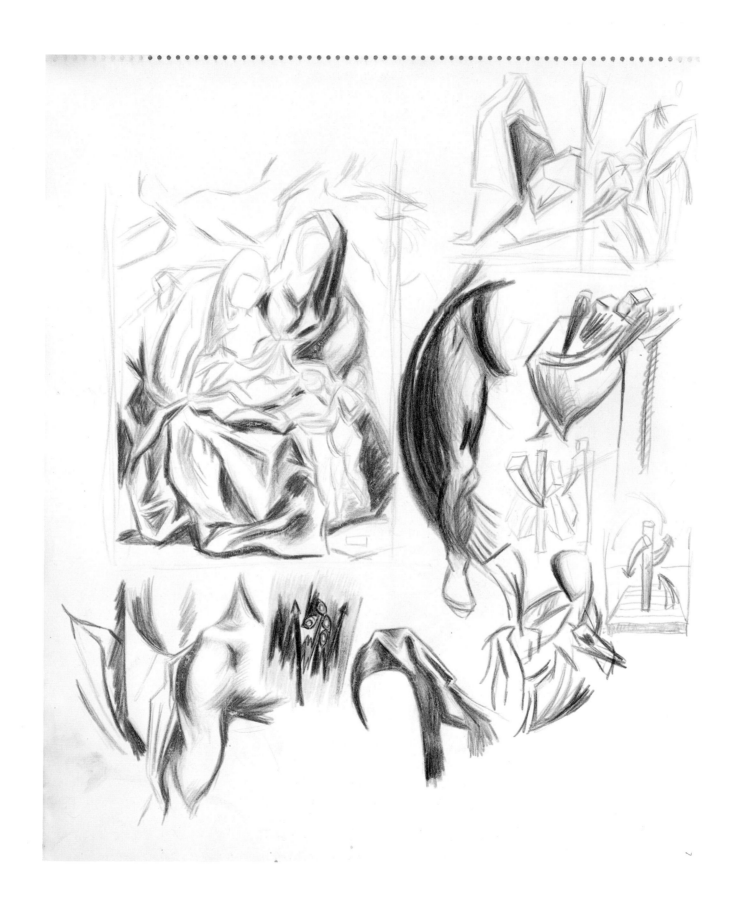

Untitled. *From sketchbook, c. 1937–38, page 7*

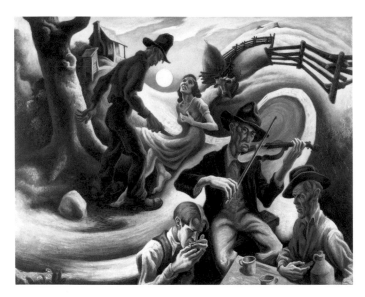

*Thomas Hart Benton.* The Ballad of the Jealous Lover of Lone Green Valley. *1934*

In Thomas Hart Benton's celebrated paintings of the thirties, such as *Arts of the West* (see page 24), or *The Ballad of the Jealous Lover of Lone Green Valley* (in both of which Jackson Pollock, who often posed for his teacher, appears as a harmonica player),[13] he appropriated the oblique spatial organization of Tintoretto, into which he set attenuated El Grecoesque figures in mannered poses. Despite Benton's professed interest in volumetric composition, the exaggerated linearity of his forms often superimposed on his works an obvious two-dimensional pattern. Thus, the "tactile sensation of alternate bulgings and recessions" that Benton proclaimed he sought to achieve was countered by an insistent flatness.

In order for his students to learn to express "the hollow and the bump," Benton encouraged them to actually touch the model, to feel his or her recesses and projections.[14] Also in the Dewey spirit of learning by doing, Benton had his pupils analyze great works in the history of art to understand firsthand their tonal and directional interplay. One of the most important lessons Benton felt an aspiring artist could be taught was how the Old Masters had put together their compositions. Pollock had first engaged in this type of analysis during high school, when he had earnest aesthetic discussions with his friends in their "little studio" in a chicken coop, decorated with postcards of great art, behind Manuel Tolegian's house. After they all moved to New York, Pollock continued to study this way with Reuben Kadish and his brother Sande, at the Frick Art Reference Library and the Metropolitan Museum of Art.

From Tom Benton, Jackson Pollock learned a defined set of standards and precise guidelines to use in order to gain a more sophisticated understanding of the construction of admired masterpieces. In addition to suggesting to his students that they follow his own example and model their compositions first in clay as Tintoretto had done (to get the *feel* of volumes in real space), Benton made it a class requirement to dissect works ranging from Assyrian bas-reliefs to Bruegel, Rubens, and El Greco. This was done by reproducing their planar dynamics in tones of black, white, and gray, or by making a cubic diagram using the study methods of Luca Cambiaso and Erhard Schön (see page 30). Benton had discovered the drawings of these sixteenth-century artists around 1919. Having just rejected the Cubism of Picasso and Braque as "aesthetic dribbling," he proceeded to adapt their actually somewhat similar method to help simplify, "rationalize," and articulate pictorial space. Benton's method of providing a geometric underpinning for a representational composition—by breaking the human figure down into cubes, slabs, and rectangular solids—was illustrated in his articles in *The Arts* and used extensively in the preparation of his major murals such as the "American Historical Epic."

Despite Benton's later assessment that Jackson Pollock did not have a very logical mind, numerous pages from the younger artist's sketchbooks dating just after his study at the League demonstrate an ability to correctly analyze the cubic arrangement of elements in space (see page 30). Benton explained his observation as referring to the fact that Jack had been incapable of creating "logical sequences" in his own work, although somehow he did catch on to "the contrapuntal logic" of formal analysis of existing paintings. "In his analytical work," Benton commented, Pollock "got things out of proportion but found the essential rhythms." At one point, Benton had even shown one of Pollock's diagrams to the whole class to demonstrate that "it was not a copy we were looking for, even a cubistic copy, but a plastic idea."[15]

Friends from the Art Students League recall the frenzied intensity with which the young

Untitled. *From sketchbook, 1933–38, page 5*

Jackson Pollock approached his work there; his process sometimes appeared like a competition between himself and his materials to see who would win out. Horn has described Jackson in "hand-to-hand combat" with his medium, and his friend's great frustration that, despite the muscularity of his process, the results did not look much like Benton's.[16] His teacher confirmed that frequent psychic blocks defied Pollock's attempts at progress. Benton believed, however (contrary to Pollock's conviction of his own deficiencies), that his most difficult pupil was saved by his intuitive sense of rhythmical relationships.

What he had learned in Thomas Hart Benton's design, easel, and mural painting classes Pollock continued to test for a number of years after his stay at the League was over. (After Benton moved to Kansas in 1933, Pollock tried a few classes with other artists, but left because he felt out of place.) Numerous drawings dating as late as 1937 show Pollock still trying to master the compositional principles of past art. Some of these were approached with Benton's faceted Cambiaso-cubist technique, others with a parallel hatching stroke, at times also heavily shaded.[17] Muscle accentuation is prominent, but with the final effect more theatrical than physiologically correct.

Pollock's Old Master studies, for the most part, evince his desire to understand the dynamics of an entire composition as opposed to formulating an in-depth study of a particular figure or section. (Once again, according to Benton, Pollock would have been totally incapable of accurate details.) This type of practice exercise dates as early as 1930–33; a sheet of drawings after Bruegel's *Massacre of the Innocents* attributed to Pollock's art school period was found, long after his death, inserted in a book. One later drawing after Rembrandt exists, as well as several based on Signorelli, about twenty from Rubens, and more than a half-dozen studies of figures from Michelangelo's Sistine Ceiling. Almost all of these have been traced directly to illustrations in monographs Pollock possessed or to which he had easy access. Often, his placement of two or more compositions on a sketchbook page directly reflects the order of illustrations in the well-known art texts published by the mid-thirties. Apparently, Pollock also visited the drawing-study room at the Metropolitan Museum in this period and asked to examine works on paper; however, most of his virtually photographic recall of Old Master paintings was based on studying them in reproduction.

Clearly, Jackson Pollock's interest in past masterworks was colored by his predilection for pictorial drama, not especially by a fascination with religious or any other type of subject matter. Based on the fact that there are more than sixty compositions after El Greco in Pollock's two earliest sketchbooks—the most, by far, devoted to any one master—it would seem that the Spanish Mannerist was a prime exemplar of the type of painting he wanted to emulate. Once again, his teacher probably stimulated this interest (Benton was first attracted to El Greco as a student in Paris); however, we know that Pollock's familiarity with El Greco dated further back, to his California days. One of the 1929 issues of *Creative Art* magazine—which Jackson wrote to Charles that he had studied—included not only a lengthy analysis of El Greco's *Burial of Count Orgaz* of 1586, but also a series of articles on the appreciation of art. In one Ana M. Berry dealt with El Greco's *Resurrection*. In a long caption she analyzed this painting:

> Every figure, every limb, every gesture, every detail, shares in the rising movement: it is sustained by the rhythmic repetition of forms and of gestures and balanced by

Untitled. *From sketchbook, 1933–38, page 1*

Untitled. *From sketchbook, 1933–38, page 9*

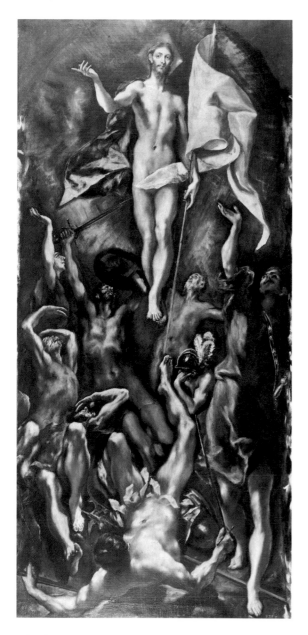

*El Greco.* The Resurrection. *c. 1608*

the extended arms of the fallen figure. Observe how this figure intensifies the height of the rising Christ; and how this is accentuated further by the line of the flagstaff; how the staff and weapons play to each other and to the balance of the two principal figures; how the difference in scale of the figures works into an ideal arrangement of form which, together with the flame-like treatment of the bodies, contributes to the emotional significance of the work.[18]

Her description pinpoints directly those aspects of El Greco that Pollock particularly admired. During the thirties he acquired reproductions of other El Greco paintings, as well as three books on this artist. All were published in 1937 or 1938, and together they include over seven hundred plates. Furthermore, he and his brother Sande visited the Hispanic Society in New York to see the works by El Greco in its collection. It is likely that, when looking at El Greco's swirling compositions, Pollock, an equally agonized and conflicted personality, felt an instinctive kinship.

A similar artist to whom Pollock was also attracted was the American nineteenth-century eccentric Albert Pinkham Ryder. As late as 1944, Pollock still spoke of Ryder as an influence. Under the auspices of Benton's wife, around 1934–35, Pollock had begun exhibiting painted ceramics in the basement of the Ferargil Gallery on East Fifty-Seventh Street. Newlin Price, the director of Ferargil, wrote an "appreciation" of Ryder during those years, and most of the young painters who congregated at Ferargil shared Price's passion. Also, a Ryder retrospective, which numbered twenty-six paintings, was held in 1935 at the Kleeman Galleries just down the street. Pollock's initial exposure to Ryder, however, once again probably predated this experience. The December 1929 issue of *Creative Art* included a feature article on Ryder, and the young Pollock would have been attracted to its characterization of this painter's career as "a lonely voyage of spiritual discovery."

Virgil Barker, the author of the essay in *Creative Art*, emphasized the acute inwardness projected by Ryder onto his subject matter. In his dark and tortured paintings, Ryder limited himself to just a few obsessively worked-over shapes. He submitted nature to an emotive and deeply felt personal transformation by significantly condensing the forms of reality and organizing them so that the rhythmic patterns of the composition proclaim the mood. An artist who was also a very poor technician, like Pollock, Ryder "fought" with his paint; both heaped up dense layers of agitated, expressive strokes of muddy color. Transcending the murkiness and poor condition of Ryder's canvases, Pollock probably experienced feelings of deep rapport when confronted with the older artist's profound understanding of the resonance of myth. Although Benton frequently applied frontier legends and Bible stories to his narrative works, he used these myths in a superficial, anecdotal way. By contrast, Ryder's subjects (also taken from the Old Testament, as well as from Shakespeare, Edgar Allan Poe, Coleridge, and Wagnerian opera) directly confront, in style as well as theme, real issues of human destiny.

It has often been noted that Albert Pinkham Ryder's romantic attraction to the sea, one of his favorite subjects, presents a visual parallel with the writings of Herman Melville, and Melville was one of the few authors Pollock admired. (He later named a pet dog after Melville's most famous character, Captain Ahab.) The direct impact of Ryder on Pollock's developing work can be seen in a comparison of similar marinescapes executed by the latter

Self-Portrait. *c. 1930–33*

*Albert Pinkham Ryder.* Moonlight Marine. *n.d.*

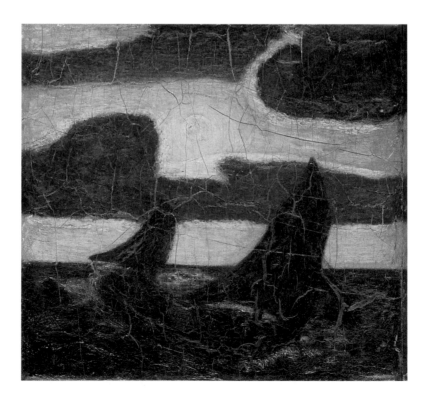

between 1933 and 1937. During these summers Pollock visited the Bentons for a few weeks at their second home on Martha's Vineyard. Despite Benton's contention that Pollock was happy there (Jackson also claimed this was the case in a letter to Becky Tarwater, his "girlfriend" for part of the time),[19] his works created during these vacations look nothing at all like what one would expect a young painter to create on hazy warm days in New England: plein-air compositions of breaking waves, lighthouses, and sailboats. Instead, Pollock's depictions of Menemsha Pond are nocturnal scenes, dark and macabre like Ryder's moonlit marines. The deeply troubled presence of their author can be felt in the somber chiaroscuro and tortured impasto of the Menemsha paintings. Pollock's earliest self-portrait, which he painted sometime between 1930 and 1933, has frequently been compared with Ryder's; however, in many ways his equally Ryderesque seascapes more accurately capture the feelings of isolation and anguish in these two men.

In Benton's estimation, Jackson Pollock's first achievement as a painter was to "have injected a mystic strain into the more generally prosaic characteristics of Regionalism";[20] attributable to his interest in Krishnamurti and Ryder, this tendency was to come to full fruition after Pollock's break from the Regionalist style in the early forties. The more pragmatic Benton worried about Pollock's penchant for the "spooky" myths of the West; Jack's visions of "wild stallions, white wolves, lost gold mines and mysterious unattended campfires," which came out in tales told to Benton's son, T. P., apparently unnerved his teacher.[21] A dutiful student, Pollock set off, when school was out, in search of more realistic material, emulating Benton's bumming trips to get to know America and its people. One such excursion led the young artist to write home, "I quit the highway in southern Kansas and

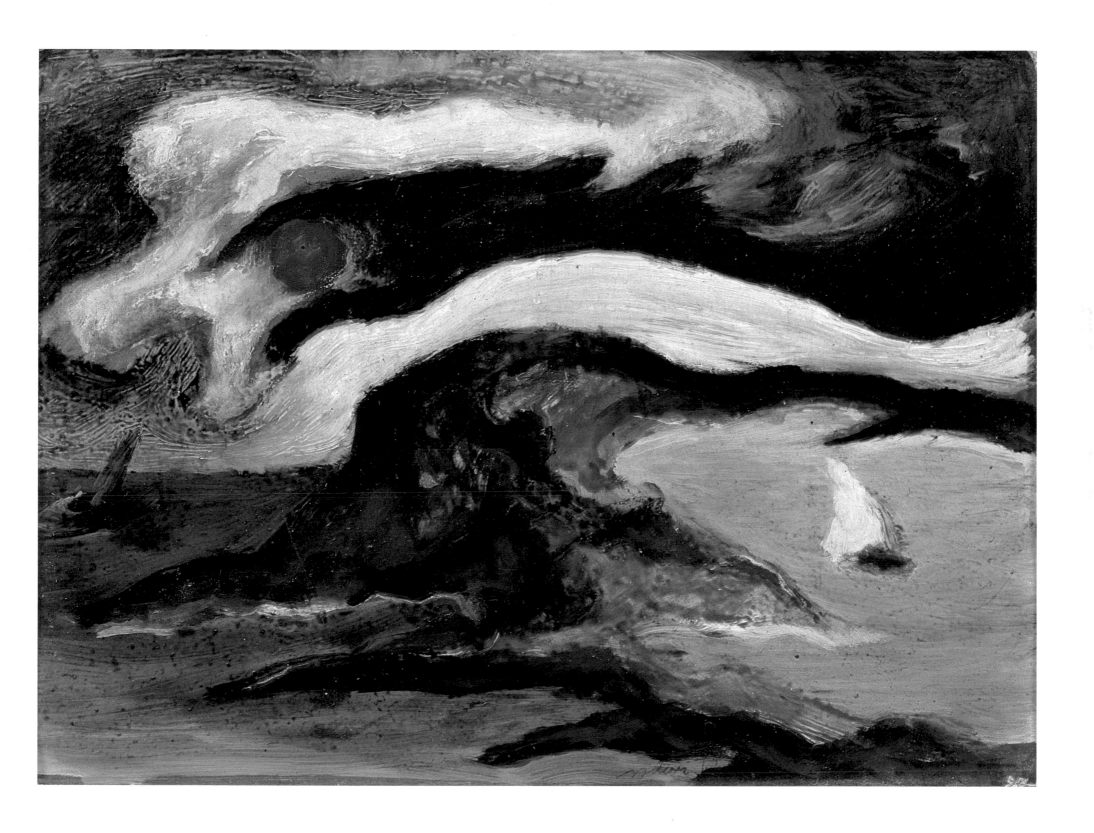

T. P.'s Boat in Menemsha Pond. *c. 1934*

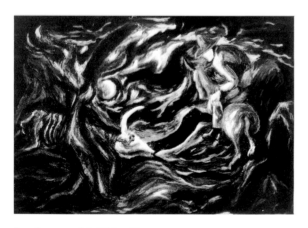

Landscape with Rider II. *1933*

grabbed a freight—went through Oklahoma and the Panhandle of Texas—met a lot of interesting bums—cut throats and the average American looking for work—the freights are full, men going west men going east and as many going north and south a million of them."[22] In his letters Pollock described how he had experienced hunger, a few short stints in jail, seen Negroes playing poker and shooting craps, and met miners and prostitutes. All, he said, "gave swell color," but surprisingly little in Pollock's early oeuvre reflects these events. No sketchbooks from this period, before 1933, remain, and very few of the pages in his sketchpads of a later date illustrate any type of direct visual impression. In the early thirties, Pollock made some lithographs when, as a member of the Art Students League, he had access to its graphics workshop. A number of lithographs done between 1934 and 1937 have survived in the collection of their printer, Theodore Wahl, and of all of Pollock's early works (except for a few gouaches and watercolors) only these prints that depict farm activities—plowing, stacking hay—and other themes of local interest adhere closely to his firsthand experiences.

Several of the prints Pollock pulled under the direction of Wahl relate to oil paintings done in the same time period. One, depicting a cowboy gazing at a steer carcass, Pollock did in at least two oil versions, both now lost. Known from photographs, these were painted on differing supports: one on canvas, one on tin. Although it is impossible to be sure which came first, the sketchy immediacy of the lithograph differs radically from the oils. On the piece of tin, Pollock greatly simplified the major shapes. In the canvas version, however, he

transformed a straightforward, everyday scene into a nocturnal meditation on death. The writhing cloud forms now dominating a spectrally lit sky mimic not only Ryder's moonlit marines, but also El Greco's stormy, phosphorescent views of Toledo, used frequently as backdrops to scenes of the Crucifixion. The attention of the lone mounted figure in Stetson hat is more boldly riveted on the animal bones.

Pollock's early oils, which fit thematically the designation "American Scene," all measure approximately 24 by 30 inches, the standard size required of painters working in the 1930s for the WPA. The Fine Arts Projects of the Professional and Service Division of the Works Progress Administration—organized by Franklin Roosevelt in the fall of 1935—were set up to provide economic opportunities for a group especially hard hit by the depression. After leaving the Art Students League, Pollock was unable to get any work except a janitorial job, which he shared with his brother Sande at a children's school where Charles taught. Their income was so meager that they had to supplement it by stealing from pushcarts. Following a brief stint cleaning statues for the Emergency Relief Bureau, Jackson passed certification for the WPA (proving he was a bona fide artist with no source of income), and although frequently disaffected from the kind of work he was expected to do, he managed to stay on the WPA's payroll, except for a few short breaks, from August 1935 until its demise in 1942. He began in the Mural Division, which required long hours of on-site participation. Pollock soon managed to switch to the Easel Section, which required the submission of only one painting a month for allocation to a government building.

Artists working for the WPA were not expected or encouraged to create technically innovative or strikingly original works. The approved style focused on representational subject matter depicting local scenes, painted with very conventional color, modeling, and tone, and with simplified shape. Often, WPA artists tried to express their sympathy and solidarity with other impoverished workers and, in Pollock's extant 24-by-30-inch canvases, such as *Cotton Pickers* (see page 37), we can see how he attempted to fit that mold. Pollock's most interesting work of the mid-thirties is a different size, however; WPA artists could do whatever they wanted when not working for the government. Free of strictures, Pollock could allow his private temperament to dominate his other paintings, but most of the works of this period, such as his 1934–38 canvas *Going West* (see page 38), still fall under the broad designation of the Regionalist style. What *Going West* noticeably lacks is Benton's specificity of detail and incident. In this painting, which depicts a frontier wagon train pulled by mules, Benton's teaching principles and Pollock's admiration for his style are evidenced in other ways, most obviously in Pollock's linkage of the shapes of his composition—probably derived from a family photograph of a bridge in Cody—into a two-dimensional rhythmic pattern that loops around and turns back in on itself.[23] Unlike the works of his mentor, however, this picture has an emotional atmosphere that is more palpable than its tactile sensations. Also akin to the works of Ryder, *Going West* is not so much a landscape, but rather an inscape, presided over by the ubiquitous moon, and the dimly felt presence of another layer of secondary or hidden imagery charges the scene with a tension that relates it to similar latencies in the work of Vincent van Gogh.[24] In *Going West*, Pollock's lone rider continues his solitary, obviously metaphorical trek into lands unknown.

Pollock tried to isolate the tentative expressiveness of *Going West* from any dependence on theme in several works he created by 1938. In these paintings he concentrated more

specifically on surface dynamics. Although vestigial imagery remains in *The Flame* and *Composition with Figures and Banners* (see pages 39 and 40), in both the powerful emphasis on flickering lights and darks and interlocking twisted shapes all but obscures the ostensible subject. Once again, Benton's lessons have not been forgotten despite Pollock's increasing lack of interest in anecdotal subject matter. In both of these paintings Pollock put to good use his teacher's requirement that students learn to manipulate the spiral dynamics of the Mannerist *figura serpentinata*. Another untitled and even more nonrepresentational composition from the same time period (see page 41) is less dependent on this kind of torsion, prophetically consisting of a densely clotted chaotic jumble of brushstrokes and palette-knife jabs. These now radically anti-Regionalist pictures Jackson described to Charles in 1940 as "pretty negative stuff." "I haven't much to say about my work and things—only that I have been going thru violent changes the past couple of years," he wrote to his eldest brother, who had moved to Detroit.[25]

Although Pollock does not say much more about it himself, his ever-worsening psychological condition was fully chronicled by Sande, who in a letter to Charles described Jack's increasing emotional instability signaled by his cyclical alcoholic binges. He informed Charles that their younger sibling's maladjustment had deeper roots than "the usual stress and strain" of transition to adulthood; "afflicted with a definate [*sic*] neurosis," their little brother, it had to be recognized, was "mentally sick." In the summer of 1938, when the WPA had refused Jackson permission to leave New York in search of new material for his paintings, he had snapped, ending up in a psychiatric care unit, where he stayed a number of months. Sande also told Charles that, after his release, Jack underwent a decisive and radical artistic change. In July 1941, describing Jackson's new paintings, such as *Birth* (see page 22), Sande explained that Jack had finally "thrown off the yoke of Benton." He was now doing work which was "creative in the most genuine sense of the word," related to Max Beckmann, Orozco, and Picasso. Despite the problems he and his wife encountered in trying to take care of Jack, Sande concluded this letter with an optimistic prognosis, "We are sure that if he is able to hold himself together his work will become of real signifigance [*sic*]."[26]

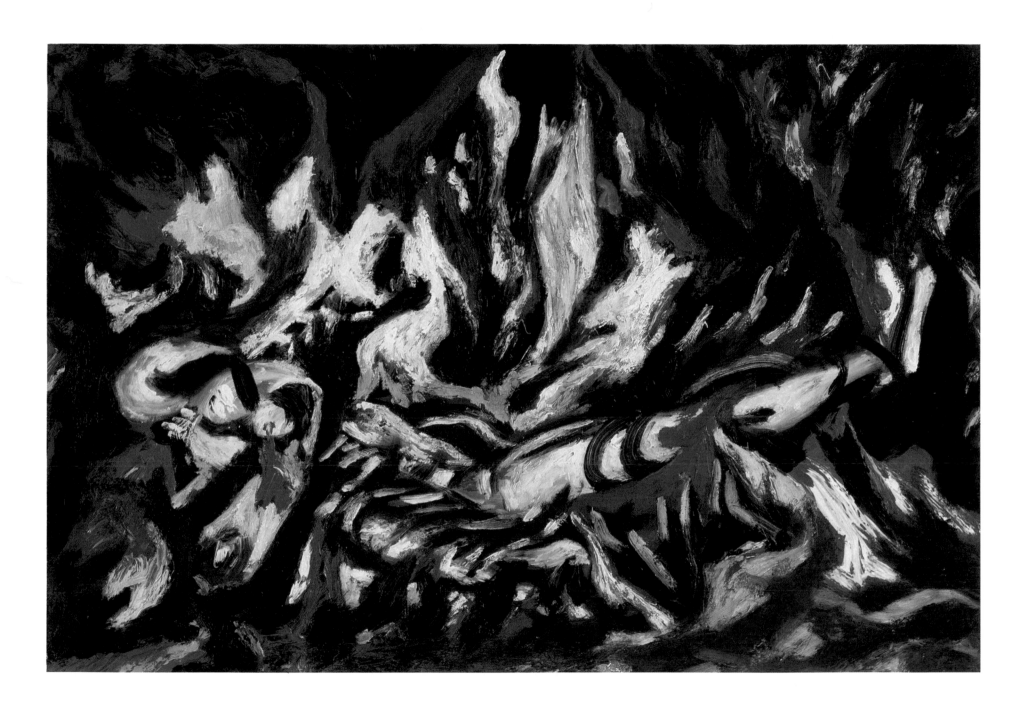

The Flame. *c. 1934–38*

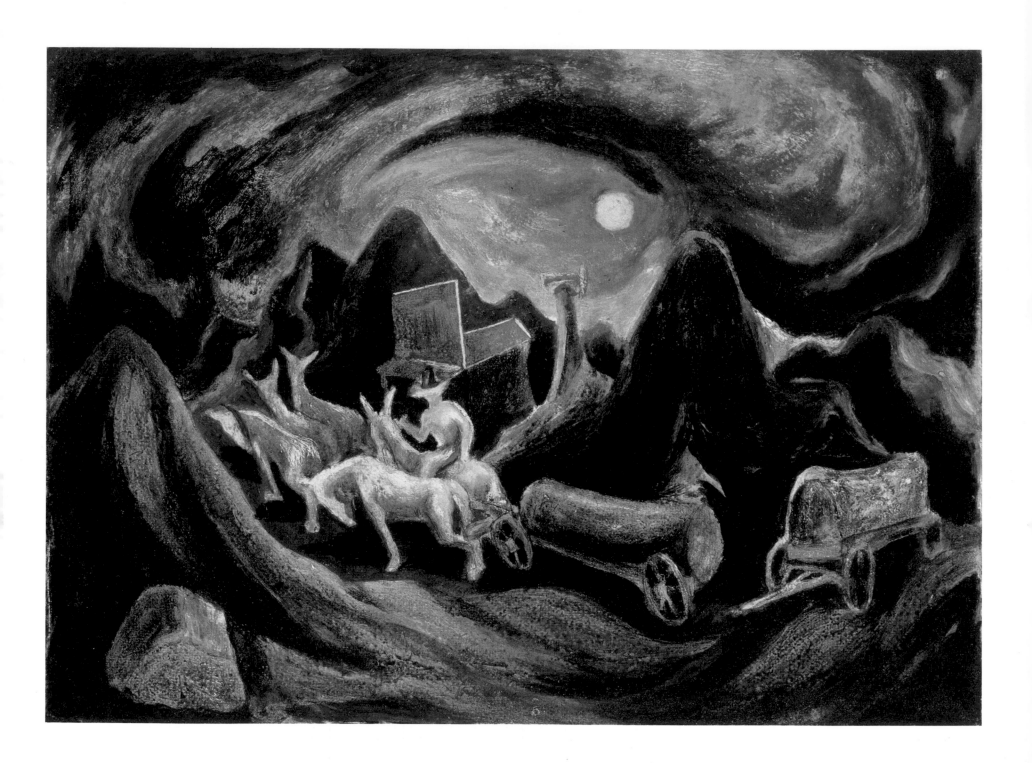

Going West. *1934–35*

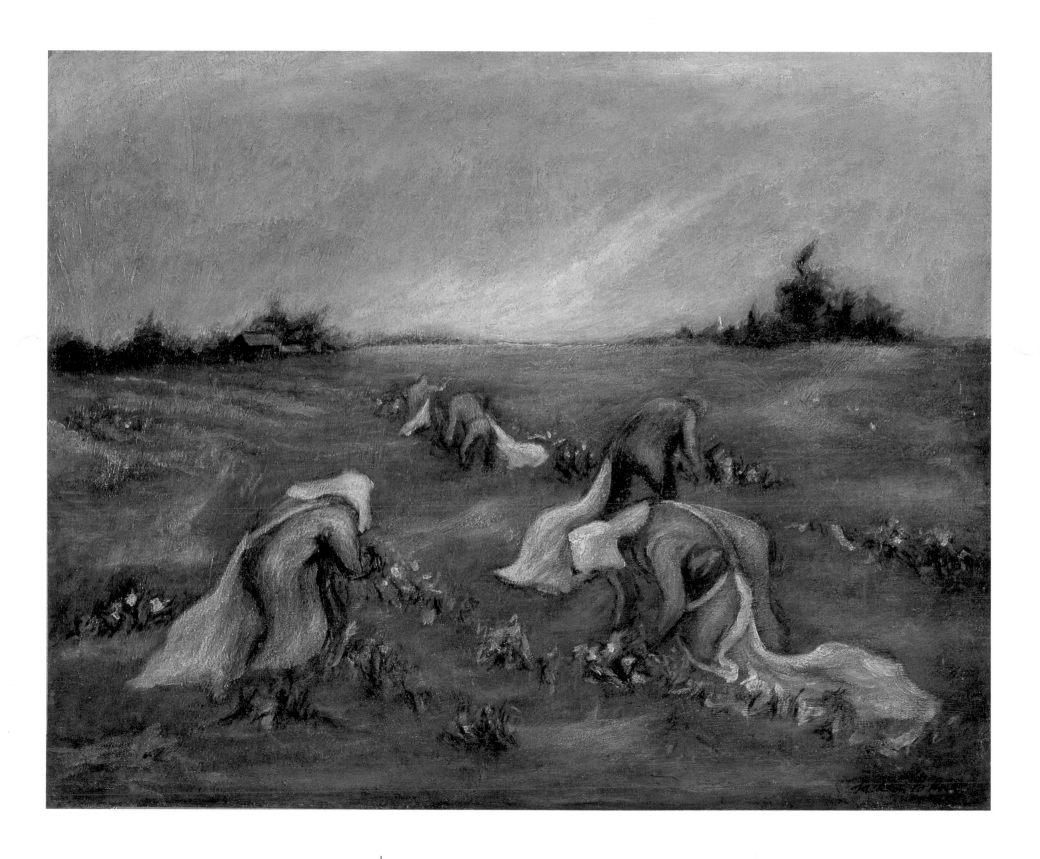

Cotton Pickers. *c. 1935*

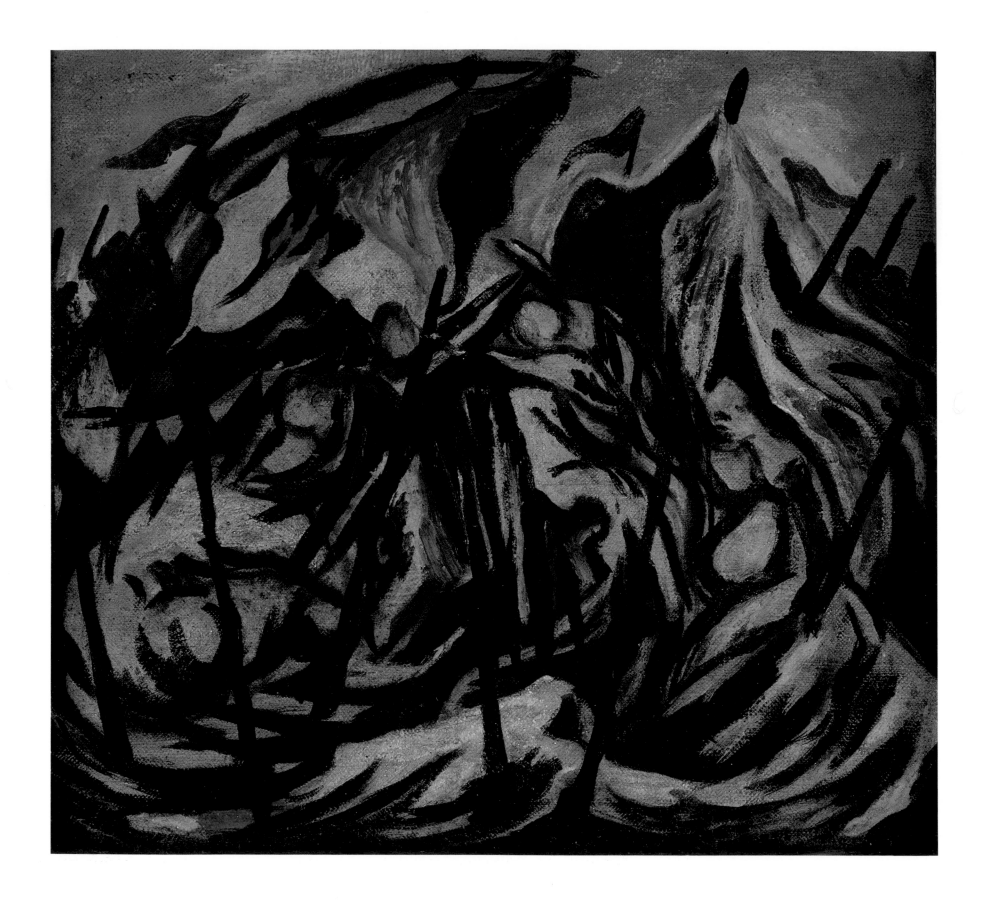

Composition with Figures and Banners. *c. 1934–38*

[Overall Composition]. *c. 1934–38*

Untitled. *c. 1939–40*

# THREE

# *Gods of the Modern World*

... when I say artist I don't mean it in the narrow
sense of the word....
         —Jackson Pollock to his father, 1931

By 1937/38, Jackson Pollock's alcoholic depression had become so acute that his friends and family were able to persuade him to seek professional treatment. Many years later, some of the doctors at the Westchester Division of New York Hospital, where Pollock was treated for four months, remembered him as an emotionally immature young man in need of a lot of "calming down," searching "hungrily" for an identity. Painting, several recalled, seemed not to be an intellectual activity for him; rather it was a skill requiring mastery of motor functions, one which could provide him an immediate outlet for expression of his thoughts and feelings, as well as an almost instantaneous sense of achievement. Pollock, they agreed, desperately needed that sense to bolster his fragile ego.[1] As additional letters from Sande to Charles indicate, not long after his release from the hospital, Jackson fell back into the old destructive patterns.

Pollock's stay in Westchester had been prompted in large measure by concern for his welfare on the part of a friend named Helen Marot,[2] an older woman who taught at the City and Country School, where he and his brothers worked. A neighbor of Benton's at Martha's Vineyard, Marot was the companion of City and Country's director, Caroline Pratt,[3] and also an editor of *The Dial* magazine. She moved freely in psychological circles in New York through another friend, Mrs. Cary Baynes. Baynes, under the aegis of the Analytical Psychology Club, was involved in a Bollingen Press project to translate into English and publish the writings of the famous Swiss psychoanalyst Carl Gustav Jung. The profoundly disturbed twenty-seven-year-old artist Marot had befriended was introduced to another young, also as-yet unknown, but soon to be important Jungian therapist, Dr. Joseph L. Henderson. Their sessions together began in 1939. In an interview conducted toward the end of his life, Pollock, who had undoubtedly first learned about Jung from Marot, made his much-quoted comment, "We're all of us influenced by Freud, I guess. I've been a Jungian for a long time."[4]

Ignoring the usual doctor-patient confidentiality, Dr. Joseph Henderson has written and lectured extensively on his sessions with Jackson Pollock, in conjunction with his sale of Pollock's "therapeutic" drawings, used by the two of them as a means of provoking

Untitled. *1939–40*

Untitled. *1939–40*

meaningful conversation during Jackson's treatment. Henderson, himself an analysand of Jung, apparently did not actually psychoanalyze Pollock in any depth; rather, he offered "vocational" support, encouragement, and advice about how to deal with the accelerating creative blocks which were the cause of Pollock's alcoholic binges. For a man clearly driven by his work as Pollock was, drinking provided the only outlet for aesthetic frustration. Henderson has stated that he found the emotionally unstable artist not only introverted, impatient, and inarticulate, but also a man with "strong male/female sides," sometimes almost schizophrenically swinging between periods of violent agitation and "states of paralysis or withdrawal." As Sande related to Charles, Henderson tried to "guide Jackson intelligently" in order to help him to find himself, primarily by demonstrating acceptance and empathy for what the tortured young man was obviously going through. " 'Cure,' in his case," Henderson later wrote of Pollock, "really meant finding his unique identity as an artist."[5]

The drawings Jackson Pollock brought to Joseph Henderson over a period of eighteen months are extraordinary, and not only from the psychological point of view, which has prompted extensive interpretation by many recent writers, but also as a catalogue of the diverse directions Pollock had begun to explore in order to "throw off the yoke of Benton" and create (as Sande put it) in a more "intense, evocative and abstract" way.[6] When they were shown to him, Henderson decided that these works were illustrative of Pollock's psychological experiences, "demonstrating phases of his sickness" and "his feelings about a possible cure," but perhaps someone with a more sophisticated artistic knowledge would have recognized in Pollock's sketches that, as opposed to an abstruse Jungian language or the totally unconscious production of personal symbolism, they exhibited a strong dependence on imagery borrowed from more famous artists. The two painters whose work Pollock passionately admired at the time were José Clemente Orozco and Pablo Picasso.[7]

Henderson admits that he did not specifically ask Pollock to try to bring to the surface his unconscious thoughts and feelings in these sketches; rather, he looked at drawings that the young artist was already making, often as studies for larger works. As a therapist, Henderson believed he and Pollock could use these as "bridges to communication." The psychiatrist has also acknowledged that he tried to push his patient in certain artistic directions, which Pollock "fought tooth and nail." Thus his diagnosis of greater "psychic regeneration" made toward the end of Pollock's treatment (which Henderson based on Pollock's acceptance of the suggested "ordering devices"—circles, crosses, mandalas, etc.) now seems somewhat suspect.

In his year and a half of treatment, Jackson Pollock apparently brought to his psychiatric sessions a total of eighty-three drawings on sixty-nine different pages, of which thirteen had representations front and back. Although some were large and more fully developed, most were crowded with a great many small images, often having little or no thematic relationship, packed into the same space. Animal or monster motifs predominate, particularly variations of the horse and bull, two creatures already part of Pollock's "cast of characters" in his "Ryderesque" paintings of the West. Now, however, these animals change form and interact with each other in ways that are strongly suggestive of the widely reproduced sketches for *Guernica,* Picasso's 1937 masterpiece. The impact of Picasso—with whose innovativeness Pollock was obsessed between 1939 and 1945—seems to have developed as a natural step following his increased interest in the paintings of the Mexican revolutionary muralists. The

Untitled. *c. 1939–40*

*Pablo Picasso.* Corrida. *1935*

latter, Diego Rivera, David Alfaro Siqueiros, and Orozco, worked extensively in the United States in the depression decade, and preliminary to understanding Picasso's potent influence on Pollock, we should first examine the liberating role the Mexicans played in Pollock's break with Benton.

Frequently quoted in the literature on Pollock is a comment once made by a friend from the Art Students League, Peter Busa, that Benton had taught them about the ideals of beauty, but the Mexicans showed Jack that "great art could also be ugly."[8] In fact, Jackson Pollock was well aware of the Mexican muralists before his study with Benton. In a letter to his brothers dated October 1929, Jackson lauded Rivera's work, explaining he had become acquainted with it at Communist meetings. Pollock mentioned seeking out the January 1929 issue of *Creative Art* because of its articles on Rivera.[9] Another artist who spent the late twenties and early thirties in California recalled that the avant-garde on the West Coast at that time thought that "more 'modern' one could not be" than Rivera. Although realistic and disseminating the ideals of Marxism, Rivera's murals were so bold and vigorous in color and shape, and so crowded and compacted that their emphasis on surface seemed stylistically radical.

On one of his trips back home, Jackson Pollock probably viewed the mural *Tropical America*, painted in 1932 by Siqueiros on Olvera Street, in Los Angeles. This mural was installed with the help of a team of local painters that included Reuben Kadish and Jackson's brother Sande. That summer Pollock certainly saw Siqueiros's paintings at the Chouinard School, also in Los Angeles. Most of *Tropical America*, which Jackson had written to Sande that he was "anxious to see," was later removed because of its political content. That Jackson did view it (at least at some stage) is likely, as echoes of its imagery appear in his later work. Kadish believes that there is no question that Pollock knew the work through discussions with his brother, and reproductions were also available.[10] The composition of *Tropical America* centered around a crucified peon,[11] above whom was a hieratically displayed eagle with prominent talons. Both bird and man were flanked by primitive objects and designs from South America's Pre-Columbian past. Just a few years after this mural was painted, Jackson Pollock took part, along with his brother and Kadish, in the experimental workshop Siqueiros set up in New York near Union Square, and as a result of what went on there, Siqueiros's primary influence on him was to be technical rather than stylistic or iconographic. In any case, Jackson repeatedly told Kadish and others too that, in his estimation, " the *real* man" was Orozco.[12]

*David Alfaro Siqueiros.* Tropical America. *1932. Detail, mural*

Composition with Ritual Scene. *c. 1938–41*

With remarkable consistency over a long period of time, Pollock was also to say that, as far he was concerned, the greatest painting in North America was Orozco's mural *Prometheus*, at Pomona College in Claremont, California. (He expressed this opinion even to the sculptor Tony Smith, a friend he made after his engagement with "Mexican" subject matter had long been over.) Before going to New York, Jackson saw *Prometheus* (in June of 1930) in the company of his brother Charles. Based on later comments by both, this viewing must have been akin to a religious experience. Located in an arched space above a massive fireplace at the far end of Pomona's Frary Dining Hall, Orozco's depiction of the Titan who gave fire to mankind against the wishes of the Greek gods was described in the Los Angeles papers as "a sublime conception," exuding (like the frescoes of Michelangelo that inspired it) an intense power of expression which literally energized the wall. The architect of Frary Hall told *Time* magazine that when he first saw the painting, it seemed to him that his building would fall if Prometheus moved.[13]

Pollock's fascination with the heroic style of the Italian High Renaissance was such that he often claimed he had moved to New York to learn to sculpt like Michelangelo. This instinctive attraction to Michelangelo paved the way for Jackson's enthusiastic reaction when he saw Orozco's giant, and his positive response to the agony on the face of Prometheus grasping toward the tongues of flame, his muscles straining to fit into the contorted space. Pollock may have continued to study this work in New York, as a number of its details were reproduced in 1932 in a monograph written by Orozco's American dealer, Alma Reed. Reed ran a gallery in New York called Delphic Studios, where Benton showed as well. Reed had succinctly characterized her client the year before in an article in *Creative Art:* "If Orozco were given to phrase-making, his definition of art undoubtedly would be: 'First, emotion; second, the power to communicate emotion; and last, the perfection of ways and means of communicating emotion.'" In this essay she interpreted the Pomona mural as a metaphor for the travails of the truly creative artist, "whose face and whose hands are inevitably burned for every new gift brought to humanity."[14]

Because of Benton's close association with Reed, Jackson Pollock was likely to have been aware of her comments. Certainly, whether it was pointed out to him or he realized it on his own, Pollock seems to have understood Orozco's achievement of a personal interpretation of an archetype. (Heroes similar to Prometheus can be found in myths worldwide; Orozco was also to chronicle the exploits of Quetzalcoatl, an Aztec/Toltec counterpart.) In the same issue of *Creative Art* that Pollock obtained to read about Rivera, he would also have seen Orozco's essay, "New World, New Races, New Art." Orozco's blazing declaration in this text that it was the "unavoidable duty" of the modern artist to "produce a new art in a new spiritual and physical medium" would undoubtedly have impressed an aspiring painter, and the brilliance of the fire which threatens to consume the giant's hands in *Prometheus* may later have provided inspiration for Pollock's *The Flame* (see page 39). This work of c. 1934–38 is usually acclaimed as one of his earliest forays into semiabstraction, and it is the work he chose to submit in 1942 when he participated in his first major group exhibition.

During the fall/winter of 1930/31, soon after his enrollment at the Art Students League, Pollock had the opportunity to observe Orozco at work; at that time, both his teacher and the Mexican muralist received simultaneous commissions to decorate Manhattan's New School

*José Clemente Orozco.* Prometheus. *1930. Center panel, mural*

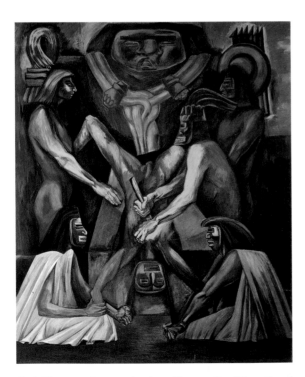

*José Clemente Orozco.* Ancient Human Sacrifice. *Panel 3 in* The Epic of American Civilization. *1932–34*

for Social Research. Pollock did "action posing" for Benton on site; since Orozco was painting only one floor away, Pollock easily extracted an introduction to his idol. Pollock apparently was also present at a number of dinners at the Bentons' when Orozco was in attendance. The frescoes Orozco created for the New School were, unfortunately, far less dynamic than *Prometheus*. As a result, with the possible exception of the similar horizontal organization of a c. 1938 *Composition with Ritual Scene*, for Pollock this group of paintings seems to have had little artistic impact.

The loudest echoes of Orozco, which reverberate strongly not only throughout Jackson Pollock's oils of 1938–41, but are seen in his "psychoanalytic" drawings as well, stem from the Mexican's more important mural cycle at Dartmouth College—*The Epic of American Civilization*. Previously, it was thought that Pollock never actually saw these murals, but recent evidence indicates that he did make a visit to Hanover, New Hampshire—mentioned once by Sande—in 1935 or 1936. There, Jackson must have examined at length Orozco's decorations for the Baker Library, executed during the Mexican's two-year stint as artist-in-residence. Upon their completion in 1934, these paintings were extensively illustrated in a variety of books and articles. Their coverage in *The New York Times* probably stimulated the Pollock brothers to undertake the Hanover trip.

Despite the fact that they looked nothing like his own compositions, Thomas Hart Benton frequently praised the works of the modern Mexicans to his students, citing the fact that Orozco, Rivera, and Siqueiros had initiated, "a profound and much-needed redirection of art toward its ancient humanistic functions."[15] Nowhere was the truth of this statement more evident than in Orozco's Dartmouth cycle, whose subject was an epic comparison of the development of civilization in North and South America pre- and post-Columbus. In these murals, Orozco provocatively juxtaposed themes of modern machinery and warfare with scenes of Aztec soldiers and ancient human oblation. Utopian visions from both periods contrast ways in which mankind has sought to control the environment, and Orozco repeatedly pointed up the parallels between Christ and Quetzalcoatl (revered by the Aztecs as the Great White God of Culture) to demonstrate humanity's unchanging aspirations.

Jackson Pollock's third extant sketchbook from the 1930s dates to the last two years of the decade, after his stay in the hospital. In it are eighteen furiously created pencil drawings, of which the majority are closely related to themes from Orozco's work at Dartmouth. Most similar is Pollock's adaptation of a semiabstract style to express varying combinations of skeletal, muscular, and mechanistic forms. One page prominently features a darkly shaded three-dimensionally projected cross lifted directly out of Orozco's triumphant depiction of the resurrected Christ at Baker Library. Only a faint reflection of Christ's legs remains in Pollock's drawing, and he radically cut down and rearranged the elements strewn around the cross, but the derivation from Dartmouth is unquestionable.

Similar to this drawing, but stemming this time from Orozco's pungently satirical Baker panel *Gods of the Modern World*, are two sketches that Pollock gave to Henderson which center around a hieratically disposed human cadaver. These may have been preparatory notes for *Bald Woman with Skeleton* (see page 52), a canvas of c. 1938–41; the adoption of the main motif from Baker Library is even more obvious in the larger painting. In addition, several loose drawing sheets from this same time period depict somewhat fleshier figures in poses of

Untitled. *From sketchbook, c. 1938–39, page 4*

Untitled. *From sketchbook, c. 1938–39, page 19*

*José Clemente Orozco.* Modern Migration of the Spirit. *Panel 14 in* The Epic of American Civilization. *1932–34*

*José Clemente Orozco.* Gods of the Modern World. *Panel 12 in* The Epic of American Civilization. *1932–34*

supplication which may have grown out of Pollock's ruminations on the theme of *Prometheus*. As noted by Reuben Kadish, Pollock went "way overboard" on this mural, and Kadish has confirmed that, without question, many of Pollock's drawings bear the stamp of his enthusiasm for Orozco's work at Pomona.[16] In one sketch done in pencil and colored crayon right before the onset of his treatment by Henderson (see page 53), Pollock disposed a rising group of bodies to the right of a much larger bearded figure. Although turned in a profile pose, this figure reaches one arm overhead in a gesture that mimics Orozco's Titan.

Apparently, it was in the paintings Pollock executed right after his hospital stay that he made his most complete attempt to work through his admiration for contemporary Mexican art and to express the close emotional rapport he felt with Orozco. In these, Pollock's manipulation of another artist's material went well beyond the formulas for analysis of Old Masters learned in Benton's class. For instance, in the aforementioned *Composition with Ritual Scene*—such a propitiatory sacrifice is also included in the designs at Dartmouth— Pollock elaborated his fascination with the Mexican's use of brutal subjects of "controlled" violence dredged up from the more primitive past.

A related work, *Naked Man with Knife*, appears to have been Pollock's own exaggerated interpretation of Orozco's 1923–24 exclamatory panel *The Two Natures of Man*, painted for the Escuela Preparatoria in Mexico City—a work Pollock certainly never saw, but which was well-known in reproduction. In both, an elemental Cain and Abel situation is terrifyingly enacted, with a bent-over muscular nude male stabbing a prone victim with one arm upraised. In each, the triangular glint of the knife is repeated in the directions taken by the thrusting, interlocking forms that comprise the claustrophobic background. The compositional similarities are so striking between these two works that it is hard to believe that Pollock had not first seen an illustration of Orozco's design for the Preparatoria. Despite the more upright stance of Pollock's stabbing figure, the derivation from Orozco seems more convincing than suggestions that he had in mind the "Kouros" figure from Picasso's 1907 *Demoiselles d'Avignon* (see page 70). That Pollock was extremely interested in the scenario he developed in *Naked Man with Knife* can be inferred from the fact that two smaller works exist that appear to be studies for this painting. (In one of these, a gouache, the vanquished figure is clearly female.)[17]

Although very different from *Naked Man with Knife*, three other canvases executed between 1938 and 1941 also appear to stem from Pollock's submersion in the world of Orozco. The feathered serpent symbol of Quetzalcoatl (and/or the snakes that banded together to form the raft that took him away from the Aztecs) figure prominently in these works—*Composition with Serpent Mask, Circle*, and *Composition with Woman* (see page 55). All were painted in intense, shrill colors reminiscent of Mexican and American Indian folk art, and arrows, zigzags, lightning and other ideographic symbols abound in their more schematic designs. Interest in the folk productions as well as in the archaeological findings of their native land was an important factor in the work of all three of the Mexican muralists. Rivera amassed an important collection of pre-Cortesian sculpture, and all three prided themselves on the use of authentic details from their heritage. Pollock's own passion for primitive North American art is substantiated by the accounts of his frequent trips in the thirties and early forties to New York's Museum of Natural History and Museum of the American Indian. He also attended a series of exhibitions at the Museum of Modern Art during these years

Bald Woman with Skeleton. *c. 1938–41*

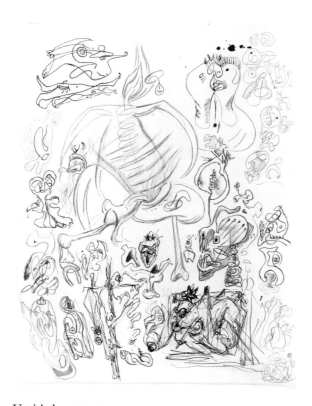

Untitled. *1939-40*

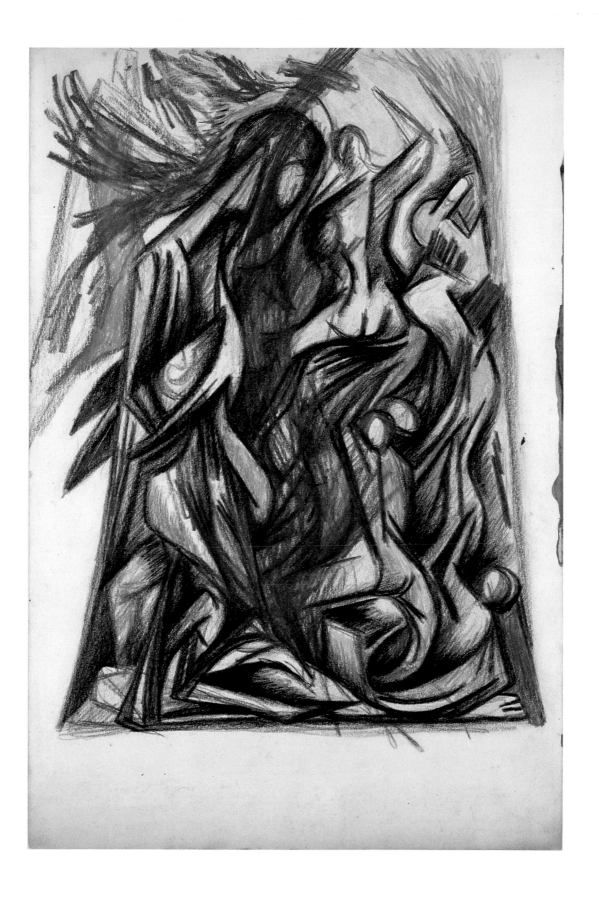

Untitled (Figure Composition). *1933-39*

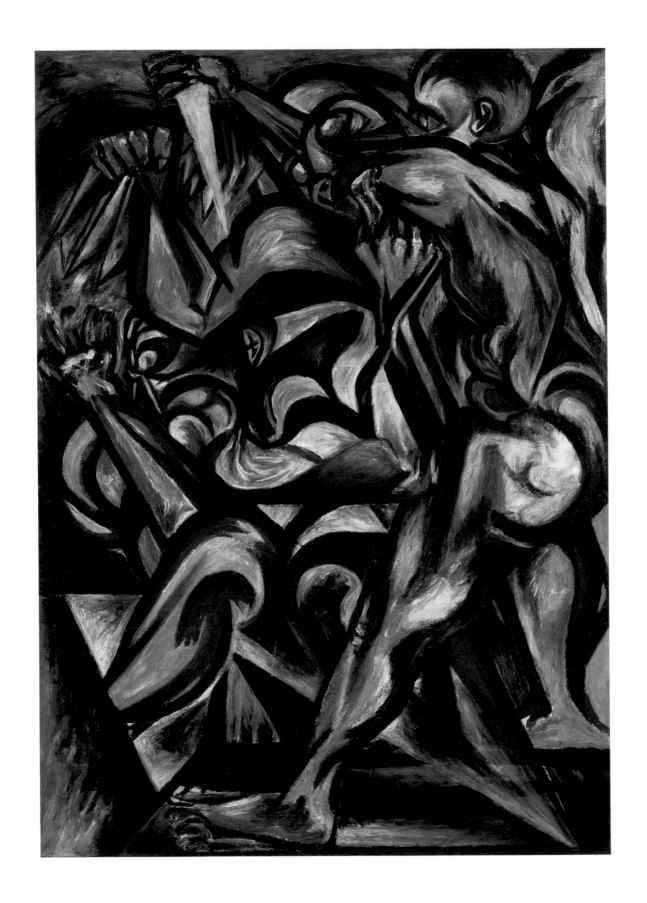

Untitled (Naked Man with Knife). *c. 1938–41*

*José Clemente Orozco. Preparatory painting for* The Two Natures of Man. *1922 (not extant)*

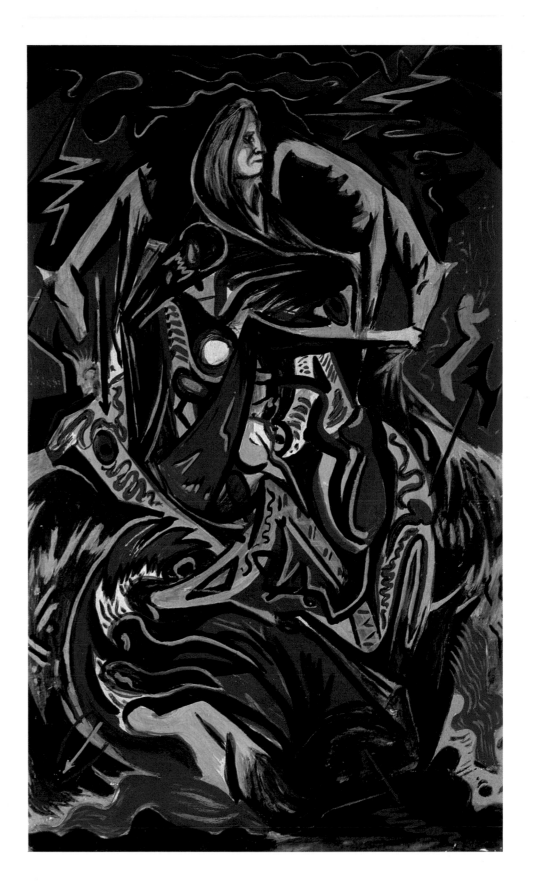

Composition with Woman. *c. 1938–41*

*José Clemente Orozco.* Aztec Warriors. *Panel 4 in* The Epic of American Civilization. *1932–34*

uncovering the "American" sources of modern art and focusing on ethnographic objects of the Western Hemisphere. (We know from his second Jungian psychiatrist, Violet Staub de Laszlo, that he went through the Modern's 1941 show "Indian Art of the United States" with her several times.)[18]

Orozco, Rivera, and Siqueiros utilized primitive imagery to revivify the Western art tradition, to provide a ready means toward greater expressiveness and simplification, and as a route for the exploration of archetypes and ancient motivations. Observing this in Mexican painting either rekindled or intensified Jackson Pollock's fascination with what he considered to be his own indigenous roots: the art of the native inhabitants of the American Southwest. (This complemented Pollock's vision of himself as a cowboy.) While in Los Angeles, Pollock also visited the Southwest Museum with Kadish. Sometime before 1935, Jackson and his brother Charles—both nostalgic for the Western lifestyle they had left behind—purchased from second-hand bookstores in New York a number of illustrated annual reports put out in the 1890s by the Smithsonian Institution's Bureau of Ethnology. Throughout his life, Jackson kept these twelve volumes stored under his bed. According to several of their wives, all five of the Pollock brothers shared "a certain feeling for Indian art and life," and the second oldest, Marvin Jay, began to collect and document Indian rugs and blankets in the mid-1920s. Apparently, Jackson looked at these often, becoming so interested in them that he later persuaded Jay to trade the whole lot for a painting (which his brother never got). Kadish, who was present on a number of occasions when these artifacts were taken out and examined, maintains that their motifs provided definite "reference points" for many of Pollock's pre-1945 works.[19]

In the early twenties, the four youngest Pollock boys had investigated Indian mounds and cliff dwellings near Phoenix, Arizona, located not far from the home of the Minsch family, for whom their mother worked briefly as housekeeper. Like his brothers, Jackson prided himself on knowing the West as it really was, and he expressed his understanding of the native American aspect of this heritage in an interview in 1944. "I have always been impressed with the plastic qualities of American Indian art," Pollock stated, adding, "The Indians have the true painter's approach in their capacity to get hold of appropriate images, and in their understanding of what constitutes painterly subject matter." "Their color," he said, "is essentially Western, their vision has the basic universality of all real art." Jackson went on to comment, however, that he wasn't sure that references to Indian art in his own current work were intentional; they were probably more "the result of early memories and enthusiasms."[20]

Perhaps this latter part of the statement (prepared, as was the entire interview, with the help of a friend and business associate, Howard Putzel)[21] *was* true by 1944; in many of Pollock's drawings, oil paintings, and gouaches of five or six years earlier, however, the calculated presence of Indian imagery cannot be disputed. In *Composition with Woman* (significantly, the title was not Pollock's), North American Indian signs and symbols are clearly intermingled with probable iconographic references to Orozco. Its most prominent image is a profile face with long "hair" that seems to preside, like Helen on the ramparts of Troy, over a scene of chaos and destruction. Although at first glance this head does resemble a woman, a close correlation can also be seen to the Aztec warriors in flowing headgear in Orozco's Baker Library. The wavy lines floating over Pollock's "female" head could very well stem from Quetzalcoatl's snakes.[22]

Untitled (Studies). *c. 1938–41*

Untitled (Dancing Shaman). *1939–40*

A substantial role in Pollock's interest in American Indian subject matter was played by his well-documented affinity with the shaman, or witch-doctor, whose duties included tribal artist. That Pollock was quite taken with the notion of a combination artist/healer has been confirmed by several friends with whom he discussed the ability of these magic men to "travel through spirit worlds." Kadish remembers that Jackson often hypothesized about the role played by the shaman's preliminary ingestion of "sacred paint" to help induce a trance; Pollock was intensely interested in finding out if shaman/artists actually saw visions *while* they worked. He also expressed to fellow painters Fritz Bultman and Peter Busa his attraction to the shaman-induced transformations between human and animal form ubiquitous in Indian art.[23]

Many writers on Pollock have emphasized that all of his works—not just the drawings he showed to Dr. Henderson and Dr. de Laszlo—may have acted therapeutically; another physician ascribed Pollock's attraction to painting as a basic extension of his "primitive need to utter."[24] Around 1939–41, his fascination with this sort of ritualized behavior and the intuitive (as opposed to rational) approach to creativity of the shaman—reinforced by what he had learned of Jung's ideas about the shared racial unconscious, as well as what he was seeing at the Museum of Modern Art—created in Pollock a fixation and intense identification with the makers of primitive art.[25]

It is not surprising that, in a number of works painted at this time (probably contemporaneous with, or just after the Modern's 1941 show), Pollock focused his attention specifically on the shaman. In one, a drawing given to Henderson, Pollock depicted a rotund, luridly colored figure clad in tribal garb who seems to shake hysterically, moving so quickly that he appears to have three legs. The upper torso confusingly amalgamates the profile face of a horse and a feathered mask with the faint suggestion of a human head. Another small sketch (probably from the following year), done in pen, ink, and gouache on deep pink paper, depicts a totemic creature (a trance-induced transformation?) who is half human, half bird. Standing upright on human legs, this monster sprouts two sets of wings on either side of its torso in place of arms. Its tiny beakless head is dominated by a large central eye, a motif we will see Pollock use again.[26]

A larger work stemming from Pollock's obsession depicts another shamanistic figure whose upright stance is similar to the bird/man in this drawing. More firmly human in the details of its anatomy, this fully developed witch doctor displays the same flattened pawlike feet seen in the dancing version. In this vertical painting, although it is titled simply *Naked Man* (see page 60), Pollock created his most visually intelligible presentation of the tribal artist/healer whose awe-inspiring godlike presence is a large part of his magic. The clearly delineated male genitalia reinforce the phallic power implied in the figure's erectile stance.

Significantly, however, Pollock's naked man does not have a human head; instead, a huge rounded form disguises his face, and the easily detectable "beak" projected inside this circle leads to the conclusion that this configuration was probably based on a Northwest Indian eagle or hawk spirit mask. Although tribes from the areas with which Jackson Pollock would have been familiar from his childhood did not make similar objects, around the time he created this work many examples of this particular type of mask were included in the large section devoted to the Northwest regions at the Museum of Modern Art. Also, a nude Aztec priest wearing a bird-type mask cuts open the splayed human body in Orozco's Dartmouth panel *Ancient Human Sacrifice*.

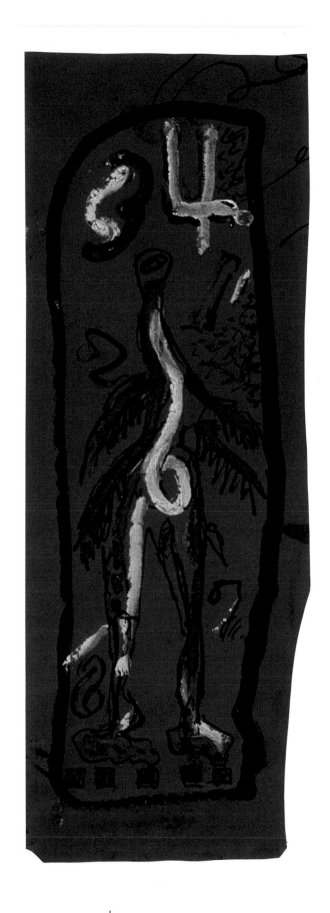

Untitled. *c. 1942*

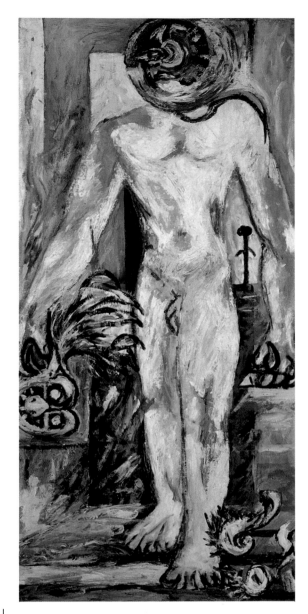

Naked Man. *c. 1938–41*

Still found among Jackson Pollock's papers after his death was a clipping from the front page of the rotogravure section of the Sunday, January 19, 1941, issue of *The New York Times*. His interest in cutting out and saving a spread of ten masks from the Modern's "Indian Art of the United States" assuredly confirms Pollock's intense fascination with this type of ceremonial paraphernalia. (Another such mask, plumed like many in the exhibition, leers in *Naked Man* from a table to the figure's right.) Similar objects, used by Pacific coast shamans to induce personality transformations in their communion with the supernatural, figure prominently in another transitional work, *Masqued Image*; their adoption is central to Pollock's most eloquent declaration of a new direction in his art in the closely related canvas titled *Birth*, which we have already seen.

Violet Staub de Laszlo, who took over Pollock's psychiatric treatment in 1941 after Joseph Henderson left New York, has confirmed that during the period she was seeing him, Jackson clearly exhibited a "shamanistic primitive attitude" toward the making of his images.[27] His expressed desire was to discover for himself the sources of the power a shaman's works released, and the strange and terrifying gyrations of the figure—or figures—in *Birth* could easily depict the generation of a shaman's hallucinatory experience. Because of the claustrophobically compacted nature of the composition, it is difficult to tell if what we are looking at is a single, agitated magician undergoing a violent and frightening metamorphosis (not unlike the one Pollock went through himself each time he drank), or whether multiple personages are present. The suggestion of both male and female sex organs further blurs the possibility of distinction. (Regardless of its gender, this figure's widely spread stance is sexually suggestive in the extreme.)[28]

Despite the visible frenzy of this dark and narrow painting done on canvas mounted on plywood, Pollock may still have been following some of the compositional precepts of Thomas Hart Benton in its structure. There is evidence that he still remembered Benton's lesson concerning the rotative arrangement of curved shapes around a vertical axis. Benton's ideas have been tempered, however, with his own current interests, as the organizational similarity of *Birth* to Northwest Coast Indian totem poles is clearly articulated. Pollock would have seen Orozco's depiction of these artifacts in two upright decorative panels when he visited Dartmouth (see page 62): a number of prominent hawk beaks protrude from the six columns of bird heads Orozco included in the decorative scheme of the west wing at Baker Library. Also, in addition to the many actual totem poles on exhibit at the Museum of the American Indian, Pollock surely examined at length the Haida example at the entrance to "Indian Art of the United States." It is likely that he intended his own use of stacked imagery in *Birth* to be read up and down, the way that Indians "write" their picture messages.

James W. Lane, the only critic who reviewed the exhibition "French and American Painting," where Pollock first exhibited *Birth*, specifically mentioned its "whirling figures."[29] That Pollock intended these to express the creative process of an Eskimo shaman (who, in his maniacally savage circular dance "gives birth" to a new personality in touch with the spirits) is given credence by his recognizable use in this painting of a particular type of mask from Alaska. As Irving Sandler and others have pointed out, such an object made at Hooper Bay (from the collection of the University of Pennsylvania Museum) was illustrated in an article we know that Pollock not only read, but also preserved. (Willem de Kooning has recounted

Birth. *c. 1938–41*

Masqued Image. *c. 1938–41*

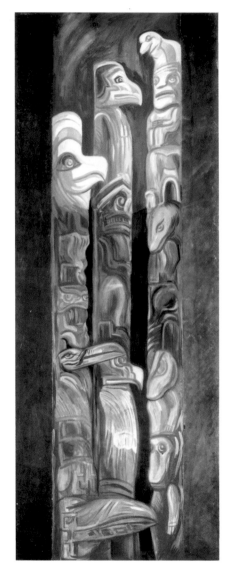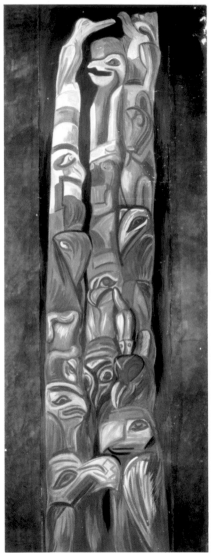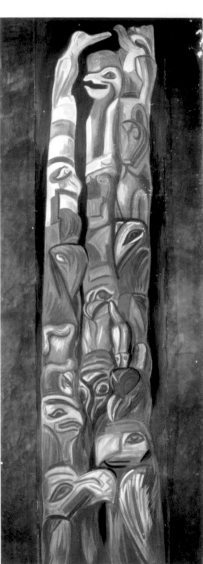

*José Clemente Orozco.* Totem Poles. *Decorative panel,*
*west wing of* The Epic of American Civilization.
*1932–34*

*Eskimo mask, from Hooper Bay Region, Alaska*

that Pollock lent this article to him and "uncharacteristically" insisted on getting it back.)[30] Entitled "Primitive Art and Picasso," this essay was written by a Russian-born artist and theorist named John Graham, and it first appeared in the April 1937 issue of *Magazine of Art*. Sometime between this date and early 1941 Jackson wrote to Graham because of his admiration for the text, and this (also uncharacteristic) letter initiated a very important friendship.

Pollock could also have studied a comparable wooden mask, very similar to the one depicted by Graham, at the Indian show at the Modern, and read in the accompanying catalogue that its extreme distortions were thought to represent the spirits seen by a medicine man. It seems that Pollock may have consciously adopted the palette favored by Eskimo shamans to recreate the same effect: *Birth* exhibits (as described in the catalogue entry) a white background relieved by areas of gray, rose, red earth, and chalky blue or green, although Pollock also mixed in some yellow and added heavy cloisonné outlines in black. The alternately jagged and centrifugal forms of the painting—obviously brushed, jabbed, and scratched by Pollock in his own state of frenzy—strongly convey their emotional origins.

Under John Graham's illustration of the false face from Hooper Bay, which was featured prominently above the title in "Primitive Art and Picasso," he placed a caption to highlight for the reader the "typical primitive insistence that nostril and eye are of the same origin and purpose." "Two similar orifices seem to say: two eyes or two nostrils," Graham wrote, explaining that this was an indication of "a master artist's freedom of speech."[31] Before painting *Birth*, Jackson Pollock seems to have thought a good deal about the implications of Graham's observations about the metamorphic power of primitive art, for his sexually ambiguous treatment of the lower part of the figure in this painting exhibits a distinctly similar "punning" approach. In addition to an obviously ejaculating penis under the masks, to the left in *Birth*, Pollock attached to the shaman's bent leg several tubular appendages which can be read as both exterior and interior anatomical forms, either male or female. It is impossible at this point to judge whether Pollock was as yet sufficiently visually astute to notice that Pablo Picasso, in his *Girl Before a Mirror* of 1932 (see page 70), which Graham also illustrated, had employed a similar visual trick.[32]

Robert Motherwell once commented that the years 1941–42, when he first knew Jackson Pollock, were clearly marked for the latter by a transition from Orozco to Picasso. The decisive event precipitating Pollock's move away from a visual and thematic dependence on the contemporary Mexicans seems to have been his making personal contact with John Graham—whose eloquently expressed belief that the achievements of Picasso were conceptually linked to ethnographic art Pollock clearly found to be eye-opening and thrilling. Encouragement from Graham (who was the organizer of "French and American Painting") helped Pollock to develop a personal dialogue with Picasso's style and imagery, a more direct route to advanced artistic experiment. Making this leap must have seemed very bold indeed, as the Spanish master's works were abhorred by Benton; but with Picasso as his major source of inspiration, Pollock could accelerate his escape from the repressive stranglehold that Regionalism had placed on his creativity.

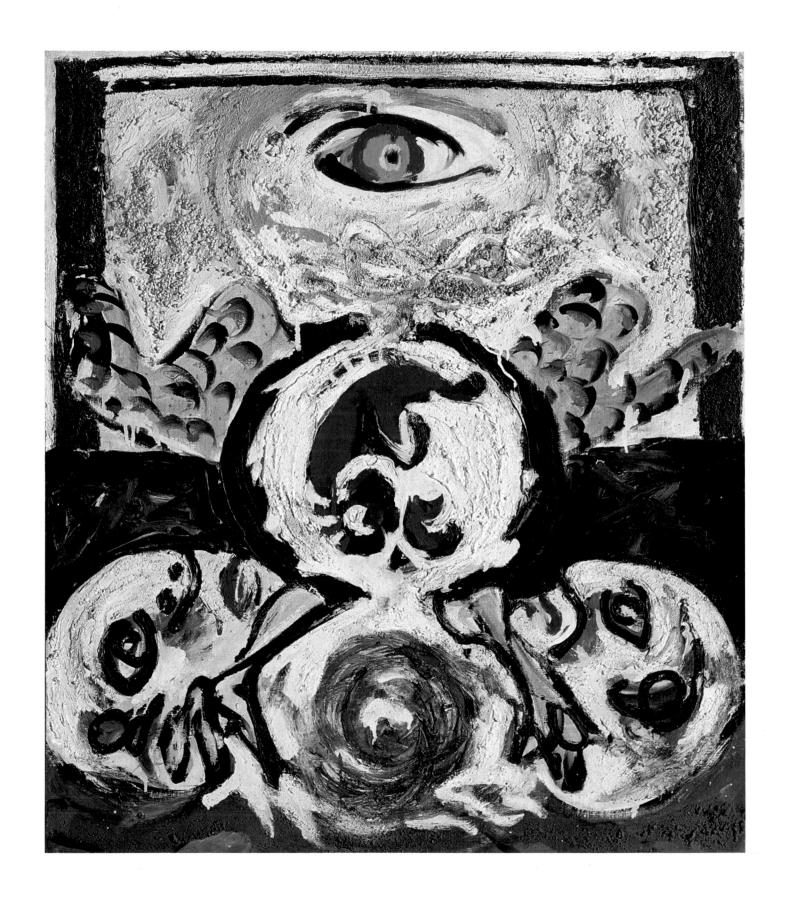

Bird. *1941*

## FOUR

# The Magic Mirror

The great art is always ceremonial. The great art is
terrifying, sometimes monstrous and repellent, but
always beautiful. When the gods speak, the figure is
stupendous and frightful.
—John Graham, *System and Dialectics of Art*, 1937

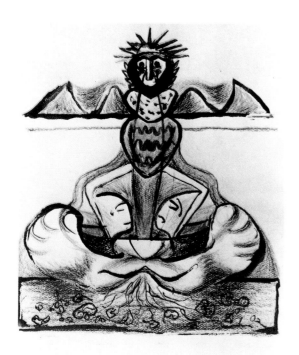

Untitled. *1941–42*

In late 1940, at the time Graham was arranging "French and American Painting" for the New York design firm McMillen Inc., there were a number of recently finished major works in Jackson Pollock's studio from which his entry could be chosen. (Graham's intent in curating this exhibition was to prove that there were young Americans whose work could be favorably compared with the European greats.) As we know, Lee Krasner's first visit to Pollock took place after she found out he was also going to be included in Graham's show. Entering the room where he worked, Krasner not only saw *Birth* and *Masqued Image*, but like Graham, she also was one of the first to view two other equally unusual canvases: one Pollock simply called *Bird*; the other, more "stunning" picture, in her estimation, was evocatively titled *The Magic Mirror* (see page 68). Although these two works had both been executed during the preceding year, there were certain very telling differences between them due to the fact that in the interval Pollock had arrived at a critical artistic juncture.

By the time he painted these works, Pollock had begun to emerge from the paralysis of invention of the previous half decade. A relentless and "fanatical" conviction had begun to form in his mind: becoming a truly great artist was the only way he could ever come to terms with his constantly threatening emotional turmoil. Pollock had become acutely aware, as Peter Busa once noted, that for better or worse his problems were what propelled him to create.[1] Perhaps he had also come to believe in Jung's notion that psychic health could result after the experience of a series of birth-death-rebirth cycles. (This was one of the few Jungian theories described to Pollock by his analysts in order to give him hope.) In any case, at this time he was clearly searching along both psychological and artistic lines for new ways to channel the primal forces that impelled him to paint.

Not long before her death, Krasner noted that her husband had always implied that there were associative links between *Bird* and *Naked Man*, the transitional work discussed in the previous chapter. Both have been assigned to the period c. 1938–41, but a date in the late thirties seems unlikely for *Bird* in view of the conceptual and compositional affinities between it and two untitled sketches of 1941–42 that Pollock gave to his second psychiatrist, Violet de

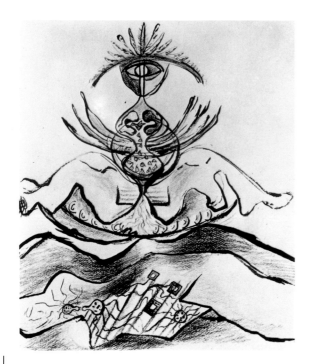

Untitled. *1941–42*

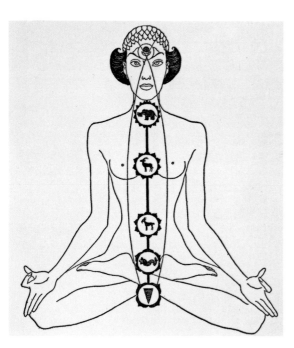

*Yoga chakras. From F. Yeats-Brown,* Yoga Explained, *1937*

Laszlo. In fact, de Laszlo has specified that Jackson created these drawings in conjunction with their joint excursions to the Museum of Modern Art's 1941 American Indian show. (Interestingly, as part of a larger conglomeration of images, Pollock had earlier drawn a similar form for Dr. Henderson.)[2]

In these drawings for de Laszlo Pollock seems to have tried to represent stages of the spiritual transformation of a meditating shaman. With India ink, watercolor, and crayon, he created in the first one a highly stylized, somewhat fancifully constructed figure in feathered headdress sitting "cross-legged" in a desert terrain. The similarity of his strange body divisions and lotus position to an illustration of the seven Hindu chakras in a 1937 book on yoga that Pollock owned has been pointed out by Elizabeth Langhorne.[3] In the second drawing, whatever tellurian features Pollock initially gave to the shaman were excised completely, with the prominent exception of a centralized circle mounted inside an almond shape that approximates the human eye. It appears as though, having undergone a spirit migration, the now "winged" figure has risen above his blanket strewn with desert animals and ritual designs. If these drawings were preparatory notations for *Bird*—an assumption generally based on their symmetrically emblematic arrangement and *Bird*'s huge floating eye—we must suppose that a complete conversion of the *Naked Man* into his animal totem was the shaman's final state.

To complement the indigenous objects shown in "Indian Art of the United States," the Museum of Modern Art arranged for demonstrations of creativity by Native Americans, and among the visiting artists who performed at the museum were medicine men (called "singers") from southwestern U.S. Navajo tribes. Although Pollock would already have been familiar with their kind of ritual sand painting from illustrations in his Smithsonian annual reports, Dr. de Laszlo noted that he was engrossed in the activity of the Navajo painters of the Singing Chant as they fashioned their images by spilling tinted sand on the floor at the Modern.[4] The easily detectable mixture of this material into the desert-toned upper half of *Bird* shows Pollock trying to duplicate their technique.

Reconstructing the complicated network of associations that prompted the style and imagery of *Bird*—the seeming culmination of Pollock's attempts to consummate his intense longing to tap into the energy of primitive art—is obviously impossible. However, it might not be too risky to posit a connection in Pollock's mind between the craft of Indian sand painters and his admiration for the methodological innovations of David Alfaro Siqueiros, one of the Mexican muralists. About four years after *Tropical America*, Siqueiros, invited to New York to address the American Artists Congress, decided to settle there for an extended stay. When, in the spring of 1936, Siqueiros founded an artists' workshop, at 5 West Fourteenth Street, near Union Square, Jackson's brother Sande and his friend Kadish (who had already assisted Siqueiros in Los Angeles) both joined as general helpers; so did Jackson and a number of other former students from the Benton class.

The purpose of Siqueiros's New York workshop was really twofold: he wanted to help revitalize North American art as a tool for political change, and to formulate a new artistic "language" understandable to the working class. The latter would be accomplished by fostering experimentation with up-to-date, primarily industrial materials and technology.[5] Siqueiros frequently expressed his belief that a resolution of the fundamental problems of

*Siqueiros and members of his Experimental Workshop in New York City, c. 1935*

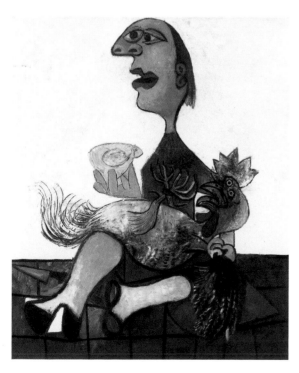

*Pablo Picasso.* Girl with a Cock. *1938*

revolutionary art would be found not in the adoption of Socialist subjects or themes, but in the development of a radically modernized form and technique.

Before his direct association with Siqueiros, we know that Jackson Pollock studied several of the Mexican's West Coast murals, including those at the Los Angeles Chouinard School. Portions of this work had been sprayed by Siqueiros and his team onto rough cement with Duco enamel; Pollock would have also seen other sections painted in encaustic and textured with a blowtorch. Many of the floats and banners created by the "comrade workers" under their leader's direction were prepared with nitrocellulose lacquers, which were sprayed, airbrushed, and stenciled, sometimes using an asbestos base. Frequently, Pollock and the others were instructed to inset pieces of wood, metal, or paper into a surface, or to add sand to roughen the texture of the paint, and he could not have failed to note the similarity of this to the procedure of the Navajo shaman/painters.

*Bird*'s powerful heraldic imagery has long intrigued art historians who have tried to link it to such wide-ranging possible sources as Picasso's 1938 *Girl with a Cock* and the Great Seal of the United States.[6] It is more probable, however, that Pollock's association of the sand technique with Siqueiros caused him to remember *Tropical America* (see page 46) and to amalgamate in *Bird* aspects of the imagery of that mural with his admiration for the hieratic flatness and transformative mythology of Indian art. (In fact, an almost identically posed bird, painted by a Nootka artist from Vancouver, was exhibited in the Indian show at the Museum of Modern Art.)

Pushed up against the picture plane of Pollock's *Bird*, centered, and enlarged to virtually fill the 27¾-by-24¼-inch canvas is a pigeon-toed cock or eagle.[7] Its wings are outspread exactly like the defiant fowl that sits menacingly over Siqueiros's tropical crucifixion, and its rotund belly enigmatically discloses an embryo. The bean-shaped forms just below the wing tips of Siqueiros's eagle have become two faces in Pollock's composition. These faces exhibit (except for their open eyes) similar physiognomic traits to Siqueiros's dead martyr with head lolling to one side. The thick noses and fleshy lips Pollock gave the two heads in *Bird* (which are sometimes identified as a man and a woman)[8] have been presented as evidence that Picasso's *Girl with a Cock* was Pollock's prototype; however, these are the peasant's features as well. (Siqueiros did not also use the "pretzel ear" Donald Gordon maintains that Pollock took from Picasso.) The very plausible inference that these heads also represent sacrificial victims over whom Pollock's bird has triumphed is made more credible by their resemblance to an "Aztec" profile drawn elsewhere by Pollock (see page 69).[9]

A number of the writers who have ascribed strict Jungian motivations to the imagery Pollock created between 1938 and 1945 have pronounced *Bird* a symbol of his strong desire to achieve a newly integrated self. This reading is primarily based on the dominance in the painting of the single floating eye, which is either located in the center of the creature's partially sand-covered head (similar to the totemic bird/man drawing we have already seen) or is hovering in space above a decapitated body. In any case, the disproportionate size of the eye marks its symbolic importance. Interpreted along Jungian lines, this "third eye" might stand for enlightenment (i.e., self-discovery); an equally credible Freudian explanation would identify this image as phallic. Whatever its import, the overstated eye contributes a great deal to the fierce intensity of the painting, whose meaning was clearly bound up with Pollock's urgent need to achieve psychological control. It has been suggested that he may have intended

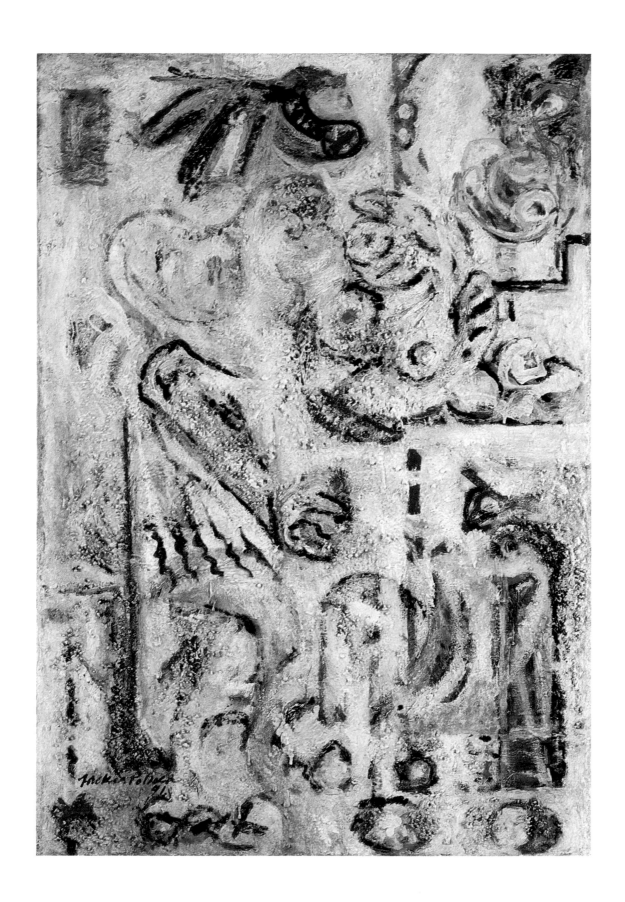

The Magic Mirror. *1941*

*Lightning snake, wolf, and thunderbird on killer whale. Nootka tribe, Vancouver Island. c. 1850*

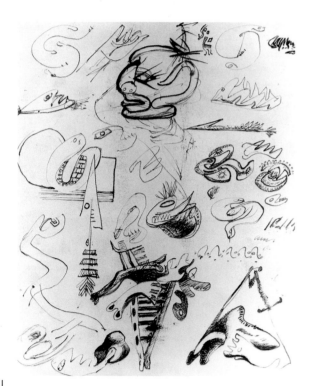

*Untitled. c. 1939–42*

in *Bird* to represent the successful synthesis of his anima and animus, which Henderson had recognized as a confused aspect of his personality.[10]

*Bird* is probably Jackson Pollock's last work in which an obvious dependence on indigenous sources can be seen to predominate. His admiration for Picasso would imminently eclipse this fascination with Mexican and American Indian stimuli, and in many ways *The Magic Mirror*, which can be firmly dated to 1941, is exemplary of his important change of focus. Certainly Pollock's choice of the adjective "magic" for the title relates the work to his continuing shamanic interests. By once again mixing sand and other debris with his paint, he implied not only the Navajo creation of pictures with colored earth, but also the surface encrustation of desert canyon walls, another typical support for magically created primitive imagery. His grayish-pink color scheme and the purposeful fading in and out of his representation reinforce these associations.[11]

Partially covered over by the roughened impasto in *The Magic Mirror* is a person seated next to a table over which hangs a square looking glass. A number of indistinguishable objects lie on the table. As the figure's head is almost totally obscured, the viewer must find other clues to its sex. Although it is probably female, one foot exhibits the heavy paw contours seen on Pollock's shamans. Because of its title and general configuration, this painting has been compared with Picasso's *Girl Before a Mirror*, a 1932 work which was readily accessible to Pollock as a model. The year after Graham illustrated it in "Primitive Art and Picasso," *Girl* was acquired by the Museum of Modern Art.

In some ways, however, *The Magic Mirror* more closely resembles a 1929 Picasso, a work exhibited in the Modern's 1939 retrospective and illustrated in the catalogue, which Pollock acquired. *The Magic Mirror* is much closer to the overall conformation of this picture, *Woman in an Armchair*, than it is to the predominantly curvilinear organization and standing figure in *Girl*. Pollock's painting can be seen as a somewhat dissociated "mirror image" of *Woman in an Armchair*, similar but reversed in its rectilinear plan. The shape and position of the mirror in Pollock's work are identical to the looking glass in the 1929 Picasso, although now on the other side. The floating circular breast with prominent nipple just below and to the left of the mirror, the upswept arm nearby, as well as the knobs, which terminate the feet of the chair and the other foot of the figure, also closely follow *Woman in an Armchair*. What has been interpreted as a flying phallus at the top could—if one refers back to the Picasso—be read alternatively as a distorted C-shape face with hair hanging down.

In all probability, Jackson Pollock melded aspects of both of these paintings by Picasso into *The Magic Mirror*: he seems to have been equally attracted to the frankly neurotic seated *Woman* and the more lyrical arabesques connotative of erotic introspection exhibited in Picasso's standing girl. What kind of magic Pollock's mirror intended to disclose remains vague. Perhaps when he painted this work, he was thinking of John Graham's comments in *Magazine of Art*. Graham (who owned an extensive looking-glass collection) had written that in his works Picasso evoked "primordial memories of the unconscious." Although in *Birth*, Pollock's motifs were primarily predicated on Orozco and Eskimo masks, he may also have borrowed from Picasso in creating it. *Les Demoiselles d'Avignon* was another Picasso masterpiece on permanent view at the Modern in New York, and the "shaman's" sharply angled leg resembles that of Picasso's most Africanized "demoiselle."[12]

*Pablo Picasso.* Girl Before a Mirror. *1932*

*Pablo Picasso.* Les Demoiselles d'Avignon. *1907*

*Pablo Picasso.* Woman in an Armchair. *1929*

Interior with Figures. *c. 1938–41*

*Pablo Picasso.* The Architect's Table. *1912*

Untitled. *c. 1939–40*

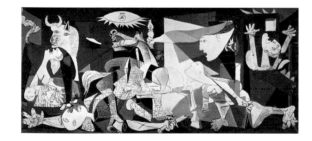

*Pablo Picasso.* Guernica. *1937*

During these same years Pollock also tried his hand at emulating Picasso's Analytic Cubist style, but with very unsatisfying results. (*Demoiselles* is a proto-Cubist painting, and both women with mirrors fall into the later Synthetic Cubist designation.) In *Interior with Figures* (opposite), Pollock attempted to replicate the oval format and shifting grid of translucent planes which had characterized the radically conceived portraits and still lifes of Picasso and Georges Braque c.1911–12. Many of these had been exhibited at the Modern in its important 1936 show entitled "Cubism and Abstract Art"; *Cahiers d'Art*, a French magazine that circulated widely in New York in the thirties, also illustrated this type of painting. *Interior with Figures* shows Pollock trying hard to "quote" the surface features of the Analytic style. He imitated its shallow space, rectilinear scaffolding, and emphasis on planar structure but could not penetrate below the surface level. As a result, his picture is crowded and nervous; he was unable to duplicate the play of ambiguity and mathematical logic that motivated Picasso and Braque.

As demonstrated in *The Magic Mirror*, when it came to the Synthetic phase of Cubism, Pollock was obviously more at ease. In keeping with his affinity for the Mexicans, he was especially drawn to Picasso's paintings after 1925, which were more expressionistically conceived. In *Orange Head* (see page 72), a canvas that was probably contemporaneous with *Interior with Figures*, Pollock painted his own version, in clashing, dissonant colors, of Picasso's well-known combination profile/frontal portraits. The double image of *Orange Head* forcefully projects its subject's schizoid state. In addition to reflecting the style of Picasso, its distorted effect relies once again on Alaskan mask imagery. Like the Northwest Indian artists, Pollock reshuffled the facial characteristics to create a crude and strident image, eliciting a disagreeable but very effective and powerful response.

*Orange Head* seems to be the culmination of a group of drawings of screaming faces Pollock gave to Dr. Henderson. In these discordant images Pollock had likewise intermingled the characteristically dyadic components of the Eskimo spirit mask with elements from Picasso, basing his own faces on the shrieking heads devised by Picasso preparatory to *Guernica*. Two of the latter's most potent images in his most famous painting—a mother mourning her dead child and a figure trapped in a burning building—were fashioned from these preparatory sketches. By the time Pollock painted *Orange Head*, he would have had ample opportunity to study *Guernica*. It was first exhibited in New York in 1939 at the Valentine Gallery, and then after a trip to Boston it moved to a more permanent home at the Modern. He would also have had easy access to photographs of the studies and earlier versions of the final work, many of which were shown in 1939 at Valentine. The same year others were included in the Museum of Modern Art's "blockbuster" show, "Picasso: Forty Years of His Art." Additional preliminary designs for *Guernica* were reproduced in catalogues, and each phase of the painting had been photo-documented in volume 12 of *Cahiers d'Art*.

Originally painted for exhibition at the Paris World's Fair, *Guernica* expressed Picasso's reaction to the senseless destruction of a Basque town by saturation bombing in the Spanish Civil War. On his mural-sized canvas Picasso syncretized childhood memories of a severe earthquake with his indignation against Franco, deploying an array of symbols and images combining mythological, art-historical, and deeply private references. Among these were quotations intensely and horrifyingly revised of wailing maenads from Greek vase paintings.[13]

Orange Head. *c. 1938–41*

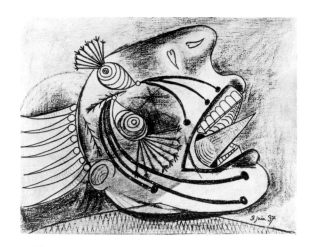

*Pablo Picasso.* Head of Weeping Woman. *Study for* Guernica, *June 3, 1937*

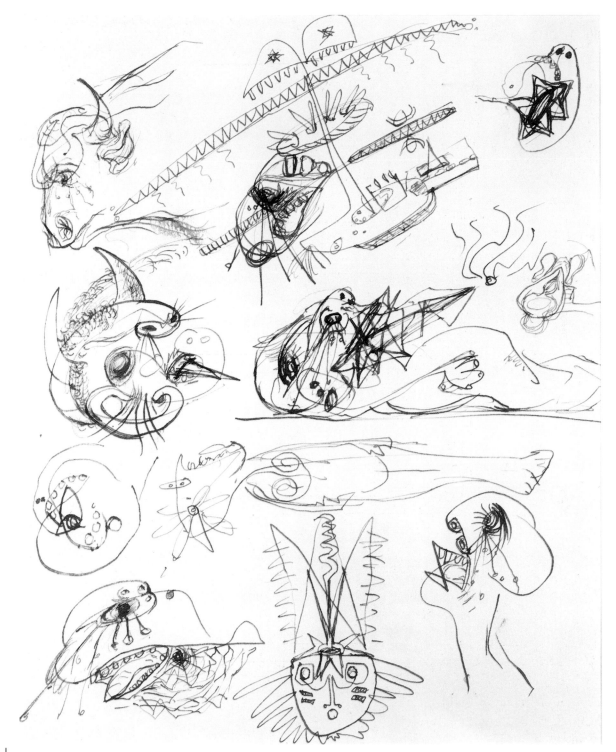

*Sheet of studies. 1939–42*

73

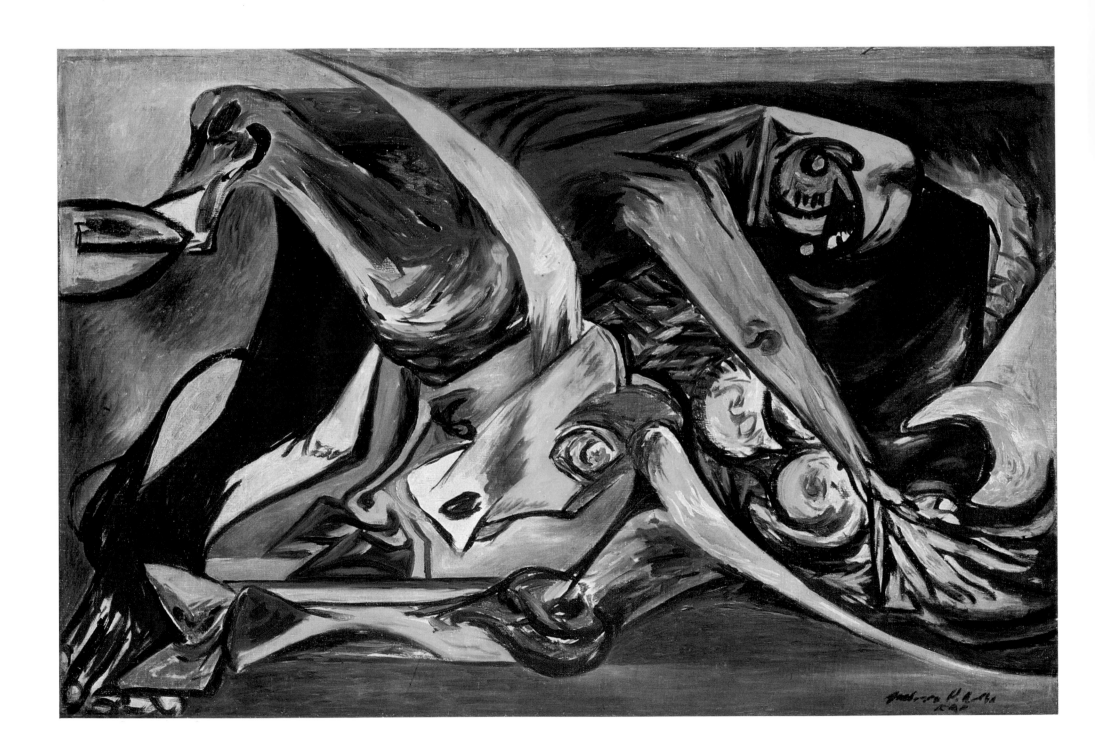

Man, Bull, Bird. *c. 1938–41*

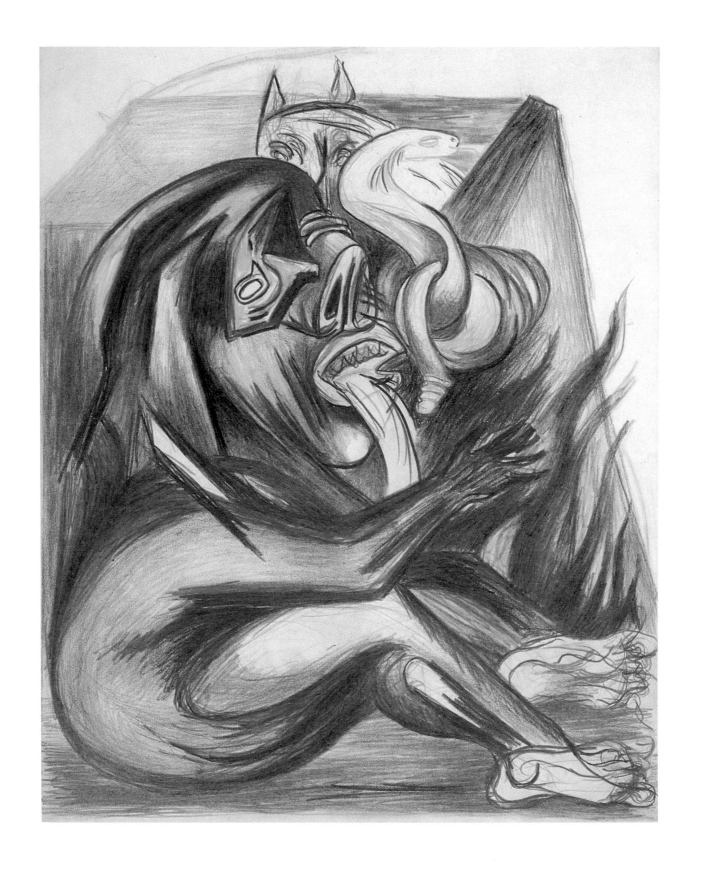

Untitled. *c. 1939–42*

*José Clemente Orozco.* Prometheus. *1930. Side panel, mural*

Illustrated in Alfred H. Barr, Jr.'s catalogue to the Modern's retrospective is a typical maenad which displays the same upturned, rounded snout, protruding fanglike teeth, pointed tongue, and extremely long "feathery" eyelashes seen in various combinations and permutations in Pollock's therapeutic drawings (see page 73).

One of the most conspicuous and unnerving features of Picasso's *Guernica* is the profile upper torso of a bull which calmly officiates over a scene of disorder and ruin, not unlike the "woman" in Pollock's own luridly colored "Indian" composition. The confused and struggling jumble of interlaced figures in *Man, Bull, Bird*, another work painted by Pollock less than four years after Picasso completed *Guernica*, is strongly reminiscent of the early stages of the latter in its hectic, centrifugal arrangement. However, the long-horned steer in *Man, Bull, Bird* more closely resembles the animal Orozco used to denote Zeus in *Chaos and the Gods*, a side panel for *Prometheus*.

Pablo Picasso's fascination with the bull related not only to his Spanish heritage; it was also partially based on that creature's mythological resonance. In the thirties it was well known that Picasso had appropriated the loathsome hybrid man/beast of Greek legend the Minotaur as his alter ego. We cannot be sure when Pollock obtained it, but the first issue (June 1933) of the French Surrealist journal named after the Minotaur was in his library when he died. On its cover is the reproduction of a collage designed by Picasso, which he made with a doily, several leaves, silver foil, cardboard, etc. Onto this background he had pasted the depiction of a seated male with the head and tail of a bull. An indication that Pollock had this magazine within a few years after its appearance is the fact that during the period of his first Jungian analysis, in one of Pollock's most striking drawings sits a correspondingly posed "demon" (see page 75).

Pollock presented his version of this mongrel creature in conjunction with attributes not typically associated with the legendary "stepson" of King Minos of Crete: fire, a horse, and a coiled snake. These were, of course, ubiquitous symbols from the repertoire of Orozco. Moreover, although his body and posture are based on the bull/monster created by Picasso for *Minotaure*, the masklike countenance of Pollock's mongrel figure closely resembles the Aztec god of war, Huitzilpochtli, seen at Dartmouth. Similarly repulsive heads with protuberant noses and projecting tongues are common in the art of many pre-Columbian cultures. It is difficult to say whether these also influenced Picasso, but in certain prototypes for *Guernica*, he had assigned a more disturbing role to his bull. Instead of having a peaceful expression, the animal looks similarly lustful and savage, with mouth open, teeth bared, tongue hanging out.

Avid in his emulation of Picasso, Jackson Pollock quite predictably chose as well to project himself into the Minotaur's libidinous personality. A common psychoanalytic interpretation of this beast sees his two halves as representative of the clash between unconscious, irrational impulse and the more controlled conscious mind. Pollock's fervent desire in the early forties—which has been vividly recalled by both Motherwell and Krasner—was not only to create a "parallel" version of Picasso, but to compete on an equal level and eventually surpass the accomplishments of the twentieth century's greatest master. An arrogation of Picasso's subjective engagement with the Minotaur would have been congruent with this ambition and with Pollock's own psychopathology.

*Pablo Picasso. Maquette for the cover of* Minotaure. *1933*

*Pablo Picasso.* Courses de Taureaux. *July 24, 1934*

During the thirties, Picasso had presented his bestial alter ego in many guises, ranging from violent and brutal to noble and piteous.[14] To all appearances, Pollock identified more closely with Picasso's renditions of the Minotaur as victim, and sometime prior to 1941, he created a radically disquieting version of the bull/man, seemingly trapped, afraid, and in terrible pain. On this canvas, entitled *Head*, Pollock wound around one side of the Minotaur's face a striped serpentine demarcation which appears to be a devouring snake. As a result of this, the pictorial proximity of this work to another drawing Pollock gave de Laszlo (see page 79) is very striking. The latter, a sepia crayon and pencil sketch, comprises two images, both faces entwined by serpents. The larger was drawn in a representational style, while the other is distorted along the lines of the Minotaur head. The patent terror on the bigger face (a probable self-portrait) duplicates the look of the man/bull creature. In the painting, Pollock magnified and compacted the image, pushing the beast right up against the picture plane, in order to elicit a correspondingly claustrophobic reaction from the viewer.[15] Once again, he increased the tension by including another disembodied eye, now clearly floating in indeterminate space. De Laszlo's comment that when she was treating him, Jackson Pollock was "a haunted man" is graphically illustrated in these two works.[16]

Pollock's first contact with the art of Pablo Picasso dated to the 1920s, when he was a student of Schwankovsky and read *Creative Art*, *The Dial*, and *The Arts*. (He saved a clipping on Picasso from the last.) Any initial attraction Jackson may have felt to the innovations of European modernism was stifled during most of the following decade because of Benton's prejudice against abstraction and partiality to the Old Masters. The revival of Pollock's interest in Picasso was the result of a confluence of events that began with the publication of Graham's article linking Picasso to both primitive art and Jungian psychology. During the following year, several issues of *Cahiers d'Art* were devoted to the new work of Picasso. This, together with the much-heralded arrival in New York by 1939 of *Guernica* and *Les Demoiselles d'Avignon*, certainly reinforced Picasso's appeal.

The development of Pollock's friendship with John Graham by early 1941 (when he brought the Russian with him to a therapy session to meet Dr. de Laszlo) certainly crystallized Picasso's position as a model for inventive emotional expression. A list exists in Pollock's own handwriting of articles recommended by The Analytical Psychology Club of New York.[17] Whether he actually read any of these is not known, but Jung's 1932 study of Picasso's "psychic journey into the unconscious" is among them. By the early forties, Pollock was so aware of the magnitude of Picasso's achievements that he exclaimed to Krasner, "Goddamn it! That guy missed nothing."[18]

By now, Jackson Pollock's partiality to artists whose attainments he perceived as mythic and heroic should be obvious: his previous attachments to Michelangelo and Orozco were excellent preparation for an appreciation of Picasso's performance. Pollock appears to have been ready and willing to believe what Graham explained in *Magazine of Art*: that there was no other artist, living or dead, whose "vision or insight into the origins of plastic forms and their ultimate logical destination" was more profound than Picasso's. The same year that he wrote "Primitive Art and Picasso" John Graham also authored a book he titled *System and Dialectics of Art*. In *SDA*—whose American publication was sponsored by Alma Reed's

Head. *c. 1938–41*

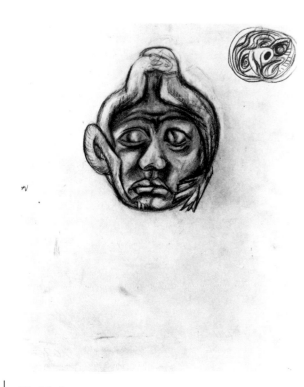

Untitled. *c. 1941–42*

Delphic Studios—Graham went even further in his appreciation of Picasso, unequivocally stating that he was "so much greater than any painter of the present or the past times that it is probable he is also the greatest painter of the future."

In all of his writings before 1945 (when he bitterly turned against Picasso), John Graham effectively characterized this artist (whom he had met in Paris) as a modern-day version of the shaman. He described Picasso's influence in *SDA* as "horizontal and vertical, constructive and pitiless"; his art was reverently portrayed as enigmatic, nostalgic, and "truly revelating," disclosing secrets of nature and reality most people cannot perceive. The superiority of Picasso's dual sense of analysis and mystery, Graham observed, was rivaled in its awesomeness only by the similarly instinctually motivated image-makers of Africa. Any painter who did not openly reveal a debt to Picasso, Graham labeled "either dishonest or unintelligent." "Picasso drops a casual remark," he commented, "and a score of artists make a life's work of it."[19]

Who was John Graham, and how and why did he come to exert so much influence on this important phase of Jackson Pollock's development? He was born with the name Ivan Dabrowsky, possibly in Russia (so he always said), but probably in Poland, in 1881. Graham boasted that he had been a cavalry officer in Grand Duke Michael's Wild Brigade. Graham always had an aura of being above the law. "I was born to power and trained to rule," he explained. Like many others, Lee Krasner remembered John Graham as devilishly handsome, "a mad, wild, beautiful person"—despite the fact that his demeanor was "taut" with the Russian army clearly in his bearing. Supposedly spirited out of his mother country after the Revolution by a sympathetic Bolshevik general, John Graham had spent the 1920s in Baltimore and Paris. Through the Cone sisters, whom he knew from the United States, Graham was introduced to the famous American expatriate collector Gertrude Stein in France, and her salon provided him with the opportunity to meet advanced artists including Picasso. Through friendship with Paul Éluard and André Breton, Graham also traveled in Surrealist circles. He had two solo exhibitions at the Galerie Zborowski in Paris in the late twenties, which were reviewed in *Cahiers d'Art*. His work was also discussed by prominent European critics in a catalogue and a monograph, both published by 1930. After settling in New York, Graham affiliated with the Valentine Gallery, but he first had a one-man show in 1929 in Washington, D.C., arranged by the perspicacious collector and modern-art authority Duncan Phillips.[20]

In addition to these credentials as a painter, in the United States, John Graham soon became well-known as a connoisseur and dealer in African and Oceanic sculpture. He regularly made purchases for the collection of Frank Crowninshield, editor of the cultural magazine *Vanity Fair* (in its first incarnation), and sold objects out of his own Greenwich Avenue studio/gallery called "The Primitive Arts." Accepted uptown not only by Crowninshield, but by other wealthy art patrons including Solomon R. Guggenheim, Graham also befriended poor fellow émigrés and ambitious, but unknown young American artists who hung around the cafeterias and studios downtown. During the thirties, Graham's extremely close relationship with Arshile Gorky and Stuart Davis resulted in their being nicknamed "The Three Musketeers."

*John Graham*. Apotheosis. *1955–57*

Lee Krasner once attempted to sum up the virtually hypnotic and definitely charismatic appeal of Graham, to whom she had been introduced in 1940 by Aristodemus Kaldis, a mutual friend. Graham, Krasner recalled, had infallible taste and was very much "in touch with" the contemporary art scene: "He knew European painters. He had an awareness of what was happening. He moved around, and in that sense I knew that John Graham was one of the people, and there were so few then, who was interested in the painting that interested me."[21] It was Graham's uniqueness, she once observed, not only to respond to avant-garde painting but, with projects like the McMillen show, to try to spread the word.

Consonant with John Graham's often eccentric behavior, his artistic theories were quite idiosyncratic. Large portions of both "Primitive Art and Picasso" and *System and Dialectics of Art* were devoted to long, rambling, and odd, to say the least, genealogies which he had devised to map the history of style. Preceding the preface to *SDA*, Graham set out in clearly Jungian terms the primary belief that governed his theories—that there is a strict differentiation between the rational discipline of science and the more intuitive activity involved in making art. "Art," he wrote, "opens access to the unconscious mind, science opens access to the conscious mind." He began *SDA* with his own definition of art, whose basis lay in "a creative process of abstracting." He described aesthetic creation subjectively, its only two sources being thought (conscious and unconscious) and emotion. The conscious mind, he wrote, is nothing but a "clearing house for one's instincts," and in order to reveal truth (the goal of all great art), an artist must reestablish lost contact with the submerged levels of his mind.

John Graham extensively defended the "virility" of abstraction in *SDA*, explaining that this kind of art "departs from reality and nature only to draw far-reaching conclusions about this reality." If they emanated from the subconscious, abstract paintings could embody meanings as significant as any representational style; great art, Graham wrote, should never be explicit. Thus, copying nature has no place in great art: a true artist changes the observed values of nature into a different set. A great painting or sculpture, according to Graham, results from the "*immediate unadorned record of an authentic intellecto-emotional REACTION of the artist set in space.*" This reaction could be recorded in terms of "brush pressure, saturation, velocity, caress or repulsion, anger or desire"; it might change and vary "*in unison* with the flow of feeling at the moment."

According to Graham's theories, every artist must develop his own automatic *ecriture*, or personal technique, a combination of training and improvisation. To achieve automatic *ecriture*, the intellect is a useless tool, because "the things we know impede us from seeing things we do not know," and revealing the latter is the goal of artistic creation. Gesture is the most important personal tool an artist can employ to reflect his emotion. He explained that the gesture of the artist is his line; like a singer's voice, "it falls and rises and vibrates differently whenever it speaks of different matter." Graham underlined the importance—for the achievement of emotional truth—of keeping every artistic situation spontaneous, of being willing to go out on a limb and to court, not deny, accident. In general, a true artist should be willing to take as many risks as possible in the generation of a work. This quality of "creative daring" was, for Graham, the most important virtue for an artist in a conventional world.[22]

Some art historians believe that John Graham wrote *System and Dialectics of Art* as a

direct rejoinder to the Museum of Modern Art's more formalist presentation of the evolution of abstraction. Graham objected to the linear chronology traced out in the Modern's exhibition "Cubism and Abstract Art." He believed in a much broader range of sources for modernist innovation. Graham not only invoked non-Western and primitive stimuli in conjunction with Marxist and Jungian psychological motivations, he also delighted in mixing occult factors into the matrix of advanced twentieth-century stylistic evolution.

A devout practitioner of tantric yoga, like Krishnamurti (whose ideas had impressed Pollock as a teenager), Graham subscribed to the tenets of Theosophy. Pollock's latent affinity for "hidden worlds" and his mystical sense must certainly have been aroused once again when he visited Graham's studio, where, in addition to African, Oceanic, and Melanesian objects, Graham displayed Renaissance bronzes, Greek and Egyptian statuettes, and his extensive collection of mirrors and crystal balls. Among his objects was a magic wand supposedly used by the eighteenth-century conjurer Cagliostro. Graham frequently greeted his guests, including Krasner and Pollock, "bare-chested and barefoot," dressed in an exotic Far Eastern or Egyptian headdress and a short ceremonial skirt.[23] His arcane interests encompassed not only Theosophy, but alchemy, spiritualism, mystical erotica, and the cabalistic ramifications of mathematics. When Pollock described his sessions at 54 Greenwich Avenue to Kadish, he characterized the crossing of Graham's threshold as comparable to entering a temple or sanctuary. In the opening years of the forties, Kadish recalls, Jackson's reverence for Graham matched that of a cult follower for his guru.[24]

Pollock's unlikely friendship with the cosmopolitan and intellectual Graham at a sensitive stage in his career served a very important purpose, helping him not only to appreciate Picasso, but legitimating his mystical proclivities. In effect, Graham's ideas granted Pollock a license to follow his own natural, subjective bent, giving him permission to experiment and encouraging him to reach further in an attempt to redefine the bases of artistic achievement.

In an important section of "Primitive Art and Picasso," Graham observed that most civilized people lose direct access to their unconscious at about the age of seven. ("By this age, all repressions, ancestral and individual, have been established and free access to the source of all power has been closed," he wrote.) This blockage can sometimes be "temporarily relaxed," however, by certain "expedients." "Danger or nervous strain, alcohol, insanity, and inspiration" can all stimulate an opening to the source of unconscious power, but only among primitive people, very young children, and "geniuses" is this free access easily obtained. In *SDA* Graham defined a "genius" as a person who has "an explosive mixture of boundless self-indulgence, vision, capacity for making stupendous efforts," as well as a propensity for "sorrow-worship, self-sacrifice and . . . destiny."[25]

We know why Pollock was drawn to Graham. It can now be seen why Graham was interested in Pollock. In this obviously talented, but emotionally disturbed young Westerner, Graham knew he had found a "primitive/genius." Instinctual and unself-conscious like Picasso, Pollock demonstrated in his art an automatic power of vision, evocation, and divination, revealing "secrets" stemming from deep within the psyche. By 1942, John Graham was introducing Jackson Pollock to his friends with the pronouncement that he was "the greatest painter" America ever produced. Without a doubt, this assessment was somewhat premature, but it provides compelling proof of Graham's self-proclaimed powers of prophecy.[26]

*John Graham, 1933*

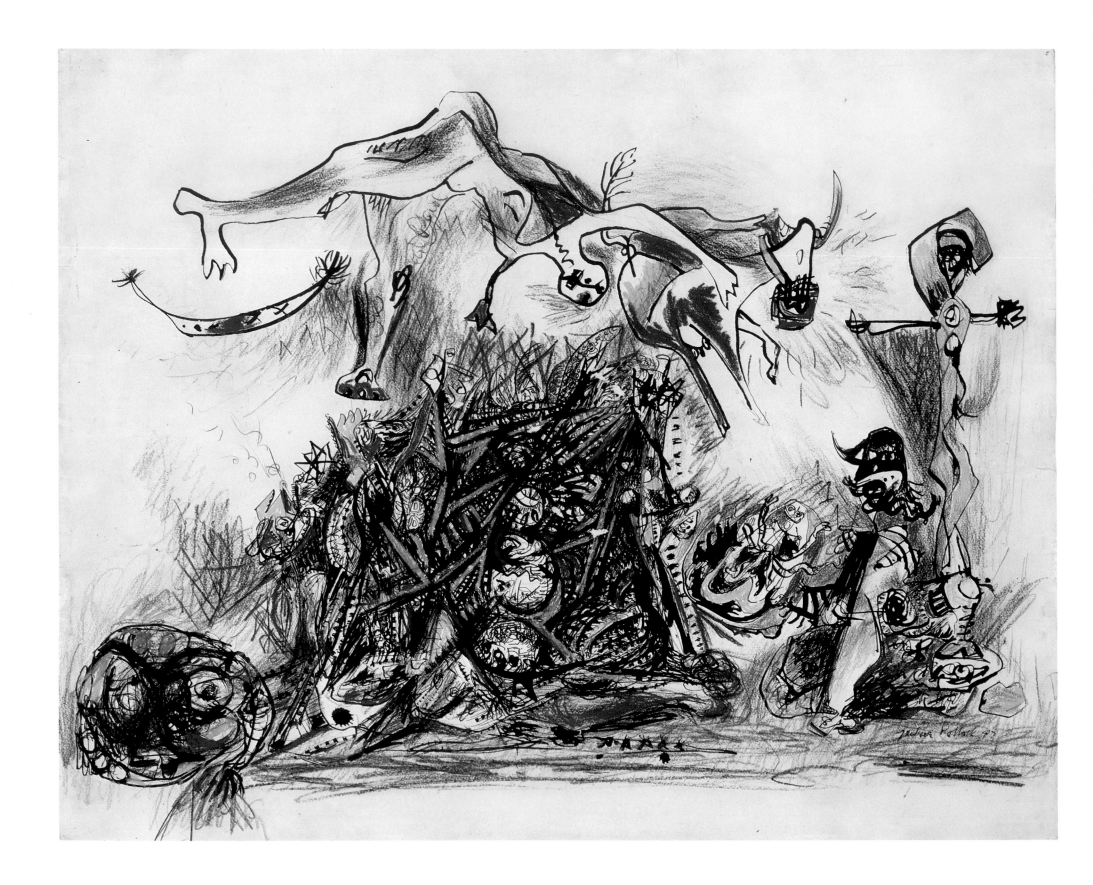

War. *1947*

# FIVE

# *Male and Female*

Man starts with impressions of general situations.
Gradually handling things (getting familiar with the
content of such general situations) he makes
distinctions. The distinctions he classifys. (names)
From these come inferences.

—Notation by Jackson Pollock, c. 1933

To underestimate the capacity of the individual to
transcend the social, is to deny the possibilities of art
now.

—Robert Motherwell, *Dyn*, 1944

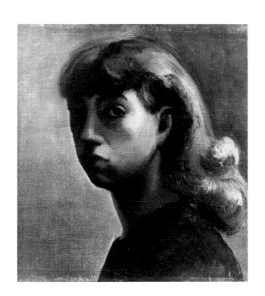

*Lee Krasner*. Self-Portrait. *1933*

Like Graham, Lee Krasner also believed she had oracular powers, a trait supposedly inherited from her father's mother, Pesa, who had become famous in her village in the old country for an ability to foretell the future. Indeed, many have remarked how uncannily anticipatory were the words Krasner inscribed on her studio wall in the late thirties—an excerpt from the Delmore Schwartz translation of Arthur Rimbaud's *A Season in Hell*: "To whom shall I hire myself out? What beast must I adore? / What holy image is attacked? What hearts shall I break? / What lie must I maintain? In what blood tread?" Her friends did not understand her odd attraction to these lines, and Krasner was fiercely protective of them when challenged. Somehow, she had become absolutely certain that they contained a special meaning for her; she surely had no rational way of knowing that, as a result of her attachment to Jackson Pollock, she would experience firsthand each of these dilemmas.[1]

Generally, those acquainted with Krasner and Pollock in the forties remember their relationship as mutually supportive, although, as John Bernard Myers, one of their closest friends, remarked, not many understood the true nature of what was between them. Ethel Baziotes, the wife of another colleague, recalls feeling that Lee's personality and Jackson's violent physical energies meshed well: Krasner had a wonderful sense of the "mechanics of living," which seemed to create an atmosphere in which Pollock was freer than ever before to concentrate on his work. Another part of the success of Krasner and Pollock's relationship was based on her not only being more articulate and cool-headed, but also more aggressive and "political." Several acquaintances remember that Lee frequently spoke for Jackson, who was reticent and almost embarrassingly self-conscious in unfamiliar social and business situations.[2]

By the time she met Pollock, Krasner was a defiant and strongly committed young artist, described by numerous peers as "remarkably sure of herself." By contrast, Pollock was still (in Krasner's words) "riddled with doubt," although—paradoxically—she was also to discover that, "no one knew as much about himself as Jackson did." Reuben Kadish, who over a long period of time had observed Jackson's inability to sustain relationships with women,

*Lee Krasner and Jackson Pollock at The Springs, Long Island, c. 1950. Left, behind Jackson Pollock,* Gothic, *1944. Right top to bottom,* Number 2, 1949; Totem Lesson 2, 1945; The Key, 1946. *Behind Lee Krasner, right,* Night Mist, 1944; *above,* Horizontal Composition, *c. 1949*

*Lee Krasner.* Seated Nude. *1940*

remembers thinking how remarkable it was that his friend was able to carry on an unusual interplay of words, thoughts, and ideas with Lee—a fact that Kadish credits to their close intellectual interests. As much as Pollock and Krasner complemented one another, there was also an air of antagonism between them, but as Fritz Bultman explained, this was a situation they thrived on.[3]

Despite their very different ethnic backgrounds—Scotch Irish and Russian Jewish—there were major points of convergence between Pollock and Krasner: a similar taste in music and literature, as well as a shared, double-edged fascination for certain aspects of both the natural and spiritual worlds. While Krasner accumulated shells and minerals, which she used as decorations where others might prefer *objets d'art*, Pollock loved the illustrations in books like D'Arcy Wentworth Thompson's *On Growth and Form* (1942), which depicted cells, snowflakes, liquid jets of water, and the like.[4] They both were especially fascinated by the moon, and later, when they moved to the country, they shared an affinity for their garden, their animals, and the local landscape. During the thirties, Krasner had begun to consult a homeopathic physician, Elizabeth Wright Hubbard, whose display of healing minerals led her patient to collect organic earth forms. Krasner's doctor was a close friend of Anthroposophist Rudolf Steiner, and the two women spoke about Theosophy and Eastern thought. Pollock, as we know, shared this somewhat esoteric interest, and in 1943, at Krasner's urging, he replaced his Jungian analyst with Dr. Hubbard.

Pollock and Krasner's receptivity to mysticism intensified by 1942 through mutual stimulation, and also as a result of conversations with John Graham, with whom they remained close for about a year after he had included them in "French and American Painting." Graham invited Jackson and Lee to his studio for tea alone, not when he had larger groups in. His increasingly vehement conviction that he was a magus who possessed occult powers impelled them to delve further into magical lore. For example, it was probably around this time that they acquired a 1940 edition of J. G. Frazer's *A Study in Magic and Religion: The Golden Bough*, as well as three early forties issues of the avant-garde periodical *View*. All of these contain articles on magic with information and illustrations that had a direct bearing on Pollock's and Krasner's subsequent work.[5]

Without a doubt, the most important common orientation Krasner and Pollock shared was an overriding interest in the newest developments in art, both possessing (as Krasner put it) "an *acute* awareness of painting." A former student of the European-trained modernist Hans Hofmann, Krasner was already well versed in Fauvism, Cubism, and the latest trends of the School of Paris when she met Pollock. In fact, when she first visited Pollock's studio, she had just been commissioned by the WPA to paint an abstract mural for radio station WNYC, a project that was never realized because of the United States entry into the Second World War. An active member of the American Abstract Artists group, she socialized with the internationally famous Dutch de Stijl movement pioneer Piet Mondrian, who had escaped the threat of Fascist oppression in Europe and was living in New York.[6] Krasner's grasp of modernist innovation clearly outstripped Pollock's, and as we have seen, during the early months of their courtship she was surprised to find that—verbally at least—he still subscribed to the more *retardataire* ideas of his teacher Tom Benton. Initially, when discussing art, they frequently disagreed.

*Lee Krasner.* Four sketches for Mural for Studio A, Radio Station WNYC. *1941*

This situation did not last long, however. Up to the point where he met Krasner (actually re-met; they soon realized that they had clumsily danced together at a loft party a few years earlier),[7] Jackson Pollock's interest in Cubism—then still considered the most advanced form of painting—had centered around the psychological meanings of Picasso's post-1925 work. Tentative forays into analytical composition had not been particularly successful for Pollock. However, Krasner's advanced artistic background and her more mature command of the formal innovations of Cubist art almost immediately evoked in him a more sophisticated response. Shortly after they moved in together, in the late fall of 1942, he began to describe his experience with Benton in much less glowing terms, now characterizing it as something very strongly to react against.[8] In the estimation of Peter Busa, who remained a good friend, Lee's influence was not only clarifying, but "absolutely catalytic" with regard to Pollock's terminal rejection of Benton.

Although both were more or less starting out in their careers, Krasner already had far broader contacts in the New York art world. Because of his Regionalist background, Pollock was not well known in more advanced circles, and Krasner set out to correct this situation with a concerted campaign to introduce him to people who would understand and appreciate the unusual nature of his work. It was through Krasner that Pollock soon met such painters as Fritz Bultman, Willem de Kooning, and Arshile Gorky. Also under her auspices Pollock made the acquaintance of certain writers and others who were to become proselytizers for his work. These included James Johnson Sweeney, Sidney Janis, Harold Rosenberg, and Clement Greenberg—the latter two Krasner's friends of long standing. In 1942 Rosenberg had just returned to New York after working for the WPA in Washington, D.C. Although Jackson never did feel totally at ease with Rosenberg's rapier-sharp intellect, the two men eventually

*Pablo Picasso.* Dream and Lie of Franco II. *1937*

developed a relationship, and a decade later, Rosenberg's lionizing of Pollock as the Existential "hero" of Action Painting would have an important impact on the career of each.

Krasner first became acquainted with Clement Greenberg at a literary party given by the Rosenbergs in the winter of 1937/38. On this occasion, the young and eager Hofmann student had advised the neophyte critic to attend her teacher's public lectures in order to learn more about the principles of modern art. (This suggestion was evidently a profitable one; Greenberg later acknowledged that he owed more to ideas gleaned from Hans Hofmann's talks than to any other source.)[9] Unlike Rosenberg, who emphasized the political and social implications of art, Greenberg concentrated on aesthetics in his criticism written during the forties for radical magazines such as *Partisan Review* and *The Nation*. After the McMillen exhibition, Krasner introduced Jackson to Clem, and although Graham had been the first to "discover" Pollock by including him in this show, Greenberg soon became the young painter's most important advocate, promoting him with obvious passion in the ensuing years of the decade.

Asked about his impression of Krasner's impact on Pollock's art, Greenberg replied, "I don't feel Pollock would have gotten where he did without her eye and her support," adding that he, too, had "learned plenty from her." On numerous occasions Greenberg has stated his belief that during the forties Krasner had "the best eye in the country for the art of painting," and that Jackson could *really* talk about art only with Lee.[10] Ethel Baziotes agrees that, especially before Jackson's first critical success, Lee alone fully understood what he was doing. Unmistakably, she predated anyone else—even John Graham—in her appreciation and support of the radical sweep of his ambition.

As Pollock's involvement with Krasner deepened, he seemed to need his Jungian analysts less and less. Violet Staub de Laszlo vividly recalled feeling when she met Lee that this woman "was going to take over and that would exclude me." De Laszlo remembers, however, that she did not perceive this as a negative development because it was clear that Krasner's strong will and goal-oriented personality were "exactly what [Pollock] needed," although her possessiveness was potentially a source of friction. (As a psychiatrist, de Laszlo had some well-grounded fears that her patient could become *too* dependent on Lee, a situation that might eventually lead to resentment.)[11] Krasner, who was born in 1908, was certainly more appropriate in age than Helen Marot as an object of Pollock's basically unrequited desire (in the estimation of Dr. Henderson) "to give and receive feeling."

The years during which America was involved in the Second World War were crisis years, even for those like Krasner and Pollock whose participation in the conflict was minimal. With the help of a letter from de Laszlo, Jackson Pollock was classified 4-F for psychological reasons in April of 1941.[12] He did continue to work for the WPA in its short-lived reincarnation as the War Services Program,[13] and both he and Krasner trained for drafting positions in aviation sheet metal, each logging hundreds of hours drawing intricate machinery, but no defense job materialized for either of them. Krasner later described the war as something of a "depressing factor" even though—luckier than many—she and Pollock did not experience its horror in a direct, immediate sense. Of course, they could not help sharing in the worldwide schizophrenic mood—a combination of a sense of adventure and the despair of holocaust and death. Unlike Benton, Pollock had no interest in becoming "a spokesman of

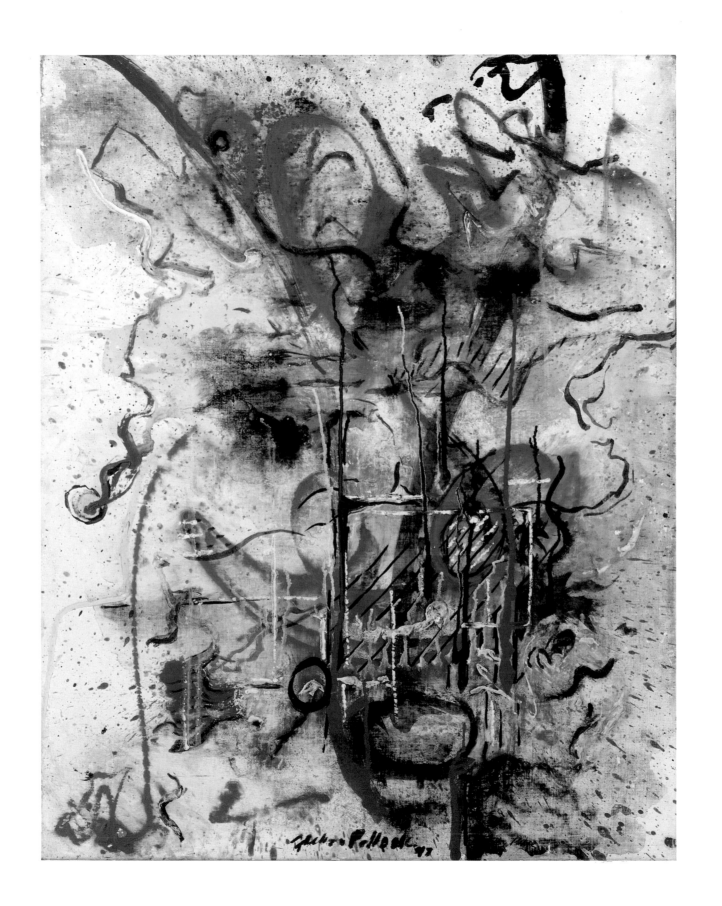

Burning Landscape. *1943*

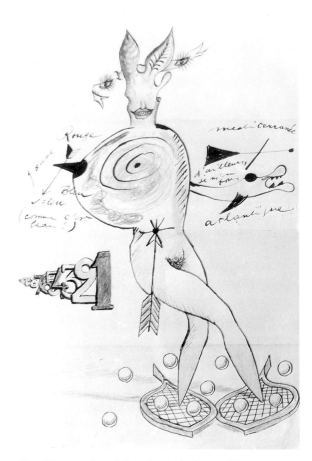

*Yves Tanguy, Joan Miró, Max Morise, and Man Ray.*
Figure (Cadavre Exquis). *c. 1926–27*

the nation's will to victory"; short of submitting *The Flame* (page 39) to the Artists for Victory organization's mammoth commemoration of the first anniversary of Pearl Harbor Day, he chose not to take part in any organized war activities other than those assigned by the WPA. This is consistent with Pollock's general political apathy. Other than attending some Communist meetings and signing a few petitions with his brother Sande in the late thirties, the only evidence of any political commitment is his work for Siqueiros.[14]

Uninterested in creating war documentation or propaganda, Pollock expressed direct concern over world events in very few of his works. A drawing titled *War* (see page 82), which seems to be dated 1947, but was possibly done earlier, presents an explosive image of a pile of human and animal bodies, with a crucifixion seen off to the side. Once again, this reflects Pollock's interest in *Guernica*. Echoes can be seen as well of Picasso's January 1937 etching and poem, *The Dream and Lie of Franco*, also a reaction to the Spanish Civil War. Immediately after its completion, *The Dream and Lie* was reproduced in American books and periodicals; it was prominently featured in the WPA Artists Union newspaper, *Art Front*. If Pollock's composition was drawn in 1947 (*after* the war) as the nearly undecipherable date seems to indicate, it may represent a recoil from postwar aftershocks: news of the devastation wrought by the atomic bombings of Hiroshima and Nagasaki or the detailed disclosures of Nazi anti-Semitic atrocities. (His wife and several of his brothers' wives were Jewish.) As Christ was mockingly labeled "King of the Jews" when nailed to the cross, the obvious reference to his martyrdom lends support to such a conclusion.[15] *Burning Landscape*, an oil on canvas painted in 1943, probably originated—at least in its title—from Pollock's awareness of the incendiary tactics of modern global warfare.[16]

An undated notation in Pollock's handwriting (found in his files after his death) may have been written around this time; it expresses very vividly the direction he had begun to pursue during the war: "Experience of our age in terms/of painting—not an illustration of—/(but *the equivalent*.)/ Concentrated/fluid." Adolph Gottlieb, another of the nascent Abstract Expressionists, succinctly expressed the tenor of thinking in the New York art community during those years of peril, pointing out in 1942 that artists have always been seen as a culture's "image-makers"; but "different times require different images." He graphically characterized "the neurosis" of contemporary life, a situation which had begun to elicit "obsessive, subterranean and pictographic forms."[17] Thus, in a complex era when so many were "tortured by doubts and fears," Pollock was no longer the misfit he had seemed during the depression years, and the more assured quality of his art beginning about 1943 may partially be credited to his own realization of this.

Jackson Pollock had met William Baziotes through their mutual involvement in the WPA art projects. In the late fall of 1942, they both were instructed—along with Peter Busa and another friend, Gerome Kamrowski—to switch from easel painting to designing posters for Navy recruiting stations. (Krasner, ironically, was their designated supervisor.) Their posters were intended to highlight the training skills required for Navy duty at sea, on land, and in the air, and to focus on high school subjects valuable in training for these positions. But as Busa recalled, their team was "the most unregimented group of artists that you can imagine as far as carrying out a project"; they were much more interested in the clandestine practice of "therapeutically automatic drawings" than in producing war propaganda.[18] In any case, their

assignment was never completed; Roosevelt gave the WPA "an honorable discharge" that December, phasing it out of existence.

During the months supposedly spent on the Navy poster project, Baziotes introduced Krasner and Pollock to a slightly younger painter named Robert Motherwell. A former student of philosophy and art history at Harvard and Columbia, Motherwell was studying engraving with a Surrealist émigré, Kurt Seligmann. Through his involvement with the expatriate Surrealists, Motherwell had become a proselytizer for the method of psychic automatism, which he believed could be adapted as a "plastic weapon to invent new forms."[19] Although, in some accounts of these years, Motherwell has implied that he taught it to them, in reality, Krasner, Pollock, and Baziotes were, all three, already familiar with at least some form of automatic drawing.[20] Jackson, of course, knew all about dredging up images from the unconscious as a result of his Jungian analysis, and Lee had practiced a version of automatism while taking the WPA drafting course. (To practice for the required rapid printing tests, instead of copying words from books, Krasner let her mind wander, and she frequently shared with both Pollock and Busa some of the more hilarious results.)

In Provincetown during the summer of 1942, Robert Motherwell began playing the Surrealist game known as the *Cadavre Exquis* with Max Ernst and a protégé of Surrealist leader André Breton, the young Chilean painter Roberto Matta Echaurren. Motherwell had met Matta the previous year at lectures on automatism given at the New School for Social Research by Gordon Onslow-Ford, an English Surrealist. The Exquisite Corpse, an invention by then almost twenty-five years old, had been developed by a group of Surrealists in Paris that included Breton, Marcel Duhamel, Jacques Prévert, and Yves Tanguy. Based on a children's game, it involved one person's writing a word on a piece of paper, folding it so the word cannot be seen, and passing it on to the next person, who, according to proper grammatical rules, would add another word, and so on, until all players had their turn. Somebody would then read aloud the resulting "sentence." At Matta's suggestion, Motherwell, Baziotes, and their wives began to play this game with Pollock and Krasner to produce their own automatic "poetry."

As we have already seen, in 1944 Jackson Pollock admitted to being "particularly impressed with the Surrealist concept of the source of art being the unconscious." But Pollock's awareness of the powers of the unconscious definitively predated any association with Surrealism. Awakened by his Jungian therapists, his interest in subconsciously generated imagery had been further encouraged by John Graham, whose own passionate ideas on this subject had been extensively explored in both *SDA* and *Magazine of Art*. It is highly likely that Pollock and Graham had continued privately to discuss how the "creative wisdom" stored in the unconscious could be spontaneously tapped. This would allow an artist, as Graham put it, to make "an imaginary journey into the primordial past."

John Graham's approach to the utilization of psychic material presupposd a universalist, Jungian point of view. "Our unconscious mind," he wrote, "contains the record of all our past experiences—individual and racial—from the first cell germination to the present day." Art, he maintained, is the best medium for making contact with its sources of power.[21] Breton and the European Surrealists agreed with the latter statement but followed a more Freudian program, believing, like the founder of psychoanalysis, that the processes of the mind, when

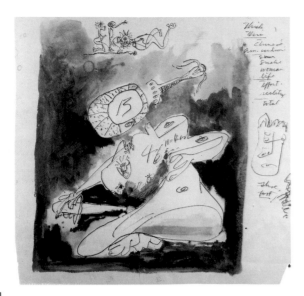

Untitled. c. 1943

freed from the necessity to repress contradictory and irrational elements, take on certain repetitive configurations. They recognized that ancient cultures had turned these patterns into myths, but they stopped short of asserting the continuing communal nature of this phenomenon, emphasizing its significance to the individual ego. Pollock's introduction to the Freudian point of view came when Motherwell introduced him to Matta, and he now had an even wider context to use in venting his compulsion—as defined by Henderson—to "paint the inner aspect of his life."

Several extant drawings by Pollock are considered to reflect his experience playing automatic games.[22] Motherwell has recalled that during these evenings, "in the beginning each of us wrote a line and then they were simply set down in turn, in no logical order." When it was concluded that this would not work, he arranged the lines in sequence. Still not satisfied, they finally decided to choose a common topic. On one particularly rainy night, they agreed to use the weather as their subject. Motherwell recalls the result was "an extremely beautiful poem," a copy of which he kept for years, with everyone's contribution acknowledged. At some later point, it was unfortunately lost.[23]

Even before they met Motherwell, Krasner and Pollock often played a visual form of the Exquisite Corpse, which they called Male and Female. Krasner has explained that "everyone was playing this game . . . if you had nothing better to do with the evening." In Male and Female the sketching in of parts of the body replaced the linkage of unrelated words, but the folding-over and passing-around process was identical. Similar group-engendered pictures had been exhibited in "Fantastic Art, Dada, Surrealism," a large show at the Museum of Modern Art in 1936, and European examples were on view at the New School in 1941, stimulating the craze. In fact, visitors to Onslow-Ford's lecture series were invited to participate in drawing a public *Cadavre Exquis*.

Both Krasner and Ethel Baziotes have agreed that they and their husbands also played Male and Female with Maria and Robert Motherwell. Following the example of the Surrealists, they did not set up rules about being figurative or abstract, and although Motherwell was the most erudite and the most "fluent" speaker among them, Pollock was the one who most frequently explicated the images, taking great delight in manipulating the psychological terminology used by his analysts. Peter Busa, who occasionally joined when these parlor games were played at Jackson and Lee's, also remembered question-and-answer contests where all present would address themselves to such inquiries as "What is ———?" (inserting the name of an animal or some such). According to Krasner, everyone tried hard to be as interesting and poetic as possible in his or her response.[24]

It is not difficult to find echoes of these experiences in Pollock's early forties work. Scribbled on several of his drawings from this period are thought fragments which could have been intended as automatic "poems." Actually, whether these "verses" were written by Pollock or resulted from some type of collaboration there is no way of knowing. One of the more coherent examples reads, "The rock the fish/was winged/and split of/Two—so one could/grow to be and/was the sun." Another consists of a group of more disjunctive words strung together, divided at intervals by single or double horizontal lines to indicate a rudimentary versification. These are found along the right side of a drawing in which a seated female with crossed legs appears about to commit hara-kiri, wielding a dagger similar to the

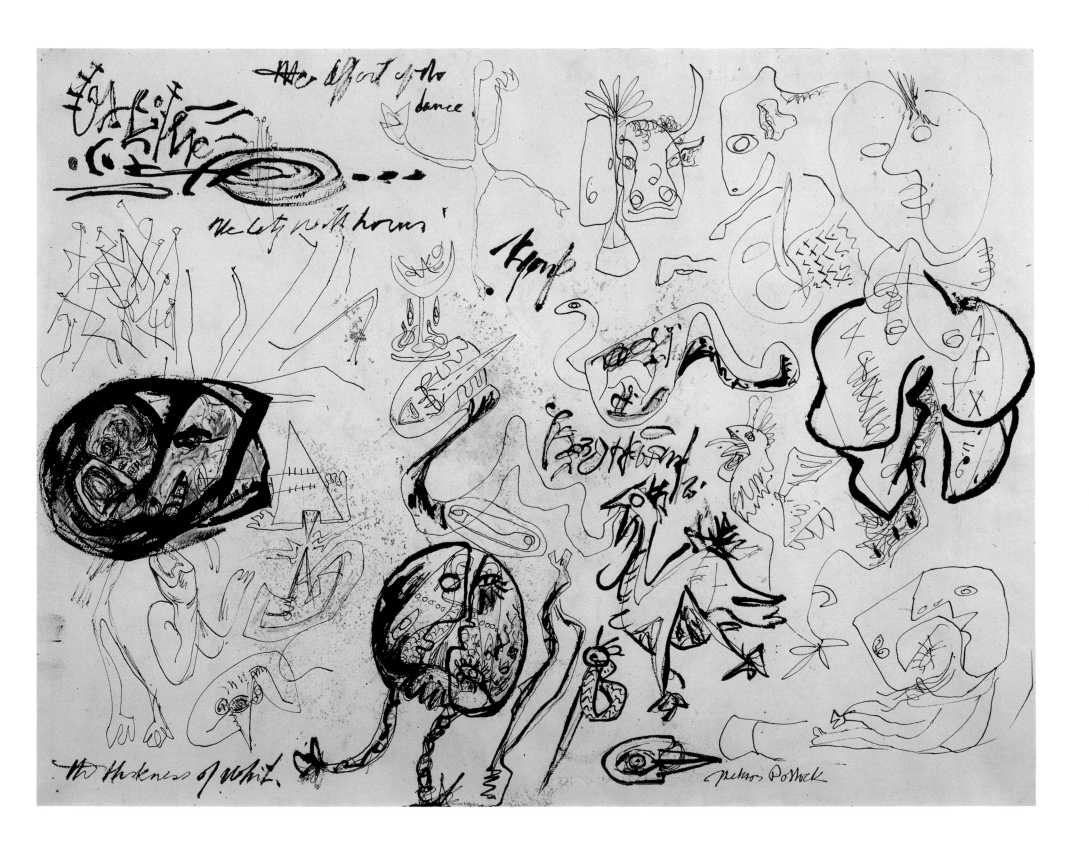

Untitled. *c. 1943*

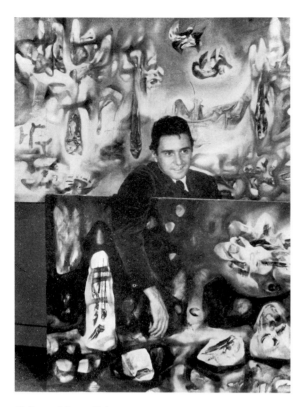

*Roberto Matta Echaurren, 1941*

one held by Pollock's *Naked Man with Knife*. Vaguely reminiscent of the meditating shamans related to *Bird*, her configuration is also deliberately unclear, and another (although smaller) "third eye" is present. Here, the eye (along with some numerical equations) is inscribed on her chest, and the numbers "1" and "3" appear where her facial features should be. Encircling her head is yet another tail-eating serpent. The text is strung along the right side of the picture, with horizontal lines (transcribed here as double slashes) separating word groups: "Thick/thin/ /Chinese/Am. indian/ /s[un?]/snake/woman/life/ /effort/reality/ /total/ / shoe/foot." It was probably meant as a description or a gloss on the picture (did it come first or after the fact?).

A large sheet (see page 91) has been identified as another picture-poem based on Pollock's experiments with the verbal and pictorial forms of Surrealist logic-suppressing games. Amid a rebus-like juxtaposition of polymorphic humanoid and animal forms (the latter include another snake, two roosters, and several bulls or cows), Pollock mixed vaginal and phallic shapes, as well as three lines which read (from top to bottom): "the effort of the dance/the city with horns/the thickness of white." With the exception of the words, which add another layer of possible meaning, the overall composition of disparate forms arranged with no particular focus is quite similar to the Picassoid drawings Pollock brought to his psychiatrists. From a purely aesthetic vantage point, the refinement and finesse of his "union of thought, feeling and automatic *écriture*" seems to have definitely increased.

Through Motherwell and Baziotes, Pollock and Krasner became directly acquainted with Matta, a former architectural assistant to Le Corbusier. Despite being widely considered as Breton's heir to the mantle of leader of Surrealism, Matta was interested in "starting a revolution of the 'young'" inside the movement aimed politically against the more literary, Marxist, and conservative psychoanalytic beliefs of the older members of the group. At Motherwell's instigation, starting in October 1942 and intermittently throughout that fall and winter, he, Pollock, Busa, and Kamrowski began to meet at Matta's studio on Ninth Street (no wives allowed) to show each other their work, discuss ideas, participate in projects to expand their automatic abilities, and to create, as Busa described it, "a travelogue of the unconscious." All of this was ultimately intended to lead to a group exhibition which would "show up" the other Surrealists.[25]

Both Matta and Motherwell have since commented that everyone was astounded that Pollock actually came to some of these sessions, although when he did show up, he said very little, and Matta remembers thinking that Jackson was totally "*fermé*, a closed man."[26] That Pollock was willing to participate at all (de Kooning and Gorky were not) may be credited to his recognition that Matta was an artist who was well established in Europe, a position to which he aspired. (Just a few years later, Pollock explained, "I accept the fact that the important painting of the last hundred years was done in France." "American painters," he asserted, "have generally missed the point of modern painting from beginning to end.")[27] Moreover, in many ways, Matta's personal magnetism was not unlike Graham's, and both have frequently been described as "seductive" in their brilliance and charm. Although these personality traits were antithetical to Pollock's, he responded to them in others. No one was especially surprised when, after the first few sessions, Pollock announced his refusal to join any proposed "group manifestation." He did not submit (as did Baziotes and Motherwell) to the now famous "First Papers of Surrealism" show held that fall.

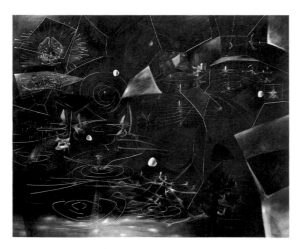

*Roberto Matta Echaurren.* Le Vertige d'Eros. *1944*

When they met, Matta was thirty, the same age as Pollock. In his own later assessment Matta recalled, "I was young in those days and very brutal." He described his intentions vis-à-vis this group of somewhat suspect American "disciples" as based on a "passion to infect them with new ideas."[28] Although from neutral Chile, Matta decided it would be wise to leave France in 1939 since he had signed anti-Nazi petitions. He and Motherwell spent the summer of 1941 in Mexico with another Surrealist émigré, Wolfgang Paalen. There, they both became steeped in Paalen's primitivistic theories concerning the appropriation for contemporary art of the powers and taboos of totemistic cultures. Obviously, this was an interest Pollock also shared. Another link of sorts was Matta's fascination with supernaturalism. In the early forties, he was studying not only the deeper implications of the fortune-telling game of tarot, but also the cabalistic speculative writings of Eliphas Lévi, a pseudonym for Alphonse-Louis Constant (1810?–1875), author of such books as *Dogme et Rituel de la Haute Magie* (Paris, 1856).

"Inscape" and "*morphologie*" were two terms used by Matta to describe his own works, the initiation of which stemmed from his personal psychic responses to life. He urged his young friends to invent *their* own morphologies, incorporating the transformative principles of anatomical, zoological, and organic forms. Matta recommended this biomorphic approach to Pollock and the others to free them of what he considered the deleterious effects of "magazine painting"; he strongly disapproved of their use of reproductions of works by famous artists (especially Picasso) as models for their own subjective expression. Matta urged the Americans to "go out on a limb," not holding back when it came to trusting their own intuition.

As much as they admired Matta's courage, sophistication, and knowledge, most of the American group rejected his painting style. Although semiabstract, it still seemed too close to orthodox Surrealism, with whose tenets Pollock and his colleagues did not feel totally comfortable. In 1924, André Breton had defined the principles of this movement in a manifesto issued in Paris:

> SURREALISM. noun, masculine. Pure psychic automatism, by which one intends to express verbally, in writing or by any other method, the real functioning of the mind. Dictation by thought, in the absence of any control exercised by reason, and beyond any aesthetic or moral preoccupations.
> ENCYCL. *Philos.* Surrealism is based on the belief in the superior reality of certain forms of association heretofore neglected, in the omnipotence of dreams, in the undirected play of thought. . . .[29]

By the mid-1930s American museums and galleries had begun to show artists associated with Breton, and there were many opportunities to see Surrealist works in New York even prior to the émigré influx into the city, beginning about 1938, of practitioners of Surrealism and other modern movements that Hitler considered "degenerate." By its last three numbers, *Minotaure*, a Paris magazine with which we know Pollock was familiar, had evolved into a Surrealist organ. In America, the French continued to voice their ideas in the exile publications *VVV* (1942–44) and *View* (1940–45), which were available at the Gotham Book

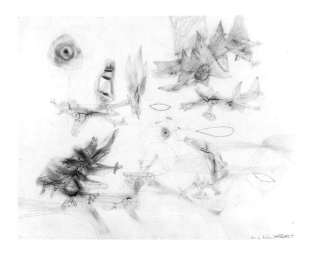

*Roberto Matta Echaurren.* Untitled. *1941*

Mart, on Forty-seventh Street in New York City. And Pollock became very friendly with John Bernard Myers, an editor at *View* and a close associate of the Surrealist émigrés.

As Lee Krasner took pains to point out, she and Pollock were very much aware of the Surrealist artists long before they had direct contact with them. In fact, with the exception of the more urbane Motherwell, most of the Americans did not mix freely with the Europeans who lived in New York during the war years, feeling as Ethel Baziotes put it, too much like "raw recruits" in their presence. The two groups did not share the same language, nor did they subscribe to the same artistic philosophy: even Motherwell believed that the Surrealists went too far in abjuring all aesthetic and formal considerations when creating a work of art. There seemed to be an almost unanimous feeling among the younger artists in New York that ultimately it was a mistake to let a work of art stem totally from "the *undirected* play of thought."

According to Peter Busa, Krasner's reaction when she first met Matta was to declare that she liked his spirit, but rejected his works as not "plastic" enough (her wording no doubt based on the tutelage of Hofmann). Matta's oil paintings of the forties typically expressed a superreal hallucinatory vision, evoking vast areas of ambiguous outer/inner space, brightly colored or spectrally lit. Vaguely cosmic and/or vaguely erotic shapes either float freely in this space or are tenuously anchored by membranous filaments. Although fluid and dreamlike, these images seemed to Pollock, Krasner, and most of their friends to be too worked over and too theatrical. Matta's works on paper elicited a quite different reaction, however. Motherwell has spoken movingly of the beauty of Matta's drawings of the early forties, and Fritz Bultman confirmed Pollock's admiration for them as well. To create these, Matta rapidly sketched in soft gray lead and then switched to a special pencil which changed colors as he drew so that the end result of his hand motions across the page would be partially fortuitous. Also predominantly biomorphic, but generated in a more stream-of-consciousness fashion, the delicate imagery in these sketches was scattered over the surface with no particular center of attention. It is probable that these works elicited such a positive response from Pollock because their arrangement was similar to many of his own 1938–42 drawings.

Another aspect of Matta's artistic practice also struck a chord of recognition in Pollock because it reinforced a previous experience. In some of his larger oils, Matta took a more painterly approach to automatism, spreading his color with sopping rags, allowing it to smear or clot, or scraping it thinly to encourage the unexpected "convulsive" image so coveted by the Surrealists (Breton had pointed out in his writings the revelatory possibilities of considering a work of art to be an "event").[30] Jackson Pollock was already familiar with the concept of regarding the art experience as more crucial than the object created: John Dewey's ideas along these same lines had been promoted by both Benton and Graham. He was also conversant with spontaneous and experimental paint handling as a way to court the kind of risks which could lead to expansion of the mechanisms of creativity. We have already seen that Siqueiros encouraged the artists who worked for him at his Union Square studio to employ atypical technology and materials in the freest ways possible. "We were going to put out to pasture the stick with hairs on its end," Axel Horn once commented about Pollock and his other friends who comprised the Siqueiros "syndicate."[31] Siqueiros, as noted already, urged the use of unusual nitrocellulose lacquers and silicone paints, and he had his assistants

*David Alfaro Siqueiros.* Collective Suicide. *1936*

Untitled. *1944* (?)

apply them with spray guns with different-sized nozzles, sometimes after implanting foreign objects into the support. Often Pollock and the others would be told to splatter and hurl color at the banners and floats they were making, so that it landed in drips or coagulated globs. All possible techniques were employed to encourage accidental effects.

Many of these same methods were used by Siqueiros to create his 1936 painting *Collective Suicide* (the title is a reference to the decision of the Incas to commit autogenocide, rather than submit to the conquistadors). To realize this work, he poured pyroxylin directly from the can onto a wooden panel laid flat on the floor. He used sticks to flick the paint, and in order to achieve dramatic effects, he also worked through friskets and used an airbrush. Jackson Pollock may or may not have watched Siqueiros make *Collective Suicide*, but he certainly had ample opportunity not only to observe, but also to take part in comparable group experimentation with nonstandard techniques. A few years later, he apparently began to try these out on his own. In 1956, as a wedding present, Pollock gave Clement Greenberg a painting on cardboard (see page 95) that he claimed to have created in 1939. Greenberg remembers Pollock terming this small work his "breakthrough picture" and describing how he had painted it at WPA headquarters and how, because of its sloppy, nonrepresentational nature, he had had to smuggle it out. Although Greenberg later expressed doubt about the early date assigned by Pollock, Busa has confirmed that, by 1940 at least, Jackson was surreptitiously squeezing tubes of tempera paint directly onto WPA canvases.[32]

There is a lithograph by Pollock (opposite) that must be even more directly dependent on his experiences at the Siqueiros workshop because it was conceived about 1936–37. It is not known who helped him to print this work—it was not Theodore Wahl—but O'Connor believes that, more than likely, it was pulled with the assistance of one of the other workshop participants. (Harold Lehman, for example, was a skilled printmaker for the WPA.) To make this image, Pollock drew on the lithographic stone a basically prosaic Regionalist "landscape with steer," but with an airbrush he added loose areas of lurid red, blue, and gold. Many visual affinities between this work and *Collective Suicide* are evident; however, it seems to have been an isolated experiment. After it, Pollock put aside for a few years any more intensive interest in pursuing such advanced techniques.

During or just before the period of the Matta group meetings (the winter of 1942/43), Pollock also participated in making a comparably radical group test painting, an event that took place at the studio of Gerome Kamrowski on Sullivan Street.[33] For a number of years, Kamrowski had been involved with Surrealist image-coaxing techniques. In a letter to B. H. Friedman, Kamrowski recalled that one day he, Pollock, and Baziotes were "fooling around" with quart cans of lacquer paint. Baziotes asked if he could use some "to show Pollock how the paint could be spun around." He then looked around the room for something to work on, and a canvas that Kamrowski had "been pouring paint on and was not going well" was handy, so Baziotes began to "throw and drip" white paint on it. He next gave the dripping palette knife to Jackson, who "with his intense concentration" started "flipping the paint with abandon." According to Kamrowski, after all had a chance to play, Baziotes identified the spiral forms he had created as "birds' nests," but Pollock refused to interpret his spots.

It is not surprising that this incident happened at Kamrowski's studio, rather than at Matta's place, where technique or formal problems were rarely discussed. Rather, Matta

Landscape with Steer. *1935–37*

*William Baziotes, Gerome Kamrowski, and Jackson Pollock.* Untitled. *1940–41*

focused the group's attention on particular subjects or themes, whose exploration he believed would help put them in touch with their feelings. In a very didactic way he gave out assignments that Pollock complained to Krasner were "too much like homework." For example, he told the Americans to draw each of the hours of the day. In order to try and discover if a "collective" thought process truly existed, Matta asked each man also to log his feelings at each of the different hours. This project was suggested by the Italian Metaphysical painter Giorgio de Chirico's masterpiece *Enigmas of the Hour*; another such "lesson" was inspired by Ernst's *The Blind Swimmer*.[34]

Resenting Matta's pedagogical attitude and frustrated with the obviously Freudian content of these highly controlled "tasks," Pollock left the group after a few meetings. Not long after his defection, Matta began to criticize the others. He accused Baziotes of painting "too well" and Motherwell's continuing interest in aesthetics, and in utilizing automatism to create abstractions, Matta found increasingly incompatible with his own ideas.[35] The two friends began to argue more explosively over the role of the unconscious, and to the consternation of some of the others, Matta "left them in the lurch" (as Busa put it), gravitating back to the Europeans.

Less than two years after his participation in the sessions at Matta's studio, Jackson Pollock was called upon to assess the influence on him of the Surrealist émigrés. At that time, he acknowledged the importance of the fact that good European moderns were now in America: "they bring with them an understanding of the problems of modern painting." It was here—in his first public interview, printed in 1944 in *Arts & Architecture* magazine—that Pollock noted his favorable impression of the Surrealist attitude toward unconscious imagery as the source of art. He declared, however, that this idea per se was much more interesting to him than were any of the specific Surrealist painters, pointing out that the two artists he admired most—Pablo Picasso and Joan Miró—were still abroad.

Pollock's omission in this discussion of Surrealism of any mention of Matta should not obscure the importance of their association. Despite artistic and personality differences, of all of the members of his study group, it seems that Matta most admired Jackson's work, and he freely expressed this opinion.[36] One of the people to whom he lauded Pollock was Peggy Guggenheim, the monied collector and art entrepreneur, currently the wife of his Surrealist colleague, Max Ernst. Without Matta's seal of approval (among others), it is unlikely that she would have extended the complete resources of her gallery to an unknown artist, and it was Guggenheim's patronage that constituted the crucial factor in the launching of Jackson Pollock.

Stenographic Figure. *1942*

# The Circle Is Broken

Jack wanted recognition as a person, and art was the
way to do it.
                                    —Whitney Darrow, Jr.

On November 11, 1943, *The Art Digest*, a popular art magazine of the era, carried a small notice practically buried on its inner pages. This item read as follows:

> Peggy Guggenheim announces, in advance, an exhibition of paintings by Jackson Pollock to be held at Art of This Century, starting Nov. 8.
>
> "I consider this exhibition to be something of an event in the contemporary history of American art," says Miss Guggenheim.
>
> "Jackson Pollock is 31 years old. He was born in Wyoming, later lived in California and in Arizona. He came to New York at the age of 19 and studied with Thomas Benton at the Art Students League, then became influenced by the work of Orozco and about five years ago, commenced painting abstractly. Now I consider him to be one of the strongest and most interesting American painters."
>
> James Johnson Sweeney has written a foreword for Pollock's catalogue.

Reactions in the press after the exhibition opened at Miss Guggenheim's gallery were mixed but, especially significant for an introductory effort, many were cautiously positive. Henry McBride, conservative critic for the *New York Sun*, was probably the least impressed; he compared one of the larger canvases in the show to "a kaleidoscope that has been insufficiently shaken." "Extravagantly, not to say savagely, romantic," was how Edward Alden Jewell of *The New York Times* described the fifteen paintings as well as various gouaches and drawings on view at 30 West Fifty-seventh Street. He decided that overall these works represented nothing, noting "here is obscurantism indeed," a judgment he softened with the comment, "it may become resolved and clarified as the artist proceeds." Quoting extensively from the gallery brochure, Jewell remarked that Sweeney had struck the right note when he wrote:

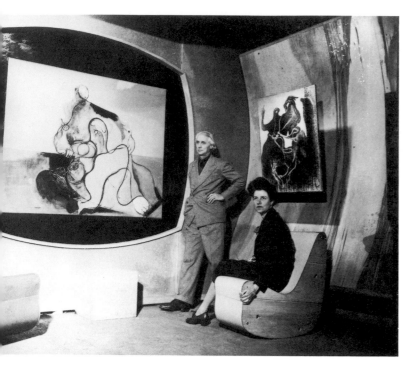

*Peggy Guggenheim and Max Ernst in the Surrealist Gallery, shortly before the opening of Art of This Century, 1942*

"Pollock's talent is volcanic. It has fire. It is unpredictable. It is undisciplined. It spills itself out in a mineral prodigality not yet crystalized. It is lavish, explosive, untidy." But, adds Mr. Sweeney, "young painters, particularly Americans, tend to be too careful of opinion. Too often the dish is allowed to chill in the serving. What we need is more young men who paint from inner impulsion without an ear to what the critic or spectator may feel—painters who will risk spoiling a canvas to say something in their own way. Pollock is one."[1]

Peggy Guggenheim's own notoriety must have contributed to this substantial media attention. Pollock, after all, was a newcomer with very few of the artistic credentials for instant success. His exhibit was actually a somewhat daring departure even for Guggenheim's gallery, already conspicuous for its unusual presentations of advanced European artistic trends, for its shocking decor, and for the flamboyant lifestyle of its owner. Described by *Time* magazine as "the black-haired, husky-voiced niece of philanthropic copper tycoon Solomon Guggenheim," Peggy had been termed "Surrealism's benevolent angel"[2] because of her espousal of the work of New York's émigré community. After a privileged, but somewhat troubled childhood, in 1920 she had expatriated herself, returning from Europe to the United States only when the Nazi bombing of London threatened to destroy her large collection of modern art. Guggenheim's extensive coverage in the American press commenced soon after her return.

As a result of her first marriage in Paris to the English artist/poet Laurence Vail, Peggy—brought up in a fairly conventional New York upper-class German-Jewish milieu—became immersed in avant-garde circles. By the time she opened Art of This Century in the United States, in October of 1942—as a successor to Guggenheim Jeune, the London gallery she had been forced to close—Peggy was married to Max Ernst, and her business was dominated by her husband's colleagues (including Matta, Breton, and Marcel Duchamp), who gladly extended to her the benefit of their artistic advice. To dispel any notion of frivolity, Guggenheim described the intention of her new enterprise as "a research laboratory for new ideas." "Opening this gallery and its collections to the public during a time when people are fighting for their lives and freedom," she noted to reporters, "is a responsibility of which I am fully conscious." The work to be exhibited, she claimed, would serve the "future" of art, rather than merely honor or record its past.

Art of This Century immediately engendered publicity primarily because of the radical design of its three major showrooms, two dedicated to the Surrealist works Guggenheim owned and one to the Cubist contingent. These exhibition spaces, created by the Viennese set designer and artist Frederick Kiesler, were eccentric in ways that mirrored and enhanced the art placed on display. A fourth, more conventionally equipped room served to accommodate temporary exhibits. The choice of works to mount was determined by Guggenheim in consultation with her Surrealist advisers, and with the help and blessing of some of the key figures in the New York art world at that time. Also, during the most important phase of the gallery's existence (1942–44), Guggenheim was assisted and—according to her own admission—very strongly influenced by her secretary, Howard Putzel. Her (at times unwilling) reliance on Putzel was to play a key role in Jackson Pollock's relationship with Guggenheim; Putzel's support for Pollock and belief in his genius predated hers. Reportedly,

*Lee Krasner and assistants.* Cryptography. *1942 (not extant)*

months before the opening of Pollock's first exhibition, Putzel excitedly announced to a friend that, with his encouragement, Peggy's gallery was going to introduce a new find and this young artist, Jackson Pollock, was going to be "the major artist in this country."[3]

A timid, yet intense man, physically unattractive, in poor health and often contentious in his behavior, Howard Putzel nevertheless had, according to Guggenheim, a great force of character. When he wanted her to do something, despite the fact that *she* was the boss, he somehow made it difficult for her to resist. Previously a music and art critic on the West Coast, Putzel had also managed galleries in the mid-thirties in both San Francisco and Los Angeles, where he had introduced European Surrealist art to Californians. After his own move to Paris in 1938, Putzel made contact with Guggenheim and began buying for her on a commission basis. (Supposedly, he was the one who introduced her to Ernst in the winter of 1938/39.) After he returned to the United States, Putzel kept up his Surrealist contacts and was responsible for organizing Gordon Onslow-Ford's lectures at the New School in 1941, as well as arranging the presentations of art that went along with them. We have already seen that Putzel helped Pollock to formulate the answers to a questionnaire that was the basis of his first full-length interview, which appeared in *Arts & Architecture* in February 1944. In fact, Lee Krasner later admitted that during the many dinners they provided Putzel (often in exchange for concert tickets), Howard constantly coached Jackson, literally rehearsing lines with him so that he would be able to deal more effectively with Peggy Guggenheim.[4] And as Putzel took on more and more of a leadership role in the gallery, the tenor of exhibitions at Art of This Century changed dramatically.

At the time Pollock became associated with Peggy Guggenheim, he was actually working for her uncle. After the WPA had terminated all programs including War Services, he had been forced to take odd jobs (among them, painting ties and lipstick cases in a downtown silkscreen shop, Creative Printmakers) in order to support Lee and himself. In May of 1943, Pollock managed to obtain a position as part-time custodian/preparator at the Museum of Non-Objective Painting, working afternoons until 6:00 P.M., every day but Monday. The museum housed Peggy's uncle's collection; it was the predecessor of today's Solomon R. Guggenheim Museum. There, for the Baroness Hilla von Rebay, director of the museum, Pollock performed general duties, which included making pedestals and gilding frames, hanging and dismantling shows, running the elevator, and counting admissions. Rebay, who held criticism sessions for the needy artists she hired to perform these menial tasks, disliked Pollock's paintings intensely, but decided to engage him anyway.[5] Just before Pollock began this job, Matta had suggested through Motherwell that the two of them consider submitting works to Art of This Century's "Spring Salon for Young Artists." Contemporaneously, and again at Matta's urging, Peggy Guggenheim proposed to Motherwell that he, Pollock, and Baziotes create collages which she would consider including in another exhibition, an international collage invitational being planned for mid-April. Although he had never made a work of this type, Pollock apparently became excited about the prospect of exhibiting in an important gallery with acknowledged masters of that medium.

He had had some exposure to the technique of collage during his tenure with the WPA, when just prior to the Navy poster project, Krasner had arranged for his assignment to another crew she was overseeing. In May of 1942, because of her supervisory experience in the Mural Division of the Fine Arts Projects, Krasner had been asked by War Services

Untitled. *c. 1943*

*Henri Matisse.* The Blue Nude. *1907*

personnel to take charge of the design and execution of nineteen displays for show windows in Manhattan and Brooklyn department stores. These were intended to advertise the war-training courses offered at municipal New York City colleges. A devotee of the Surrealist films of Salvador Dalí and Luis Buñuel as well as of the Russian montage filmmakers Sergei Eisenstein and Vladimir Pudovkin, Krasner used their methods and images as inspiration for the creation of photocollage compositions combining—as seen in her panel on cryptography—various relevant images and identifying information with dynamically placed geometric panels and decorative abstract linear configurations. Thus Pollock, one of an eight-member team that put these displays together (Baziotes, Busa, and Kamrowski were not part of this group), was at least somewhat conversant with the thought processes—especially those involving discontinuity and fragmentation—used in creating a collage.[6] Until Guggenheim's proposal, however, he had never chosen to make one on his own.

According to Motherwell, because of Pollock's apprehension about treading by himself in little-known waters, he asked if they could work on their entries together. As a result, we have a detailed description of how Pollock went about creating his collage, even though the work does not seem to be extant. (Motherwell and Baziotes sold the pieces they made for this exhibition, but Pollock did not. Motherwell believes that Pollock destroyed his collage after the show.) The most explicit memory Motherwell retained of their joint session in Pollock's studio is of his surprise at the "violence" with which Jackson approached this new problem, and the attack he perpetrated on his materials, accosting them, Motherwell recalled, with "the intense aura of a sleepwalker." Actually, Motherwell's description of the rapidity of Pollock's movements, and his "assault" on the fragments he chose (ripping them, burning and spitting on them) brings to mind the trancelike state of a shaman engrossed in his ritual, and Axel Horn's remembrance of Pollock at work in Benton's class is strikingly similar. Motherwell described Pollock as seeming to be "possessed" that day, acting as he had never seen him act before.[7]

The only reflection of this experience in Pollock's existing work can be found in three collaged compositions thought to date about 1943. None of these, however, evidences any indication of the actual methods described above, and two are basically illustrational, with images related to his concurrent paintings and drawings. The other one, whose largest shape is a free-form rectangle of colored paper, is less readable. Some of the lines that Pollock overlaid in black ink on the pasted purple background form themselves into numbers and letters. Other markings, made with a brush dipped in yellow or orange gouache, are less obvious. At first, this composition seems to be totally abstract, but two eyes and a group of yellow squiggles below them—suggesting either a beard, or a partial hand outline—soon detach themselves. Along the side opposite the "eyes," letters spelling out "Jack Pollock" in what seems to be mirror-writing (i.e., backward) are visible. In a departure ascribable only to probably unconscious psychological motivations, the second syllable of his first name ("son") was printed not only separately, but reading from left to right and on a different line.[8]

On May 29, 1943, a writer for *The Nation* reviewed Art of This Century's first "Spring Salon," explaining that it was intended by Guggenheim to highlight the work of artists under the age of thirty-five,[9] and "for once," the critic Jean Connelly wrote, "the future reveals a gleam of hope." In this vein, Connelly noted that "there is a large painting by Jackson Pollack

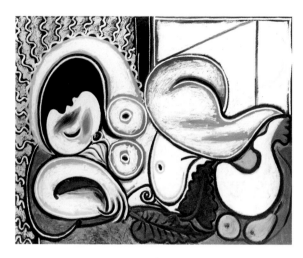

*Pablo Picasso.* Sleeping Nude. *1932*

[*sic*] which, I am told, made the jury starry-eyed." Although she was a close friend of Peggy Guggenheim's, Connelly was not the first—nor would she be the last—to spell Pollock's name incorrectly. As a result of her position in Guggenheim's entourage, Connelly did have an inside track on the reaction to Pollock's entry, which during the run of the Salon was simply called *Painting*, but would soon be retitled *Stenographic Figure* (see page 100).

A few months later, Pollock wrote to his brother Charles about the somewhat startling success of *Stenographic Figure*, asserting that, although it did not sell, "things really broke with the showing of that painting."[10] The story has been retold many times of how Peggy Guggenheim observed one of the eminent judges of the Salon, famed abstractionist Piet Mondrian, standing for a long time in front of Pollock's canvas. (The other judges were Guggenheim herself, Duchamp, James Thrall Soby, Sweeney, Putzel; it is uncertain whether Barr was also a juror.) Peggy apparently made a disparaging comment with which she expected Mondrian to agree heartily, labeling the picture dreadful and deploring its total lack of discipline. To her astonishment, Mondrian dissented, lauding the painting as one of the most interesting works he had seen in America. "Something very important is happening here," Mondrian supposedly told Guggenheim, resulting in her reassessment of the work—and its artist. At least one other important observer recognized the revolutionary nature of *Stenographic Figure*. Robert Coates concluded in *The New Yorker* that "In Jackson Pollock's abstract 'Painting,' with its curious reminiscences of both Matisse and Miró, we have a real discovery."[11]

Coates was right on the mark in looking for the genesis of *Stenographic Figure* in advanced European art; however, its composition more closely resembled an amalgam of Picasso and Miró, rather than Miró and Matisse, although some subtle echoes of the latter may be recognized—perhaps in the change in his general color scheme away from the turgid browns and reds, or too-bright yellows and oranges that had predominated in his palette for the past seven or eight years. In *Stenographic Figure*, these have been replaced by mauves, more saturated reds, and an almost turquoise blue that mixes into the figure and also forms the background.

Before 1942–43, Jackson Pollock was not at all interested in the works of Matisse, although Krasner had admired him ever since her stint, in the late 1920s, as a student at the conservative National Academy of Design. Despite his denigration by her academy teachers, while haunting the galleries of the newly opened Museum of Modern Art, Krasner had discovered the pictorial power of Matisse's high-keyed palette and decorative sinuosity. This aroused a passion for the Fauvist painting style which remained with her throughout her life. What Krasner so admired in Matisse the artist himself had articulated in 1908 in his "Notes of a Painter": "I am unable to distinguish between the feeling I have for life and my way of expressing it." Matisse continued, "The whole arrangement of my picture is expressive. The place occupied by figures or objects, the empty spaces around them, the proportions, everything plays a part." Pollock's similar attitude toward composition, in addition to his newly heightened color sense, may have reminded Robert Coates of Matisse; the only influence Krasner would ever admit to having had on Pollock was to have made him more aware of the contributions of Matisse.

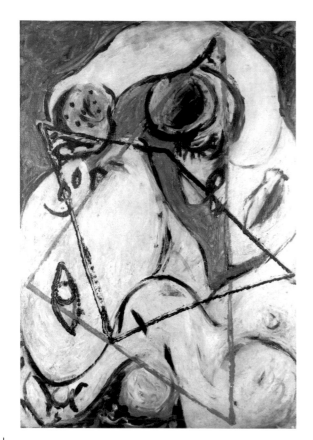

Head with Polygons. *c. 1938–41*

Plaque. *1938*

What initially chagrined Peggy Guggenheim about *Stenographic Figure* was the fact that upon first examination its composition is extremely confusing. A closer look, however, reveals that it is a somewhat eccentric version of a reclining female studio pose, although the figure has been recast as an abstracted Surrealist personage. Matisse painted many such reclining compositions throughout his career, and so did Picasso. In fact, there is a striking similarity between Pollock's painting and a series of works depicting women asleep created by Picasso in 1932 at Boisgeloup. A number of the Boisgeloup compositions were exhibited in Picasso's 1939 retrospective at the Modern, and they were also illustrated in the show's catalogue, which Pollock owned. Evidence that Pollock was stimulated by this show to explore this pose is present in an earlier painting, most likely done just after the Picasso exhibition and usually titled *Head with Polygons*. Despite the awkwardness of Pollock's truncated rendition of the reclining nude theme, comparison of this work to Picasso's sleeping nudes reveals many areas of convergence.

Until *Head with Polygons*, Jackson Pollock does not appear to have been particularly interested in depicting the nude female body. With the exception of one painting (which will be discussed below), a few gouache sketches, and a series of early thirties drawings of a popular model at the Art Students League, this subject is completely absent from Pollock's previous work—unless an unclothed woman happened to be part of an Old Master composition he had decided to copy. Many more nude males are found in Pollock's early oeuvre, and one of his doctors at Bloomingdale's recalled Jackson's seeming obsession with the Bentonian/Michelangelesque male figure, which was still his predominant subject at the time of his hospitalization.

The absence of grace and lack of sexual ease in Pollock's rendition of the female body seen in *Head with Polygons* becomes still more evident if *Stenographic Figure* is compared with even the most distorted reclining female compositions by either Matisse or Picasso. Pollock's inability to draw hands and feet except as pawlike appendages has already been remarked, and it is obvious here. Most jarring, however, is *Stenographic Figure*'s clownlike head, with its protuberant bulbous nose, which seems to pop up, like a jack-in-the-box, in front of the rest of the body. At first, this head does give the picture an appalling crudity. However, when Pollock's professed admiration at this point in his career for the works of Joan Miró is taken into account, this feature begins to make more sense. Reference to any number of Miró's paintings—for instance, his *Seated Woman II* of 1938–39, which was owned by Guggenheim (although Pollock may not have had a chance to see it before he painted *Stenographic Figure*)— might help to explain the derivation of this bizarre portion of Pollock's image.[12] Rather than stemming from Matisse, the poster-like flat blue ground of Pollock's composition could also have been a debt to Miró, who often used this type of backdrop.[13]

Jackson Pollock's decision (if it was his) to retitle this work *Stenographic Figure* when he had, at first, simply called it *Painting*, must have been prompted by a desire to emphasize its second stratum of imagery, a scattering of calligraphic signs and symbols seen to randomly overlap the background as well as the figure. Some parts of the picture, indeed, look like loosened-up sections of Pollock's Exquisite Corpse–influenced drawings. Others are strongly reminiscent of the freely scribbled portions of the War Services window displays on which Pollock and Krasner had jointly worked, and it is tempting to postulate that those more

*Pablo Picasso.* Figures Making Love I. *April 21, 1933*

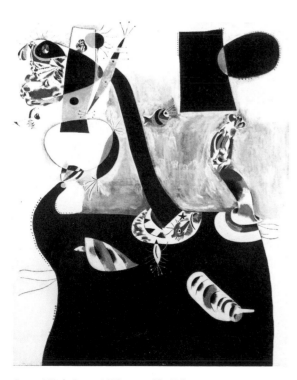

*Joan Miró.* Seated Woman II. *February 27, 1939*

abstract sections were his contribution to the project. Other areas of *Stenographic Figure* once again include disembodied numerals (especially "4" and "6," components of his current address on Eighth Street; according to Krasner, Pollock considered these to be his magic numbers). Mathematical equations, ticktacktoe graphs, and other notations similar to those found in Thompson's *On Growth and Form* are also rapidly inscribed all over the surface, in some places destroying the image's overall readability. Pollock reportedly considered this pictorial strategy a visible link to his unconscious.

As a result of the more or less positive critical reception of the puzzling new look of *Stenographic Figure,* Howard Putzel seems to have been able to convince Peggy Guggenheim to launch Jackson Pollock with his own solo exhibition. They scheduled Pollock's first one-man show for November of 1943, which meant that it would roughly coincide with the anniversary of the opening of Guggenheim's gallery. Further, the combined lobbying efforts of both Putzel and Matta persuaded Peggy Guggenheim to extend a one-year contract to the virtually indigent Pollock, guaranteeing him one hundred fifty dollars per month and enabling him to resign from the Museum of Non-Objective Painting, so that he could create full time. (According to the further terms of their agreement, at the end of the year, if twenty-seven hundred dollars' worth of Pollock's art had been sold, Art of This Century would take a one-third commission. If not, Jackson would have to make up the difference in paintings.) In July of 1943, both Jackson and Lee wrote to his mother that "wonderful things" were happening to her son. In his own letter home and in others sent to his brothers at about the same time, perhaps because of the confidence people were so obviously showing in him, Pollock's previously fragile sense of self-worth appears to have become bolstered temporarily, and despite some understandable fears expressed to certain of his friends that his first show might be a "flop," that summer Pollock began a concentrated effort to prepare a body of fresh new work.[14]

Interestingly, it was just after Pollock signed his contract with Art of This Century that he made another important decision, to terminate his Jungian sessions with Violet Staub de Laszlo and to initiate a very different kind of treatment with Elizabeth Wright Hubbard, Krasner's doctor, who would later become world renowned as an eminent practitioner of homeopathy. Lee Krasner's belief in the efficacy of the holistic approach to health apparently convinced Pollock it might be worth trying; he continued to be willing to go to any and all lengths to alleviate his alcohol dependency and psychological problems. Hubbard must have discussed with her new patient the belief of homeopathy's founder, Dr. Samuel Hahnemann, that "like treats like" (i.e., small amounts of that which—in larger doses—causes stress or disease, can be used to cure that very same problem) because, in his new paintings, Pollock began to demonstrate a similar, "therapeutic" procedure. By forcing out in his imagery the characteristic signs of his own deeper problems, Pollock may have been attempting to precipitate the homeopathic healing process.[15]

By the late summer of 1943, Jackson Pollock apparently felt confident enough to begin to expand upon the themes (so closely allied to his psychopathology) that had subconsciously begun to "assert themselves" in his drawings done while under the care of his Jungian analysts. Now, however, with greater experience in mining his unconscious as a result of his practice of Surrealist automatism, Pollock was better able to manipulate the archetypes his

Male and Female. *1942*

*Pablo Picasso.* The Studio. *1928*

psyche produced, and do so with a kind of aesthetic control that while he was a patient of both Henderson and de Laszlo he still lacked. Certainly no longer "unaware" that his painting ideas emanated from his unconscious, Pollock began, in an intuitive way, to try to work out various solutions to his emotional needs; as Krasner put it, he began to express on canvas "his eroticism, joy and pain," emotions he was not otherwise equipped to articulate.

One of the most important issues Pollock seemingly attacked head-on was his continuing quest to differentiate and integrate the masculine and feminine sides of his personality,[16] and the painting eventually chosen to illustrate his first exhibition brochure focused on this theme, setting the keynote for the rest of his contemporaneous work. Probably titled after Pollock's favorite Surrealist game, this canvas, *Male and Female*, displays two upright totemic figures iconically disposed against a lighter, still bluish background. Because of its "flirty" eyelashes and curvaceous red upper torso, the left figure seems to represent the female principle; the right figure is much more ambiguous, with less-defined anatomical features (is the vertical "blackboard" part of the body?).

Despite the overall confusion again created by another layer of notational markings over the larger geometrical shapes now combined with smears, drips, and splats of thickly and sloppily applied paint, Pollock's continuing reliance on cues from Picasso is obvious. This time, there is a basic similarity in the organization of *Male and Female* to Picasso's studio subjects of the late 1920s. In this grouping of highly synthetic works, Picasso had set up symmetrical compositions in which he placed a radically abstracted artist next to his equally simplified model or standing by a canvas on which a model is depicted. Despite the pared-down nature of Picasso's studio images, these works were often charged with erotic tension, an issue we know that Pollock was at this time also trying to confront. In fact, *Male and Female* does not seem to have been Pollock's first attempt to address sexual confrontation by referring to solutions already posed by Picasso. For example, the upper right portion of a drawing dated c. 1939–42 appears as if it might have been stimulated by Picasso's famous mid-thirties illustrations for Aristophanes's *Lysistrata* (see page 112). Curiously, however, the male partner of Pollock's rather inelegant embracing couple watches with apparent consternation a (his?) phallus fly away. The underlying meaning of this image, of course, could be viewed in several different ways, but they all are clearly evocative of sexual fear.[17]

Virtually all who knew him were acutely aware that Jackson Pollock's conflicted feelings about women were traceable to unresolved emotions toward his own mother, emotions ranging from guilt to contempt. A "source close to Henderson" has observed that it was obvious when Pollock talked that "there was a hell of a mother problem." This was recognized by his brothers as well; Sande wrote to Charles in 1941 that part of Jack's trouble—"perhaps a large part"—was the residue of "his childhood relationships with his Mother in particular and family in general"; "it would be extrem[e]ly trying and might be disastrous," Sande added, "for him to see her at this time."[18] A large, unemotional woman, Stella Mae McClure Pollock[19] clearly dominated her family, and in the eyes of her sons, the result of her extreme fortitude was to "castrate" their quiet, more mild-mannered father, turning him into a "non-entity," a failure. Because of her overriding ambitions for her sons, she constantly moved the family (often taking her husband away from surroundings where jobs he could do were available). As a result, for large portions of his later married life, LeRoy Pollock chose to work far away from his wife and children. "Mother had him pretty well

Woman. *c. 1930–33*

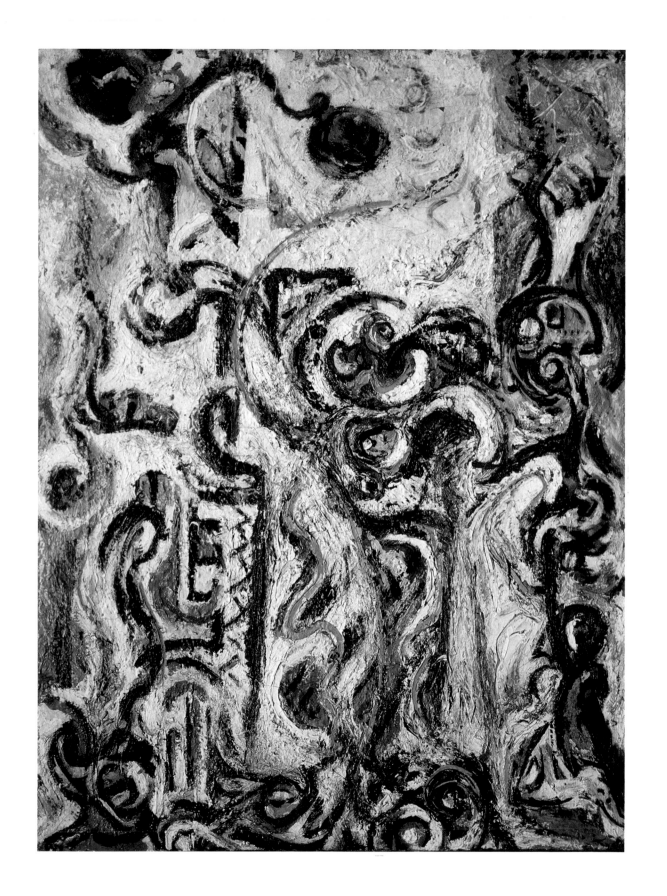

The Mad Moon-Woman. *1941*

Untitled. *1941–42*

*Pablo Picasso*. Myrrhina and Kinesias from Lysistrata, by Aristophanes. *1934*

throttled," Frank, another of Jackson's siblings, once observed, describing their father by middle-age as "a beaten man."[20] As the youngest, ostensibly still pampered son, Jack nevertheless seems to have fully understood his father's situation and to have become terrified that Stella (or some other woman) would also siphon his manhood away.

It is generally believed that Jackson Pollock best expressed his feelings toward his mother's seemingly "monolithic" strength and smothering assertiveness in a painting of the early thirties probably based on the 1917 family photograph (page 13). However, that snapshot, which shows a composed and robust Stella posing amid her six men, seemingly underwent a nightmarish metamorphosis in Pollock's imagination. In his early 1930s painting *Woman*, he produced a hieratic image of his mother, projecting her as a modern-day version of the all-powerful matriarchal goddesses of early civilizations, perhaps filtered through Orozco's representations of prostitutes.[21]

Like the Venus of Willendorf and other prehistoric fertility idols, the woman in Pollock's painting is naked (except for high-heeled shoes), and her secondary sex characteristics are emphasized. Long dangling earrings point directly to her huge, pendulous phallic breasts. As witnessed by the cadaverous faces of the six huddled figures behind her, this "mother" is clearly not a nurturer but a destroyer, and it should be noted that Pollock's haunted early self-portrait (page 32) was done at the same time and in the same style as this canvas. Jackson apparently continued to make comments throughout his life that divulged his potent mother-anxiety. "To be free we got to unload mothers," Pollock reportedly told his friend Jeffrey Potter in the early 1950s; Potter also remembered Pollock referring to his own (and every) mom as "that old womb with a built-in tomb."[22] It is probably psychologically relevant that Jackson gave Stella *Naked Man with Knife*, one of his most violent and aggressive works (and one which, in an earlier version, depicted a female victim). His mother did not like the painting at all and asked Sande to take it away.

Pollock's relationship with Lee Krasner clearly altered his view of women. Although, like Stella, Lee was strong, aggressive, and more organized than Pollock, at least at first her love seemed to nourish and support his ego, instead of beating it down. Consequently, a distinctly different atmosphere is evident in *Male and Female*, probably painted by Jackson in the fall of 1942, after he and Lee had begun living together. Since this new commitment represented Pollock's first emotionally and intimately successful female partnership, it seems quite natural that he would choose at this time to explore in more depth the masculine/feminine theme.[23]

Ethel Baziotes once remarked that she and her husband, Bill, came to believe that being with Lee allowed Jackson to feel a "sense of wholeness" he had never had before. In Jungian terms, Pollock could have been trying to project the anima, or feminine creative portion, of his personality onto Krasner, helping him to strive toward a successful integration of his male and female tendencies. This widely held theory is given credence by the fact (first pointed out by poet Frank O'Hara, and subsequently discussed at length by a number of writers) that the somewhat ambiguous figures in *Male and Female* actually repeat each other's physiological qualities.[24] Indeed, the white rectangle between them seems to be a mirror which reflects onto the male the female's hourglass form. The prominence of the three diamonds (shapes that reappear in other closely dated paintings) suggests yet another source in Picasso for the imagery of *Male and Female*, actually one that we have seen Pollock use before. Not only the diamonds, but also the perimeter configurations of both the male and female profiles roughly

Untitled. *1941–42*

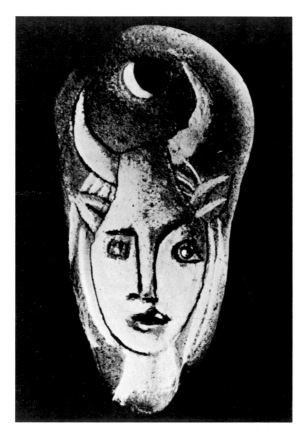

*Pablo Picasso*. Caillou gravé. *1937*

echo similar forms in Picasso's 1932 *Girl Before a Mirror* (page 70), and the free-floating circular "breast" of the flirty-eyed figure underscores this provocative connection. Instead of viewing herself (like Picasso's girl) as she might look in the future, Pollock's female seems to be observing her own physical characteristics projected onto her male incarnation.

As was true of many young Americans in the early decades of this century, Jackson Pollock was highly responsive to events in the New York art world. The Museum of Modern Art's Joan Miró retrospective, which was held from November 1941 through January 1942, probably had as important an effect on him as the similar Picasso exhibition had a year or so earlier. Pollock's close colleagues at the time, Peter Busa and Bill Baziotes, were likewise strongly moved by the Mirós on view; Krasner, too, shared Pollock's passion. (She had first discovered Miró—whose paintings she described as "little miracles"—around 1935.)[25] Both Lee and Jackson must have separately bought the Miró retrospective catalogue, since their joint library had two copies. As might be expected, intimations of Miroesque biomorphic forms in Pollock's earlier works became much more explicit after the Modern's huge show: Jackson clearly found the Catalan's simplified, yet fantastic symbologies to be useful in his own search for a more personal vocabulary. While the premises for *Male and Female* still stem primarily from works by Picasso, three other paintings in Pollock's first one-man show at Art of This Century—all of which are variations on a single theme—more obviously combine elements from Miró. In them, Pollock allowed the inherently rigid structure of Synthetic Cubism to become freer and more disjointed. Now taking his cue from Miró, Pollock created stick figures that are more curvaceous and truncated, and even stranger transformations and recombinations take place in a much less defined space.

These three pictures—*The Moon-Woman, The Mad Moon-Woman,* and *The Moon-Woman Cuts the Circle* (see pages 111, 114, and 115) numbered four, five, and six in the show's catalogue—seem to form a small series because of their single subject. Krasner acknowledged that the moon "had a tremendous effect" on Jackson. He spoke about it often, not only to her but to de Laszlo as well, and it was easy for de Laszlo to interpret this fixation as arising out of the strongly bipolar elements in Pollock's nature. The sun (Sol), whose gods are Apollo, Ra, etc., is typically considered masculine, whereas in mythology worldwide the moon (Luna), represented by Selene/Artemis/Diana, et al., stands because of its periodicity for the principles and activities of the opposite gender. Reminiscences by a number of friends portray Pollock both cursing at the moon and reciting poetry to it.[26] He was particularly fascinated with what might be found on, or symbolized by, the moon's dark side, and many drawings from the period of his analysis with de Laszlo include variations on the moon's waning/waxing configurations. He may have associated his doctor with the moon because of her sex.

The composition of *The Mad Moon-Woman*, painted in 1941 and therefore the earliest of the series, still remains close to Picasso. Comparable to *Magic Mirror*, to which it closely relates in color and style, *The Mad Moon-Woman* had a probable source in one of Picasso's works of the twenties; this time it seems that Picasso's frenzied *Three Dancers* of 1925 gave Pollock the idea for his manic composition. (To support the association conclusively, one of Picasso's bacchantes even exhibits a half-moon profile.) In Pollock's still tentative 1941 canvas, it is somewhat difficult to discern the outlines of the actual "moon woman," but in her next embodiment, in a work titled simply with her name, she recognizably displays Picasso's distinctive double/lunar side-view face. The moon woman's body, however, takes on the

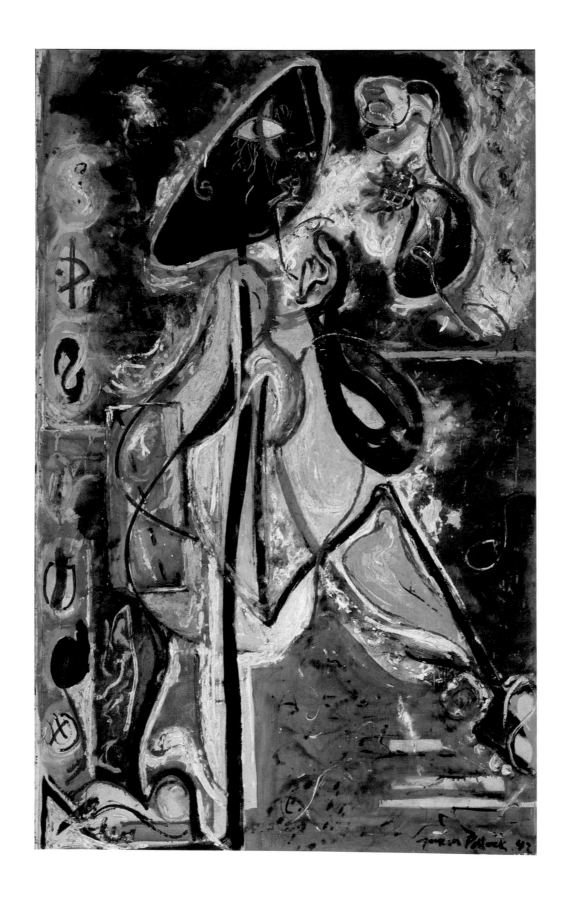

The Moon-Woman. *1942*

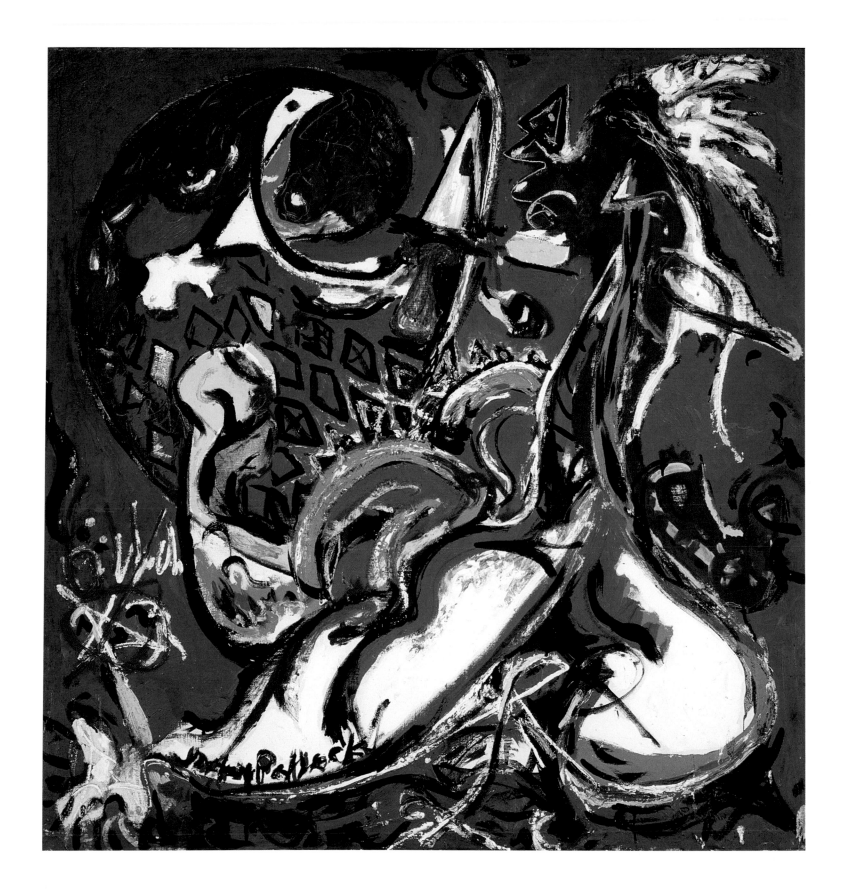

The Moon-Woman Cuts the Circle. *c. 1943*

*Pablo Picasso.* The Three Dancers. *1925*

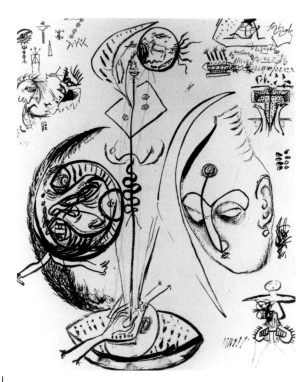

Untitled. *1939–42*

distinct skinny outlines of a Miró *personnage*. Her archaic frontal eye extrudes dagger-like from a small crescent,[27] which, combined with the painting's dark purplish-maroon coloration, lends the image an air of menace. Suggesting thematic ties to several earlier works by Pollock, the moon woman appears to be directing the viewer's attention to yet another eye, which floats nearby in a gold-colored area of space.

It is not surprising that those art historians who ascribe Pollock's primary motivation from 1939 to 1945 to his involvement with Jungian theory have all utilized the moon woman pictures as evidence to support their contention. Like the snake that sloughs its skin and grows another one, the regularly self-transforming moon is an apt symbol for the birth/death/rebirth cycle Jung described as necessary for psychic individuation. As such, the moon is considered to be "the ruler of the unconscious," and Jung called particular attention not only to its associations with regeneration, but also to its link with man's intuitive—as opposed to his rational—faculties.

Elizabeth Langhorne, whose interpretation of these paintings has been the most specific, has noted Pollock's inclusion of a flower in the yellowish upper portion of *The Moon-Woman* (the protagonist seems to be staring at it), citing the fact that Jung wrote a commentary on the symbolic significance of alchemy for modern psychology in a book entitled *The Secret of the Golden Flower*. (This text was published in 1929, and translated into English just two years later.) The golden flower, Langhorne has pointed out, is a symbol of Tao, a Chinese route to the unification of opposites symbolized by yin and yang. It is impossible to be certain that Pollock knew about this book (it is not on his list of psychological source material to consult); however, the surmise that he may indeed have associated the flower and Eastern religion is supported by the presence in a drawing done c. 1939–42 of a Buddhist head placed next to a conflation of the human body with the stem, leaves, and blossom of a plant.[28] Of course, a less esoteric explanation for the components of *The Moon-Woman* might position it as simply another example of Pollock's admiration for Miró. In some of Miró's works, for instance *Portrait IV* of 1938, we find the free association of a woman's torso with a flower.

The final painting of this small group, in which the moon woman "cuts the circle," has lately become one of the most controversial paintings ever created by Pollock; the amount of space devoted to its analysis in recent art criticism is astounding. Although it was one of his first works to be reproduced in a magazine (*Dyn*, November 1944), until the early seventies *The Moon-Woman Cuts the Circle* was never considered a major work in Pollock's oeuvre. As many have noted, however, this painting lends itself to interpretation because its imagery is ambiguous, while its title is specific. Even a cursory glance indicates continued reference to *Girl Before a Mirror*; once again, the conspicuous inclusion of diamond patterning suggests Picasso's wallpaper in that work. The overall arabesque of the composition may also have been inspired by paintings, like *Girl*, from Picasso's curvilinear Cubist phase. Now, however, the moon woman seems to have been crossbred by combining Picasso's *Girl* and the severely deformed humanoid creatures often created by Miró. For example, in his 1926 *Person Throwing a Stone at a Bird*, on view at the Museum of Modern Art beginning in 1937, Miró reduced his main character to a huge leg and foot attached to a tiny head with a single eye, and a strikingly similar abbreviation of anatomy defines Pollock's new version of the moon woman. Moreover, Pollock's color scheme of vivid orange and yellow on a flat monochrome field of brilliant blue is, as previously noted, also typical of Miró, and Pollock's inclusion of an

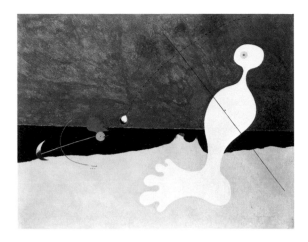

*Joan Miró.* Person Throwing a Stone at a Bird. *1926*

*The woman in the moon. Haida tattoo pattern. From Carl G. Jung,* Collected Works

elaborate headdress on the moon woman's head has possible precedents in certain other "portrait" compositions by the Catalan Surrealist.[29]

The fact that Pollock chose to dress his figure in a feathered "bonnet" should raise no eyebrows in view of his preoccupation with the American Indian (although this type of headdress would be worn by male Indian braves, not by squaws). Because of the fact that this article of clothing serves to particularize the figure, a number of interpretations of the painting have drawn on Indian legend. For instance, the moon woman has been identified as Nokomos, the grandmother of Henry Wadsworth Longfellow's Hiawatha.[30] "Daughter of the moon," Nokomos lived there as a girl until an envious suitor snipped the vines on which she swung. Not only did Jung discuss at length the psychological implications of the Hiawatha legend, he also reproduced a Haida tattoo illustrating the woman in the moon, and several art historians have seized upon this to construct a Jungian explication of *The Moon-Woman Cuts the Circle.* Although it has subsequently been shown that Pollock could not have seen the tattoo when he painted this work (it was not used in editions of Jung's *Psychology of the Unconscious* until the 1950s), Joseph Henderson's special interest in the symbolic interpretation of myths and legends could have alerted Pollock to Jung's ideas about Hiawatha. On the other hand, it is entirely possible that the striated pointed shape of the long hair of Picasso's female figure in *Girl Before a Mirror* simply reminded Pollock of a feather, causing him to elaborate the metaphor without any Jungian input.

There does appear to be no question that, in this new painting, the moon woman figure—whoever she is—once more wields the same triangular weapon seen several times in Pollock's earlier work.[31] In fact, there are probably enough visual parallels between *The Moon-Woman Cuts the Circle* and *Naked Man with Knife* to see it as a kind of updated version of a theme that clearly still gripped Pollock's imagination, repeating a chain of events that preoccupied his unconscious.[32] (We might note here that the knife-wielding Aztec in Orozco's *Ancient Human Sacrifice* wears a large plumed hat.) Adding to the curious mixture of detail and equivocality in *The Moon-Woman Cuts the Circle* is the fact that the red form the feathered personage appears to have slashed takes on a distinctly embryonic shape. It is not clear whether the wound the moon woman has inflicted on the fetus is the source of the hail of diamonds, or if Pollock merely placed them in the painting—as Picasso had done—to animate an empty area. Despite its obvious reliance on Picasso and Miró, *The Moon-Woman Cuts the Circle* has about it a "spirit of dread" (in Peter Busa's words) that is not present in any of the works that might have inspired it.

All in all, although there has been extensive discussion of this work, major questions remain unanswered. If he were queried today, Jackson Pollock might very well give the same answer he used when Sidney Janis asked why another of the works in his first one-man show had been created. Confronted with a request to explicate this painting—which Janis reproduced very prominently in his 1944 book, *Abstract and Surrealist Art in America*, and helped persuade the Museum of Modern Art to buy that same year—Pollock replied, "*She-Wolf* came into existence because I *had* to paint it." He then added, in a deliberately mysterious but meaningful way, "Any attempt on my part to say something about it, to attempt an explanation of the inexplicable, could only destroy it."

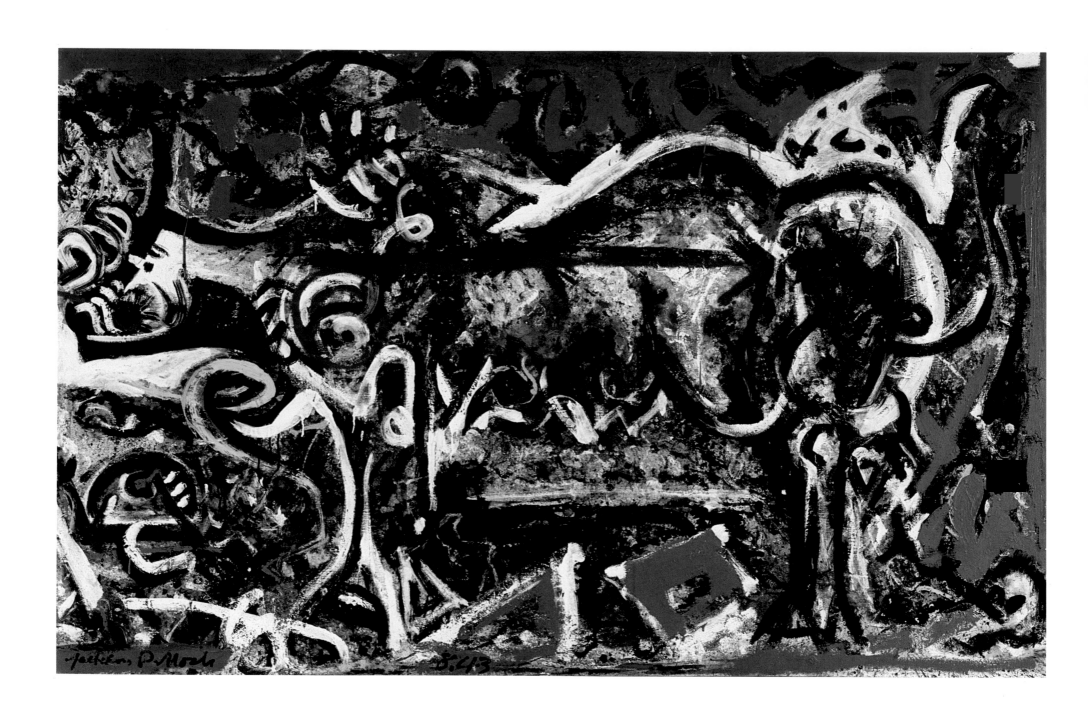

The She-Wolf. *1943*

# A Whiff of Primal Hordes

*She-wolf. c. 1500–50*

*Rufino Tamayo. Animals. 1941*

Jack had a way of making magic out of things. When he saw something interesting, it was created strictly for him as an artist.

—Reuben Kadish to Jeffrey Potter

Painting is self-discovery. Every good artist paints what he is.

—Jackson Pollock to Selden Rodman

It is clear that during the early forties Jackson Pollock was well aware that there were thematic interconnections between his works. This is evident in conversations recalled by several close friends. For instance, despite his generally secretive nature and his unresponsiveness when specifically asked about the meaning of *The She-Wolf*, Pollock betrayed the compulsive origins of this and other current pictures when he told Sidney Janis that it had "come into existence because I *had* to paint it." Although Pollock never actually confirmed that this was so, the protagonist of *The She-Wolf*'s title appears to be Lupa, the wild animal of classical legend who suckled Romulus and Remus, the twin founders of Rome. This seems like an odd theme for him to choose; however, not long before Pollock created this obviously allegorical canvas, his widowed mother had decided to move east to live with Sande and his wife in Connecticut. Stella came to New York first for a visit with Jackson, and his well-documented traumatic response to this event (he ended up in the drunk tank at Bellevue Hospital) leads to the conclusion that her unwelcome reentry into Jackson's life may have triggered his need to create this painting.[1]

The fact that Pollock omitted the two babies associated with Lupa has always been credited to his probable use of an Etruscan-style bronze in the Frick Collection as his prototype for *The She-Wolf*. Pollock liked to wander the galleries of the Frick, located at Fifth Avenue and East 70th Street, and would have been quite familiar with the childless New York version of Lupa. (A more famous variation—with children attached—resides in the Capitoline Museum in Rome.) Fritz Bultman has recalled that, around the time he created *The She-Wolf*, Pollock also spoke about his admiration for a contemporary painting that had recently been placed on view at the Museum of Modern Art. This 1942 canvas, *Animals*, depicted several vicious-looking wolflike dogs painted by the Mexican artist Rufino Tamayo. Perhaps, in Jackson's state of agitation over seeing his mother again, he superimposed the menace projected by these bitches onto his angry feelings toward Stella's rigidity: the she-wolf's empty udders in the exact center of his composition strongly express negative nurturance. As many previous writers have taken pains to point out, Jung discussed Lupa as a symbol of the possessive, all-devouring mother in his *Psychology of the Unconscious*, but once again there is

*Bison and hind. Frontispiece to* The Art of the Cave Dweller, *by G. Baldwin Brown, 1931*

*Bison pierced with darts. Cave painting at Niaux. c. 10,000 B.C. From* The Art of the Cave Dweller, *by G. Baldwin Brown, 1931*

no way of knowing if Pollock was actually aware of this very specific psychoanalytic interpretation.[2] He clearly still resented Stella's treatment of his father and himself, however, and this painting could have become a way for him to address or curse her real or imagined offenses. These had left him with uncertainty about his self-image and a feeling of deprivation.

By the time Pollock painted *The She-Wolf*, Jung's linkage of the contents of modern man's individual unconscious with the collective exploration of archetypes in myths and legends throughout the history of civilization was well-known even among those who had no experience as Jungian analysands; indeed, this idea was turning out to be an important impetus for current trends in painting. "Only that subject matter is valid which is tragic and timeless," Pollock's contemporaries Mark Rothko and Adolph Gottlieb (artists whom he had not yet met)[3] wrote in the Jungian vein in a June 13, 1943, letter to the editor of *The New York Times*. This belief, they explained, helped account for the widespread feeling of "spiritual kinship" that they and many of their peers felt with primitive and archaic art.[4] Extensive interest in the Jungian idea that symbol-making was a natural part of life lived at a more primal level was a key factor in the almost pervasive atavism felt during the war years in artistic circles in New York. In the face of cataclysmic world events, the devaluation of a sophisticated and rational approach to art and the elevation of the rudimentary and instinctual was widely noticeable on the easels of many downtown studios.

Seen in this context, *The She-Wolf*—signed and dated by Pollock two months after the appearance of Gottlieb and Rothko's letter—projects a potent communal meaning in addition to encompassing his own personal crises. Once past the Lupa association, it is not difficult to find numerous other references to the primitive and mythic in the style and iconography of this painting. For instance, if the outlines of the she-wolf's body are followed to its rump, it suddenly appears that there are really two creatures represented in this painting, or one that "faces" in two opposite directions. In a few swelling curves, the rear of the wolf is seen to become the hump and head of a prehistoric mastodon, and underneath, its udders elide into the foreparts of this long-extinct beast. Although Pollock's original impetus for this conception may have been his own earlier schizoid psychological drawings (see page 44), a more specific source for the she-wolf's bifurcation may be found in illustrations of similar back-to-back animal superimpositions in a book he owned, a 1931 edition of G. Baldwin Brown's *The Art of the Cave Dweller*. (William Baziotes, who was particularly interested in paleontology at this time, may have encouraged Pollock to acquire this volume.)

In *The Art of the Cave Dweller*, Brown reproduced a number of plates with overlapping drawings of different species copied from the walls of Paleolithic caves such as Altamira and Font de Gaume. The book's frontispiece, which depicts a confusion of bison and hind, is a likely visual prototype for Pollock's bipolar she-wolf. We do not know whether he delved into this volume beyond the pictures, but if he did read Brown's text, Pollock would have encountered a lengthy discussion of the *modus operandi* of the prehistoric painter. In particular, Brown emphasized the fact that these shaman/artists did not care if their walls were already image-occupied, and this often resulted in what the author termed a "most admired confusion."

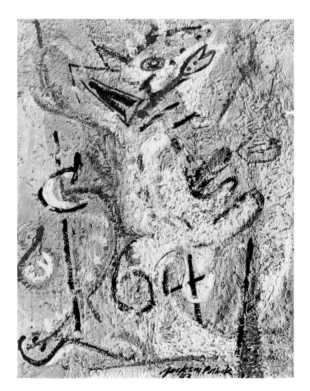

Wounded Animal. *1943*

*Pablo Picasso.* Bullfight: Death of the Female Toreador. *1933*

In an elaborately detailed comparative figure, Brown showed the reader variations of tusked mammoths identical to the one Pollock used for the back half of the she-wolf. Brown also reproduced a number of cave images which show mastodons, bison, and other animals being pierced by arrows or darts. Thus the prominently situated black arrow which leads across Pollock's hybrid animal (from the wolf's head toward the neck of the mastodon) more definitively associates this image with Franco-Cantabrian art. Pollock repeated this well-known prehistoric (and Navajo) allusion in another contemporaneous painting, *Wounded Animal.* If he had skimmed Brown's text, Pollock would have learned that the shaman's drawing of an arrow piercing an animal's side was believed to have the power to effectuate the wound of a hunter's lance into the flesh of actual prey and that this thrusting image—plainly demonstrative of male potency—appears over and over in geographically widespread prehistoric locations. Rephrased in twentieth-century psychological jargon, Jung stipulated the arrow as a designation for the libido; on a more vernacular level, this symbol is commonly associated with Cupid and "falling in love." With these meanings in mind, John Graham's provocative comment about Picasso—that he often created works in which "cosmic-form-beings, of all time consort and separate, yearn for each other. . . . Un-heard of creatures protrude themselves"[5]—could be borrowed to describe Pollock's *The She-Wolf.*

If not directly stimulated by a suggestion made by Baziotes, Jackson Pollock's purchase of Brown's text may have taken place as a result of interest piqued by another landmark exhibition at the Museum of Modern Art, "Prehistoric Rock Pictures in Europe and Africa." Although this show was mounted six years before Pollock painted *The She-Wolf,* he may have acquired Brown's book at that time. In the Modern's show, replicas of scenes from various prehistoric caves were gathered on the gallery walls. Most sensational were images copied from Altamira, in northern Spain; the other best-known Franco-Cantabrian cave, Lascaux, had not been discovered yet. The "chalky encrustation" of Pollock's *Wounded Animal* (this term was used to describe its surface by Clement Greenberg)[6] may have been prompted by the artist's remembrance of his glimpse through reproductions at the Modern of the calcareous texture of the slabs of stone that formed the background for most cave art. The museum's replicas had made this point both visually and tactilely explicit. To achieve a similar granularity, Pollock mixed plaster with his paint in both *The She-Wolf* and *Wounded Animal.* In the latter, he closely approximated the decortication of cave walls associated with their exposure to oxidation and the aging process over many millennia. Additionally, Pollock layered, slashed, patched-onto, and even scarified the surface in this painting to achieve a Paleolithic look.

Another canvas dated 1943, and also closely related to *The She-Wolf* in style and imagery, was not included in Pollock's first one-man show because it was not completed in time. A page of notations exists in Pollock's files that seems to have been written to explain the unusual title given to this work. Originally designated either *Moby Dick* or *The White Whale* (contemporaries, including Krasner, differ in their recollection of the name), Pollock changed this painting's title to *Pasiphaë* because Peggy Guggenheim did not like the Herman Melville connection. James Johnson Sweeney, on a visit to Pollock's studio, proposed *Pasiphaë* as an alternative because what he saw in this work reminded him of the story of the origins of the Minotaur. The notes (which Sweeney must have jotted down for Pollock) explain that, in

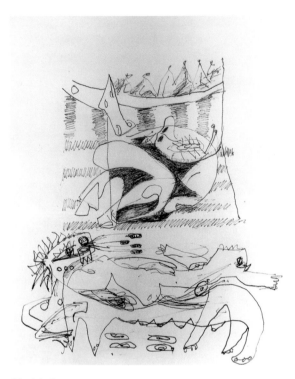

Untitled. *1941–42*

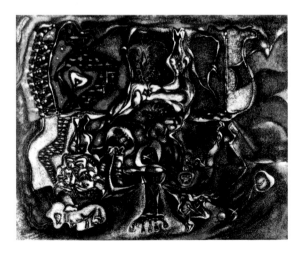

*André Masson*. Pasiphaë. *1943*

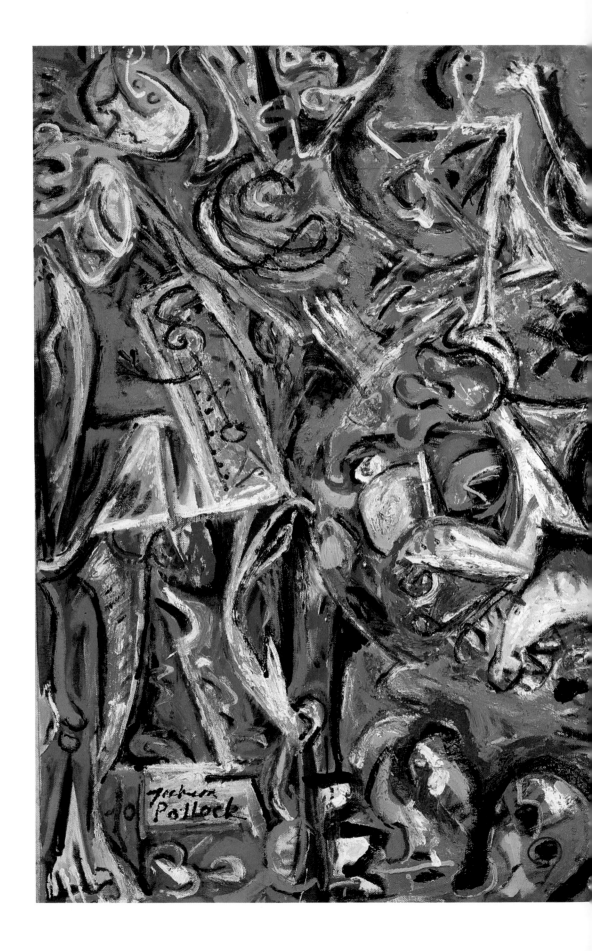

Pasiphaë. *1943*

Greek mythology, Pasiphaë was the daughter of Helios the Sun and a nymph. She married King Minos of Crete, but was bewitched by the gods into falling in love with a bull who lived at the base of a rumbling mountain on the island. Wearing a wooden cow costume, which the famous inventor Daedalus designed for her, Pasiphaë descended to the bowels of the volcano where she mated with the bull, a union which produced her bestial son. Sweeney cited for Pollock portions of Ovid's *Metamorphoses* and Virgil's *Aeneid* where further details of this story could be found.

Why might Sweeney have associated Jackson Pollock's newest composition with the legend of Pasiphaë? First of all, the guardian figures Pollock again included at the extreme left and right flanks of this painting now strongly resemble Greek warriors. Even more germane to this interpretation, however, is the central image contained in an oval medallion which looks very much like a human figure in an animal's sexual embrace. Reinforcing this impression is the extreme agitation of the lines Pollock used to describe his narrative: these multidirectional thrusts suggest the excitement of an orgasmic state. In a drawing of around the same time (see page 122) Pollock actually depicted a woman swooning on an animal's back, but there is no way to determine whether this sketch came before or after the painting's redefinition of theme. There is always the possibility that, once again, Pollock was creating his own variation of something he had seen in the work of Pablo Picasso. During the early thirties, Picasso had created a series based on the theme of a female toreador killed in the bullring. In several sexually charged paintings and prints he draped the body of a torera over her horse. Both were shown ignominiously borne on the back of a prancing and pawing victorious bull. (Another related drawing by Pollock also includes a horse.)[7]

His acquaintance with several recent works illustrating the Pasiphaë myth in the oeuvre of French Surrealist André Masson could also have prompted Sweeney to suggest this theme to Pollock. One of these had been exhibited in New York during the early months of 1943, and at an earlier time it was thought that perhaps Pollock himself had seen this work by Masson and used its retelling of the birth of the Minotaur as a direct model for this painting. Lee Krasner's distinct remembrance of Pollock's first reaction to Sweeney's title suggestion— the perplexed question "Who the hell is Pasiphaë?"—would seem to negate that possibility.[8]

To interpret Pollock's intentions toward his imagery in *Pasiphaë* accurately, it might be more fruitful to look back at its original title (although this may not be relevant either, as many of his works were not generated by any specific a priori theme). Interestingly, Melville's story of *Moby Dick* is not totally unrelated to the myth of Pasiphaë; in both, a human being becomes possessed by thoughts of an animal.[9] Lust and ambition, two preoccupations of the libido, are tangled elements in both the ancient story and Melville's great American novel, published in 1851. However, unlike the Queen of Crete, who really was a victim, Melville's Captain Ahab (despite the conflicts in his personality) more closely follows the archetype of the hero engaged in an agon, or epic conflict. Some art historians believe that, because of his years of Jungian analysis, Pollock may have been able to associate Ahab's search for the great white whale with what Jung called the Nekyia, or night sea journey. This term from Homer's *Odyssey* was borrowed by Jung to describe the descent into, or harrowing of, the unconscious which must be undertaken by any individual who wishes to achieve a complete personality integration. In *Modern Man in Search of a Soul*, published in

1933, Jung characterized Herman Melville's novels as prototypical for such mythic interpretation, and he cited in particular the possibilities for psychological insight inherent in *Moby Dick*.[10]

Once more, there is a good chance that William Baziotes may have exerted some influence on Pollock's interests; according to his wife and a number of other friends, Bill was extremely fond of Melville's most famous book. Many remember that he loved to quote one of Ishmael's early lines in *Moby Dick* about "a damp drizzly November in my soul." Since Jackson "was not much of a reader," there is a legitimate question as to how much, if any, of this novel he ever got through by himself.[11] He certainly appears to have somehow absorbed the general theme of *Moby Dick*, perhaps from high school English, or through the interest in Melville of Krasner and others around him (a kind of "fad" for Melville was at its peak in the early forties). The summer after he painted *Pasiphaë*, Pollock and Krasner may have attended some of the sessions in Provincetown when Joe Hazen (a friend of Tennessee Williams) read passages from *Moby Dick* aloud by lamplight; discussions that took place eight or ten years later on the beach at East Hampton, however, led B. H. Friedman to doubt whether Jackson really knew the book from firsthand experience.[12]

Whatever the extent of his actual exposure to *Moby Dick* at the time he painted *Pasiphaë*, as Clement Greenberg was to point out in one of his first Pollock reviews, in both subject matter and style there did seem to be certain almost uncanny analogies between the author of that nineteenth-century novel and this new young painter. (As noted already, Pollock also identified and was identified by others with the main character in Melville's *Billy Budd*.) In many ways quite comparable to the affinity he felt for Albert Pinkham Ryder, another tortured artist of a previous age, Pollock shared with Melville not only feelings of paranoia, but also a definite preoccupation with moody and tragic violence, and their mutual penchant for uncertain and indefinite imagery is seemingly equivalent. Because of these similarities both, as Greenberg put it, projected in their respective art forms, a particularly "American chiaroscuro."[13]

Jackson Pollock made possible reference to Herman Melville's *Moby Dick* at least twice more, once some years later in the naming of a pet, and perhaps also in the titling of a gouache and ink composition painted around the same time as *Pasiphaë*. Pollock's *Blue (Moby Dick)* (see page 128), composed primarily of Miroesque biomorphic shapes, is in its lower half more strongly visually suggestive than *Pasiphaë* of an actual sea theme: the way Pollock organized his forms in this small mixed-media work approximates the rhythms of the roiling ocean depths. Fish and what appear to be lower marine forms toss about on the waves, although no discernible white whale is anywhere in sight. There do not seem to be any obvious pictorial or thematic parallels between *Blue (Moby Dick)* and *Pasiphaë*; moreover, it is not even known whether Pollock himself assigned the gouache's title.

Relying once again for compositional inspiration on Picasso's studio compositions, Pollock painted another major canvas, *Guardians of the Secret* (see page 129), also in the summer of 1943. This work was the most startling entry in his first show, and it represents the most thoroughgoing synthesis of his themes and influences up to that time. In *Guardians of the Secret*, world mythology, Miró, African, American Indian, and prehistoric art were successfully synthesized with Picassoid elements to form a psychologically redolent whole. Its composition once more features an abstracted male and female who now seem to face in

*John Graham.* Queen of Hearts. *1941*

*Reliquary figure. Gabon, Kota*

toward a figured "canvas" displayed heraldically between them. Less confused in overall impression than *Pasiphaë*, *Guardian*'s distinct symmetricality of plan is evident.[14] The upright stance of the flattened side figures suggests that Pollock may have still been thinking of the vertebral columnar poles of Northwest Indian cultures, which often acted as intermediaries to ward off strangers. Not only is the right-hand figure bearded, but it appears to be in the process of semen ejaculation; thus it is certainly the male. Because of its crown and flattened appearance, Pollock could also have used the jack or king on a picture card as his visual source (Graham had set a precedent for this in a 1941 painting, *Queen of Hearts*), or alternatively, perhaps this figure was inspired by a chess piece. Just as the gender of the "king" has been clearly indicated, the womanly form of his companion causes her sex identification to be equally unequivocal. Large-bosomed, she is dressed in a flowing gown, but the section above her neck is more confused. Either her head is absent, or akin to the dancing shaman in Pollock's earlier drawing, she is wearing a horse-faced mask. Or she could be a conflation of the knight and queen of the chess board.

Moving in the picture from the horse's head to the right, we find that above the central slab Pollock enigmatically lined up a number of other small images which extend from one side guardian to the other. Their juxtapositions, however, seem to lack any obvious connection. Next to the horse is the ghostly outline of a shield-shaped mask whose overall configuration, proportions, and O-shaped mouth closely approximate African guardian figures such as those created by the Bakota tribes in Gabon, Equatorial Africa. These had been admired and used as inspiration by Picasso and Braque. A number of examples could be seen in museums in New York, and Peggy Guggenheim had one in her collection.

Suspended next to the African mask, seemingly hanging on the perimeter of an interior frame, we find an embryonic shape similar to the one featured in *Moon-Woman Cuts the Circle*, although presently it is facing in the opposite direction. Scarab-like, this new version of the fetus resembles even more strongly the Haida tattoo which supposedly Pollock still could not have known. There are strong formal parallels as well to a beetle image found in the center of a Mimbres pottery bowl from New Mexico (see page 129) that may have caught Pollock's eye in the Modern's 1941 Indian show. (This bowl was illustrated in *Art News* and in the catalogue Pollock owned.)[15] On the other hand, the fetus, a form which made its dramatic debut in *Bird*, could quite simply have been generated out of Pollock's psyche, without being based on any preexisting visual source.

The next two symbols in the top section of *Guardians of the Secret* are closer to the "king," and they seem to be interrelated. The flamelike splashes of red appearing right after the embryo appear to coalesce into a rooster, and the shape that follows also approximates a cock's head. Although it would be difficult to impute any particular personal significance to the African mask, Pollock's known preoccupation with childbirth (his own experience was traumatic: he was born choked by his umbilical cord) may explain this fetal obsession.[16]

The role of the rooster in Pollock's on-going psychological drama can be gauged with even more certainty. According to accounts given by his friend Axel Horn and his older brother Frank, as a boy Jack had had a "run-in" with a barnyard cock that literally scarred him for life. Photographs show that the top joint of his right middle finger was missing. Apparently, he had once brashly put his finger on a chopping block to show another boy,

*Vignette of Anubis, from The Book of the Dead, Papyrus of Ani. c. 1550–1305 B.C.*

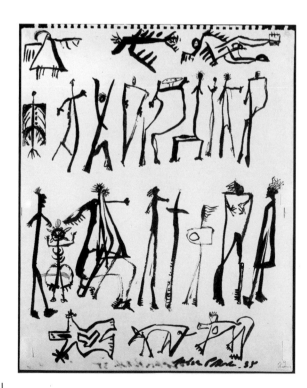

Untitled. *1939–42*

Johnny Porter, where to strike his ax. The rest of their friends were appalled when Porter actually swung the blade and cut off the tip of Jack's finger. To make matters worse, before the digit could be retrieved, a rooster allegedly ran up and stole it.[17] This may explain why, among the welter of images in Pollock's therapeutic drawings, a rooster's head appears numerous times. (We have also seen it in one of the sketches generated by playing Surrealist automatic games.) As noted, *Bird* may have been intended as a headless cock; Frank Pollock has vividly recalled his mother's frequent and brutal decapitation of cooking chickens when they lived in Phoenix, a memory which may have haunted Jack as well.[18] It is quite possible that Jackson Pollock could have realized that Picasso had often used this very same animal in guises leading to its interpretation as another of his alter egos.[19] In *Guardians of the Secret*, Pollock's king reaches one arm out toward the red rooster in what looks like a ceremonial gesture.

Reinforced by this line-up of "relics," the overall arrangement of *Guardians* may be deemed reminiscent of the hieratically designed murals found in ancient Egyptian tombs and descriptions in the Egyptian Book of the Dead. Moreover, underneath the cursively inscribed white rectangle which occupies the center of his painting, Pollock placed a dog with pointed ears that strongly suggests Anubis, the jackal-headed god who guarded the Egyptian underworld.[20] (Alternatively, it could have been suggested by one of Tamayo's snarling animals.) Once more we should not be surprised to find that Jung discussed Anubis in his writings, citing his role as protector of the secrets of the land of the dead. Pollock could have specifically intended the dog and the African face to constitute alternative forms of the totemic guardian: in his maddeningly inscrutable fashion, he once identified the dog to Lee Krasner as "a father figure, of course." In this statement Pollock was perhaps alluding to what he may have considered to be the most important role of a parent, to guard the threshold which separates his children from the adult world until the proper time for their release.

The central slab in *Guardians of the Secret* is the most interesting part of the painting. It appears to represent the front or top face of an altar or casket tipped forward into the viewer's space. Pollock covered this area with hieroglyphic symbols suggestive of ancient civilizations, indicating that herein must be contained the restricted message of the title, one intended only for the eyes of those whom its protectors will let pass. To suggest that this is indeed the "secret," on the white rectangle Pollock combined arcane-looking sigils with a few more easily readable images including the well-defined outline of a fish. If you turn the rectangle upside down, at least two stick figures emerge. Joined together in rebus-like fashion, this mixture of semiotic markings sits on top of a loosely brushed surface with many visible underlayers of differently colored paint.[21]

Where might Pollock have gotten the idea for the format of his "secret"? If he were still perusing Brown's book on prehistoric art, Pollock could have found a plate illustrating almost identical "enigmatical signs" from the caves of Altamira, Lortet, Pêche Merle, and La Pasiega. Another figure in the text demonstrates the degradation of natural forms into runic markings on Azilian pebbles. Of course, many such primitive alphabetic symbols—as well as comparably schematized stick figures—were also present on the American Indian petroglyphs shown in 1941 at the Museum of Modern Art. Visually related examples from the Libyan desert were included as well in the Modern's earlier "Rock Pictures" show; in the four-year period between those two exhibitions, Pollock frequently drew primitivistic stick personages.

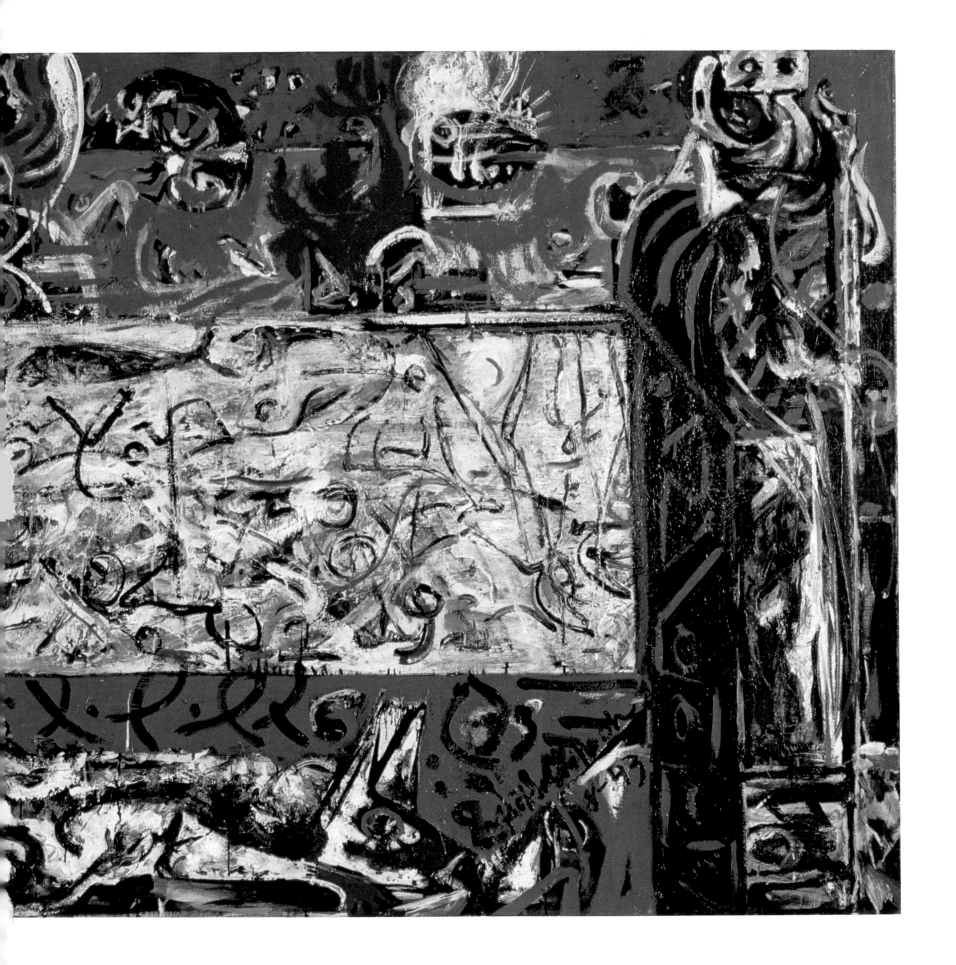

Mimbres bowl. Mimbres culture area. c. 1000–1150

Untitled. 1939–42

Guardians of the Secret. 1943

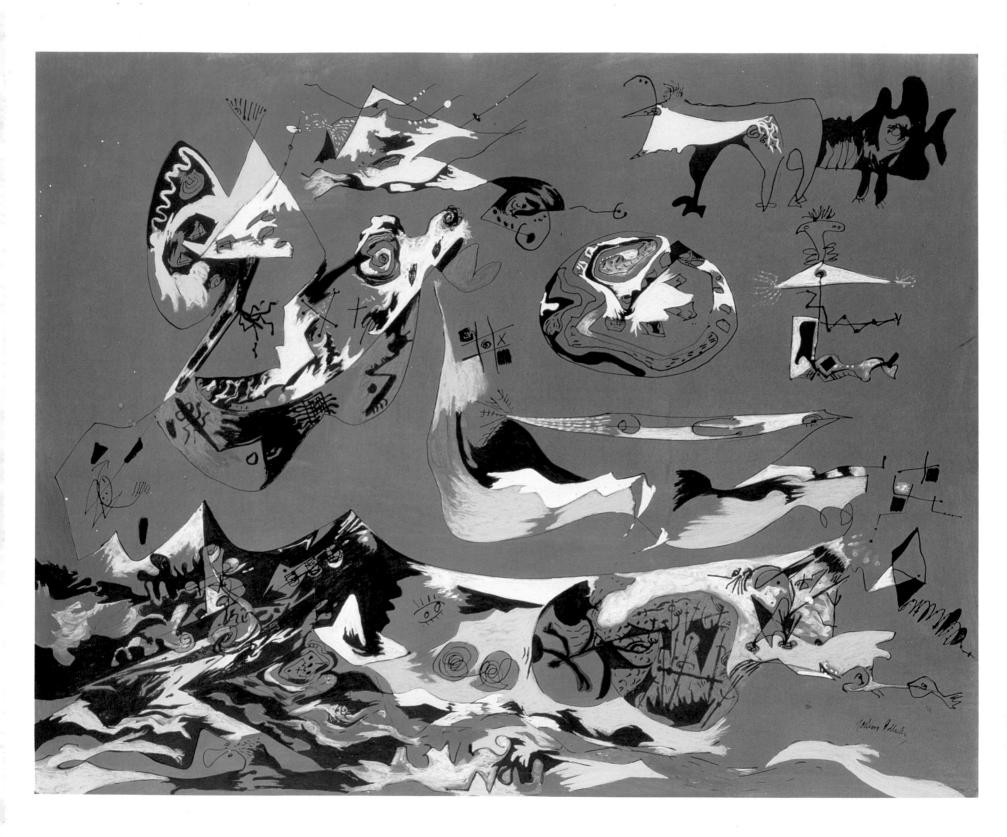

Blue (Moby Dick). *c. 1943*

Pages from The Fourth Book of Occult Philosophy,
by Cornelius Agrippa, c. 1500

*Paul Klee*. Everything Comes Running After! (Alles
Lauft Nach!). *1940*

Another impetus for the arcana of Pollock's secret could have been the illustrations included in an essay Pollock kept by Surrealist Kurt Seligmann. This appeared in *View* magazine in February–March 1942. To amplify the discussion in this text, "Magic Circles," Seligmann had reproduced two pages from Cornelius Agrippa's *Fourth Book of Occult Philosophy* identifying the astrological and alchemical characters symbolic of good and evil spirits. A comparison of Pollock's cryptic "message" with Agrippa's magic signs discloses a number of roughly equivalent sigil formations.[22]

In 1941, complementing its American Indian show, the Museum of Modern Art mounted a memorial exhibition honoring the Swiss painter Paul Klee, who had died the previous year. Also during 1941 and extending into 1942, the Nierendorf Galleries in New York presented a series of five one-man shows of Klee's work and, when Peggy Guggenheim's Art of This Century opened, the permanent exhibition rooms included an installation of works by this artist built into the design. (Frederick Kiesler attached a number of Klee's small paintings to a mechanized conveyor belt which rotated automatically every ten seconds.) Although Klee was not destined to become one of his favorite painters, Pollock would have had ample opportunity to become familiar with this artist's style before painting *Guardians of the Secret*.[23] And, in fact, Robert Motherwell has recalled that, on at least one occasion, Jackson listened "very intently" to a disquisition by Matta on the importance of Klee for the development of abstract Surrealist art. Pollock was never to revere Klee because of the Swiss artist's lack of monumentality; however, Klee's purposely rudimentary, whimsical little stick figures, simultaneously childlike and sophisticated, possibly had some impact on the pictograms included in *Guardians of the Secret*. As Leland Bell has commented, however, the grandiloquence and baroque force of Pollock's work surpasses anything similar done by Klee.[24]

In the early pages of *Moby Dick*, Herman Melville described at length a picture that hung on the walls of the novel's fictitious Spouter Inn. Anyone reading the book soon realizes that this painting was introduced as a metaphor for Ahab's quest, and a number of writers on Pollock have invoked Melville's Spouter Inn passage in conjunction with the mysterious aura of the white rectangle which forms a "picture-within-a-picture" in the center of *Guardians of the Secret*. In fact, because of the seeming buoyancy of its forms as well as its incorporation of some sea imagery, this slab has been likened to an aquarium; whether or not this analogy "holds water," in many ways the overall configuration of Pollock's rectangle does echo Melville's Spouter Inn painting, which the author described as having "dim, perpendicular lines floating in a nameless yeast." "A boggy, soggy, squitchy picture truly, enough to drive a nervous man distracted," Melville's Ishmael pronounced the painting when he first saw it. Yet, Ishmael admitted that it had "a sort of indefinite, half-attained, unimaginable sublimity about it that fairly froze you to it." After studying it a bit, Ishmael realized that he was "hooked"; he just had to find out what the painting meant.[25]

Because of Pollock's Jungian proclivities, the most commonly held interpretation of the meaning of this panel is that its markings contain the contents of his unconscious. Many believe that, in *Guardians*, Pollock meant to demonstrate that he himself had finally managed to obtain meaningful psychological information as a result of attempting his own Nekyia, and that he realized that this information, although deeply personal, could be generalized to all mankind (thus its archaic look). "Through buried strata of the individual soul," Jung said,

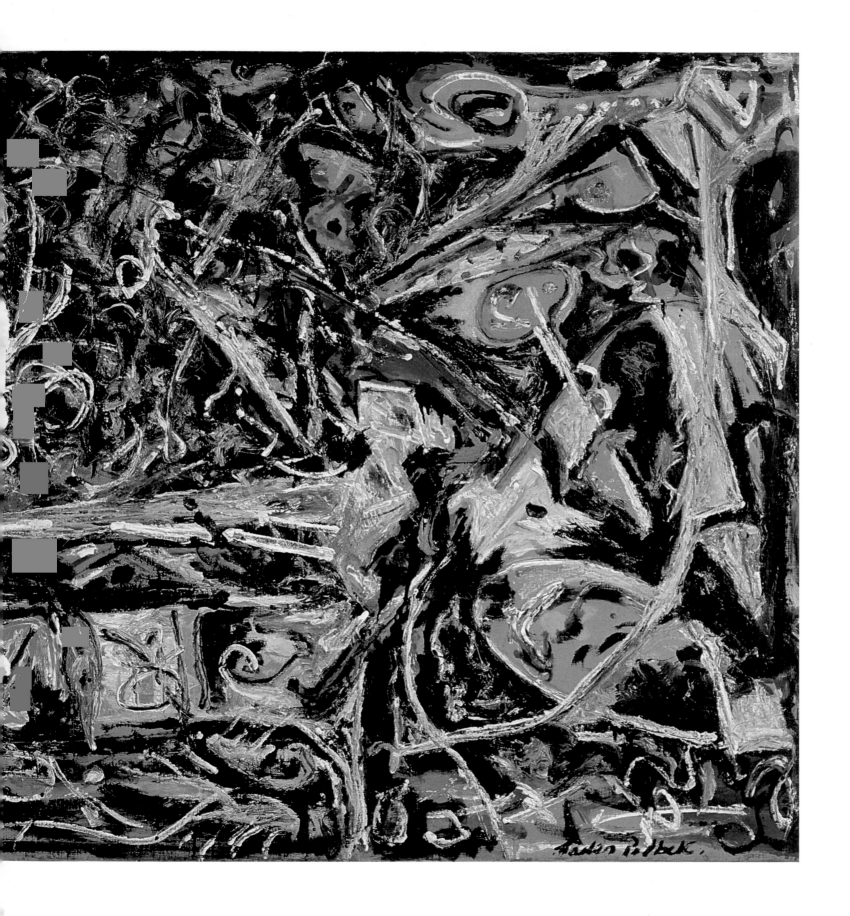

Night Mist. *1945*

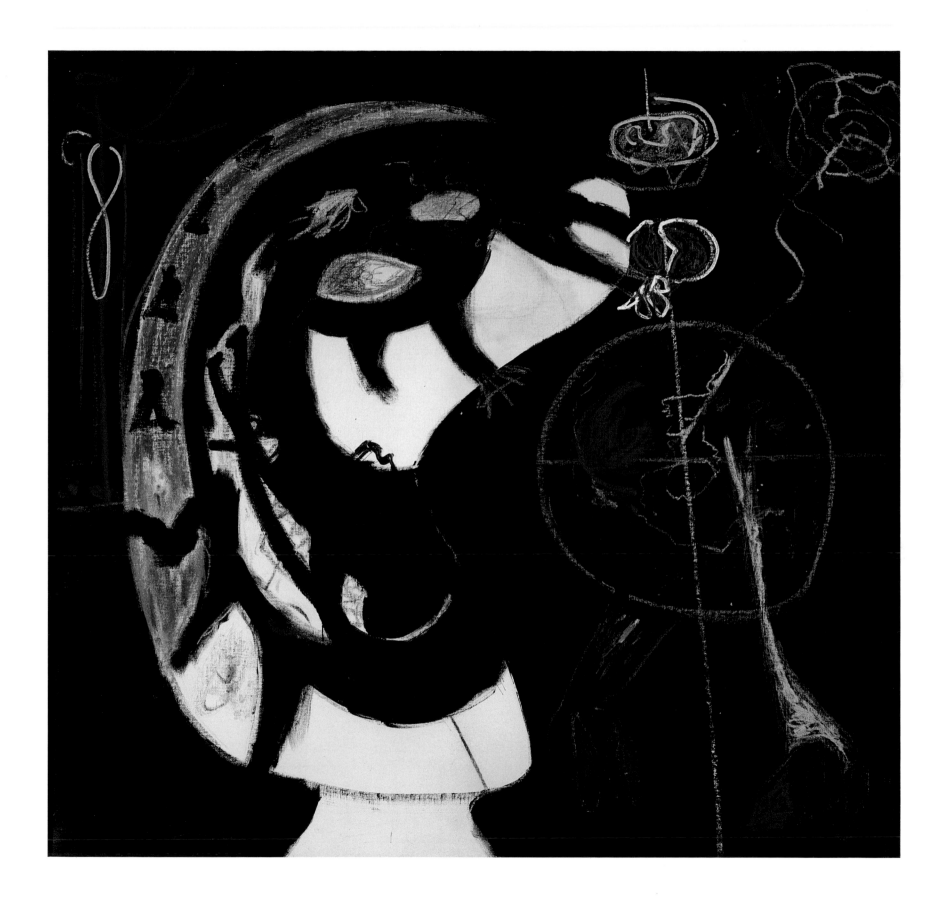

Night Sounds. *c. 1944*

Untitled. *From sketchbook, 1938–39, page 10*

"we come indirectly into possession of the living mind of ancient culture."[26] While in its form the imagery in Pollock's central panel looks backward in time, like *The She-Wolf* it can be interpreted as simultaneously looking ahead: there is no arguing the fact that its allover conformations clearly prefigure by a number of years Pollock's mature artistic breakthrough.

Pollock's generally improved assurance about his own creative and personal goals at the time he painted *Guardians* can be intuited from the very precise location of his signature in this work. Once again, he has made crystal clear the direct analogy in his mind between artistic and sexual potency.

In 1964, when Thomas Hess wrote that many of Jackson Pollock's early forties paintings give off "a whiff of the shaman and Jung in the atmosphere and Freud's primal hordes," *Guardians of the Secret* was one of the paintings he must have specifically had in mind.[27] Oddly, despite Pollock's years of Jungian analysis, Krasner confirmed that Pollock considered Sigmund Freud to be the more seminal figure in modern thought: he repeatedly said that Freud and Albert Einstein were the two greatest minds of the twentieth century. This comment notwithstanding, writers after Hess have focused much more precisely on the Jungian, rather than the Freudian implications of Pollock in mid-career. Pollock himself (in a note to Sweeney prompted by the latter's essay for his first one-man show) made reference to his intent to strive toward "a deeper, more integrated, experience,"[28] and this remark has been used as fuel for the fire by those who have argued for his deliberate elaboration of a Jungian iconography. In *Modern Man in Search of a Soul*, Jung described how psychically aware patients often seem impelled to paint their "active fantasies." In 1938 or 1939, during his period of treatment with Dr. Henderson, Jackson Pollock had scrawled this very phrase (and its opposite) on an abstracted, frankly phallo-erotic drawing, and if taken from this broad point of view, Pollock was definitely "a Jungian."[29] More concrete assertions that he consciously undertook a particularized program of auto-psychoanalysis will never be proved to everyone's satisfaction.

Fortuitously for Jackson Pollock, his debut at Art of This Century coincided with the breakup of Peggy Guggenheim's marriage to Max Ernst (he left her for the artist Dorothea Tanning). As a result, Peggy defiantly switched the emphasis of her gallery away from the European Surrealists, and using Pollock's critically successful first exhibition as her springboard, she began to focus on the promotion of a young set of American unknowns she called her "war babies." She and Putzel allowed Pollock's show to set the tone for the others, and Jackson Pollock, Guggenheim wrote in her memoirs, soon became "the central point" of Art of This Century. Before she moved back to Europe, Guggenheim mounted three more Pollock shows, including his works in a number of important group exhibitions as well.

For the most part, the paintings featured in Pollock's second and third solo presentations at Art of This Century (March/April 1945 and approximately one year later) presented a further exploration of familiar themes. For example, in his 1945 show Pollock continued a trend begun in the moon woman pictures by exhibiting a group of compositions focusing on the theme of night. (Matta's hour-of-the-day exercises, which Pollock had despised when forced to do them, turned out to be useful.) *The Night Dancer, Night Ceremony, Night Mist,* and *Night Magic*, included in Pollock's second one-man show, were all canvases with comparably dark backgrounds, and in them Pollock employed extensive *sgraffito* techniques

(scratching into the surface) as well as other unorthodox methods of direct painting. A fifth canvas on this theme, *Night Sounds*, was completed around the same time, but not exhibited until 1958. In *Night Sounds* Pollock resurrected the lop-sided Eskimo mask used a number of times before, combining it with another favored shape, the crescent moon. Also, reprising a device introduced in *Male and Female*, Pollock treated a portion of the canvas of *Night Sounds* as if it were a chalkboard, sketching on it what looks like a rudimentary version of the lower half of *Bird*.

Those who were familiar with Jackson Pollock's first one-man show may have felt that the night compositions exhibited a year and a half later were nothing but fragmented, hallucinatory shadows of the earlier paintings. They looked, as his friend Busa put it, almost like the "debris" of his own previous work and that of other artists who had influenced him. Compulsive and chaotic, their more loosely delineated forms probably seemed confusing to many observers. Jon Stroup, a perceptive critic who wrote about Pollock in the April 1945 issue of *Town & Country*, had this to say about the young artist's surprising new pictures: "In most of [Pollock's] latest canvases the image is not distinguishable. It is as if he presents only the emotional essence of experiences almost unbearable in their intensity." Pollock's latest works, Stroup wrote, "give the impression of having been painted while the artist was in the throes of a nearly ungovernable passion." "Dark curved lines," he noted, "slash across the picture planes [where they become] interspersed with areas of turbulent-looking color." Stroup compared the surfaces of some of the recent Pollock paintings on view at Art of This Century to relief maps because of their textural complexity, a result of thickly applied pigment. This physical "third dimension" Stroup pointed out had become "an important and integral part of Pollock's form," and when his efforts along these lines were most successful, Pollock achieved a seldom equaled degree of "directed intensity."[30]

In addition to the night series, included in Pollock's 1945 exhibition were two paintings again involving the theme of the Indian totem. Designating these canvases as *Totem Lessons*, Pollock in them once more set out to explore aspects of his continuing interest in Native American shamanism, possibly refocused by the "AmerIndian" issue of *Dyn* magazine, which had come out in the spring of 1944. Busa had a copy of this journal which featured a lengthy article on totemism written by its editor, Surrealist Wolfgang Paalen. In his extensively illustrated essay, Paalen dissected North American totemistic customs, beliefs, and art, exhaustively interpreting their roles and meanings.[31]

Stylistically, Pollock's *Totem Lesson* paintings continued his recent tendency, conspicuous in the night series pictures, toward a more diffuse pictorial organization with less symmetry and less recognizable images. Although a totemic personage is perceivable in the center of *Totem Lesson 2*, in the earlier version Pollock fractured his shapes and symbols more thoroughly, scattering them haphazardly across the picture surface. As in *Night Ceremony*, there seems to be no designated focal point in *Totem Lesson 1*, no place where the eye can rest for more than a few seconds. It is now harder than ever before to distinguish where the positive forms end and the background begins: as in much of the American Indian art he admired, there seems to be only one layer of space.

This loosening up of Pollock's compositional fabric can be traced to the fact that, between his first and second presentations at Peggy Guggenheim's gallery, he had begun to

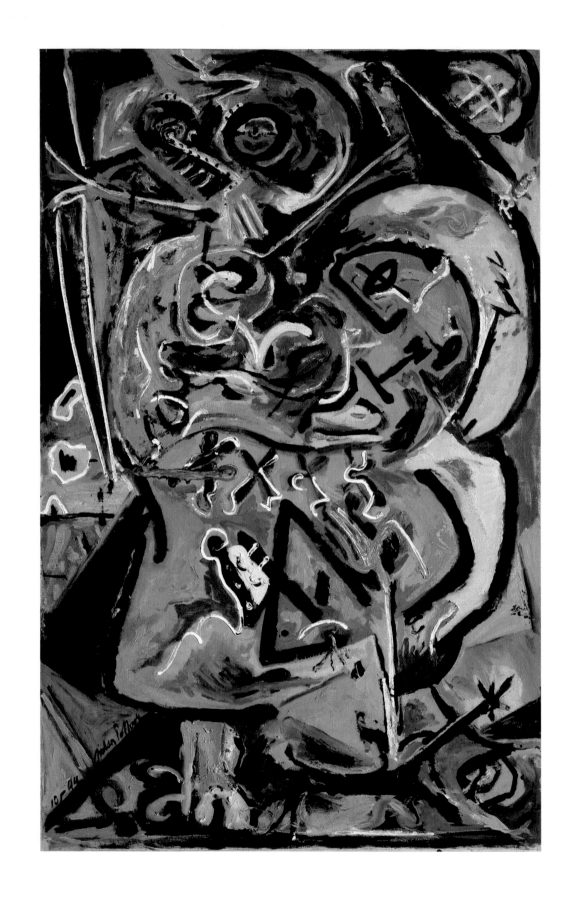

Totem Lesson 1. *1944*

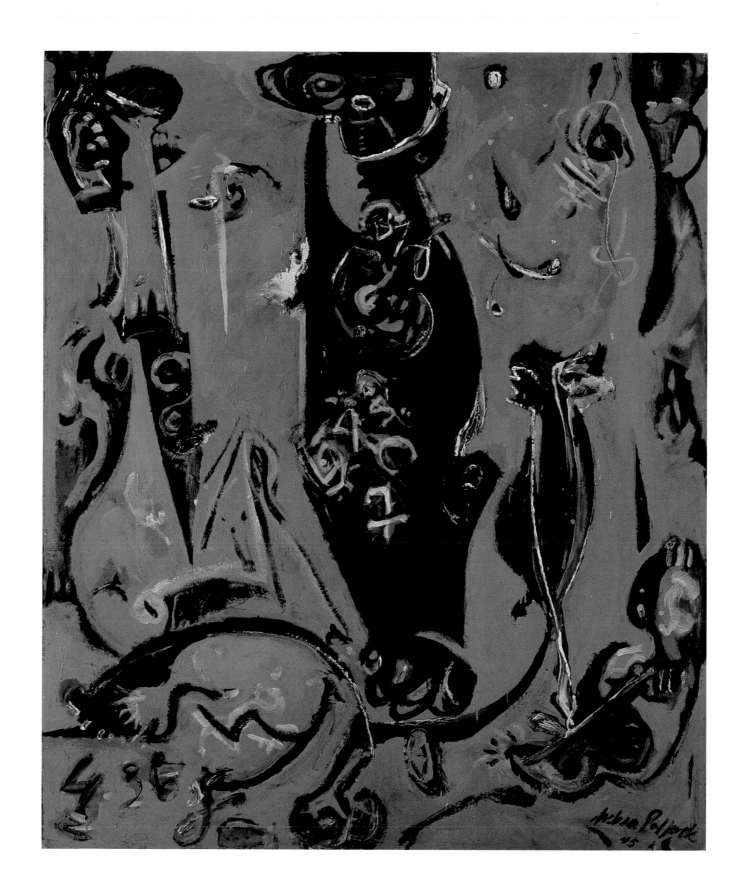

Totem Lesson 2. *1945*

*Stanley William Hayter.* Combat. *1936*

Untitled 5. *c. 1944–45, printed posthumously*

frequent Atelier 17, the graphic workshop run by Stanley William Hayter. Although Pollock had undoubtedly first heard about Hayter from John Graham, who was familiar with the Paris branch of Hayter's studio, Pollock and Graham had by now drifted apart and it was through Kadish that Jackson made direct contact with the famed British printmaker, another escapee from Hitler now working in New York. By the late fall of 1944, Pollock had become a regular at Hayter's workshop conveniently located at 43 East Eighth Street, across the street and a few doors down from his own apartment.

Stanley William Hayter, now considered one of the foremost graphic artists of the modern era, had originally trained in England as a petrochemist. After working in oil fields in the Middle East, he switched his career to art and moved to Paris, where he informally affiliated with the Surrealists and established his first communal printmaking facility at 17 Rue Campagne Première. After the Nazis overran France, Hayter moved Atelier 17 to New York, where it remained until 1950. Its American version soon became not only a haven for European expatriates, but a beacon to attract local talent. By the time Pollock decided to try his hand at printmaking there, both Baziotes and Motherwell had finished their own stints at Atelier 17. Although Jackson primarily came in with Kadish at odd hours and at night, he did have the opportunity to meet and exchange ideas (on a limited basis because of the language barrier) with some of the European émigrés who also congregated there.[32]

Most of the artists who chose to become part of Atelier 17 were specialists in other media who wanted to experiment with graphics as a way to expand the possibilities of their own craft. The atmosphere was informal and egalitarian, with discoveries and techniques shared by workshop participants. New "associates" were usually asked by Hayter to create an experimental copper plate under his direction in order to become familiar with the processes of intaglio (etching and engraving), the specialty of the shop. Automatic drawing was encouraged as a way to create imagery for this plate—as opposed to representational or ornamental design—and Hayter insisted that proofs be pulled and criticized at every stage of the process. He recommended constant rotation of the piece of copper to discourage a traditional top-to-bottom, left-to-right orientation, and effects obtained "by accident" were welcomed, not spurned. Pollock's subsequent much-remarked practice of working from all sides of the canvas undoubtedly owed a great deal to Hayter's training.

As was his wont, Jackson Pollock mostly kept to himself at Atelier 17 and did not participate in group discussions, and it does not appear that Hayter required him to fulfill this initial assignment. Hayter's teachings seem to have made a strong impression on Pollock, nevertheless, and the two developed a friendly after-hours camaraderie as well as an in-studio relationship. Hayter and Pollock talked about art on many occasions in the mid-forties; these conversations usually took place when Jackson was in his famous "lucid" phase, i.e., half drunk. Miró and Klee were among Hayter's favorite topics, and in many of the eleven prints Pollock made at Atelier 17, resonant echoes of the heavily outlined graphic symbology and dispersed configurations of these two artists can be seen.

It should be noted that Pollock and Hayter were artistically linked before they actually knew each other: when James W. Lane reviewed the McMillen Inc. exhibition, he had described *Birth*'s "whirling figures" as resembling Hayter's imagery.[33] Hayter favored circular compositional movement, and through working with printmaker's tools under Hayter's direction, Pollock increased his sense of centrifugality, originally a legacy of Benton. Hayter's

Untitled 1. *1944; second state printed 1967*

Untitled 4. *c. 1944–45; printed 1967*

own stress on velocity—fluid, spontaneous, and rhythmic movement in space—seems to have encouraged Pollock to aim in his graphic work to increase the intuitive and expressive effects he also wanted in his paintings. There are strong points of comparison between the prints Pollock made at Atelier 17 and contemporaneous canvases such as *Totem Lesson 1* and *Night Ceremony.*

Prior to his association with Hayter's studio, Jackson Pollock had never made an etching or engraving. His printmaking experience was limited to the design of lithographs and silkscreens, mostly made during the early thirties when he had had access to the Art Students League's graphics workshop. He never mastered the technical aspects of graphics production and could not pull his own prints, either at the League or at Atelier 17. Kadish helped Jackson to produce trial proofs at Hayter's and none of Pollock's compositions was published in edition form until long after his death. In his intaglio designs, Pollock at first simulated the vaguely biomorphic imagery he had been working with for a number of years, transferring his painting style from brush to burin. An example of this is the combination engraving and drypoint *Untitled 5*. In late 1944 or early 1945, however, his pattern of innovation reversed itself, and new technical and stylistic developments first appearing in Pollock's prints began to affect his larger works as well.

To achieve the deep darks in prints such as *Untitled 4* and *Untitled 1*, Pollock had to hatch and crosshatch with his tool innumerable times, a task which requires great self-discipline. (Sweeney had cited Pollock's lack of this quality in the essay written for his first

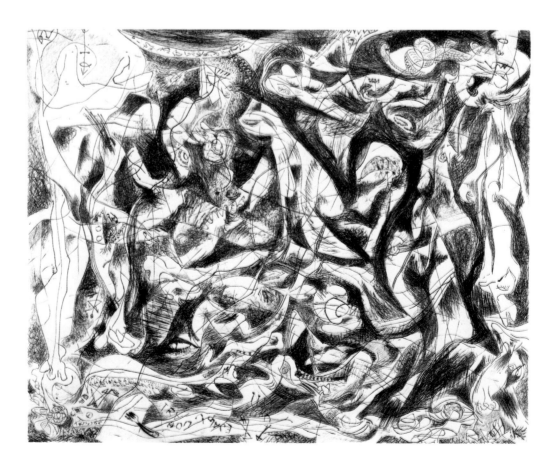

one-man show.) As he began to feel more proficient in printmaking, Pollock sought to attack many of the shortcomings for which he had been taken to task not only by Sweeney, but also by other critics. In his typically perverse fashion[34] though, Pollock daringly began to emphasize and accelerate, rather than to correct, these "faults." In *Untitled 4*, for instance, he started out with guardian figures and other totemic imagery; however, he all but annihilated these forms by overworking them with a totally arbitrary and claustrophobic pattern of looping lines. He soon extended this somewhat antagonistic procedure to his oil paintings. From the looks of such works as *Night Mist* or *Portrait of H. M.*, it does seem plausible—as Robert Motherwell has suggested—that this compulsively destructive technique was intended to exorcise all traces of Picasso, whose "pitiless" influence Pollock had by now come to believe was holding back his own development.[35]

Many observers were puzzled or repelled by the new "supercharged" Pollocks. One critic called them scrabbled and hectic; another wrote, "this is not a comfortable roomful at Art of This Century."[36] Why was he belligerently burying his subjects under these heavy and arbitrary expressionistic overlays of line or blotted pigment? Not only were many of Pollock's latest canvases dense in a truly suffocating way, but their color was turgid and "sloppy." Why was he now applying his paint in a turbulent and careless way?

These characteristics were so unappealing and even threatening to the average observer (one critic, Manny Farber, compared the effects he achieved to lava, blood, fire, and smoke)[37] that Clement Greenberg apparently thought it necessary to offer an apologia in his April 1946 review in *The Nation* of Pollock's third solo show. Earlier Greenberg had written that, "Pollock has gone through the influences of Miró, Picasso, Mexican paintings and what not, and has come out on the other side at the age of thirty-one, painting mostly with his own brush. In his search for style he is liable to relapse into an influence, but if the times are propitious, it won't be for long."[38] Now Greenberg had to explain that "one has to learn Pollock's idiom to realize its flexibility." "What is thought to be Pollock's bad taste," Greenberg intoned, "is in reality simply his willingness to be ugly in terms of contemporary taste." But, he added, echoing Gertrude Stein, "all profoundly original art looks ugly at first."[39]

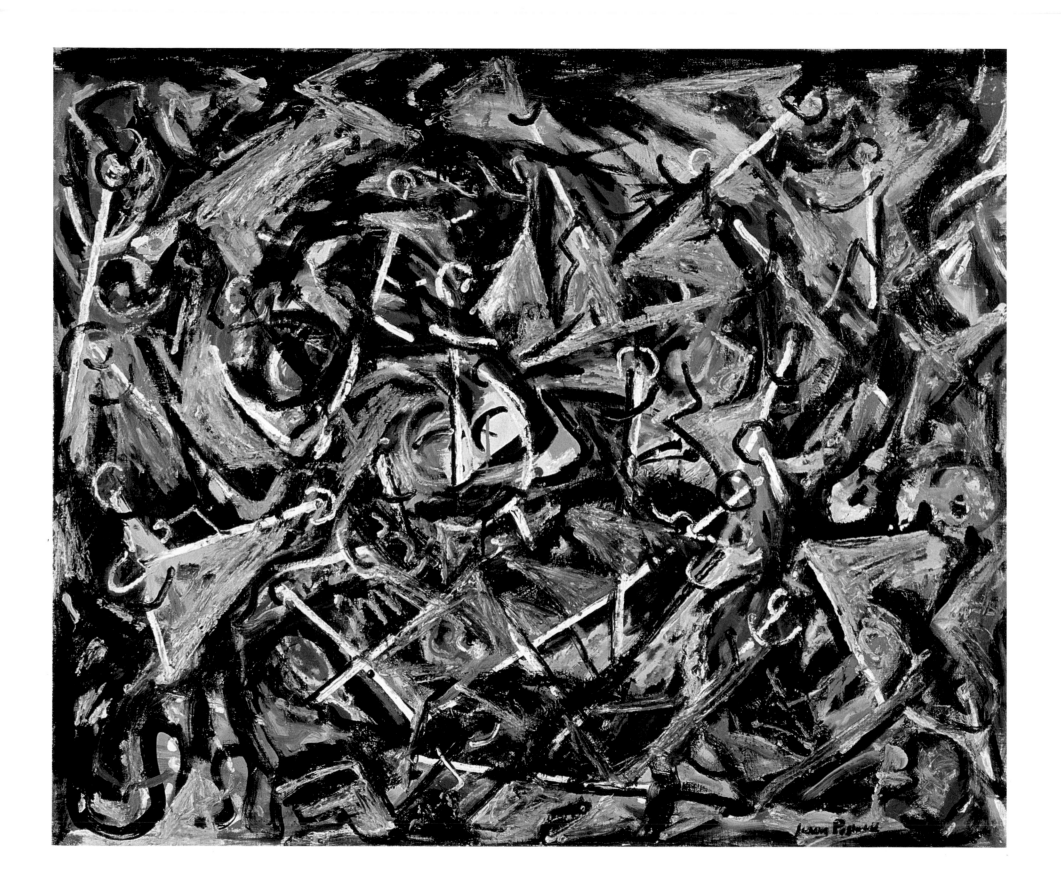

Portrait of H. M. *1945*

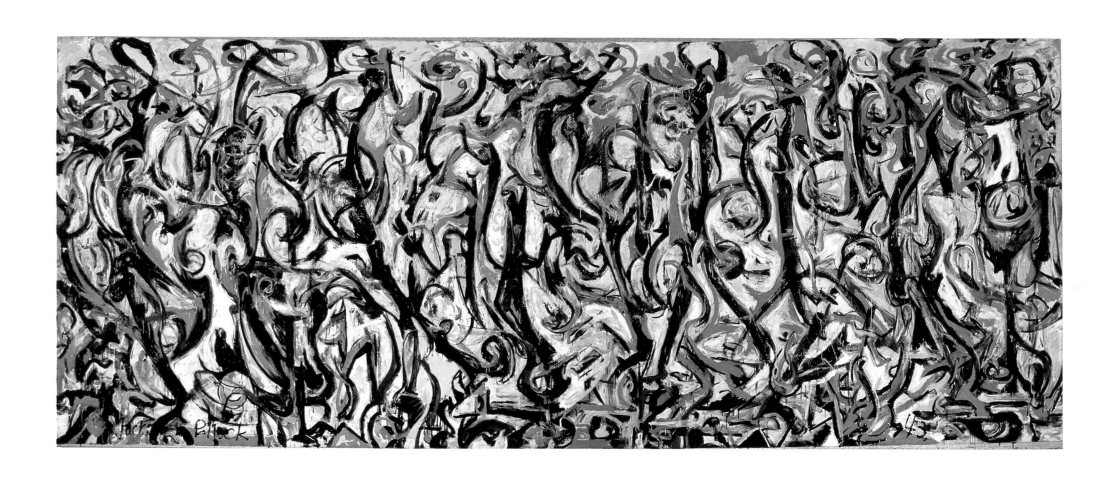

Mural. *1943*

# *Acceptance and Transition*

Of this we are sure, art in the United States has
within the last decade or so gone exhilaratingly
forward. If there is to be a new movement, it would
not be too fantastic to conceive of its forming here.
—Edward Alden Jewell,
*The New York Times*, June 2, 1941

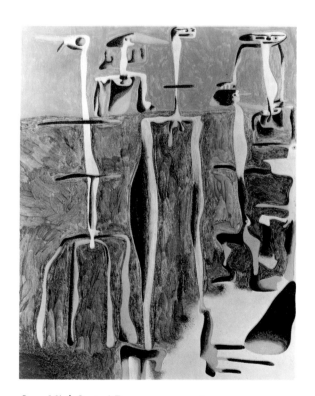

*Joan Miró.* Seated Personages. *1936*

At the same time as Peggy Guggenheim agreed to give Pollock his first solo exhibition and to offer him a monthly contract, she also commissioned him to decorate the front foyer of the duplex apartment on East Sixty-first Street in Manhattan that she shared with writer Kenneth McPherson. Marcel Duchamp wisely suggested that Jackson's mural be painted on canvas rather than directly on the wall so it could be moved and shown elsewhere, and Peggy intended to unveil and present this work to the public concurrent with Pollock's debut. However, a month or more after Pollock's November 1943 premiere at Art of This Century, he had made no progress on the mural except to have illegally ripped out a partition in his Eighth Street apartment to accommodate the approximately eight-by-twenty-foot canvas needed to fill Peggy's hallway. (So as not to alert their landlord, Sailors Snug Harbor, of their radical lease infraction, Krasner and Pollock carried huge pieces of plaster down to the alley in buckets during the dead of night.)

Although he wrote to his brother Charles that the prospect of painting Peggy's mural was "exciting as all hell," Jackson's procrastination was evidence of his terror at the thought of executing a work that large "with no strings attached as to what or how I paint."[1] He sat on a keg and stared at the huge blank canvas for months, paralyzed. As we know, Pollock had watched Benton at work on a number of mural commissions and had even done a brief stint in the Mural Division of the WPA before switching to the easel section, where his major assignment was to assist another former Benton student, Job Goodman, with the execution and installation of *The Spirit of Modern Civilization*, for the auditorium of a high school in Queens. However, he had had no real direct experience organizing a composition that large before being assigned the Guggenheim project.

In the final days of 1943, at precisely the time that Pollock was trying to concentrate on Peggy's mural, Robert Motherwell unwittingly outlined the approach he would finally take. After lauding his friend and colleague as "one of the younger generation's chances," Motherwell observed in the January 1944 issue of *Partisan Review* that, based on what could be seen of his work in his debut at Art of This Century, Pollock's principal problem was "to discover what his true subject is." Motherwell noticed that, more than is usually the case,

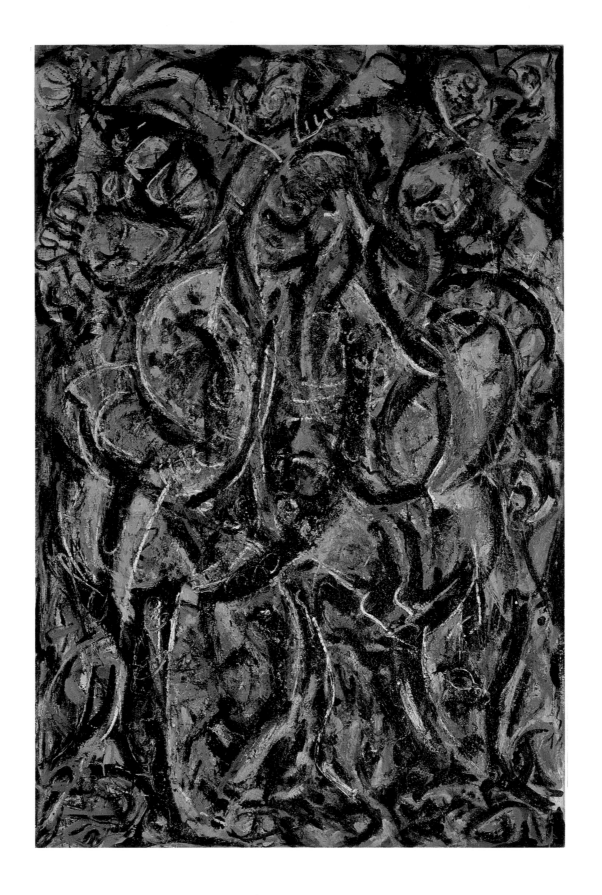

Gothic. *1944*

Pollock seemed to be using paint as "his thought's medium." Thus he concluded that Pollock's artistic destiny was a confrontation with the process of painting itself. After months of indecision about the subject of his mural, Pollock decided to let his mode of creation constitute his theme.

We have already observed that, turned upside down, the central portion of *Guardians of the Secret* discloses striding stick figures. Close examination of Pollock's *Mural* reveals similarly reductive personages reminiscent of Miró now repeated rhythmically across a much larger expanse of space. The imagery of *Mural* neatly bridges the gap between *Guardians* of mid-1943—still obviously totemic and psychological—and a new type of work to be initiated the following year, in which more abstract energies would be substituted for the resolution of Jungian problems. In their catalogue, the organizers of a Pollock retrospective held at the Centre Pompidou in Paris in 1982 highlighted a section of *Mural* which they placed next to the reproduction of a canvas of about four months later, a work given its title by Clement Greenberg. As seen in this juxtaposition, the subsequent painting, which Greenberg called *Gothic* (an adjective we know he used to describe Pollock the man as well),[2] demonstrates with great clarity the beginnings of a transition in the artist's mind. Bolstered perhaps by his experience with the Guggenheim mural, he began to move more definitely away from dependence on therapeutic sources, combined with the innovations of modern European art, to a rapidly increasing nonobjectivity and self-reliance.

A brief notation by Pollock probably concerns the canvas known as *Gothic*. "Blue detail (Mural) Black Dancer with three parts," Pollock scrawled on the back of an old Art of This Century catalogue, implying that this painting originally was a study for an intended larger work. This description is followed with dimensions that match *Gothic*, confirming its identity. When *Gothic* is viewed with Pollock's own characterization in mind, it appears that Picasso's 1925 *Three Dancers* (see page 114)—a work Pollock had used as a jumping-off point before—was also behind this composition, and Pollock acknowledged to Greenberg that he had still been thinking of Picasso when he executed this canvas.[3] It remains now to discover how revisionist his approach to Picasso as a source had become.

*Gothic*'s cool "stained-glass" palette is markedly different from *Mural*'s preponderance of warm yellow, orange, and reddish tones; however, in both we find an equal stress on all parts of the canvas, with loosely delineated forms rendered in black outline evenly distributed from edge to edge. Although nonrepresentational, these lines definitely suggest motions of the human body, and the viewer's reaction to each is elicited through kinesthetic identification with arabesque movement. In the horizontally oriented format of *Mural*, one is led to visualize not only the lateral progression of the "figures" across the canvas, but also the movements of the artist in the process of creating them. Pollock may have been enabled to bring the tortured prelude to this work to a close by remembering, then radically updating, Benton's physicality when faced with the task of filling a huge space. Pollock seems to have attacked this composition (which was finally created in a single night) in a frenzy of inspiration. Like the Indian shamans he admired, he meditated first, then moved rapidly into action.[4] Despite having given himself over to the moment, Pollock apparently had the presence of mind to remember his teacher's ideas concerning the decorative potential of linear rhythm. Benton's lesson that dynamic visual movement could be created by rotating curves

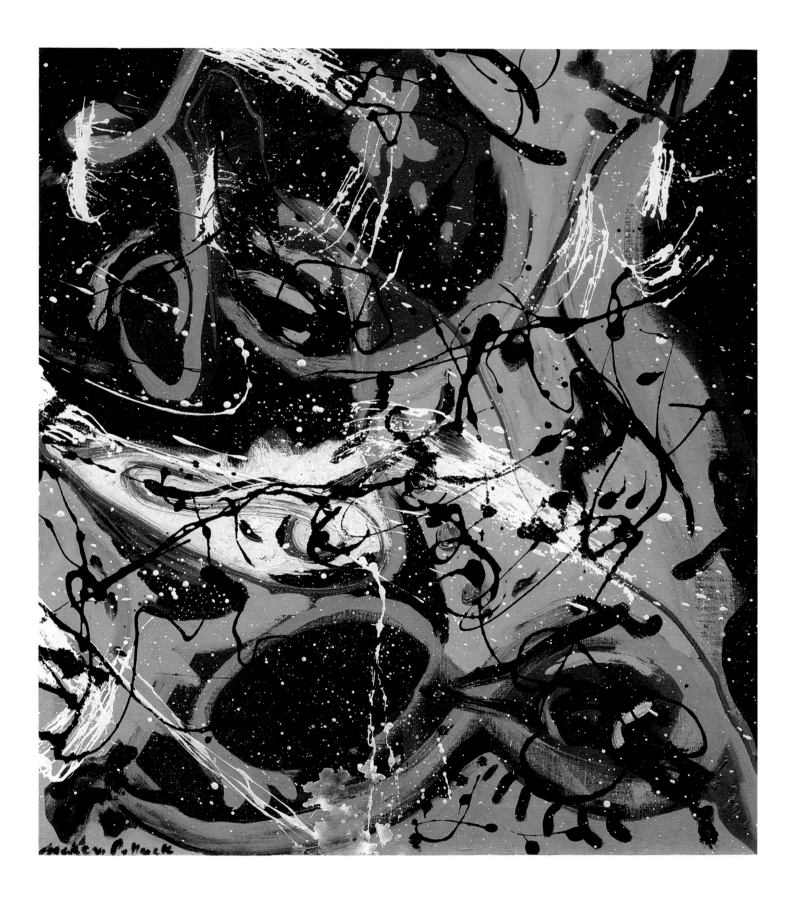

Composition with Pouring II. *1943*

around verticals was obviously implanted permanently in Pollock's brain; his use of Bentonian principles in *Mural* was propelled, however, by a wildness and vigor purely his own.[5]

"*No Sketches* /acceptance of /*what I do*—." Once again, this notation is impossible to date, but Pollock must have articulated this important premise of his mature style in his mind as least as early as the Guggenheim mural. A close look at virtually any section of this painting reveals an unprecedented freedom in application of paint, which, in places, is splashed on so aggressively and spontaneously that drips and puddles form which he then did not edit. Although never considered as an end in itself, as we have seen, a similarly direct and painterly approach was common practice at the Siqueiros workshop where Pollock had been an active participant. Everyone who worked there remembers that the floor was covered from end to end with varicolored splats and spatters, and certainly the composition of Siqueiros's *Collective Suicide* anticipated Pollock's alloverness in *Mural*. Siqueiros was a strong advocate for the generative value of what he termed "controlled accident"; Pollock could not have escaped this lesson. Siqueiros frequently prepared panels by flipping and dripping color on them so as to create an abstractly patterned layer of underpainting, which he hoped would help stimulate more innovative figural imagery. Reuben Kadish distinctly recalls that Jackson was fascinated with this procedure. Just prior to painting *Mural*, Pollock had created three smaller pictures in which he had returned for the first time in a number of years to Siqueiros-inspired experiments.

Although these works are listed only as "untitled" in the gallery brochure, labels on the backs indicate that these were the ones included in Pollock's first solo show. Curiously, in view of their extremely minimalist approach to what constitutes a painting, they were not remarked by the critics. Two of these pictures are still unnamed; the third is titled *Water Birds*. In all of these compositions, which Pollock created before November 1943, what Siqueiros would have considered a preliminary stage was allowed to retain primacy. Perhaps, in making these, Pollock added to his memories from the Union Square workshop John Graham's advice in *SDA* that "the flow of paint ought to be free and final."[6] In his book (and surely in private conversations in the early forties as well) Graham had advocated the reduction of painting to its barest ingredients, stressing that emotions could be represented by pure gesture unencumbered by traditional subject matter.[7] On the canvas now known as *Composition with Pouring II*, Pollock swirled green, bright blue, black, brown, and maroon pigments to form nonspecific shapes. On top of these he smeared in yellow and poured, dripped, and dabbed another layer in black. As opposed to the predominantly warm *Composition with Pouring I*, where recognizable triangles, eyes, etc., peek out from beneath the dripped pigment, no imagery is discernible in this second "poured" painting. Despite its title, a similar nonspecificity characterizes *Water Birds*, parts of which resemble blown-up sections of *Male and Female*, the first canvas to incorporate splashed and runny passages.

It is not at all surprising that these three innovative works were created around the time of (or just after) Pollock's association with Matta and his technical experimentation with Baziotes, Busa, and Kamrowski. Despite Matta's own more superrealistic orientation, Busa remembers that he encouraged his American friends to work with paint as if it were a kind of free agent, to minimize conscious control over it, and to try to eliminate—as much as possible—direct contact between the brush and canvas or paper. Somewhat later, Lee Krasner

*Hans Hofmann.* Spring. *1940 (?)*

was to remark that the secret of Pollock's success was his ability to work in the air and know exactly where the paint would land.[8] At this point, however, he was just beginning to explore different degrees of freedom and control, although he had somewhat earlier laid the groundwork for this reductive approach in the direct evocations of emotional energy he sometimes gave to Henderson.

As many writers have noted, Jackson Pollock was not the first artist ever to spill paint to create a composition. William Rubin, who has thoroughly explored this issue, has demonstrated that in addition to Siqueiros, Matta, and Kamrowski, numerous other artists had already used this technique. Some of them Pollock could have known about; of others he was probably totally unaware. For instance, it is not likely that Pollock would have been conversant with the Dada gesture of Duchamp's French colleague Francis Picabia, who spilled ink on a piece of paper and satirically christened it *La Sainte Vièrge* in 1917. However, some of the Surrealists living in America, with whom Pollock did have contact, were adopting various pouring methods in the early forties to induce inspiration. These included Gordon Onslow-Ford and Wolfgang Paalen, as well as Max Ernst (the latter's experimental images made by swinging on a string a paint can with a hole in it were widely publicized).[9] In 1945, a few years after his first "poured" works, Pollock had the opportunity to observe a similar experiment in oscillation with a compound pendulum at Hayter's Atelier 17.[10]

Another supposed forerunner of Pollock's newly elected method was Hans Hofmann, Lee Krasner's former teacher and still her friend. Hofmann occasionally featured chance dripping as part of his technique in such paintings as *Red Trickle* and *Spring,* usually dated 1939–40. Although Hofmann was one of the first of Lee's acquaintances whom she wanted Jackson to meet (their introduction took place in late 1942 or early '43), the much older European-born artist was not allowing anyone to see his own paintings at that time. As legend has it, Pollock's belligerent comment to Hofmann, "Put up, or shut up," which so embarrassed Krasner at this meeting, startled Hofmann and encouraged him to seek a showing for his work. Because of his pedagogical commitments, Hofmann had not had a one-man exhibition for many years, and through the auspices of Jackson and Lee, Peggy Guggenheim was persuaded to become his sponsor. Since paintings with dripped portions were a minor direction in Hofmann's oeuvre, they were not shown at Art of This Century, and Krasner said that she and Pollock did not know of them.[11]

Despite the innovative solutions to image-making that Jackson Pollock was beginning to experiment with in such paintings as *Water Birds* and *Mural,* many of the works created for his second solo show, as previously discussed, retained figurative (i.e., totemic) associations, as well as demonstrating continued reliance on American Indian and European modernist sources. In his equine series of around this time, for instance, Pollock brazenly continued his ongoing dialogue with Picasso's bullfight paintings. Only one work shown in 1945 was appreciably similar to *Mural.* Cryptically titled *There Were Seven in Eight,* this canvas may actually have been begun prior to his execution of the Guggenheim foyer commission. According to Krasner, Pollock started *There Were Seven in Eight* in the fall of 1943, abandoned it for a while, and then returned to it after many months had passed.

As Krasner remembered it, Pollock began this composition with "more or less recognizable imagery—heads, parts of the body, fantastic creatures," but these are no longer obvious. Apparently she later inquired why he had not stopped when these images were

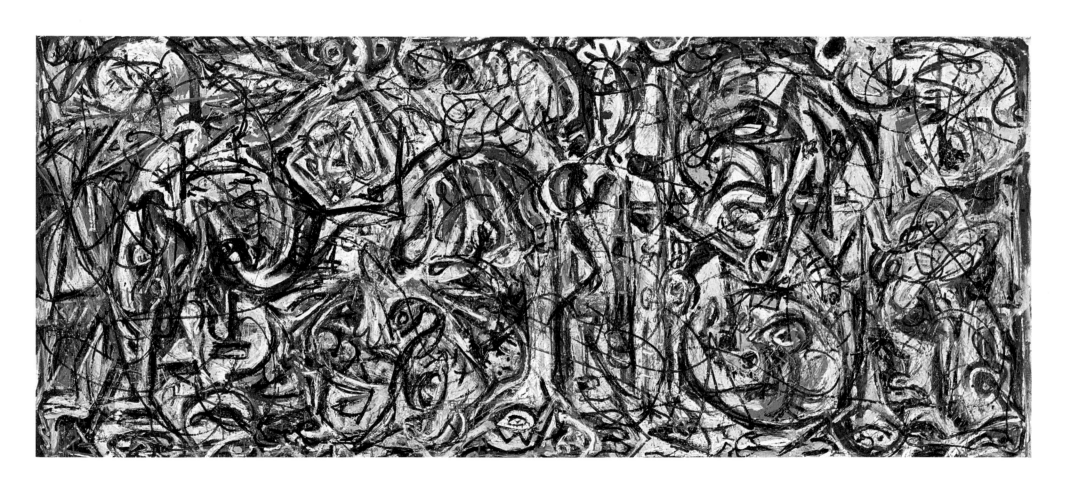

There Were Seven in Eight. *c. 1945*

Untitled. *c. 1944–45*

*André Masson.* Rape. *1941; printed in 1958*

"exposed"; "I choose to veil the imagery," was his reply. This story was first recounted by Krasner in a 1969 interview with B. H. Friedman, creating a storm of controversy.[12] Others close to Pollock have surmised that the "elegant" wording of this phrase was perhaps not Pollock's. Furthermore, at the time of the Friedman interview, Krasner did not identify *There Were Seven in Eight* as the specific painting in Pollock's description; she only did so a number of years later in response to a request for clarification from William Rubin. In 1969 she actually stated that "many of the most abstract" of Pollock's works began with "recognizable" images, and this has led to the frequent and erroneous supposition on the part of some writers that an underlayer of realistic depictions is present in even the most radical of Pollock's later poured paintings. The artist's own equivocal statement, "I'm very representational some of the time, and a little all of the time," made in 1956 to Selden Rodman,[13] has further confused this issue.

*There Were Seven in Eight*, a large work almost half the size of *Mural*, is simultaneously more compacted and freer in its allover configuration. In fact, the rhythmic repetition of almost identical forms in *Mural* visually bracketed at either end, takes on an almost classical cast when compared with the expressionistic helter-skelter scribble-scrabble of *There Were Seven in Eight*. When she visited Pollock's second one-man show, Maude Riley, a reviewer for *Art Digest*, pronounced the latter "a chaotic tangle of broad lines, wiry lines, threads and speckles of color. . . . What it means, or intends, I've no idea." In her description Riley introduced an adjective that was to haunt Pollock in the coming years, causing him great irritation. Indeed, he was so angry at seeing his work described this way yet again in 1950 that he wired the offending publication, *Time* magazine, "NO CHAOS DAMN IT. DAMNED BUSY PAINTING. . . ."[14]

*There Were Seven in Eight* can be said to demonstrate Pollock's ultimate expansion of the automatically engendered linear overlay first developed in the prints he created under the tutelage of Stanley William Hayter. The intermingled weblike formation of its image, however, seems to have no precise relationship to the title. Although Frank O'Hara once suggested that this painting's name derives from the Greek story of "Seven against Thebes," there is no visual evidence to back this up, and a satisfactory explanation has yet to come forth for the conundrum Pollock posed.[15] Many more suggestions have been made for the source of the look of this canvas than for its title or meaning. For example, it has been pointed out that Matta had earlier begun to superimpose a filamented "veil" formation across his paintings, supposedly inspired by Duchamp's network of cords crisscrossing the main gallery at the landmark 1942 "First Papers of Surrealism" exhibition.[16] Hayter often employed a continuous linear overlay, as did André Masson, a French colleague who worked in New York at Atelier 17. It has been suggested that Hayter may have shown Pollock Masson's 1941 drypoint *Rape* (which had been created in the English printmaker's New York studio) because there are numerous compelling visual parallels between this print and certain of Pollock's own Atelier creations. Furthermore, this similarity carries over on a larger scale into *There Were Seven in Eight*, whose *Rape*-like features include lines that meander and then suddenly double back upon themselves, as well as the distribution here and there across the surface of dark nodules where energy rests for a moment.[17]

*Wassily Kandinsky.* Untitled. *1918*

True to his tendency to work out his problems in different media simultaneously, Pollock also explored the creation of compositions out of tangled skeins of linear movement in a group of pen, ink, and gouache sketches around the same time as *There Were Seven in Eight*. Certain of these drawings (see page 154) share characteristics very much like the approach of this painting; however, they noticeably lack the edge-to-edge lattice-like overlay possibly derived from Masson's compositions. Looking at these smaller works, the observer again feels that Pollock's formerly recognizable imagery has somehow become ensnared, this time in a maelstrom of shorter arced and wiggling lines, now very different from those used by Masson, Matta, or Hayter. In fact, the thatched configurations in these works are more reminiscent of the distinctive style of the famed Russian-born Expressionist Wassily Kandinsky in the 1910s and '20s. Pollock had had concentrated exposure to Kandinsky during his employment at the Museum of Non-Objective Painting: Hilla Rebay, who was Peggy's uncle Solomon's curator, concentrated her buying in the area of Expressionism, emphasizing the works of Kandinsky and Rudolf Bauer, a much less talented look-alike.[18]

Pollock had worked at the Museum of Non-Objective Painting during the summer of 1943, after the demise of the WPA and before he began to receive a stipend from Peggy. Why suddenly, almost two years later, would he decide to try out Kandinsky's style in these minor works on paper? The answer is quite simple. In March of 1945—at the same time as Pollock's second one-man show—the Baroness von Rebay opened a huge memorial retrospective of Kandinsky's career, and this confluence of events led some critics to essay a comparison of the two artists. The reviewer for *Art News* went so far as to state that, "Jackson Pollock derives his style from Kandinsky, but lacks Kandinsky's airy freedom and imagination in color."[19] Whether because of relatively inappropriate comments like this one, or stimulated by the interest in the Kandinsky memorial shown by his friends Hayter and Bultman, Pollock seems to have made it a point to attend the memorial show, a visit documented once more by his purchase of the catalogue. And as exhaustively analyzed by Gail Levin, certain similarities to Kandinsky that did not exist previously begin to show up in some of Pollock's c. 1945–46 works on paper.

If we place the Russian artist's *Untitled* of 1918, or *Kleine Welten VIII*, 1922 (both in Solomon R. Guggenheim's collection), next to some of Pollock's drawings during these two years, we find the same use of a network of abstract lines which markedly obliterates all other shapes. However, Pollock's overlay seems more jumbled and obsessively applied; random blots of ink or paint disturb the continuous movement of his marks hatched and crosshatched in short staccato bursts. Several of Pollock's sketches also resemble Kandinsky's signature woodcuts, drawings, and paintings in that no gravitational anchor for the markings is indicated, and white space is left around the perimeters. As a result, the overall character of these drawings differs markedly from *There Were Seven in Eight*, where the final layer of loops and swirls covers the entire surface with equal pressure. However, soon after the completion of that painting, a distinct lightening or opening up of Pollock's previously very tight configurations began to occur, and it is very possible that his short-lived circumstantial engagement with Kandinsky's ideas may have exerted a decisive influence on this new direction.

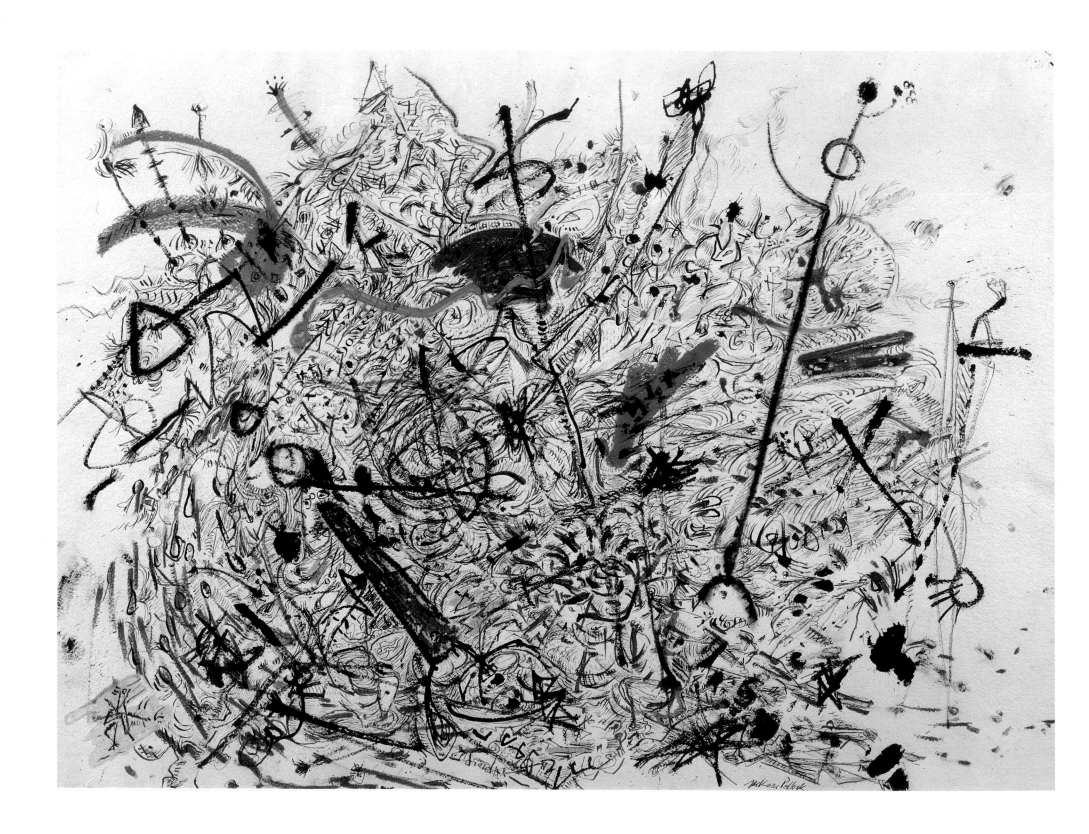

Untitled. *c. 1946*

Despite the fact that his three major shows held in fairly rapid succession at Art of This Century between 1943 and 1945 were relatively triumphant, Jackson, according to close associates, was still "living on the edge" during this period. Deemed by various reviewers in these years a painter who was "thoroughly incautious" and "belligerent," but "with power and curious animal imagination," Pollock alternated on a personal level, even more conspicuously than before, between confidence in his talent ("some part of him knew he was terrific," Krasner stated) and feelings of inadequacy and rage. On a visit in 1943, his brother Sande and sister-in-law Arloie were pleased to find Jackson "in fairly good shape," but his own fixated self-critical tendency and the readily available opportunities to drink at Peggy Guggenheim's parties began to take a too-heavy toll on Pollock's shaky equilibrium by the middle of the following year.

Their sojourn in Provincetown in the summer of 1944 thus constituted a well-needed respite from what Jackson himself later termed "the wear and tear" of New York. Despite a comment made in a letter a few years hence to his WPA friend Lou Bunce, that "New York seems to be the only place in America where painting (in the real sense) can come through,"[20] by 1944 Pollock had begun to realize that the frantic pace and politics of life in New York's burgeoning wartime art community were counterproductive for him. By the time he penned these words (June 1946), Jackson and Lee had moved several hours away from the city, to a small sleepy village close to the tip of Long Island.

Their association with Long Island started a year after their vacation in Massachusetts, when they accompanied Reuben Kadish and his wife, Barbara, to East Hampton to help them look for a house. This was their first trip to the South Fork. (The Kadishes ended up taking over Hayter's lease on a place in nearby Amagansett.) This part of New York State had been attractive to artists since the 1850s; landscapist Thomas Moran lived and painted in East Hampton shortly after the Civil War, and American Impressionist Childe Hassam had also gone there in the late nineteenth century. In the 1930s, trend-setters Gerald and Sara Murphy had brought out another painter, Lucia Wilcox, who opened her house to European émigrés, including Fernand Léger and Max Ernst. Peggy Guggenheim and a number of Surrealists spent summers in the Hamptons during the war years. In August 1945, when Pollock and Krasner visited, they not only saw Hayter, but found Robert Motherwell, David Hare, and Harold and May Rosenberg on vacation there, as well.

At that time the area around East Hampton was essentially rural, a juxtaposition of potato fields, pastures, scrub oak, dunes, and ocean. Life was much cheaper, quieter, and more conservative than in the city. Krasner, in particular, felt very relaxed on Long Island, and it was she who first suggested that they sublet their apartment on Eighth Street, pack some canvases and books, and try it out there during the off season. Pollock's first reaction was that she had "gone nuts" even to think of leaving New York. However, after brooding for a few days back home, he reversed his thinking completely and announced that they were going to give up their Manhattan place altogether and make a more definitive commitment to the country; they would buy, not rent, a house. This was a momentous decision because it not only necessitated renegotiating his contract with Peggy Guggenheim to raise the needed money (her well-known stinginess made this experience painful, particularly for Lee who had to do all the persuading), but it also resulted in their marrying.

155

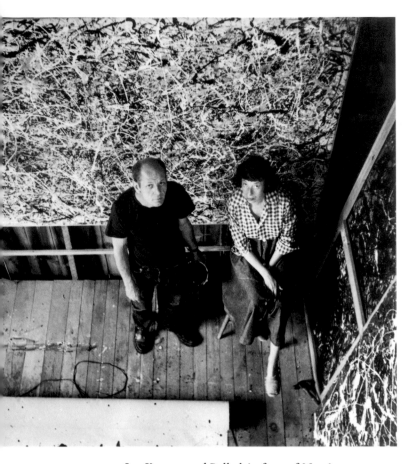

*Lee Krasner and Pollock in front of* Number 1, 1949

Although neither had cared particularly about propriety or convention when they first moved in together, by the fall of 1945, for differing reasons, both Pollock and Krasner were looking for more stability. Again, it was Krasner who precipitated the decision. Her father had just died, leaving her feeling somewhat adrift and removing family objections to her union with a non-Jewish man. As Lee once noted, almost everyone in their circle of friends and acquaintances assumed that she and Jackson were married already; Peggy supposedly admonished them, "Aren't you married enough?" when they unsuccessfully tried to persuade her to be a witness at their wedding.[21] Despite their incompatible religious (or, in Pollock's case, areligious) backgrounds, true to his attraction to ritual he insisted on a traditional church wedding, and it fell to May Rosenberg to buy a hat for Lee and to search for a clergyman who would unite them. According to May, who was their only guest, Charles J. Haulenbeek, the Dutch Reform minister she finally procured, kindly proclaimed during the brief October 25, 1945 ceremony at Marble Collegiate Church, that "it made God happy" to bless mixed unions such as theirs.[22]

A few weeks later, the Pollocks packed all of their belongings and relocated to a small, very plain-looking white clapboard nineteenth-century farmhouse on Long Island that they had found for sale. This dwelling, which came with a barn and one and a quarter acres, cost five thousand dollars, advanced grudgingly by Guggenheim in return for stringent new contractual terms that guaranteed her virtually all of Pollock's production for the foreseeable future (he was allowed to give Lee only one picture per year). The front of their house faced Fireplace Road, the main thoroughfare in a little fishing community called The Springs, about seven miles from the center of the more "swanky" (in Pollock's estimation) East Hampton. The structure itself, Ulysses S. Grant-era architecture (it was built in 1879 by Henry Hale Parsons), was nondescript, but from the rear—once they had moved the barn farther to the north side of their property—Jackson and Lee had a beautiful view of the marshes of Accabonac Creek and Gardiners Bay. Krasner once recounted their move this way:

> We arrived in Springs in November during a Northeaster. What an entrance! We knew no one. I wondered what we were doing there. We had given up the New York place and burned all our bridges. . . . the house was stuffed from floor to ceiling with the belongings of the people who had lived there. The mackinaw of the man who had lived there was still hanging on the rocker in the kitchen. It was a rough scene we walked into. The barn was packed solid with cast iron farm tools. It was a matter of cleaning everything out before we could move in or work.

As a result, she recalled, their entire first year there was "really about reclaiming the house."[23] A long way from the rural hardships of his youth in the West, Jackson wrote to friends, soon after they moved, that life in Springs was "a little tuff on a city slicker."[24]

Since some wartime shortages were still in effect, the Pollocks could not get coal for heat, and their only warmth came from a wood range in the kitchen. After a complete overhaul, they painted the inside of the house stark white, and Lee fixed it up sparsely with a few pieces of Victorian furniture, their own paintings, and objects they could gather from the land: plants, gourds, shells, and interesting stones. Guggenheim's small stipend was the only

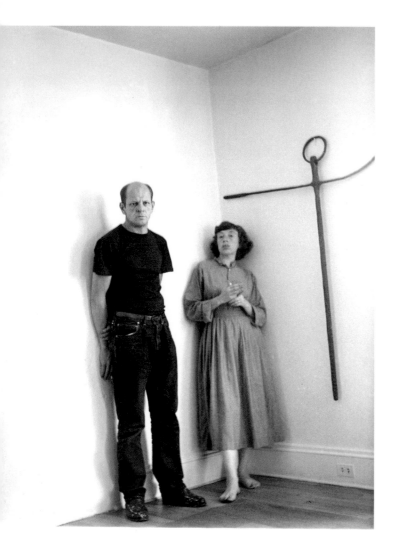

*Lee Krasner and Jackson Pollock with anchor, 1951*

steady money coming in at this time, and their financial situation was very precarious. In *The New Yorker* article, Pollock later wryly described how they subsisted at first: "Somebody had bought one of my pictures. We lived a year on that picture, and a few clams I dug out of the bay with my toes." However, he also explained, "I had an underneath confidence that I could begin to live on my painting," and this had helped to sustain them.[25]

By the summer following their arrival, other anecdotes written in letters show that Jackson was less depressed about all the work that needed to be done. He had, in fact, become so acclimated to his new life—even the endless chores—that he was moved to extol his situation on a postcard to friends he was inviting to visit, exclaiming, "the country is wonderful!"[26] Seemingly more content in The Springs than he had been in a long time, Pollock began developing friendships with some of the townspeople, even changing his sleeping and working habits to earn their respect. Perhaps in direct reaction to his rootless upbringing, the fierce pride he took in his own land began to show in the care he took of his property. As one neighbor described the situation, he also gloried in the quality of the home Lee made for him despite their lack of money.[27] Baking, gardening, tinkering with machinery in the yard, walking the dunes, and bicycling into town: during the first few years at The Springs these domestic tasks and mundane activities seemed to fill Pollock with a deep and unaccustomed pleasure and a serenity he had never felt in New York. Once again to Lou Bunce, Pollock wrote that the change of light and space on Long Island was forcing him to reorient his artistic thinking; to a local friend, Fuller Potter, he remarked on his relief at finally emerging from "eight grey years in the Village." Daniel Miller, a nearby grocer with whom Pollock spent many hours talking, once reflected that Jackson had not really moved *to* The Springs, he had moved *away* from the city; Miller recalled Pollock himself using precisely these words.[28] Krasner (who, as we know, believed strongly in her own intuitions) seems to have been quite right in her belief that a more peaceful, less demanding, and harried atmosphere would be conducive to the advancement of her husband's work.

Perusing some of the now-famous pictures of Krasner and Pollock taken a few years after they moved to the country can help to assess their new situation and relationship. One in particular, shot by Hans Namuth, is fascinating; like Degas's famous painting of the Bellelli family, it provides unusual insight into the psychodynamics of a married couple. In this photograph Lee and Jackson Pollock are posed against a corner of their wall, standing next to a large cruciform anchor Jackson had scavenged from the beach. Dressed in a dark tee shirt and jeans, Pollock stares outward with his prominent deeply ridged and furrowed brow. His look is typically dour, intense, and yet strangely meek. Krasner, in a drab cotton dress with no shoes, is posed with hands together and face tilted more defiantly upward. In very different ways—each commensurate with their individual personalities—the body language and facial expressions of both exude their commitment to a life each had freely chosen, whatever would turn out to be the ultimate cost.

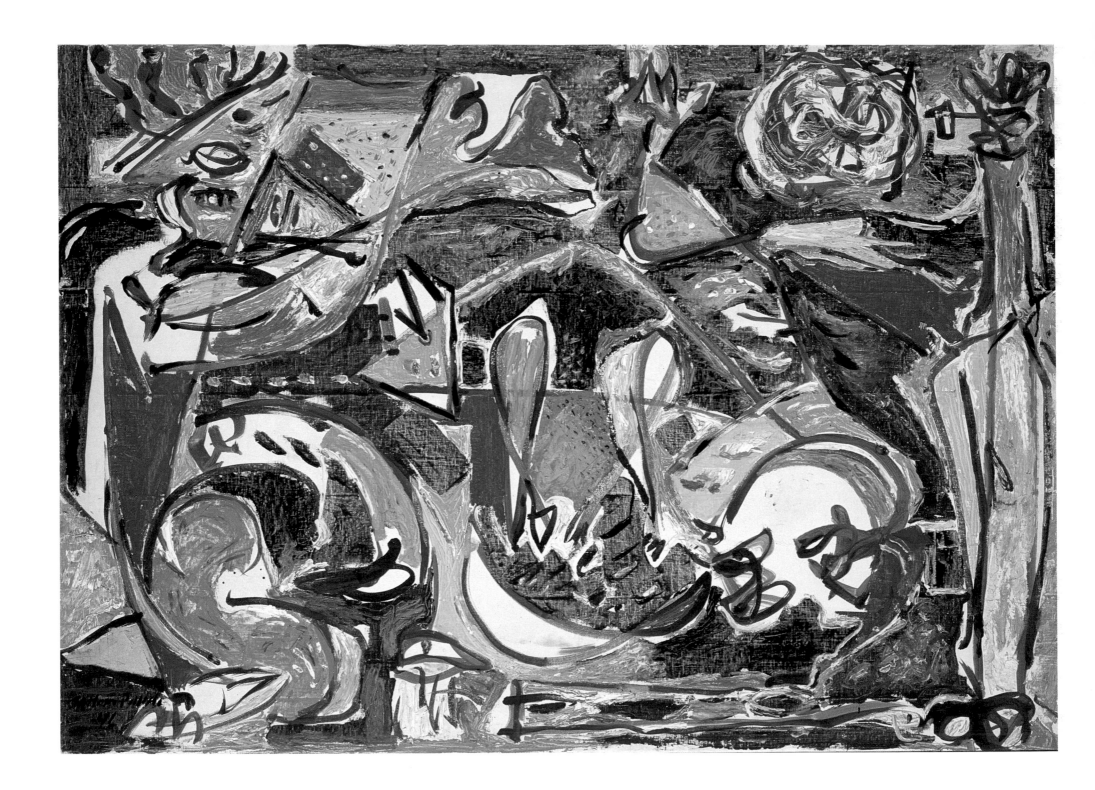

The Key. *1946*

# Sounds in the Grass

My concern is with the rhythms of nature. . . . I work inside out, like nature.

—Jackson Pollock to B. H. Friedman

We don't think of Jackson as a poet, I suppose because of the hazard words were for him. These words of his stay with me, although he said them between pauses: "You can hear the life in grass, hear it growing. Next thing there's a dry spell—it doesn't take much in Bonac sandy soil—and the life is gone. Put your ear to it then and all you hear is the wind."

—Julien Levy to Jeffrey Potter

An aspect of Krishnamurti's teachings that continued to influence Pollock throughout his life was the Indian Theosophist's pantheism; many friends and associates have noted that Pollock's comprehension of the world of man and his surroundings was unusually all-inclusive. In keeping with what we know so far, it should come as no surprise to find that his sensibility in this regard was very like that of so-called primitives, and his deeply felt sympathy with the rhythms of the universe vocalized in the quotation above would also classify Pollock as inherently shamanistic. His participatory sentiments in regard to the non-man-made world were once described by his second art dealer, Betty Parsons, as truly "cosmic" in their parameters. As far as nature was concerned, it was Parsons's sense that Pollock had an unusually intuitive recognition of the "scariness" and "power" of it all.[1] His aggressive rejoinder to Hans Hofmann—after being admonished by him at their first meeting for painting not from nature but from his imagination—has become one of the most famous quips in modern art history. To Hofmann, Pollock replied tersely, "I *am* nature."[2]

As Frazer explained in *The Golden Bough*, it was the symbiosis felt by primitive man toward his environment that led to his desire to identify more closely with, and express the forces of nature through, the totem (Paalen also discussed this subject in *Dyn*). We can assume that Pollock's own use of this device was of similar origin. After he moved to the rural setting of The Springs, however, Jackson seemed to feel less of a need to rely on this symbolic expedient. Away from the city, he could now spend much time outdoors, exploring in both a rational and mystical way the elemental bond he felt with the land. As a result of his innate restlessness and curiosity, Pollock soon came to know intimately "every inch" of eastern Long Island: the dunes, the northwest woods, and the beaches between East Hampton and Montauk.[3]

Pollock's strong sense of identity with his adopted terrain doubtless stemmed from the reverberations it set up in his mind with the locales of his childhood. "The ocean's what the expanse of the West was for me," he once explained to B. H. Friedman. Strolling on the beach in the wintertime, with the snow on the sand creating a vast and endless vista, was an

The Tea Cup. *1946*

activity that, Krasner recalled, excited her husband immensely. When they could not sleep at night, the Pollocks often walked the woods together, or sat on the porch for hours staring up at the stars. Very quickly, it seems, eastern Long Island became an integral part of Jackson Pollock's consciousness; specifically attracted to its horizontality and the concomitant feeling of open space, he extrapolated from these a new sense of freedom and potential. Another adopted "Bonacker" friend remarked of Pollock's early years there, "The land, the sky, the weather, they were parts of a whole in which [Jackson] felt as right as he could."[4]

The first paintings that Pollock created after moving to Long Island testify to these new, more expansive feelings, despite the cramped conditions under which they were created. In late 1946, temporarily using a small upstairs bedroom as his studio, Jackson began what Lee was to suggest he call the "Accabonac Creek Series" after the body of water visible behind their house. At least one work in this eight-painting series, *The Key*, was finished on the floor in the bedroom; in all or most of the rest Pollock had the advantage of working in his converted barn/studio, moved to its final site after they had lived on Fireplace Road for eight months. *Magic Light*, *The Tea Cup*, *The Water Bull*, *Yellow Triangle*, *Grey Center*, *Constellation*, and *Bird Effort* comprise the rest of the extant paintings from this first group of works created on Long Island; their titles were Pollock's.[5]

In the works of the Accabonac Creek Series, Pollock's apparent *horror vacui*—which had caused such recent canvases as *There Were Seven in Eight* to seem oppressive and suffocating—was relaxed markedly. Although it is still possible to discern impulsively generated imagery (stars, hearts, triangles, arrows, floral forms, and the like) "doodled" into these paintings, any possibility of reading rational or mythic associations between these shapes has been edited out. Hints of former totem figures are definitely present, but they are now so fragmented as to render their previous psychological force inoperable. These compositions seem more decorative than any of Pollock's earlier paintings, and W. N. M. Davis, an early avid collector who wrote a prefatory note for the artist's 1947 Art of This Century show, observed that many of the works on view introduced Jackson Pollock in a "somewhat gayer mood," one that those following his career so far might not have expected.

This change Davis defined was a result of the fact that, of all the paintings in Pollock's oeuvre, the Accabonac Creeks seem to constitute the most sustained effort on his part to exploit the expressiveness of color. Thomas Hart Benton had discouraged such an emphasis in his students based on his belief in the superiority of line in constituting a great work of art. As a result, fellow Benton classmates recall that Jack was literally afraid of color, and the muddiness of his pictures throughout the thirties testifies to the continuation of this inhibition. As we have seen, his color did not begin to improve until the early forties under the influence of Picasso and especially Miró. Still, it is with a certain amazement that we experience the new variety and richness of hue in such paintings as *The Key*, *The Tea Cup*, and *The Water Bull*. Searching for a visual precedent does not uncover Miró or Picasso; rather more immediately brought to mind are the mixed technique or "broken touch" pre-Fauve works of Matisse. Underlining the parallel is the fact that these, too, were a response to new surroundings; in the years 1905 and 1906 Matisse had left Paris for the south of France, whose light and color beguiled him, inspiring a change in his work.

The Water Bull. *c. 1946*

*Henri Matisse.* Girl Reading (La Lecture). *1905–06*

A comparison of the paintings of the Accabonac Creek Series with the landscapes created by Matisse during his period at Collioure indicates a similar palette of both pale and saturated, somewhat dissonant color relationships applied in a comparably nonspecific, summary fashion. Even a work like *Girl Reading*, created by Matisse just after his return to Paris, although it is a more obviously representational image, is remarkably close in its overall "look" to *The Key*, painted by Pollock forty years later.[6] Both artists applied bright pigment freely and sketchily in fluid areas that would probably make little or no coherent sense without the intermittent broken outlines that tie the compositions together. Incorporation of the white of the canvas as a "color" of equal value (a device especially prominent in *The Water Bull*) causes these new works by Pollock to seem buoyant, expansive, and spacious, again characteristics of the style of Matisse.[7]

Although he applied his paint more thickly on several canvases of this series (e.g., *The Magic Light*), Pollock's manipulation of the large light-colored areas in these also underscores the overall impression of flux and decongestion. "He has now largely abandoned his customary heavy black-and-whitish or gun-metal chiaroscuro for the higher scales," Clement Greenberg wrote of Pollock in the February 1947 issue of *The Nation* after the Accabonac Creeks were first publicly shown. More lyrical, with their predominance of "alizarins, cream-whites, cerulean blues, pinks, and sharp greens," these paintings were, however, no less potent than the more "Gothic" works which had come before.

With the exception of *Mural*, finally on view two years after its completion, the remainder of Jackson Pollock's last exhibition under the aegis of Peggy Guggenheim consisted of seven very different, but equally innovative freshly finished works. These paintings, all created during the latter half of 1946, were grouped together under the designation Sounds in the Grass. Except for the first picture in the group, *The Blue Unconscious*, a further revision in Pollock's thinking characterized this series. In some ways, this revision represents a return to previous concerns, as many of the Sounds in the Grass paintings are a throwback to earlier, more claustrophobic compositions, highly textured impasto, and neutral coloration. "Rougher and more brutal" (as Greenberg noted), the majority of these works project tension, not gaiety, and their mode of presentation recreates in the viewer the artist's more anxious frame of mind. In a representative example, the jagged, nervous-looking canvas *Something of the Past*, Pollock succeeded in communicating these sensations through his choice of color, the aggressively haphazard organization of predominantly angular forms, and his much more assertive application of paint.

The level of excitability increases in another canvas from this group, *Croaking Movement*, whose title suggests the staccato sounds and motions emanating from a weed-choked meadow, and whose composition features appropriately jerky *sgraffito* marks. In *Croaking Movement* Pollock etched the final suggestive layer of scribbled imagery into thickened wet paint squeezed on the canvas directly from the tube. Pushed up to the very edge of the picture plane, the incised notations of this painting energetically transform it into a teeming microcosm of natural change. *Eyes in the Heat* and *Earth Worms*, two other key works of the series, both exhibit more gyrating and bulkier strokes which swirl sensuously in a continuum from edge to edge, generating an actively charged and explosive emotional intensity previously unknown in American art. Motivated by Pollock's desire to assert through gesture and materiality the quality of his medium, these paintings look like products of manic motor

Croaking Movement. *c. 1946*

Eyes in the Heat. *1946*

Earth Worms. *c. 1946*

*Claude Monet.* Nymphéas: Pont Japonais. *c. 1922*

activity. In them, Pollock truly took advantage for the first time of the "extreme awareness" he had always had of the physical aspect of his talent. Put up next to the Accabonac Creeks, *Eyes in the Heat* and *Earth Worms*, in particular, are absolutely inelegant and furthermore seem quite disturbed; the vigorous active rhythms of the Sounds in the Grass series, aimed toward evoking the inner life of nature, nevertheless encourage an empathic viewer response.

Its much lighter coloration links the final painting of this second series, the very appropriately titled *Shimmering Substance*, to the slightly earlier Accabonac Creeks. The configuration of this canvas comprises almost identical pale, short arcing strokes which smother a barely visible darker underlayer of pigment. As is also true of *Eyes in the Heat*, small opaque orbs peer out from behind the semicircular jabbings generated by repeated rotations of Pollock's wrist. A step back from *Shimmering Substance* causes the distinct impression of a large golden circle to coalesce; this circle seems to move in front of the other strokes and to hover in ambiguous space. Oddly reminiscent of some of the very late works of the French Impressionist Claude Monet (works to which Pollock would have had at that time absolutely no access), *Shimmering Substance* evokes in its curving rhythms, its texture, and gleaming coloration the illusion of a midday in summer, when extreme heat can cause an almost supernatural luminescence and retinal diffusion. The sense of mystery that informed Pollock's relationship to nature is readily apparent in *Shimmering Substance*.[8] Krasner perhaps pinpointed its origin in a strange reminiscence of her husband she told to B. H. Friedman in 1969: "The only time I heard [Jackson] use the word landscape in connection with his own work was one morning before going to the studio, when he said, 'I saw a landscape the likes of which no human being could have seen.'"[9]

By late spring of 1947, with the war over and the rebuilding of Europe begun, Peggy Guggenheim closed her New York gallery and began making plans to move permanently to Venice. After a variety of negotiations that fell through, she finally managed to persuade Betty Parsons to take Pollock into her stable, although Guggenheim had to continue his monthly stipend until the expiration of his current contract.[10] Their agreement, signed in May, stipulated that a one-man show for Pollock be planned for the following winter. Three months later Jackson, a man who worked in fits and starts, wrote to Bunce, "I'm just now getting into painting again, and the stuff is really beginning to flow. Grand feeling when it happens."[11] By then, the barn was fully converted, and he began in earnest to prepare the works for his first Parsons show.

Perhaps it was the prospect of a new venue for presentation of his painting (there are other explanations equally plausible); in any case, we will never know exactly what initiated the radical breakthrough in technique that occurred between Pollock's last exhibition at Art of This Century and his first public showing after Guggenheim left. Somewhat unusual and very helpful, we do have two written statements dating to this period in which Pollock took great pains to explain his latest intentions. With Howard Putzel no longer available to help him formulate his thoughts (Putzel died tragically in 1945), Pollock may have had other help or written these on his own. The first was prepared in October 1947 as part of an application for a fellowship from the John Simon Guggenheim Foundation (despite an excellent recommendation from Tom Benton, he did not get it). Jackson's formulation seems inspired by Clement Greenberg's review of his previous show in which he wrote, "Pollock points a

Shimmering Substance. *1946*

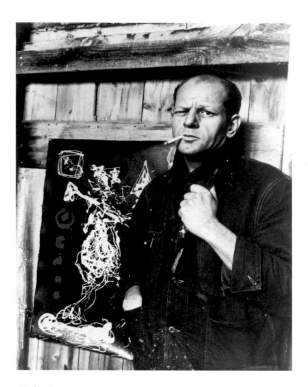

*Pollock, 1949.*
Photograph © Arnold Newman

way beyond the easel, beyond the mobile, framed picture, to the mural." However, Greenberg softened this rather assertive prognostication in an uncharacteristically indecisive way, adding "perhaps—or perhaps not, I cannot tell."[12]

In his Guggenheim Fellowship statement Pollock told the reviewing committee: "I intend to paint large movable pictures which will function between the easel and mural." He also pointed out that, "I have set a precedent in this genre in a large painting for Miss Peggy Guggenheim which was installed in her house and was later shown in the 'Large Scale Paintings' show at the Museum of Modern Art. It is at present on loan at Yale University." He continued with this prediction, "I believe the easel picture to be a dying form, and the tendency of modern feeling is towards the wall picture or mural." However, he noted, "I believe the time is not yet ripe for a *full* transition from easel to mural. The pictures I contemplate painting would constitute a halfway state, and an attempt to point out the direction of the future, without arriving there completely."[13]

How he was going to achieve this new exciting hybrid form Pollock explained more fully in comments he was asked to write by Harold Rosenberg and Robert Motherwell for their "occasional review," *Possibilities*. In his statement, "My Painting," Pollock went into unaccustomed detail, describing not only his overall intentions, but the actual technique he devised for the first works he showed at Betty Parsons's:

> My painting does not come from the easel. I hardly ever stretch my canvas before painting. I prefer to tack the unstretched canvas to the hard wall or the floor. I need the resistance of a hard surface. On the floor I am more at ease. I feel nearer, more a part of the painting, since this way I can walk around it, work from the four sides and literally be *in* the painting. This is akin to the method of the Indian sand painters of the West.

He also explained, "I continue to get further away from the usual painter's tools such as easel, palette, brushes, etc." Instead, he pointed out, "I prefer sticks, trowels, knives and dripping fluid paint or a heavy impasto with sand, broken glass and other foreign matter added." It was here that Pollock inserted what has become his most notorious statement, even more well-known than "I *am* nature": "When I am *in* my painting," he now said, "I'm not aware of what I'm doing. It is only after a sort of 'get acquainted' period that I see what I have been about." However, he maintained, "I have no fears about making changes, destroying the image, etc., because the painting has a life of its own. I try to let it come through. It is only when I lose contact with the painting that the result is a mess. Otherwise there is pure harmony, an easy give and take, and the painting comes out well."[14]

Unfortunately, Pollock's text in *Possibilities* was not accompanied by a recent picture, as none had been photographed yet. Thus, when his fifth one-man show opened at the Parsons Gallery on January 5, 1948, the critics were nonplussed. Pollock's new work "makes me think of webs of very white ash with tar judiciously dribbled for accents in what may or may not be meaningful patterns," wrote the unawed reviewer for *The New York Times*, Aline Louchheim. "I can say of such pieces . . . only that they seem mere unorganized explosions of random energy, and therefore meaningless," decided the previously sympathetic *New Yorker* critic Robert Coates.[15] The equivocal position Pollock was now in, critically speaking, was

summoned up by Alonzo Lansford in *Art Digest*: "You have to hand it to Jackson Pollock, he does get a rise out of his audience—either wild applause or thundering condemnation. Something must be said for such a performance, if only for the virtue of positiveness." Lansford informed his readers that "At least two foremost critics here and in England have recently included Pollock in their lists of the half-dozen most important of America's 'advanced' painters; other equally prestigious authorities have dismissed him, at least verbally, with an oath."[16]

When Clement Greenberg (undoubtedly one of the "foremost critics" cited above) reviewed the 1947 annual exhibition of the American Abstract Artists group around this time, he complained that "not one is bold, extravagant, pertinacious or obsessed";[17] obviously, he was measuring the participants against the new standard set by Jackson Pollock, for all of these adjectives perfectly describe the latter's new approach. Hanging on the walls of the Parsons Gallery at 15 West Fifty-seventh Street were thirteen new canvases the likes of which New York had never seen. Pollock's freely admitted total retrenchment from traditional methods of oil painting was patently obvious in such works as *Galaxy*, *Lucifer*, and *Full Fathom Five*. From the looks of its imagery, *Galaxy*—one of the first of these—had begun in a similar vein to works of the previous year such as *Eyes in the Heat*.[18] However, at some point in the process of painting, Pollock laid down his brush and began instead to drip and spatter his pigment, not quite completely covering the underlayer, into which he also embedded small pieces of gravel to increase the texture. The thousands of tiny droplets of color scattered across the surface of this picture must have reminded Pollock's neighbor author Ralph Manheim of Long Island's clear night sky. Manheim, whom Krasner confirmed as the source of the titles for all of Pollock's first Parsons show works, invoked a similar astral metaphor for three other contemporaneous canvases, as well. These paintings, *Comet*, *Shooting Star*, and *Reflection of the Big Dipper*, differ from *Galaxy*, however, in the more continuous flow of the "lines" of pigment Pollock poured directly onto each.

At exactly what point and why Jackson Pollock decided to focus his efforts on a deliberate and sustained exploration of the possibilities of creating an entire composition by dripping or pouring paint is another "fact" of art history that will never be definitively established. A full four years after his first experimentation with this technique Pollock returned to it with a vengeance, but also now with a logic and control that signaled his maturity and independence of all of the well-known precedents for it. No longer content with the interruption to free movement caused each time he had to reload his brush, Pollock devised a handy way to create a more continuous line by tilting a commercial can of thinner, more liquid paint, and allowing it to run down a stick placed in the can at an angle. In this way he believed that the energy behind his imagery could literally "flow" straight from his unconscious.

"I approach painting the same way I approach drawing, that is, direct," Pollock had scribbled on the first draft of his *Possibilities* statement, extending the implications of his notation, "*No sketches /acceptance of /what I do—*." He later elaborated, "the more immediate, the more direct—the greater the possibilities of making. . . a statement."[19] Naturally inherent in this unplanned and unedited approach he had now adopted was the danger of "undesired" effects: puddles, spills, and random spatters. According to Peter Busa, who questioned his friend about the role of accident in his work, Pollock remarked that there

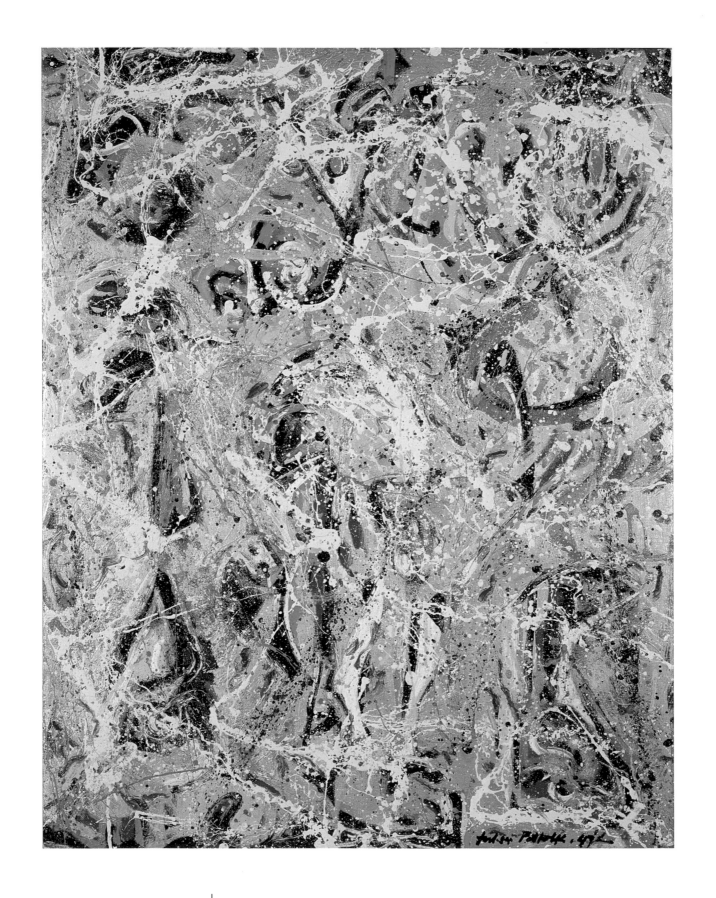

Galaxy. *1947*

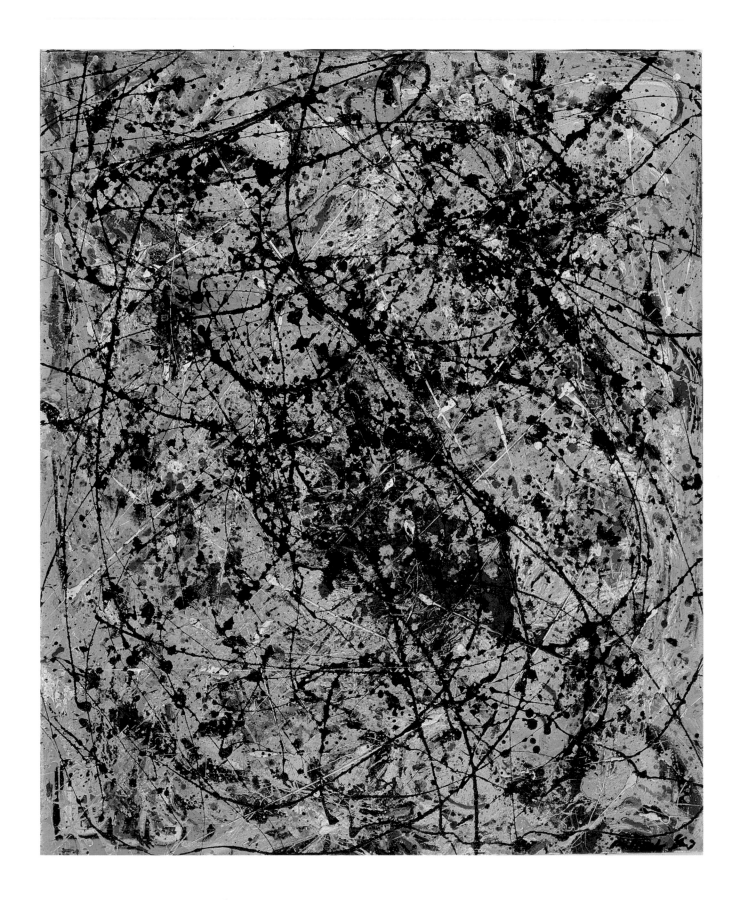

Reflection of the Big Dipper. *1947*

was "logic in the free agent and in chance." "I asked if he controlled the accident or used it," Busa has recounted, "and he said, 'What makes you think it's an accident when I know what I'm going to drip before I work?'"[20] Later, Pollock would elaborate to a wider audience, "When I am painting I have a general notion as to what I am about." He pointed out, "I *can* control the flow of paint; there is no accident, just as there is no beginning or end," although he admitted, "Sometimes I lose a painting. But I have no fear of changes, of destroying the image, because a painting has a life of its own."[21]

The main impetus for adoption of this radical new technique seems to have been Pollock's desire to create a holistic experience for both himself and the spectator, and this he knew was dependent on sustaining the same amount of interest and emphasis throughout each new canvas. In 1950, Pollock would remark in *The New Yorker*, "There was a reviewer a while back who wrote that my pictures didn't have any beginning or end. He didn't mean it as a compliment, but it was. It was a fine compliment." As Siqueiros had suggested, Pollock now believed that in a painting "one should be able to start anywhere and end anywhere," and by late 1947 his goal in painting (as described by Krasner) was to formulate "unframed space."[22]

One of the most important works in Pollock's first show at Betty Parsons was an uncharacteristically vertical canvas, *Full Fathom Five*, a work whose lilting title had several layers of literary resonance.

> Full fathom five thy father lies;
>      Of his bones are coral made;
> Those are pearls that were his eyes.
>      Nothing of him doth fade
> But doth suffer a sea change
>      Into something rich and strange.

These famous lines appear, of course, in Act I, scene ii, of Shakespeare's great comedy *The Tempest*. Ralph Manheim, who suggested this name, clearly admired this passage for he took more than one of Pollock's titles from it, suggesting *Sea Change* for a squarer canvas, visually related to *Full Fathom Five* although not as complex. As Evan Firestone has pointed out, however, the references conjured up by Manheim's first title do not stop with Shakespeare's poetry.[23] For instance:

> Five fathoms out there. Full fathom five thy father lies. At once he said. Found drowned. High water at Dublin bar. Driving before it a loose drift of rubble, fanshoals of fishes, silly shells. A corpse rising saltwhite from the undertow, bobbing landward, a pace a pace a porpoise. There he is. Hook it quick. Sunk though he be beneath the watery floor. We have him. Easy now.[24]

Although Shakespeare's lines had been recently quoted in an issue of the avant-garde magazine *Tiger's Eye*,[25] if Pollock had heard the phrase "full fathom five" at all before Manheim's suggestion of it as a title for his painting, he would have probably been acquainted with its incorporation into these lines from James Joyce's 1922 novel, *Ulysses*. Pollock, as we know, did not read very much. According to both Krasner and Alfonso Ossorio, however, he listened

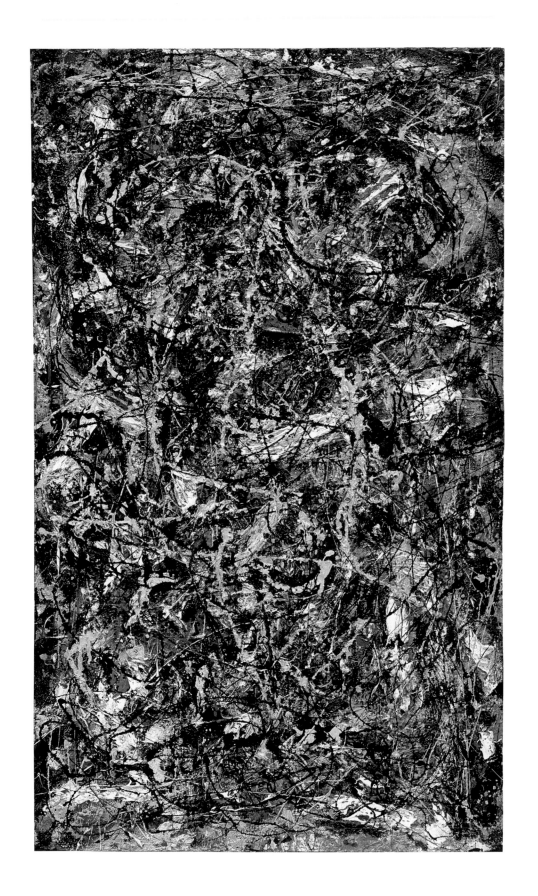

Full Fathom Five. *1947*

*Mosaic. c. 1938–41*

avidly to recordings he had acquired of Joyce's collected works (these were possibly originally introduced to him by Howard Putzel), and Jackson was especially fond of hearing Joyce read from "Anna Livia Plurabelle."[26] Although it is not known exactly when they were obtained, Pollock and Krasner owned mid-forties editions of three of Joyce's novels, *Ulysses, Stephen Hero,* and *Finnegans Wake,* as well as Joseph Campbell and Henry Morton Robinson's 1944 *Skeleton Key* explaining the latter. His close friend at this time the architect and sculptor Tony Smith loved to recite from memory whole portions of Joyce's stream-of-consciousness prose. Since at least one of these books was originally inscribed to Tony Smith, it seems likely that he was the catalyst for their acquisition.

Of all of the titles assigned by Manheim, *Full Fathom Five* is the most apposite, based on its evocation of the remarkable similarity of Pollock's new style with Joyce's "all-over" *bricolage* prose, rife with strange juxtapositions and an irreverent attitude toward literary rules. There is a defiance of tradition on each page of *Ulysses* which equates directly with Pollock's new approach to painting.[27] Indeed, Ossorio has noted that Jackson was very much in tune with Joyce's idea that one word could mean many and even contradictory things. "The reduction of experience to expression for the sake of expression, the expression mattering more than what is being expressed"—this description of Joyce made by Clement Greenberg in 1939 was unknowingly and uncannily prophetic of the mature style of Jackson Pollock, the artist who would become known as the critic's protégé.[28]

In his *Possibilities* statement, Pollock had noted his predilection for incorporating foreign material into his paintings. By *Full Fathom Five* he had progressed well beyond the admixture of sand into early forties works such as *Wounded Animal* and *Magic Mirror.* In *Full Fathom Five,* as in *Galaxy,* Pollock embedded pebbles; he also added nails, tacks, buttons, pennies, two keys, combs, torn cigarettes, matches, and paint tube tops, all of which he hid amid thickly interwoven skeins of silver, green-blue, and white industrial paint.[29] These objects were not obtrusive in the design, and Pollock allowed them to retain their individuality despite their transformed role.

Sometime between 1938 and 1941, as a WPA project, Pollock had done a 54 x 24″ design in mosaic pieces set in cement and braced in a wooden frame. This work was not assigned to any government building, so Pollock and Krasner brought it with them to The Springs, along with bits and pieces of whole and broken tesserae that he had collected but not used in the final composition. Since Krasner had no studio space during the first winter and spring there (before Pollock moved to the barn), he had given her these leftovers, suggesting that she try her hand at making mosaics in the living room. They needed furniture desperately, so, using large iron wagon-wheel rims as armatures, Krasner made two mosaic tables for their house.

Perhaps stimulated by her recollection of Peggy Guggenheim's 1915 relief *Merzbild* by the German artist Kurt Schwitters (into which were incorporated a butterfly and fragments of rubbish),[30] perhaps a leftover of the salvage mentality of the war, Krasner decided to add bits of broken glass, keys, coins, shell, pebbles, and pieces of her own costume jewelry (pins that she hammered flat) to Pollock's tesserae. She put these materials together in a totally free way, without working from a preliminary sketch. After they were organized, Jackson poured cement over her compositions as he had done with his own mosaic to set the pieces in place, and he asked a local ironworker to attach the legs. These tables were very important for

*Lee Krasner. Mosaic table. 1947*

*Lee Krasner.* Noon (Little Image). *1947*

Krasner as they constituted the first substantive works she had been able to bring to a successful conclusion since her association with Pollock, and it was not long after she finished them that her husband began more aggressively to embed found objects into his paintings out in the barn. (In turn, Krasner was able to progress to her Little Image Series after Pollock's *Sounds in the Grass*.)[31]

Some writers have suggested that Jackson Pollock's incorporation of small three-dimensional objects into *Full Fathom Five* was stimulated by his early sculptural inclinations.[32] Still in high school, we recall, his intention had been to become a sculptor, and he had studied three-dimensional art briefly in the thirties with both Robert Laurent and Ahron Ben-Schmuel. One of the reasons Pollock agreed to move to Long Island, according to Krasner, was his notion at that time that he should get back to his original goal, and once settled on Fireplace Road he began to collect driftwood, weather-worn rocks, pieces of scrap iron, and other items of junk, which he piled in the backyard for possible later use. As he had written to his father in 1932, deep down Pollock seemed to still admire men who could "build things": "creating molding the earth . . ." he wrote, "Its all abig [*sic*] game of construction."[33]

In *Full Fathom Five* not only are there odd collaged objects suggestive of eroded treasures buried in the sea, but also helping to create a strong sense of tactility is the energetic buildup of heavy paint, with varicolored patches visible beneath swirling tangled skeins. The apparently unintentional, but very real elicitation of watery depths is underscored by the dominance of oceanic green shot through with glints of red, yellow, blue, and purple powerfully reminiscent of the sun and shade of underwater crevices. Manheim, who was coincidentally also a translator of Jung, may very well have called upon the sea allusion in connection with this painting because of the Swiss psychoanalyst's famous association of the ocean with the collective unconscious, an association Pollock had previously evoked in *Guardians of the Secret*. This may have been a reason that Jackson readily approved Manheim's suggestion.

*Alchemy*, another title provided by Manheim, could also have stemmed from the author's close association with the writings of Jung. The publication in 1936 of Jung's *Psychology and Alchemy* had created quite a stir in analytic and Surrealist circles. In this text, Jung explained further the roots of his theory that individuation is achievable only through proper combination of the male and female aspects inherent in the human personality. Jung elaborated on his source for the formulation of these ideas, *Rosarium philosophorum*, an alchemical treatise of the sixteenth century. Alchemy, the process by which base metals—sulfur (solar or male) and mercury (lunar or female)—could allegedly be transmuted into gold in a closed (womblike) retort, was originally proposed in ancient Egypt and its practice attained great popularity in medieval and Renaissance times. The revival of interest in this pseudo science in the early 1940s—clearly Jung-inspired—resulted in numerous essays on alchemy appearing at that time in such avant-garde magazines as *transition*, *VVV*, and *View*. Very pertinent was an article by Kurt Seligmann, who pointed out that the alchemic process, being of a psychic nature, is "analogous to the artist's labor."[34]

That Pollock was fully cognizant of alchemy can be inferred from several sources. He owned the copy of *View* which had Seligmann's explanation of this, and *Redemption Ideas in Alchemy*, by M. Esther Harding, was on his Analytical Psychology Club booklist. Matta and

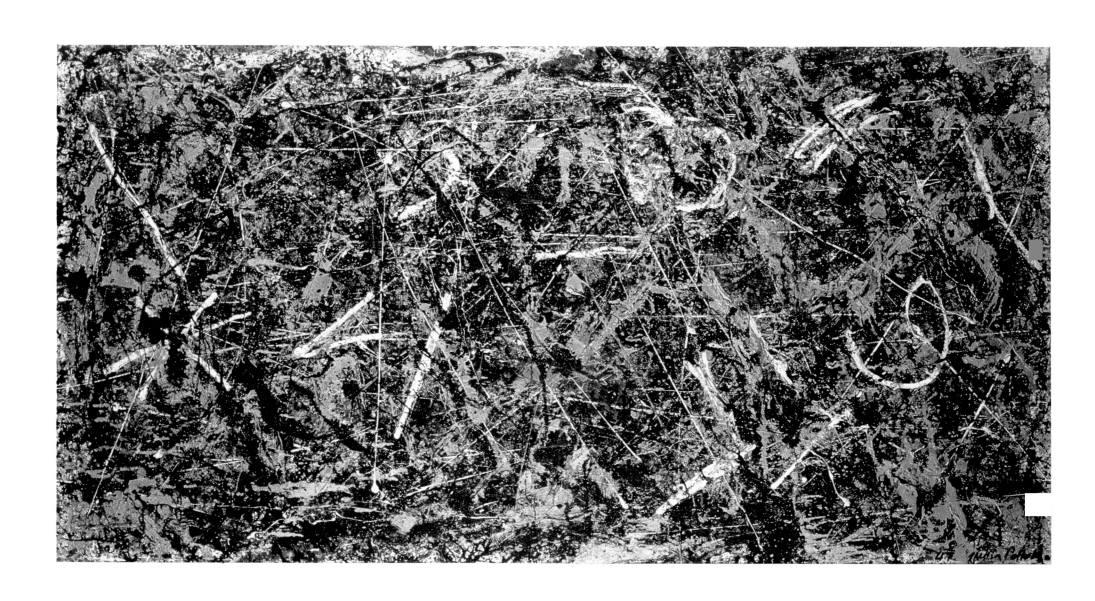

Alchemy. *1947*

Graham had both been fascinated by this subject and no doubt discussed it with Pollock along with their other mutually shared occult interests. Krasner was also aware of alchemy, as indicated by the notes she took while investigating a class in the study of explosives for the WPA War Services window-display project. She characterized one of the items she was shown in 1942 as "a weird looking device like some alchemist's dream,"[35] and Lawrence Alloway has suggested that a very early painting by Pollock (one of several panels done on masonite sometime between 1934 and 1938) may represent part of a similar contraption. In this work, a skeletal figure appears to be placing a bone in an alchemical retort. Other art historians have conjectured that alchemical symbols constitute the true source of the "king" and "queen" archetypes in *Guardians of the Secret*, as well as of the moon-woman. Also, an elaborate case has been made for alchemical history as the root of the iconography of a 1946 painting called *The White Angel*.[36]

Whether Pollock was also aware of James Joyce's reputation as "an alchemist of the word" (he was first described this way by Eugene Jolas in a 1938 issue of *transition*),[37] it is difficult to say; but if he were, it would be even more likely that he would have been gratified by Manheim's similar characterization of one of his works. We know from his own comments that Pollock's new technique truly aimed at more efficaciously projecting untrammeled psychic material onto his canvas.[38] That the overlapping skeins of paint in one of the five works in his Parsons show are predominantly black, red, white, and gold (the colors traditionally identified as representing the four stages of the alchemical process) was probably the basis for Manheim's naming of it.[39] Furthermore, Jung's association of white with quicksilver (an important alchemical substance) provides another rationale for the title based on Pollock's liberal admixture of aluminum paint into these colors. Also, his lucky numbers, four and six, show up again suddenly, here combined with a superimposed white asterisk. It has been pointed out that all three of these notations have possible alchemical interpretations: the star equaling the quintessence, or agent which catalyzes alchemical transmutation, the four representing completeness, and the six standing for the union of male and female which will produce this desired state.

Of all of the paintings Pollock created for his fifth one-man show, another in the vertical format, *Cathedral*, was to become the best-known, as a result of being featured in a round table discussion in *Life* magazine on October 11, 1948.[40] Russell W. Davenport was the moderator of a panel of distinguished international experts including Clement Greenberg, Georges Duthuit, Alfred Frankfurter, Aldous Huxley, Meyer Schapiro, James Johnson Sweeney, H. W. Janson, and others equally notable in their fields. The question the editors of *Life* asked these men to address was deceptively simple: "Is modern art, considered as a whole, a good or bad development? That is to say, is it something that responsible people can support, or may they neglect it as a minor and impermanent phase of culture?" *Life* pointed out that at issue was the seeming intrusion into the aesthetic framework of the "Classical-Christian" art tradition of a newer tradition which implies, to the detriment of morality, that "esthetics stands alone as a part of human experience." According to *Life*, such art (the implication is, sadly) purports to be "good or bad purely in its own terms with no ethical or theological references."[41]

To initiate discussion, Davenport quoted noted historian Arnold Toynbee's

Panel A. *c. 1936*

The White Angel. *c. 1946*

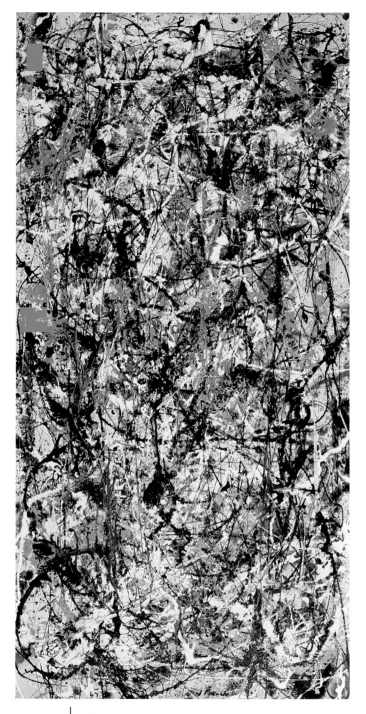

Cathedral. *1947*

pronouncement that "modern art" is symptomatic of a decay in the values of our age. One of the primary examples to be considered in this context was Pollock's *Cathedral*. Championed by Greenberg, it received mixed reviews from the other panel members. A. Hyatt Mayor, curator of prints at the Metropolitan Museum of Art, was most strongly opposed, saying with a sniff, "I suspect any picture I think I could have made myself." British author Aldous Huxley brought up the issue of *Cathedral*'s puzzling lack of focus, which Pollock must have remembered in making his *New Yorker* defense, two years later, of his allover approach. When asked his opinion of *Cathedral*, Huxley said, "It raises a question of why it stops when it does. The artist could go on forever. [Laughter] I don't know. It seems to me like a panel for a wallpaper which is repeated indefinitely around the wall." This was actually a somewhat more flattering observation than that of Professor Theodore Greene of Yale University, who remarked that the composition of *Cathedral* seemed a pleasant design for a necktie; Sir Leigh Ashton of the Victoria and Albert Museum proposed similarly that "it would make a most enchanting printed silk."[42]

With the exception of Greenberg, Sweeney, and a few others, the commentators at the *Life* round table—who were speaking to and for the general public—were obviously not yet attuned to such an unconventional painting. They would probably have laughed again had they been privy to subsequent analyses of *Cathedral* and other similar works by Pollock as representing the exact opposite of immorality and godlessness. In fact, just a dozen or so years later, many observers deemed viewing Pollock's poured paintings a truly modern "religious" experience, but one that followed the esteemed artistic tradition of evocation of the Sublime. Indeed, art historian Robert Rosenblum remarked in 1961 that this philosophical and aesthetic category, whose importance first emerged in the eighteenth century, had acquired "fresh relevance in the face of the most astonishing summits of pictorial heresy attained in America in the last fifteen years." Jackson Pollock was cited as one of the key "heretics." The very lack of form and boundlessness which Huxley castigated Rosenblum interpreted as both mystical and spiritual in its evocation of nature's breathtaking beauty.[43]

Rosenblum's updated application of the concept of Sublimity (which he attributed to works by Mark Rothko, Clyfford Still, and Barnett Newman, as well as Pollock) particularly suited the aptly titled *Cathedral*, which exhibited Pollock's most liberal use so far of the shine and glitter of aluminum paint. Seen in this new context, its icy pale coloration projects awesomeness and radiance. Still alluding to the resonance of myth, as Harold Rosenberg later pointed out, in works like *Cathedral* Pollock no longer needed to include or define specific mythic content. As never before in modern painting, in his new work Pollock had succeeded in finding a way to project "the expression of a pure state."[44]

179

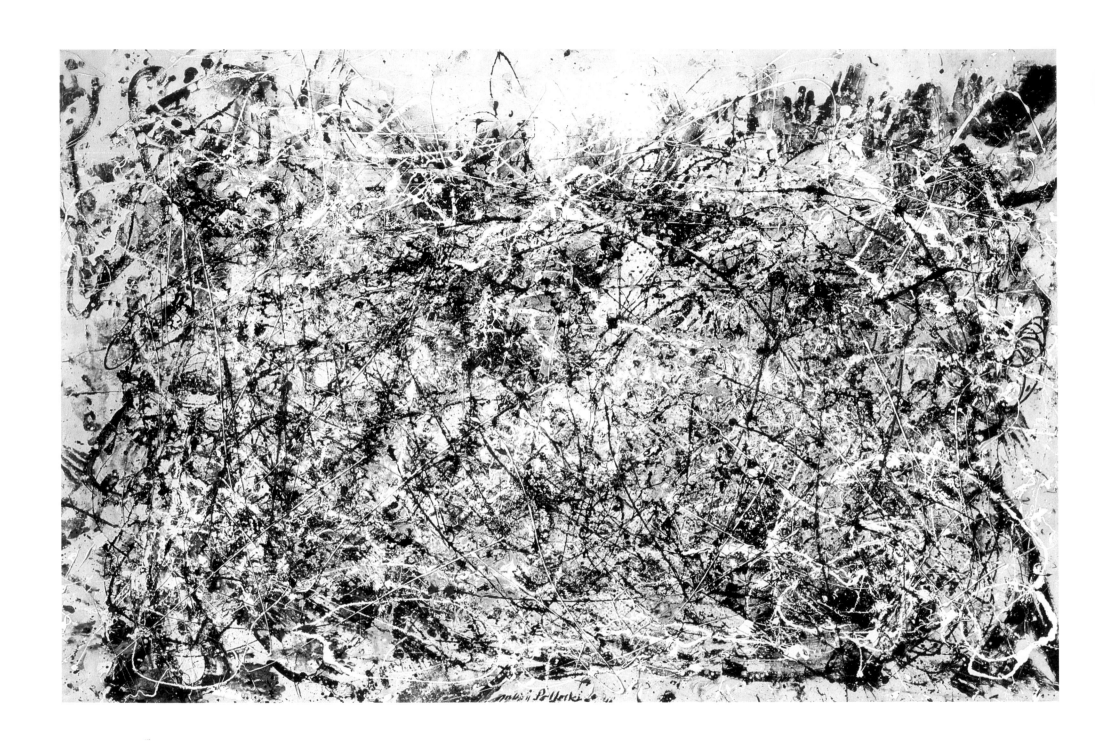

Number 1A, 1948. *1948*

# TEN

# *States of Order*

A shaman is a wizard whose charms work. . . .
Another doing what seems very much the same thing
wouldn't have the power at all.
—William Fifield, *In Search of Genius*, 1982

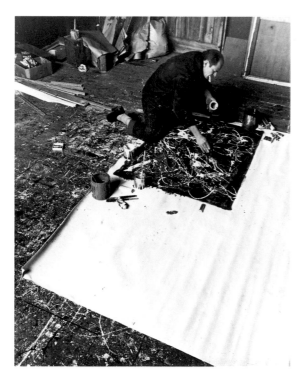

*Pollock painting, 1949.*
*Photograph © Arnold Newman*

"Is he the greatest living painter in the United States?," *Life*'s feature story on Pollock, which followed the round table by exactly nine months, stimulated five hundred thirty-two letters to the editor—more than any other article in the magazine that year.[1] Not surprisingly, over eighty percent of those who wrote did so in order to criticize the publication of such nonsense. Granted, *Life*'s snide presentation of Pollock as an artist who "drools" paint, "inadvertently" incorporating into his compositions stray cigarette ashes and dead bees, invited reader indignation. Having branded him *one* of America's young extremists at the round table, *Life*'s editors, by now singling him out for an in-depth presentation, elevated Pollock to an icon of the outlandish and farfetched. In August 1949, at the time this issue hit the newsstands, its claim that Pollock, at age thirty-seven, had burst forth as "the shining new phenomenon of American art" was typical media hype. However, as B. H. Friedman pointed out, the magazine's own motto—"*Life* makes things happen"—ironically proved to be true. Despite the mocking tone of this story, it stirred up critical and collector interest. The long-term effects on Pollock's psyche—of both the praise and the ridicule—were to prove more equivocal.

Actually, the timing of *Life*'s full-color spread was excellent, coinciding with a period of high creative energy and self-satisfaction for Pollock. Under the care of a sympathetic local doctor, for the first time in years he had brought his drinking under control. "Devoted" to Lee at this time, Jackson obviously enjoyed the relatively peaceful atmosphere which permeated their house on Fireplace Road. This idyllic domesticity could not last, however, predicated as it was on Pollock's long conversations with Dr. Edwin H. Heller and the latter's prescribing of the tranquilizer Miltown. When the physician was killed in an automobile accident in mid-1950, Pollock could not sustain his temperance.[2] Many who remember him during his years on the wagon recall that he consumed gallons of coffee, and although it hardly seems possible, he was even more silent than heretofore. But this disquieting social withdrawal contrasted absolutely with the assuredness and self-confidence Pollock demonstrated when he was at work. Undated, but psychologically consistent with

181

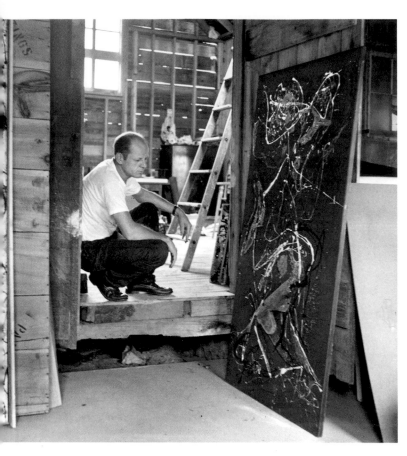

*Pollock with* The Wooden Horse, *c. 1948*

this time period, is Pollock's well-known, quite eloquent (for a nonverbal man) summation of himself and his work:

> Technic is the result of a need—
> new needs demand new technics—
> total control—denial of
> the accident—
> States of order—
> organic intensity—
> energy and motion
> made visible—
> memories arrested in space,
> human needs and motives—
> acceptance—[3]

In connection with the *Life* story, Pollock reluctantly agreed to be interviewed by the art editor, Dorothy Sieberling (a painful experience for both), and also to allow Arnold Newman, a young freelance photographer, to try to capture him in the act of painting. In actuality, Pollock consented only to mime his famous technique. A few months later he once again simulated his method, this time for Rudolph Burckhardt, who had been sent to Long Island for similar shots to accompany an article scheduled for *Art News*.[4] Reversing his earlier unwillingness several weeks later, at the urging of his wife, Pollock finally decided to say yes when local photographer Hans Namuth also asked to shoot him at work. Neither dreamed that a legend would arise out of their collaboration.

Despite having left behind in New York the urge to include in his paintings specific iconographic references to his shamanic beliefs, from time to time in The Springs, Jackson Pollock continued to describe his motivation to work in terms that evoked shamanic practice. "I have to get into the painting to relax," he confided to Ossorio; to Jeffrey Potter and others he often spoke of a desire to use art to leave his surroundings and enter a place where "outside things don't matter."[5] Before 1950, his methods for achieving this were his own well-guarded secret. But the pictures Namuth took in the late summer and early fall of that year confirmed and exposed the dimensions of Pollock's breakthrough to the magical state after which he had always yearned: total involvement, release, and self-transformation ritually induced in the process of making art.[6]

Namuth's more that five hundred black-and-white still photographs have provided posterity with stunning visual proof of the psychic and physical changes which took place in Pollock as he worked.[7] It is evident from these pictures that, under the spell of his creativity, Pollock's body motions—often awkward and heavy in a more conscious state—took on the fluency and agility of a well-trained acrobat or athlete. No longer fighting his medium, he seems to become one with it, absorbed and "transfixed" by actions over which he admitted to having only varying degrees of emotional and motor control. "It was great drama," Namuth characterized his first glimpse of Jackson Pollock in the studio: "the flame of explosion when the paint hit the canvas; the dancelike movement; the eyes tormented before knowing where to strike next; the tension; then the explosion again. My hands were

trembling."[8] Namuth's photos show that, by 1950, Pollock had expanded to unheard-of proportions Benton's advice of twenty years earlier to articulate form and composition on a muscular basis. Now, in the successive stages of creation, Pollock's movements had become aesthetic statements equivalent in their potency to the marks they engendered.

Not actually making direct physical contact with the forms he was inventing ("the brush doesn't touch the surface of the canvas," he explained, "it's just above"),[9] Pollock, as Namuth's pictures reveal, was engaged nevertheless in an intense dialogue with his materials, expanding or, more to the point, exploding the notion of any technical limitation attendant upon making a work of art. Numerous subsequent writers on Pollock have noted the close visual approximation of his technique in these photos to the extemporaneous aspects of jazz. As early as 1945, in fact, one prescient critic had compared the "flare, spatter and fury" of Pollock's paintings to modern music, citing both as the result of inspired improvisation.[10] As already noted, Pollock loved jazz, and he played his records constantly, "rocking and rolling" for days on end to Dizzy Gillespie, Bird, Dixieland, and bebop.[11] What undoubtedly attracted him to this type of sound was not just its rhythm and tempo, but its naked presentation of honest and deeply felt emotion. By the late forties, with his confidence momentarily increased, Pollock could tell his wife that jazz was "the only *other* creative thing happening in this country."[12] On those occasions when she was invited out to the barn,[13] Krasner could experience the analogy on her own. Now, when her husband started painting, she saw that he would "take off, so to speak," working in a similar mode of impromptu freedom.

In addition to documenting Pollock's procedure, Namuth's photos reveal the momentous changes taking place in the look of his poured paintings. The culmination of over two years of experimentation in this style, the canvases he worked on under Namuth's camera eye took on a new focus and quality. As opposed to the bravura approach and more complex superposition of skeins in his earlier drip works, by mid-1950 Pollock was developing a simpler, airier, more controlled and "classic" composition.

The first steps in this direction had been taken a little over a year earlier, when Pollock predicted his classic paintings in a canvas he designated *Number 1A, 1948* (see page 180).[14] In the course of an interview taped for radio in 1950, while he was making his classical works, Pollock remarked to his neighbor William Wright that he felt much more at ease in a big area than when he was working "on something 2 x 2." Resonating to his childhood experiences, he explained that within a larger space he felt "more at home." Before *Number 1A*, however, with the exception of Peggy Guggenheim's mural and *Lucifer*, Pollock had not actually created any really big paintings. Now, finally following the guidelines he had set for himself, the proportions of *Number 1A* were such that Pollock could say that he had achieved a midway position between the easel and the mural approach. Whether stemming from his ingrained admiration for the heroics of Orozco and Michelangelo or from the fact that the spaciousness of the Wild West was duplicated in his mind by the nearby ocean, Pollock's comments to Wright show that he was cognizant of the fact that this move toward outsize dimensions more fully satisfied the demands of his new style of painting.

Pollock was also fully aware—not only from his training with Benton, but also from his association with Hayter—that an increase in scale requires extensive physical displacement.

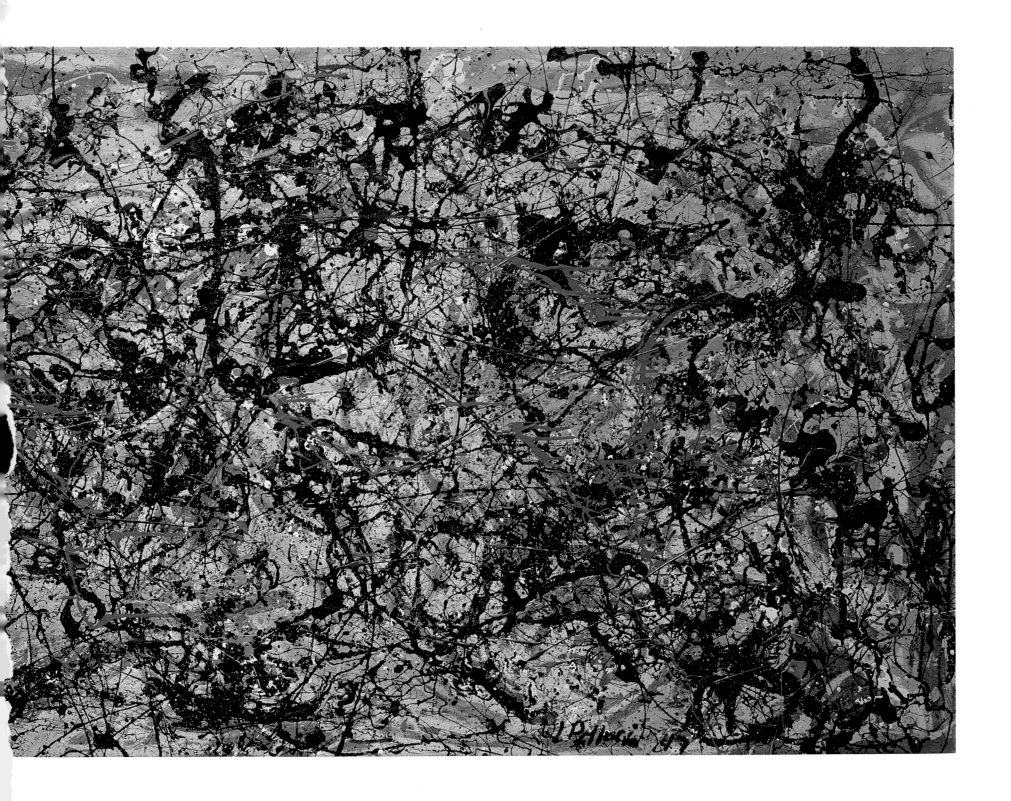

Lucifer. *1947*

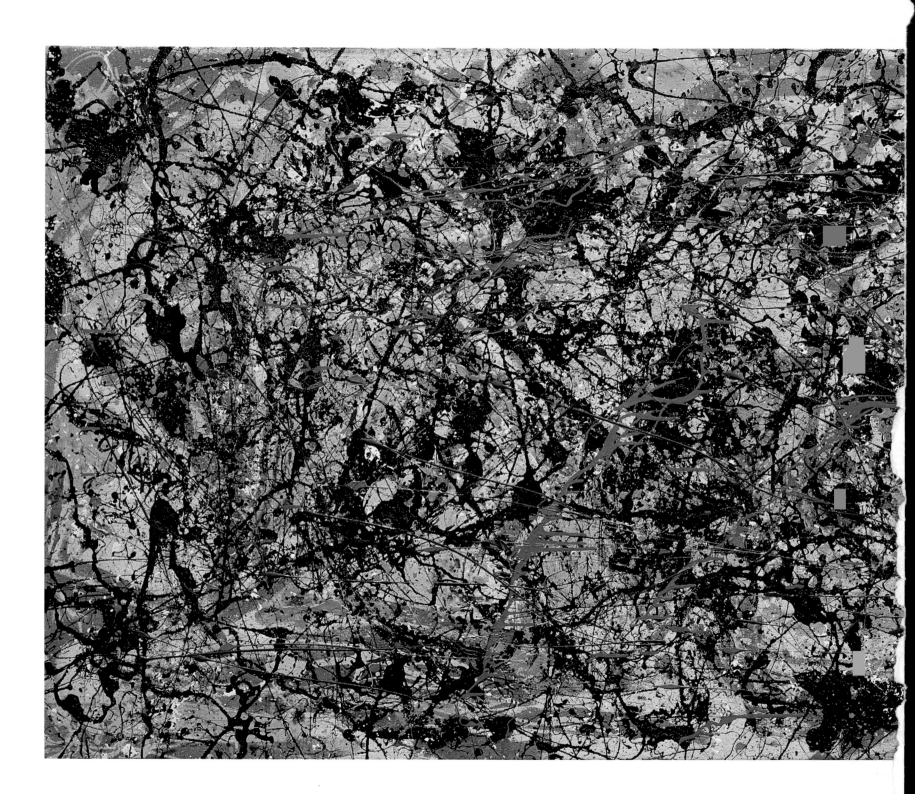

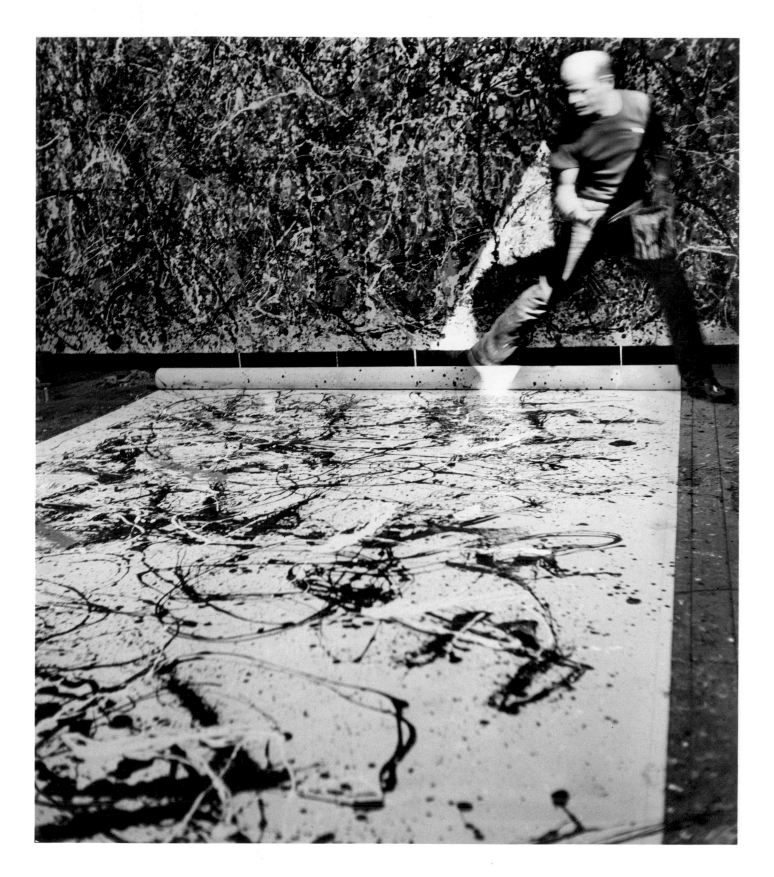

*Pollock painting* Autumn Rhythm, *1950.*
*Photograph by Hans Namuth*

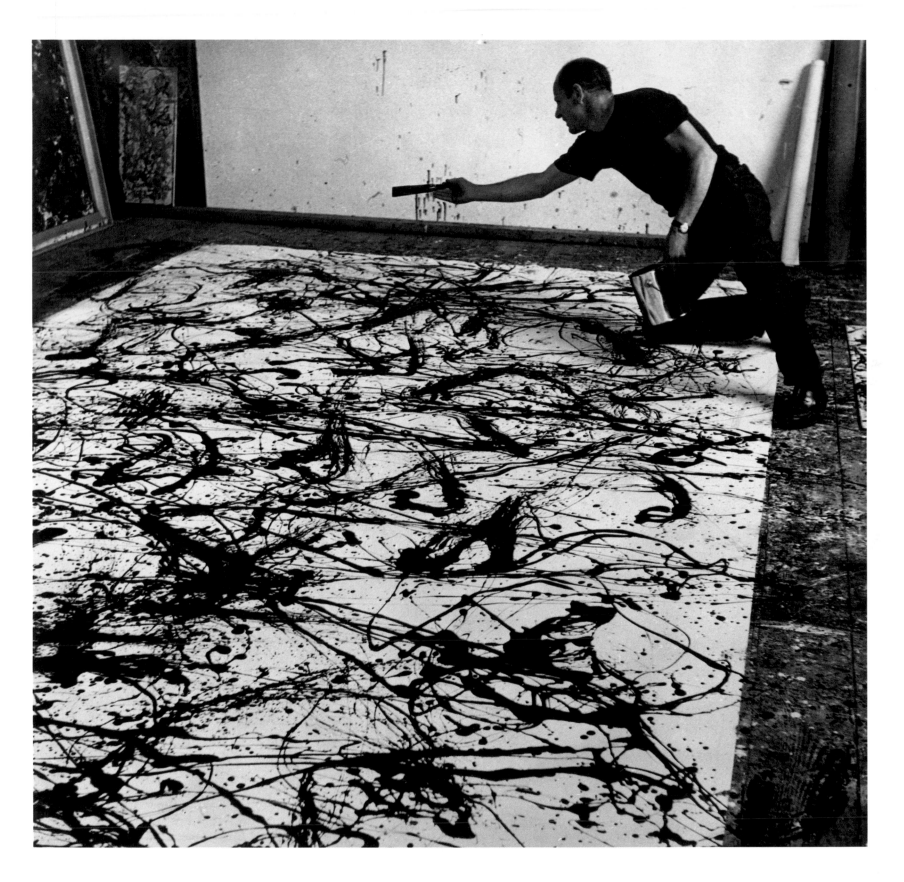

*Pollock painting, 1950.*
*Photograph by Rudolph Burckhardt*

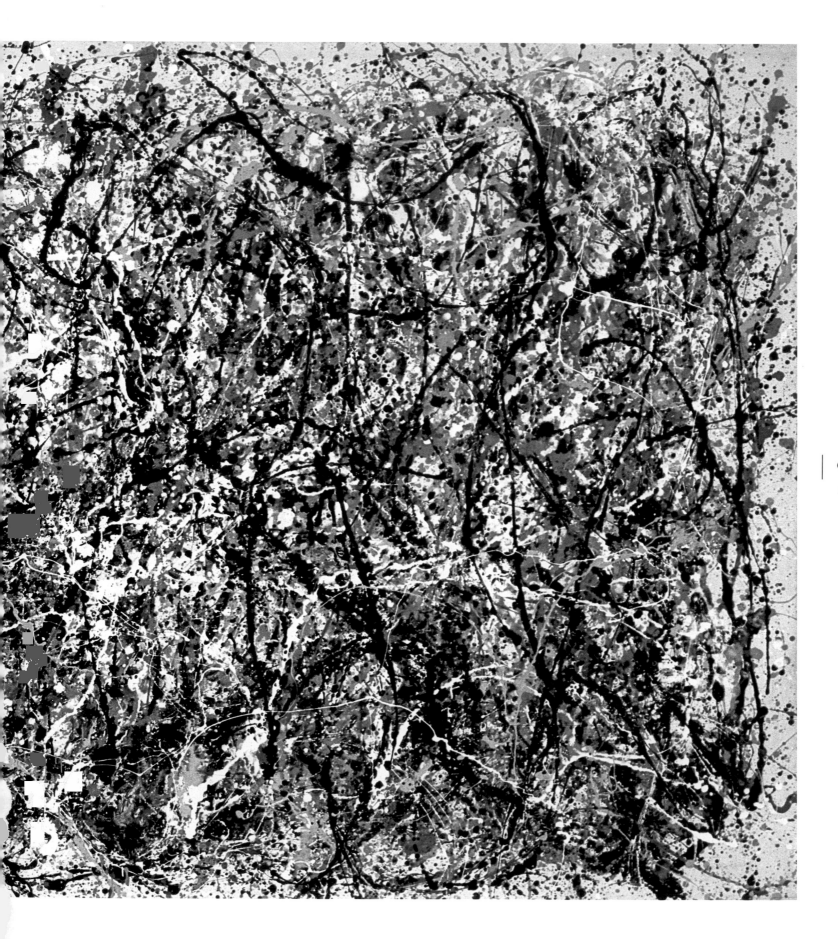

One: Number 31, 1950.

*1950*

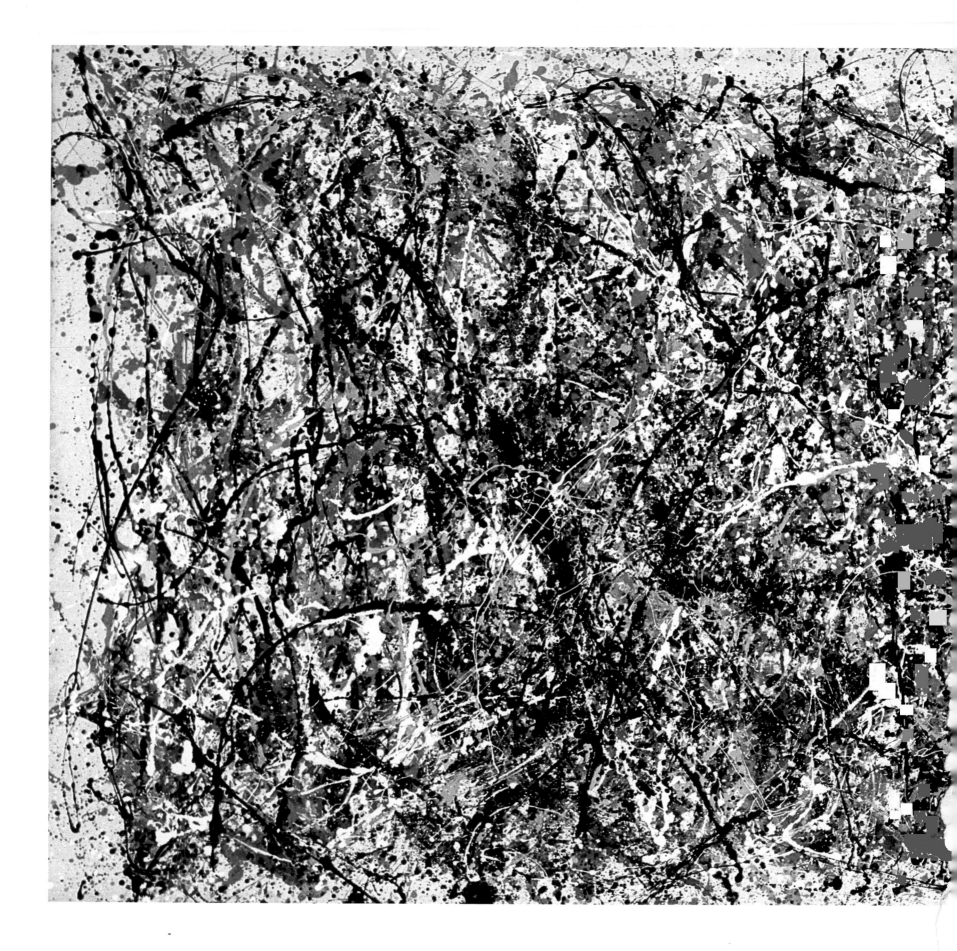

*Number 1A* is one of the first works where it is clear that, in order to create it, he had involved virtually every bone and muscle in his body. As if to emphasize this more comprehensive physicality, Pollock decorated this painting with a handprint frieze. We have already seen that in 1943 he impressed his hand upon *The She-Wolf* in order to evoke the authorship talisman of the prehistoric caves.[15] The successive marks of Pollock's hand reiterated around three of the edges of *Number 1A* range in intensity from a dark henna-tinged maroon to a pale brownish-pink. Some writers, in keeping with the Romantic myth of Jackson Pollock as a violent and mindless painter, have visualized these prints as originating in a vehement slapping motion. An interesting anecdote recounted years later shows that they may be interpretable in a very different light. Although it is not clear if she was speaking specifically about *Number 1A* or *Lavender Mist* (another painting in which he used this device), Mercedes Matter had a poignant recollection in a PBS interview. Matter (who, with her husband, Herbert, was friendly with both Krasner and Pollock) told of an occasion when she had been privileged to watch Jackson paint. In the midst of his pouring, she remembered he suddenly bent down, and his hands covered with "purplish" pigment, she saw him begin to "caress" his composition.[16]

In *Number 1A* Pollock also previewed the general format of the later classical paintings. In this huge canvas a welter of crisscrossing skeins dramatically dips toward the center of the work, coalescing into a powerful centrifugal vortex. Updating the optical illusion of *Shimmering Substance*, in *Number 1A* Pollock projected the feeling that his entire configuration was hovering in the viewer's space. The pyrotechnical dazzle of this painting, a result of myriad tiny outbursts of colored energy, was praised by contemporary critics when it was shown in 1948 at the Venice Biennale. Alfred H. Barr, Jr., of the Museum of Modern Art termed it "a *luna park* full of fireworks, pitfalls, surprises and delights."[17] As Barr noted, the light effects of this work were experienced as phosphorescent; Pollock had previously accepted this term for the title of another work in which he also emphasized shooting, sparkling glints of aluminum radiator paint.

Barr also characterized *Number 1A* as "an energetic adventure for the eyes." Its dizzying rotations were to be tamed and refined somewhat in the more classical allover works. This shift of emphasis can be seen by comparing *Number 1A* to the slightly later, more majestic *One: Number 31, 1950.* By the fall of 1950 when the latter was painted, Pollock had enlarged the size of his canvas, which allowed him more latitude. In this case, he added a pointillistic layer of droplets of paint, and here the subtle suggestion of latent imagery resurfaced. The illusion it creates is strongest on the right side of the work, where some of the downward rivulets coalesce into configurations that evoke the dancing, swaying figures of *Gothic*. Ultimately, however, the powerfully holistic effect of the marks in *One* defeats the eye's tendency to establish figure/ground relationships. Also, most of the darker paths appear to have been intended to begin the structure rather than to impose order or design.

We can visualize what the initial stage of *One: Number 31* probably looked like by comparing it to a related painting of the same year, a work designated *Number 32* even though it was done earlier. (Pollock's numeration was obviously not strictly sequential.)[18] For reasons probably related to his original reluctance to be photographed, Pollock decided to halt this work after laying in what was usually just a preliminary web of poured black

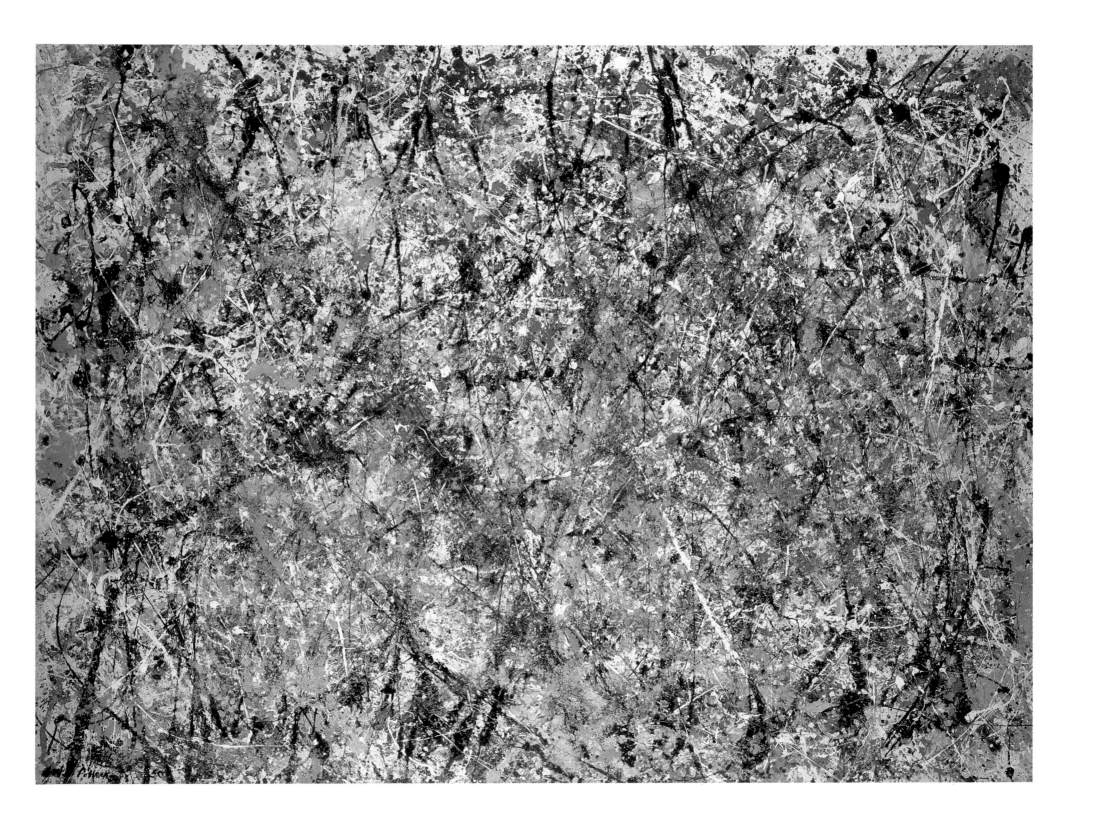

Lavender Mist: Number 1, 1950. *1950*

*Claude Monet*. Water Lilies. *c. 1920*

*Joan Miró*. The Nightingale's Song at Midnight and Morning Rain. *1940*

lines. (In Burckhardt's photos he can be seen pretending to work on *Number 32*, after he told the photographer it was complete.) Suggesting the probability of influence is the fact that Namuth's pictures indicate that Pollock was in close visual contact with *Number 32* while he was working on *One*.

In *Number 1A*, Jackson Pollock provided his viewers with specific clues as to how the work should be experienced: our gaze is drawn immediately inward from the four corners to focus on a central core. No such obvious pattern now governs *One*, where, through various devices, Pollock managed to sustain an even amount of interest throughout. In fact, the contiguous webs of *One* repeatedly separate and lead the eye in endless directions. With the laterally circuitous network of white he created an especially effective counterpoint. Repeating an aspect of his mature compositions introduced in *Number 1A*, Pollock did not allow the image area in *One* to extend to the outermost edges of his canvas. The fact that it is moored more tightly at the bottom indicates that, although he moved around a great deal as he worked, he knew early on which perimeter would be which. In the process of creating his large poured works, Pollock would frequently ask Krasner to help him hoist a dry, but unfinished canvas up onto the two by fours he had attached to the wall of the barn. In this way he could study his progress, sometimes leaving a work in this upright position for as long as several months. As E. A. Carmean, Jr., has shown, Namuth's pictures provide surprising evidence that the visually complicated *One: Number 31* was created without the benefit of this meditative phase.[19]

Causing more confusion, Pollock's next painting, a work begun more than halfway through 1950, was the one to which he eventually assigned that year's *Number 1*. *One*—which was Pollock's own title for *Number 31*—was a subjective, not a numerical designation. (The painting had first been called *Lowering Weather*, at the suggestion of Clement Greenberg.)[20] Because of its subtle, delicate pastel-tinted surface, Greenberg suggested that Pollock's new *Number 1* be subtitled *Lavender Mist*. Elaborated from point to point into a more minutely detailed and tightly woven composition than *One*, *Lavender Mist* appears to emit into the surrounding air a suffused haze of finely pulverized opalescent color. Like one of its predecessors, *Shimmering Substance* (page 167), the atmospheric effect of this painting has frequently elicited comparisons with the work of Claude Monet: the similarities now perceived are to his *Nymphéas* or waterlily subjects. Painted over a period of more than twenty years, right up to the artist's death, the last of these had been completed by Monet only a few decades before Pollock painted *Lavender Mist*.

Although Impressionism is usually defined as a realistic mode, Monet's relatively indistinct late compositions, including most of the waterlilies, can for all intents and purposes be considered abstract. By the time he painted *Lavender Mist*, Pollock still would have had no direct access to Monet's late paintings: the mural-sized *Nymphéas* most similar to his own work were permanently installed in the Orangerie in Paris, and Pollock never left the United States. There were no examples on view as yet in New York; moreover, since at that time Monet's works were not esteemed very highly, it is unlikely that Pollock would have sought them out. However, as William Rubin has explained, some of the affinities between *Lavender Mist* and the late Monet are so obvious that, at the very least, they suggest a parallel approach. For instance, the equability of tone and texture, the evocation of mood through color, and the micronization of form in *Lavender Mist* are remarkably reminiscent

*Mark Tobey*. Universal Field. *1949*

*Janet Sobel*. Milky Way. *1945*

of the most advanced works of Monet. In contrast to the sublime fury of many earlier allovers such as *Number 1A*, *Lavender Mist*, like the Impressionists' work, shows Pollock evoking nature's transcendent beauty, combining feeling and sense perception into a lyrical visual totality.[21]

One characteristic of Monet's final paintings is at odds with later Pollocks: in the best of the waterlily series Monet excluded linear structure, allowing patches of color to suggest form and mood. In conformance with the approach of the Mannerist masters he had learned to admire when studying with Benton, line had always been more important to Pollock than color. However, a 1945 exhibition at the Pierre Matisse Gallery may have been what gave fresh impetus to the development of his distinctively linear allover format. This show, which had an important impact on the American wartime art scene, consisted of small gouaches by Miró recently smuggled out of occupied France. Comprised of scattered cartoon-like forms connected by a thin tracery of autonomous lines, these works were called *Constellations* by Miró, invoking a stellar metaphor. Only the year before the Pierre Matisse exhibition Pollock had cited Miró as one of the two artists he admired most.[22] After the *Constellations* were shown, Howard Putzel, in a statement written to accompany one of the few presentations in his own short-lived gallery, flatly declared Miró to be a direct precursor of the type of work Pollock was now doing. Putzel explained their shared goal as "a new metamorphosism."[23] Verifying that Pollock was aware of Miró's latest inventions is the fact that one of his contemporaneous Atelier 17 prints *Untitled 1* derives its composition from *The Poetess*, a work on view at Pierre Matisse.[24]

Sometimes also raised as a possible source for the look of Pollock's mature poured works are the so-called white writings of the contemporary West Coast artist Mark Tobey. These relatively small pictures, which were exhibited in New York a year before the *Constellations*, likewise comprise thinly skeined unbroken linear networks which loop and cross innumerable times. Totally unlike many of Pollock's webs, however, most of Tobey's extend from edge to edge and bottom to top. Whether or not Pollock actually saw Tobey's Willard Gallery exhibition in 1944 is not really important, since their joint inclusion in several major group shows by then means that Pollock surely knew Tobey's work.[25] However, it is unlikely that the white writings were critical to Pollock's development not only because of their radically smaller dimensions, but also because of the fact that Tobey's rather crabbed scrawl closes rather than opens up pictorial space. More closely controlled by the artist's hand and wrist, Tobey's marking system (partly based on experiments with Zen calligraphy) exhibits a calculability alien to Pollock's factural freedom.

Also conceivable, but even less probable as a direct stimulus for works like *One* and *Lavender Mist*, are the slightly earlier canvases of Janet Sobel, an untutored Russian-born Brooklyn housewife whose son managed to secure an entree for her into Peggy Guggenheim's circle. Due to the enthusiasm of Max Ernst, Sobel had several showings of her intuitive allover paintings in the mid-forties. Treating her like the Douanier Rousseau, many critics admired Sobel's naïve approach, and her painting patterns were likened to spiderwebs, milk drops, and other wonders of nature. Although both Greenberg and Busa have confirmed that Jackson was secretly "enthralled" with her compositions,[26] Sobel's more measured and decorative style appears too thin to have had more than a superficial impact on his own formulations.

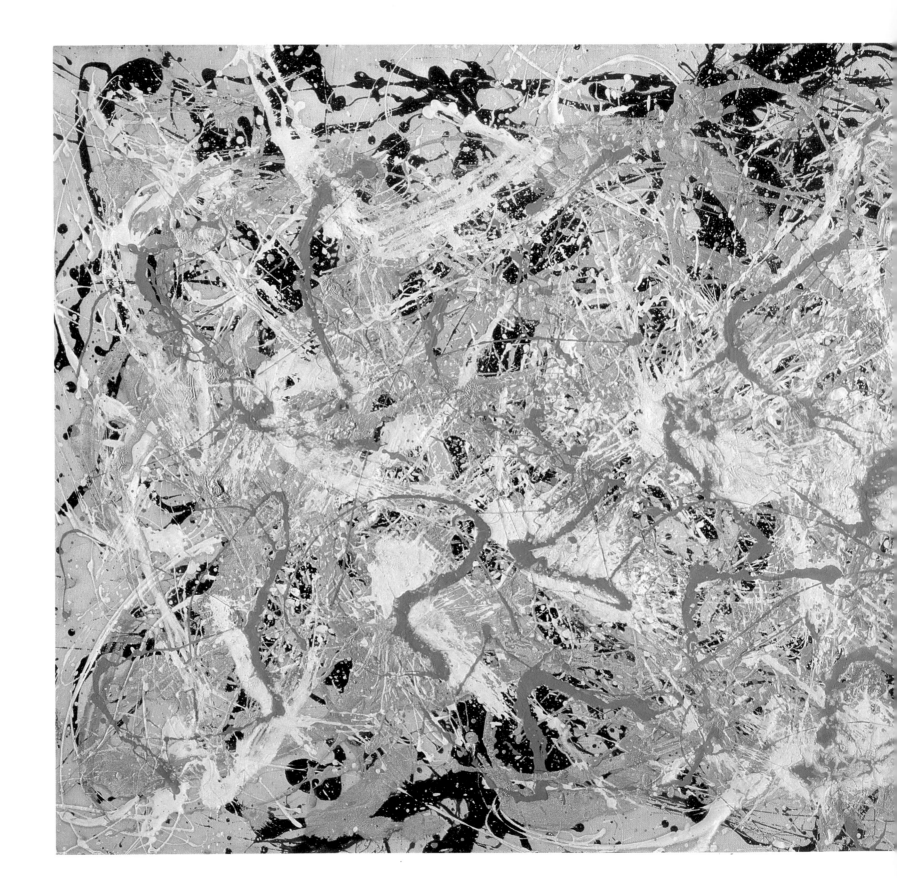

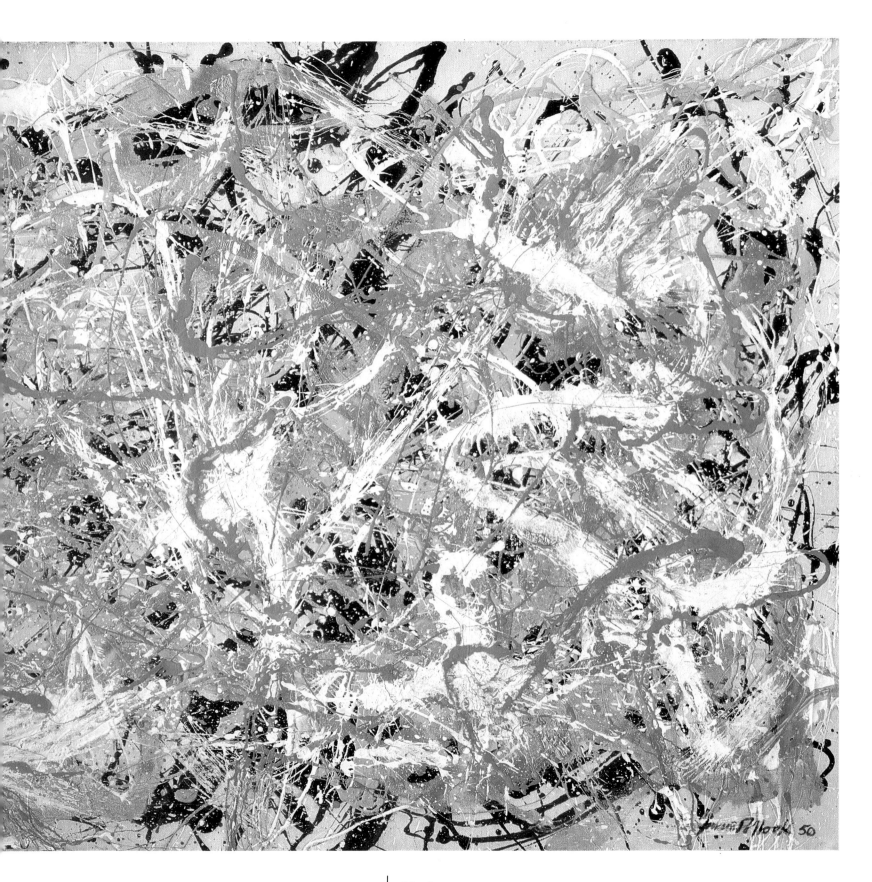

Number 27, 1950. *1950*

*Piet Mondrian.* Pier and Ocean. *1915*

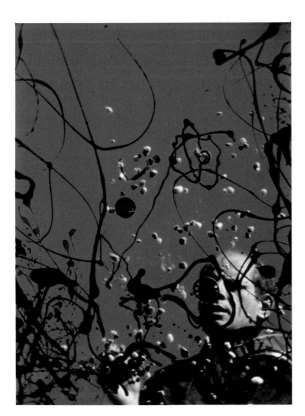

*Pollock painting on glass, 1950. Still from second film by Hans Namuth*

A far more important theory—set out by Greenberg and extensively explored by Rubin[27]—points out that what makes Pollock's fully perfected allover poured works so successful is the fact that they expand the premises of Analytic Cubism. Despite the passage of more than three decades, it was Greenberg's contention in the late forties that artists with advanced ambitions still had to confront the critical tenets set out c. 1910 by Picasso and Braque. Greenberg concluded that one of the most important aspects of Jackson Pollock's breakthrough was the final abandonment of his long-term infatuation with Picasso's psychologically tainted Synthetic Cubist style, to take on a more invigorating challenge: elaboration of the transparent planes of the more purely formal Analytic mode. We have already seen how badly Pollock mishandled the four-dimensional spatial cues in his c. 1938–41 *Interior with Figures* (see page 70). By 1950, however, he had conquered this shortcoming. In fact, Greenberg believed that Pollock, now aided by his understanding of the dynamics of the "plus and minus" pictures of Mondrian,[28] was *the* modern artist best equipped to extend the work of Picasso.

Incorrectly ignoring the crucial Surrealist input into Pollock's mature works (the liberation of his imagination through psychic automatism), Greenberg declared that even Pollock's "drip pictures" had an "almost completely Cubist basis."[29] Since proof of this contention is not obvious, Greenberg had to explain how Pollock's appropriation of Analytic Cubism was embedded in the infrastructure of his classic paintings. Pollock, Greenberg maintained, was able to heighten the "interstitial"[30] effects of four-dimensional oscillation by replacing his previously more diffuse organization and bright palette with centralized pictorial energy and a more tonal composition.

Possibly the best example to illustrate this thesis is *Autumn Rhythm: Number 30, 1950* (see pages 201–2), the last of the outsized classic poured paintings. Virtually the same size as *One: Number 31, Autumn Rhythm,* like Picasso's *Guernica,* is an important painting in the history of modern art which has been made even more so by the fact that its gestational stages have been visually chronicled. Namuth's extensive series of photographs of this work in progress, all taken in late October 1950, indicates that—with *One* and *Number 32* mounted in front of and behind him (and *Lavender Mist* hanging nearby)—Pollock enveloped himself in a heady atmosphere of his own creation while working on *Autumn Rhythm.* In order to produce this picture, he is seen to have quickly and expertly flipped, flung, twirled, thrust, and splattered his pigment, manipulating mundane hardware-store materials with a masterful combination of abandon and grace. Namuth's superb shots of Pollock painting *Autumn Rhythm* disclose a man totally immersed in his work, alternately hunching over, leaning sideways, leaping in the air, shifting one foot forward, then the other, crossing his legs, stepping back from and stepping into the canvas. Pollock's facial expressions are equally varied and fascinating; with the aid of Namuth's photographs we can see how, in *Autumn Rhythm,* his physical tracks and his psychic transformations[31] are immortalized in the final work.

After several months of observing and recording Pollock's choreographic process, Namuth became convinced that to properly capture the creative drama unfolding before his eyes, he should switch to moving pictures. Jackson and Lee agreed that he should be allowed to give this a try. Namuth took a position on a platform above Pollock, and with a simple hand-held camera and only natural light, he captured in black and white the pacing (a

*Pollock and Peter Blake with model museum they jointly designed, at Pollock's show at Betty Parsons, 1949*

progression from slow and cautious to fast, fever pitch) and the staging of a Pollock painting. In this case, Jackson began by dripping a vaguely figurative image with black enamel, but this configuration is seen on film to disappear under a blanket of interwoven skeins of multicolored paint.

The tentative success of this exploratory effort led Namuth to a second attempt in color with the addition of Paul Falkenberg as adviser and editor. They moved outdoors to avoid the need for artificial lighting, commandeering a cement platform on the property to act as a stage. The new film begins with a striking shadow sequence in which an earlier painting, *Summertime: Number 9A, 1948* (see pages 203–4)—(the horizontal canvas that Arnold Newman had used as a backdrop for the artist's "moody" portrait in *Life* (see page 11)—is panned over very slowly so that it seems to "float" before the viewer. Pollock is then seen affixing it to the walls of the Parsons Gallery. For the main portion of the film, Namuth came up with a gimmick that enabled him to capture the entire flow of Pollock's revolutionary working method. Instead of looking down on him (which was the vantage point Burckhardt had used), Namuth decided to capture the action from underneath. To make this possible, Pollock was to create a new work on a piece of clear glass attached to a slightly elevated wooden scaffold, and the photographer would lie flat on his back under the glass and shoot.[32] In this way, what Pollock meant by being "in" his painting could be exposed with greater clarity. Pollock agreed, and after a false start (which he wiped out on screen, explaining that he sometimes initially "loses" a painting), he proceeded to create a three-dimensional collage into which he incorporated available materials: beach pebbles, shells, sand, and pieces of colored plastic. Other odds and ends, including agates, marbles, and sections of wire mesh, were also embedded in a layering of skeins of oil and enamel paint.

In his interview with William Wright—which took place soon after—Pollock described the experience of painting on glass as very exciting, lauding the endless possibilities this method suggested for architectural decoration.[33] Most likely as a result of his current friendships with Tony Smith and another architect, Peter Blake, at this point Pollock seemed very interested in such a collaborative effort. In fact, at his last Parsons show, he and Blake had exhibited a model they jointly devised for a museum intended to highlight his own works. Blake later described the impetus for their design as his own belief that Pollock's poured paintings were not merely definitions of space, but actually part and parcel of it. To achieve the effect of suspension in midair, Blake mounted miniature paintings on free-standing panels and lined the model with mirrors.[34]

Although this project was never realized, *Number 29, 1950* (see page 205)—the work that Pollock created in the Namuth film—would soon be displayed along the lines Blake had suggested. Less than two years after the movie's completion and debut at the Museum of Modern Art, Pollock was chosen for a prestigious group show there, "Fifteen Americans," one in an ongoing series organized by curator Dorothy Miller. When the show opened, he discovered that Miller had placed *Number 29* in an open frame in the center of a room. The result of this display was the suggestion of parallels with *The Large Glass*, the famous 1915–23 work by Marcel Duchamp exhibited in this fashion in Philadelphia. Before this exhibition, Pollock had kept *Number 29* outdoors, obsessed with the idea of using it as a framing device for the East Hampton landscape. As Duchamp had refused to repair his glass when it cracked, Pollock had allowed *Number 29* to be altered by the imprint of falling

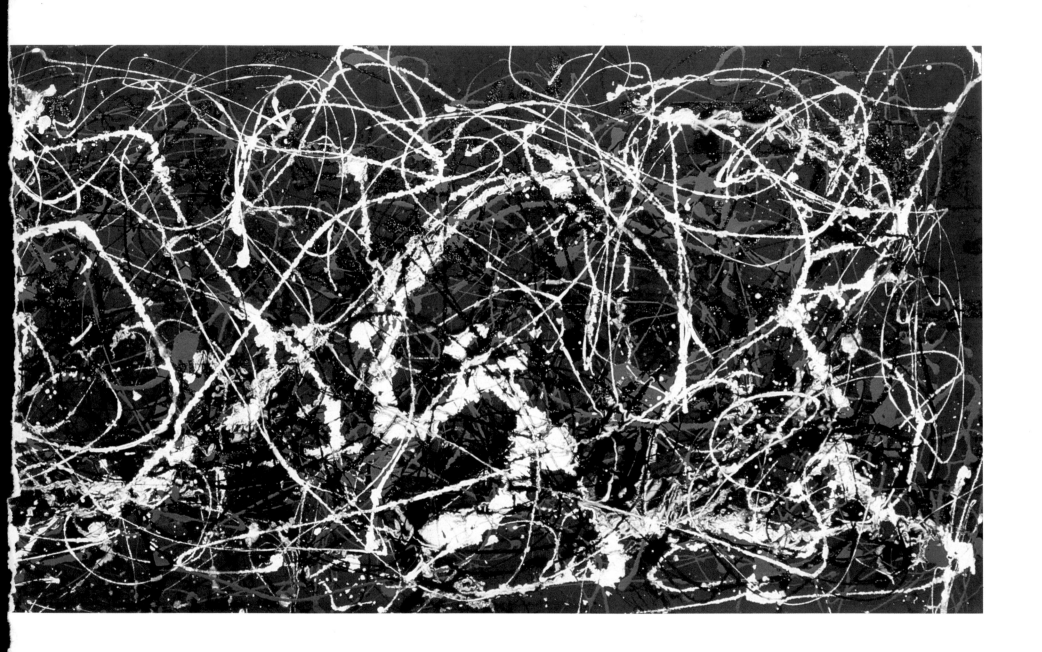

Number 13A, 1948: Arabesque. *1948*

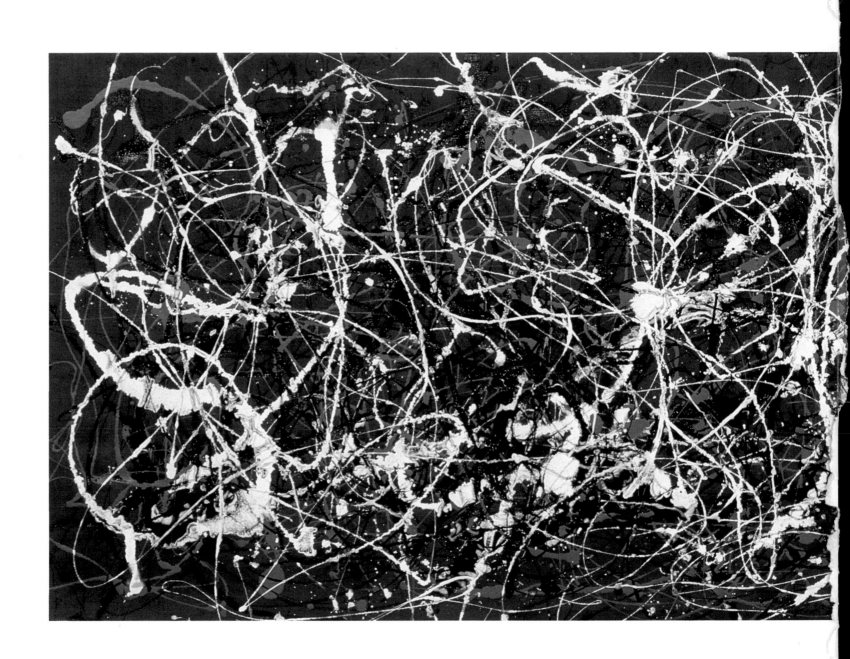

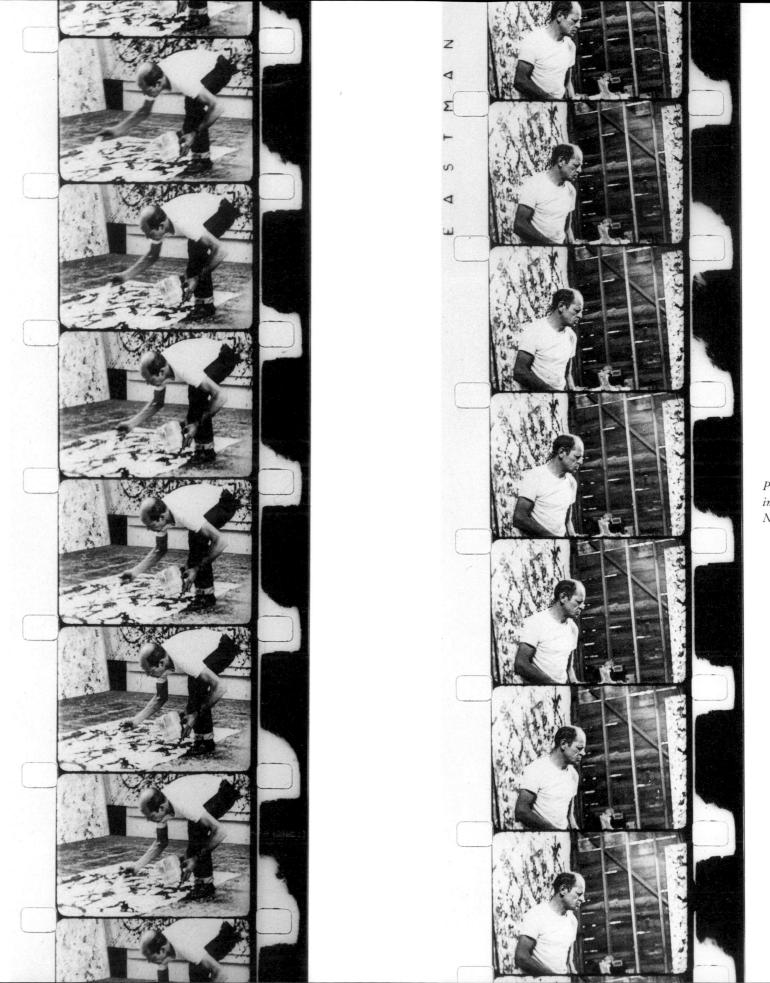

*Pollock painting
in the first Hans
Namuth film, 1950*

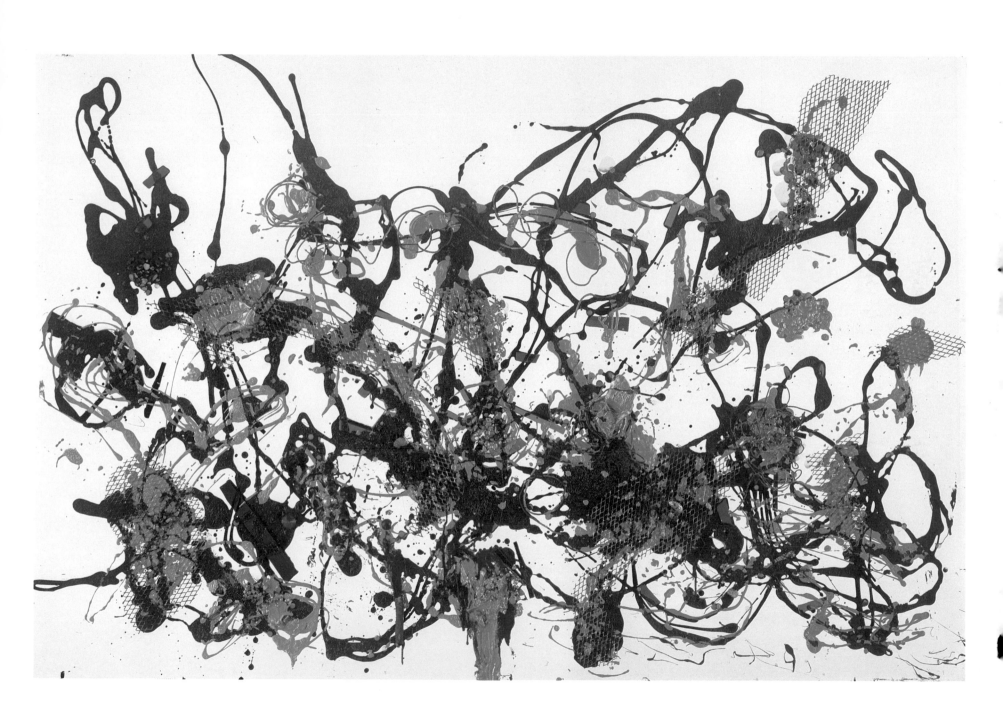

Number 29, 1950. *1950*

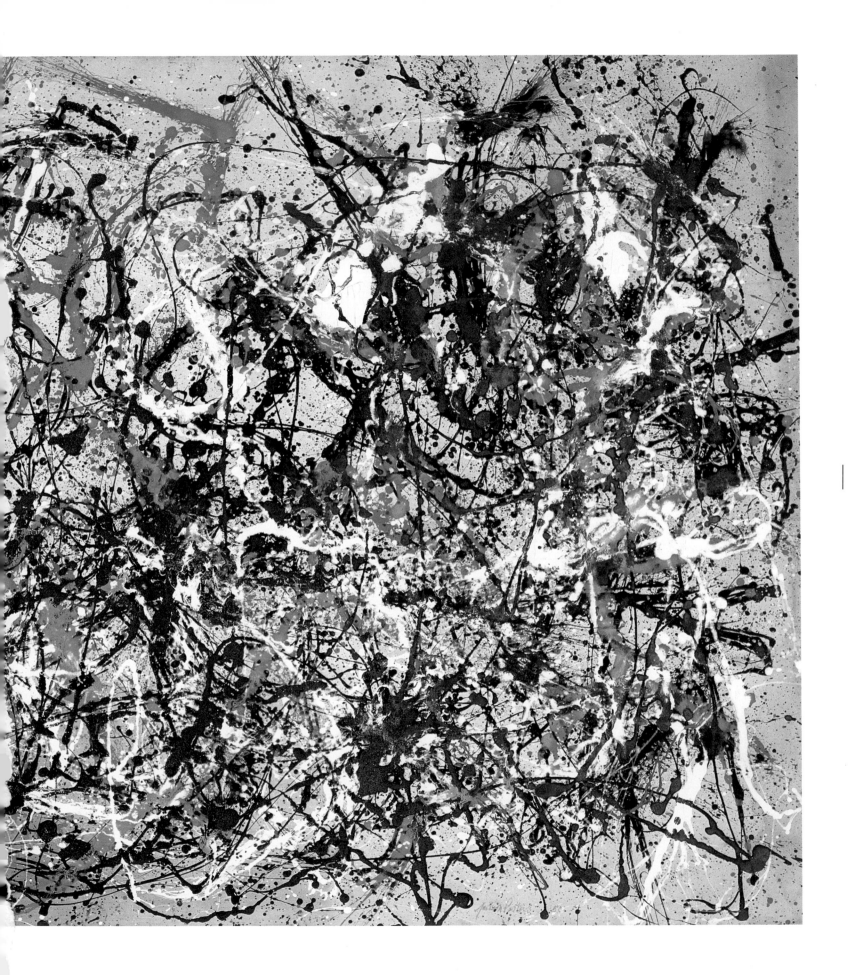

Autumn Rhythm:

Number 30, 1950. *1950*

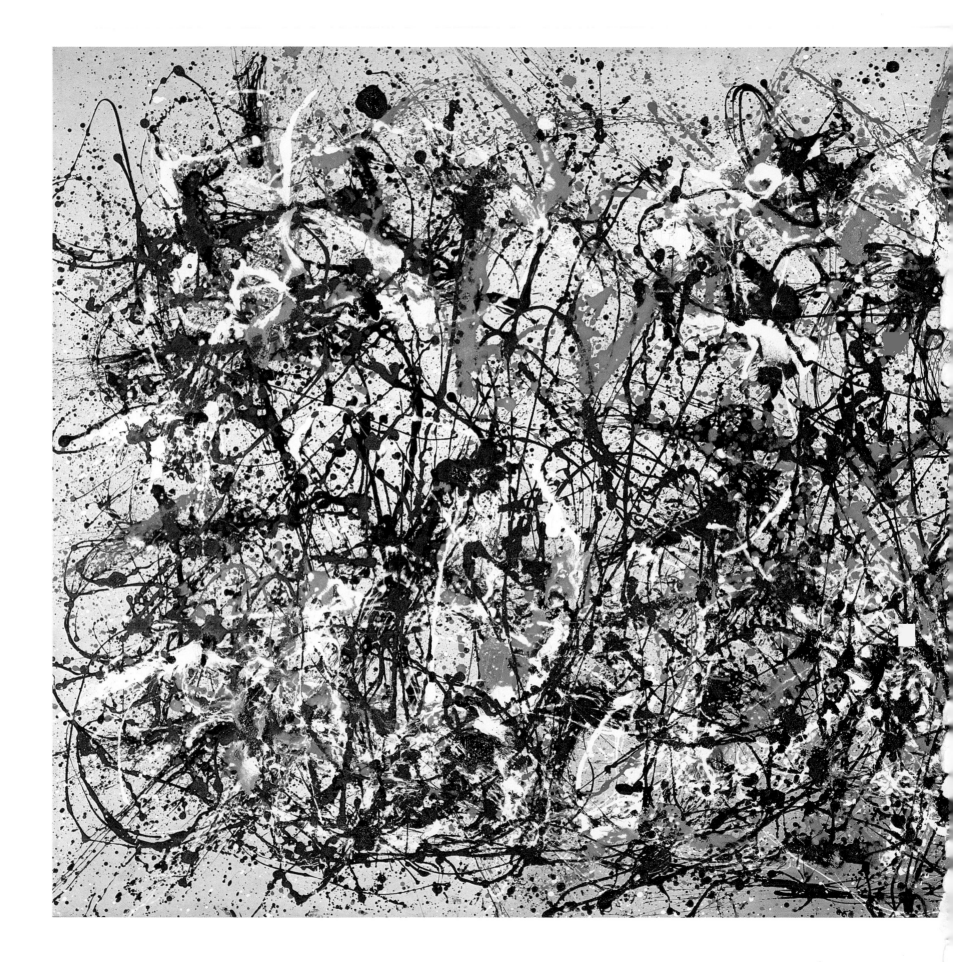

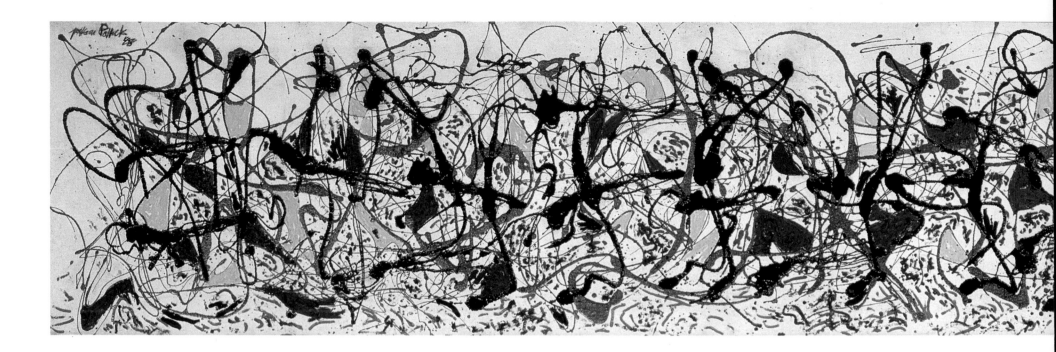

leaves, the salt air, and other phenomena of Long Island weather. For a time he talked about installing the work on his front porch, but he did not do it, and despite his comments to Wright, Pollock never again explored the ramifications of working on a transparent surface.

In his memoir of their collaboration, Hans Namuth relates that it took five or six autumn weekends to complete the second film. By the time it was finished, the character of the season had changed and evidence of the chill can be seen on Jackson's face. Except for the fact that he looks cold in some of the scenes, throughout the movie Pollock appears to be unconcerned by Namuth's camera, but this may not actually have been the case. After it was all over, Pollock admitted to Jeffrey Potter that he agreed with primitive peoples who believe that when a photographer takes your picture he steals your soul.[35] Whether he had felt this way all along (as we know, Pollock harbored many superstitions) is hard to tell, although his initial reluctance to be photographed at all points to the possibility that the idea had bothered him. That this notion may have been quietly gnawing at him is borne out by what happened as soon as the movie was completed. To everyone's shock, Jackson Pollock immediately walked into the house and poured himself a succession of stiff drinks. A few hours later, after having been stone sober for two years, he was so out of control that he overturned the dinner table, in an appalling reprise of many an earlier drunken rage.[36]

About a decade after Pollock's death, the painter James Brooks tried to explain why his friend's creativity had deteriorated so after he made the Namuth film. Jackson, Brooks observed, had worked best when there was no value to his work, when "an impulse would

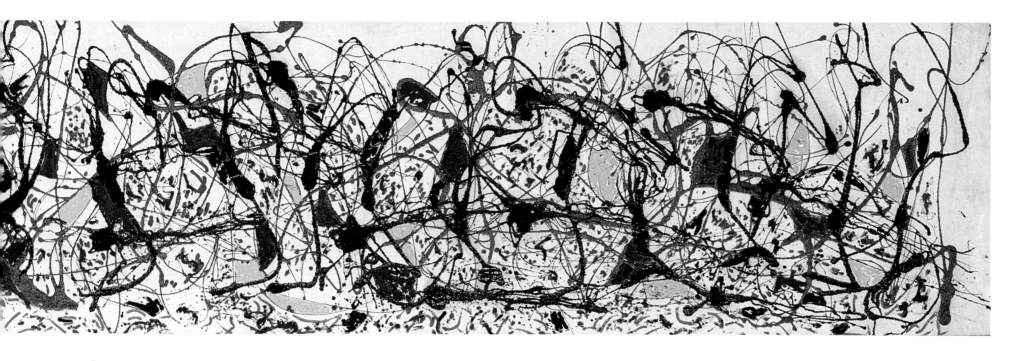

Summertime: Number 9A, 1948. *1948*

go down without any premeditation." When he began to realize that every stroke he made was worth money, or was potentially famous, Brooks saw Pollock become self-conscious and paralyzed.[37] Although he had not been overly pressured into participating, Pollock seems to have felt that doing the film was a big mistake. All his life he had vacillated between extremes of egotism and insecurity. Earlier unprepared to handle the unwanted recognition created by the article in *Life*, by all accounts he was terrified that the film would further erode his privacy. Perhaps the greatest paradox of Jackson Pollock's complicated personality is the fact that countermanding his innate passivity was an inordinate ambition. With his wife's encouragement, despite his often precarious mental health, Pollock had been actively seeking serious acclaim for the better part of his adult life. What neither he nor Krasner seems to have realized is that once it was achieved, he would not be able to deal with it. Even though he had the talent and she had the drive, Pollock's vulnerability was too deep for them ever to be able to enjoy his success.

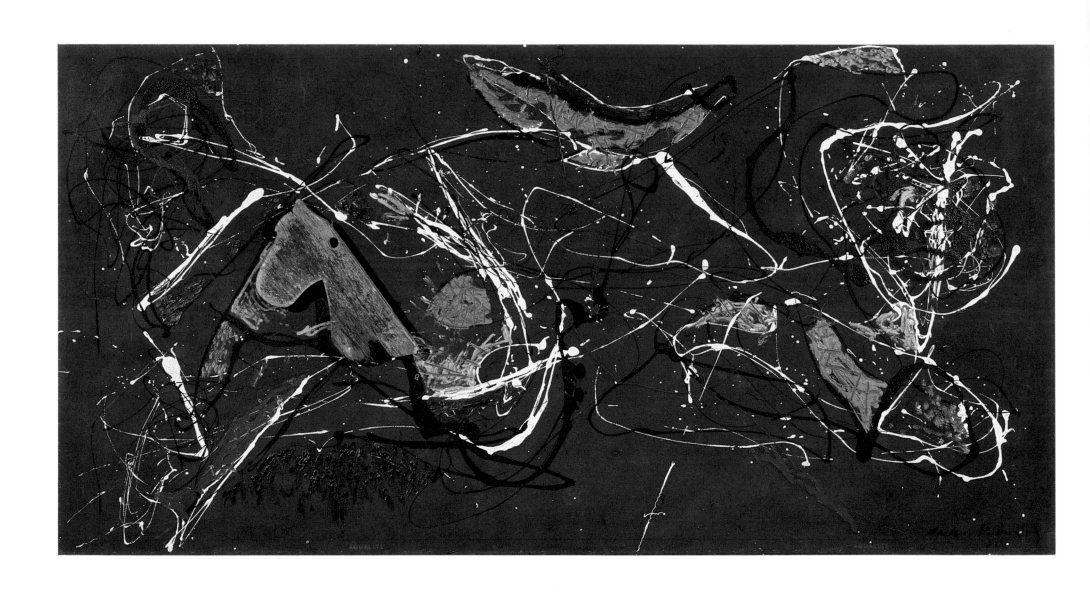

The Wooden Horse. *1948*

# "The Dying of the Light"

The man who deals with originality is desperately
needed, but seldom wanted. For along with his
promise of victory he lets loose the shadows of chaos.
—David Hare on Jackson Pollock

*Cecil Beaton. "The New Soft Look." 1951.
Photographed against a background of Pollock's show at
Betty Parsons*

In March of 1951, two years after the initial glare of *Life*'s spotlight on Pollock, his newest and most advanced paintings were to receive similar widespread exposure, this time in an even more atypical context. Except for a few of Namuth's photos, which had appeared in a very specialized journal, *Portfolio*, none of Pollock's classic works had been published when the editors of *Vogue*, the popular fashion magazine, chose to feature his recent show at Betty Parsons as a backdrop for the latest evening wear. Through the lens of chic photographer Cecil Beaton, whose dispassionate, brilliantly posed shots created a stunning conjunction of high and low art, Pollock's "dazzling and curious" environmental paintings were introduced to the American public as icons of glamour and taste.[1]

In today's art world, the instant status conferred by Beaton's choice of Pollock for the sleek pages of *Vogue* would automatically ensure collector interest, but Alfonso Ossorio's purchase of *Lavender Mist* was the only sale Parsons made, with the result that Pollock collapsed into a state of indecision about continuing in what by now had become known as his signature style. Just before the *Vogue* spread appeared, Pollock wrote to Ossorio (who had become his main confidant) that after his show closed he had "really hit an all-time low—with depression and drinking." He added, "NYC is brutal" (he was temporarily in residence with Krasner at Ossorio's Manhattan townhouse) and by May, he and Lee decided to return home. The next month Pollock sent more optimistic news: he had at last returned to work but with a surprising redirection. "I've had a period of drawing on canvas in black," he explained to Ossorio and his friend Ted Dragon, who were in Paris, "with some of my early images coming through." He added prophetically, "think the non-objectivists will find them disturbing—and the kids who think it simple to splash a Pollock out."[2]

Actually, even before his classic works, Pollock had been experimenting with reintroducing some form of figuration into his increasingly abstract style. In 1948, the year of such totally nonrepresentational paintings as *Number 1A*, Pollock also created several poured compositions in which he alluded to recognizable imagery. We might cite, for example, *Summertime*, a work which became known (as *Number 9A, 1948*) not only because of its

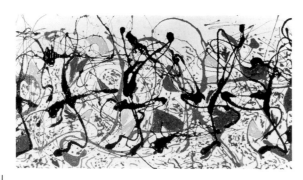

Summertime *(detail). 1948.*

visibility behind the cocky-looking artist in Newman's *Life* photograph but also because of its featured appearance in Namuth's color film. In *Summertime*, an 18′ 2″-wide frieze, Pollock had decided to fill in some of the enclosed spaces created by the crossing of his poured black and gray skeins. Because these opaque areas—either yellow, blue, red, or ocher—are silhouetted against an open light ground, they read as positive, although nonspecific, shapes, and their measured disposition across the wide expanse of the canvas charts a direction for the eye to follow. Pollock created similar effects in another numbered work of the same year that, by 1955, when it was dramatically hung on the ceiling of the Sidney Janis Gallery, acquired the name *White Cockatoo*. In this dense, more nervously drawn composition, his placement of bounded forms was less balanced; a prominent white shape in the center looks exactly like the suggested bird. This probably unintended, but interesting effect may have prompted a more purposeful animal reference in a related work. After rescuing a weatherbeaten head of a toy hobbyhorse during renovation in his friend John Little's house, Pollock glued the three-dimensional object onto a similar, although sketchier design.

In the later forties, Jackson Pollock also made a few tentative attempts to describe forms directly with dripping paint, but the results, as seen for example in *Triad* of 1948, were clumsy and repetitious. He knew he had to find a way to make a more radical break, and what he came up with was the idea to cut away, instead of adding, in order to create a figured area. Realizing that he could set up a situation where negative space would be made to serve a figurative function, Pollock first tried out this method in several small paper collages made with oil paint. After excising figure-shaped forms with a knife or scissors, he mounted the remainder of the sheet onto canvas or masonite. Sometimes he also made a companion version where he redeployed the leftover "paper dolls" as positive figural elements.

The following autumn Pollock made his only attempt to integrate this concept into a larger context. Evelyn Segal, a visitor to his studio on September 25, 1949, noted in her journal that she saw there an unusual work in which simple nonnatural forms had been cut into a masonite panel. These were definitely recessed, having been gouged out as if the surface were a huge linoleum block. Segal observed that, although Pollock continued the paint sparingly onto the recessed parts, he left the backing mostly empty to provide another color and texture. She was certainly referring to *Number 7, 1949*, a work exhibited at Janis six years later as *Out of the Web* (see page 212).[3] A view of his studio shot a few months prior to Segal's visit shows that Pollock's original intention with this work had been more conventional. In this picture *Number 7* is seen propped against the barn wall, seemingly finished, with its intricate surface intact. The extreme thickness of the work, which was comprised of a more than typical number of layers, seems to have made Pollock doubtful of its success. He may have concluded that the only remedy for saving the work might be to apply the technique of the cut-out collages.

Only vaguely biomorphic, the absent areas in *Out of the Web* do not represent human beings as clearly as they did in the small works on paper. That at least one was intended as a dancing figure is suggested by the fact that Pollock glued its remnant onto a piece of wood, attached strings to it and gave it to John Bernard Myers for use as a puppet.[4] Another difference from the smaller cut-out works is that there is no intervening layer in *Out of the Web*; Pollock scraped and then extracted sections of pigment directly from the masonite—a

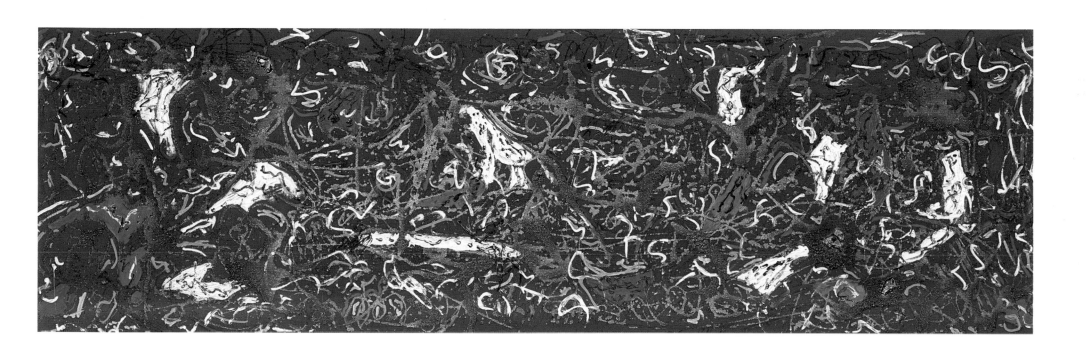

White Cockatoo: Number 24A, 1948. *1948*

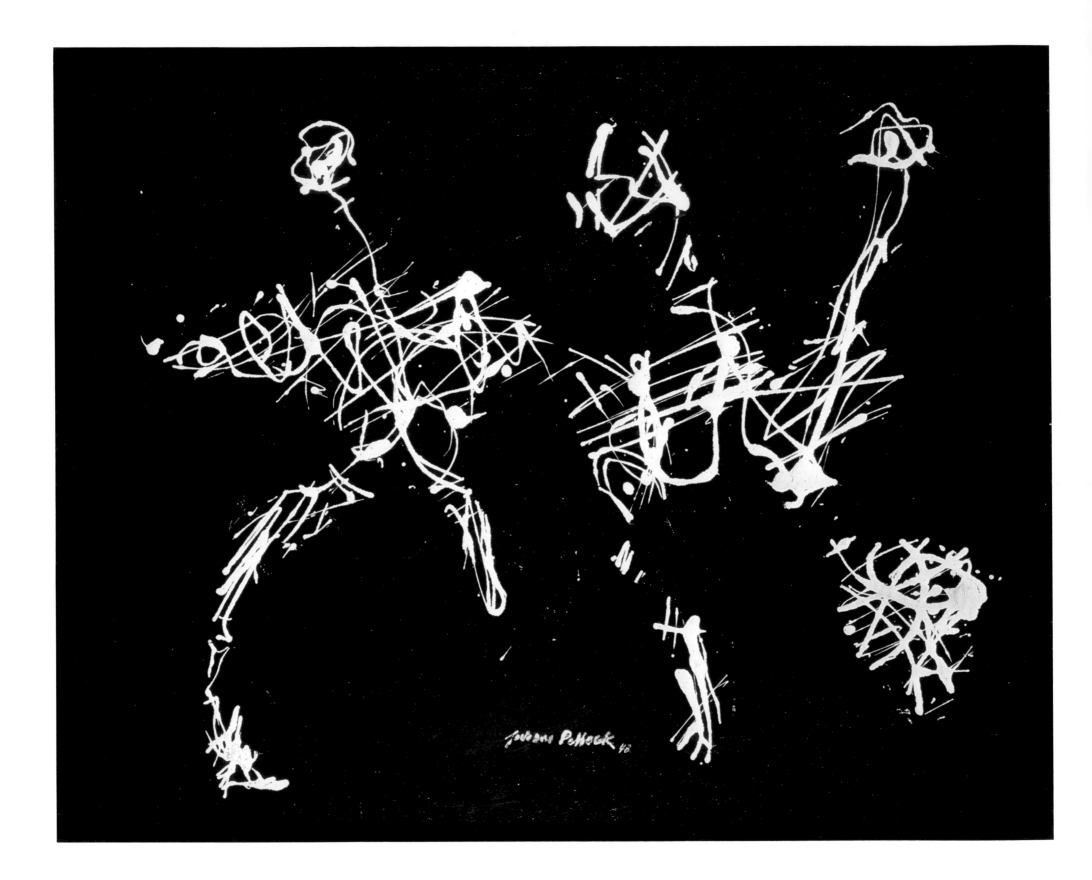

Triad. *1948*

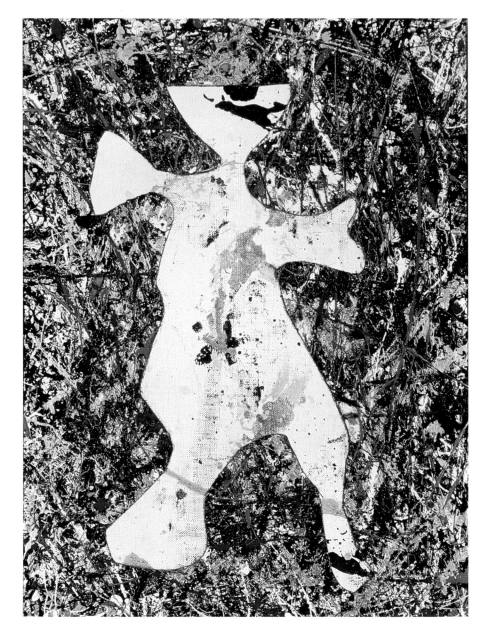

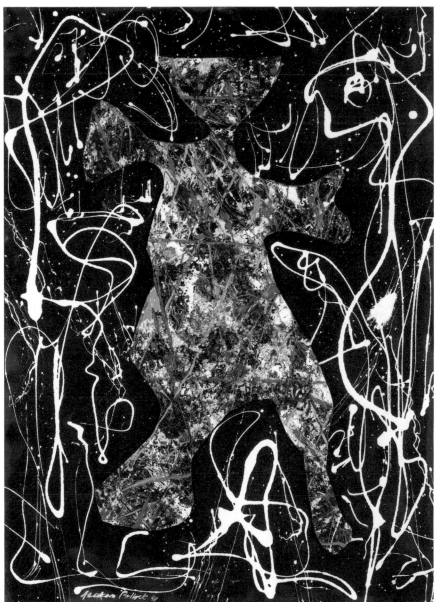

Cut Out. *c. 1948–50*　　　　　　　　　　　　Cut Out Figure. *1948*

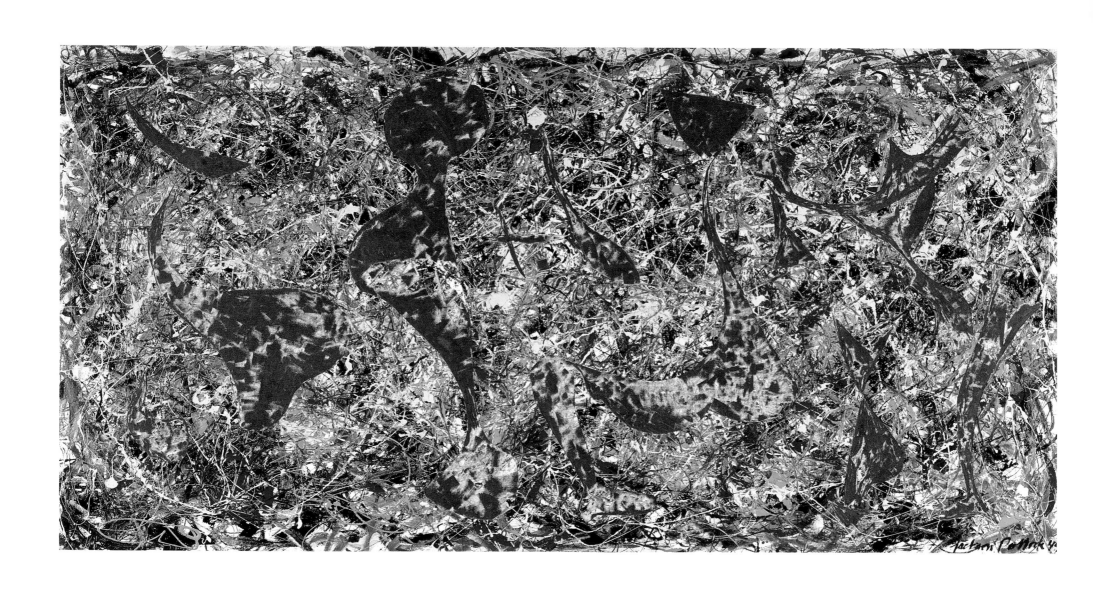

Out of the Web: Number 7, 1949. *1949*

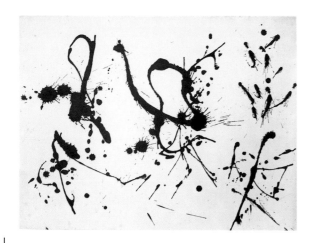

Untitled. *c. 1950*

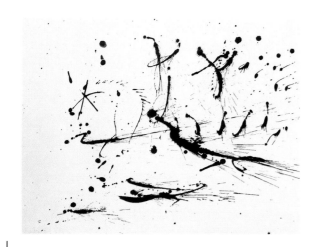

Untitled. *c. 1950*

Untitled. *1950*

reversal of his method and intentions in many of the earlier works, where he began with imagery he would later expunge. Here the shapes only implied in previous pourings are "unveiled," their mystery heightened as the result of this unexpected exposure.

As we have already seen, in 1956, not long before his death, Jackson Pollock made the bold and rather curiously inaccurate contention that, as an artist, he was "very representational some of the time, and a little all of the time," seemingly ignoring the fact that, with only these sporadic attempts at figuration, his paintings between mid-1947 and early 1951 had been overwhelmingly abstract. Since drawing had been the primary medium he used to explore the images recessed in his psyche, it is interesting to note that during the period when he was most consistently sober, he did very few works on paper. Only five very slight and marginally imagistic drawings can be firmly assigned to 1948–49. From the following year, about a dozen small ink and paper sketches exist, but all are nonobjective. In 1950, Pollock also executed a few paper panels in enamel, colored crayon, or gouache—also abstract—and he did nothing at all in pencil. The only explanation for this is that Pollock's calligraphic urge must have been completely satisfied by his large-scale manipulation of the flow of paint; in his newly temperate condition, he felt no urge to add anything psychological or otherwise realistic.

The June 1951 letter addressed to Ossorio and Dragon in Paris indicates that less than a year after *Autumn Rhythm*, Pollock—upset about his lack of sales and clearly apprehensive about the descent into a mere habit that he feared was inherent in the poured style—had totally changed his mind. Triggered by his return to drinking, he seems to have urgently felt the need to expose again his former compulsive imagery, although he is said to have admitted that he really did not know exactly where this imagery was coming from.[5]

Many identical motifs immediately reappeared—eyes, totems, guardians, and the like—but it would not be possible to mistake Pollock's "representational" works beginning in 1951 for those he had done before the allover paintings. Most obviously different was his unilateral rejection of color in these new canvases. Similar to *Number 32* of 1950, these new works were conceived more like drawings and created with a palette limited to drastically thinned down black (or occasionally brown) Duco, Devoe & Raynolds, or Devoelac industrial paint. To provide a support for them, Pollock unrolled huge bolts of the cotton duck used for ships and upholstery onto his studio floor. Some he sized first with Rivet glue; others were not sealed until after they were completed. All were left unprimed so that the tightly woven material would absorb the viscid paint.[6]

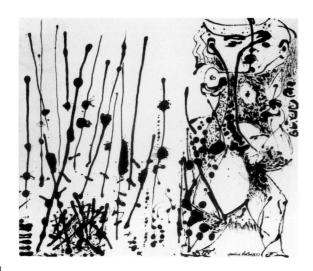

Number 7, 1951. *1951*

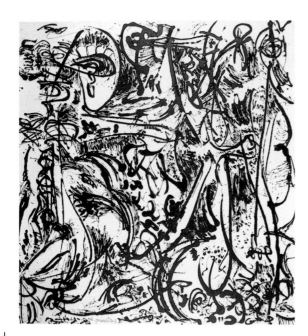

Echo: Number 25, 1951. *1951*

Treating his surface in the manner of an Oriental scroll painter, Pollock developed on each available twenty-foot section (the barn was only two feet wider) a continuous cycle of quasi-figurative forms situated either next to each other or above and below. Only small spaces were left in between. Pollock continued to work on these by moving all around the flat canvas, applying his pigment with the same dried brushes and sticks, or else he used turkey basters, filling them with liquid as if they were fountain pens. A markedly increased use of the baster (which had already been employed in some of the poured paintings) is responsible for a different emphasis in these works, on puddled and blotted effects, rather than on looping lines that sit on the surface. When his soaked-in paint blurred along the edge, Pollock made no attempt to eradicate the stains.

Although Pollock (with Krasner's help) spent long hours deciding how to group and crop these pictures, there is no evidence that he made any direct revisions in these all-black poured works. His process was as totally automatic as it had been in his allover abstractions, and he therefore did not perceive these pictures as constituting a true break or disruption in his development. But when they were first shown, the critics were not able to evaluate the black pourings from this vantage point and there was almost universal dismay. Many friends and colleagues were also shocked that he had reintroduced subject matter, and Pollock found himself having to justify these works with the explanation that he had found it necessary to take the image and break it up, but he now had an equally strong need to put it back together again.

Even if they were created with more limited means than he had used in his previous imagistic works, Pollock's black poured paintings are equally complex; they are also a good deal more horrifying, foreboding and tough. Many old unresolved psychological issues resurfaced when he went back to drinking, and the prevailing negative mood of these paintings proves that numerous aspects of his inner life remained at odds. An indication of the stubborn intransigence of certain of his problems is Krasner's recollection that Jackson would sometimes complain during this period that a vision of his mother came over him so strongly that it was impossible for him to work.[7]

Another of Pollock's continuing hangups, his neurotic compulsion to be perceived as *the* best, no doubt provided an additional impetus for the black poured paintings. By 1950, Picasso was no longer his primary competition—as Bruno Alfieri, a European critic had recently written, Jackson Pollock's poured paintings had rendered "poor" Picasso "a painter of the past."[8] Pollock believed that his foremost rival now was Willem de Kooning, another artist who had achieved his first real notice after inclusion in Graham's McMillen show. In fact, ever since that time, the rise of their reputations had been inextricably linked. It apparently exhilarated Jackson when drunk to denounce his friend de Kooning as nothing but a "French" painter (Pollock meant this as a negative comment on de Kooning's facture and style); deep down, however, he respected de Kooning and was worried about his growing popularity.[9]

In the late forties and early fifties, Willem de Kooning still lived year-round in downtown Manhattan. A much more accessible personality than Pollock, de Kooning, who was married to a younger artist, made himself available to advise others of the "second generation," many of whom began to emulate his smear and spatter style. Pollock was also admired by younger Abstract Expressionists, but not only did he live far away, his passive/

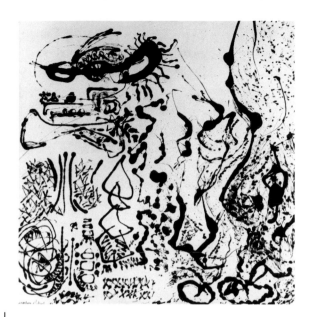

Number 5, 1951: "Elegant Lady." *1951*

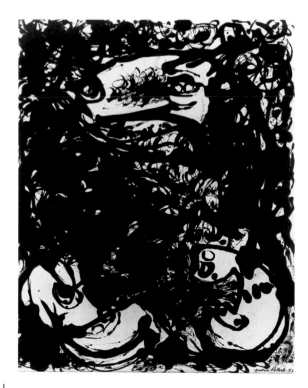

Number 23, 1951: "Frogman." *1951*

aggressive manner was difficult to deal with, and his works were judged *too* original—he could only be copied and no one wanted to do that. Although Greenberg did not like de Kooning and would remain Pollock's champion at least until 1953, by 1950 Rosenberg and Hess had begun to defect toward de Kooning's camp, a situation that exacerbated Pollock's competitiveness.

Since de Kooning had recently abandoned abstraction for a recognizable, although savagely distorted figural style, one of Pollock's goals may very well have been a duplication of this accomplishment, but in terms that would outdistance his rival. Pollock's new avoidance of color could have been stimulated by de Kooning also, as for both practical and aesthetic reasons, between 1947 and 1951, Bill had mostly worked in black and white. Although no longer close to him, Pollock surely knew about Motherwell's recently successful all black-and-white show at the Kootz Gallery (a show which also stimulated Franz Kline). His own new work differed, however, from all of these in that Pollock decided to employ black paint alone, with the warm tan of his unprimed canvas the only light value admitted. The fact that none of the others was producing works with a similarly morbid quality of self-awareness is another reminder that, even when he incorporated an outside impetus, Pollock's work continued to follow its own inner course.[10]

Since photographic documentation proves that the major black poured works of 1951–52 were created in serial fashion, it might be logical to conjecture that Jackson Pollock had a story or sequence in mind when making them, but there is no visual or oral evidence to support this supposition. The earliest specifically figurative black pouring, *Number 3, 1951*, is a vertical canvas on which Pollock drew a rough approximation of the human anatomy similar to what he had done in white on *Triad*. After Pollock's death, *Number 3* would acquire the more explicit title *Image of Man*. Actually, with one important (and very late) exception, Pollock continued to give his black poured paintings numerical designations only, although some of the others also were given other names by which they have generally become known. For example, in 1955, Pollock traded two works from 1951 to the art dealer Martha Jackson in exchange for a late-model Oldsmobile coupe (he had cracked up his Cadillac). These two black poured paintings, *Number 5* and *Number 23*, received new titles from their new owner. It is not difficult to see why Martha Jackson renamed *Number 5* "*Elegant Lady*"; prominent in its otherwise loosely articulated composition are the flirty eyelashes from *Male and Female*. Her choice of "*Frogman*" for *Number 23* is more abstruse; if anything is readable at all in this extremely dense work, it is that the composition is a heavily overscribbled version of *Bird*.

"*Elegant Lady*" and "*Frogman*" are good examples of how, in many of the black pourings, Pollock essentially created more gestural reworkings of identifiable configurations from the past. In an extremely careful study of these works, O'Connor has deciphered and classified these former relationships,[11] pointing out that the fact that so many of Pollock's new details and effects go all the way back to the thirties is indicative of another period of erosion of confidence. All too familiar are recurrences from his Orozco period, especially disembodied eyes and dismembered human limbs, the detritus of ritual violence. O'Connor compared *Number 18* and *Number 22*, both disturbingly rendered seated females done in this style in 1951, to de Kooning's contemporaneous series of vicious, predatory women.[12] Of course, Pollock's phantasmagorical reformulation of the photograph of his family (page 110) provides an internal precedent, as does his squatting c. 1943 girl about to stab herself with a knife.

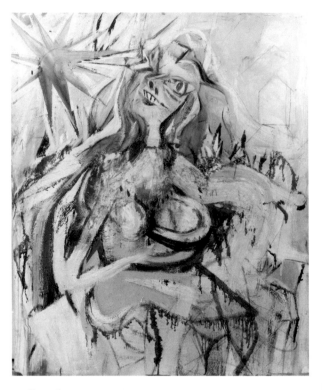

*Willem de Kooning.* Woman. *1948*

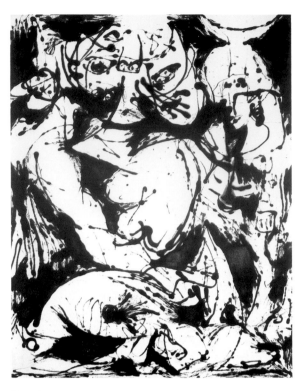

Number 22, 1951. *1951*

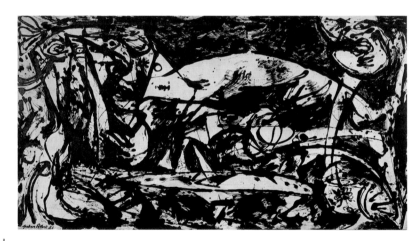

Number 14, 1951. *1951*

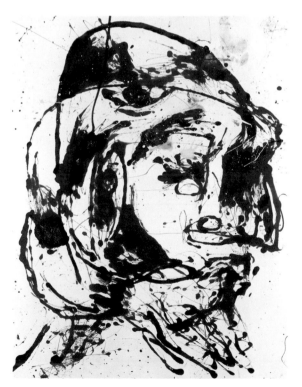

Number 7, 1952. *1952*

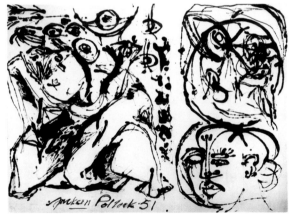

Number 27, 1951. *1951*

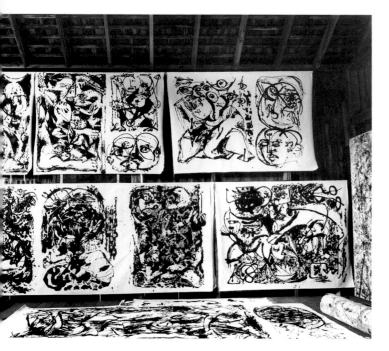

*Black and white paintings pinned on Pollock's barn wall, 1951*

Although 1951 was the key year for his most psychologically charged black pourings (constituting twenty-nine out of thirty-three canvases), Jackson Pollock continued to do similar works as late as 1953, his last productive year as a painter, and an examination of the run of the series shows that the human head was his most persistent image. Pollock, who by his own admission did not like people, had never before been particularly interested in portraiture, and he had done less than a dozen in his work so far. Of his works on paper, only a partial self-image in the first post-Benton sketchbook, two heads of unidentified young women made c. 1937–38, and an unknown girl in braids, also sketched in the thirties, exist. Although a number of his automatic drawings of the following decade incorporate small Picassoid heads, as far as single-head compositions are concerned, there are just two: his "self-portrait" entwined with a serpent, and his most realistic version of the the moon woman, both drawn during his analysis with Violet de Laszlo. Among finished paintings in which he focused on the human face, all we can find are his dreary and ominous Ryderesque self-visage done at the very beginning of his career; *Orange Head* and *Mask*, Synthetic Cubist experiments of the late thirties; and his anguished Minotaur of around the same time.

We already know that, taking various malevolent guises, probably including the persona of *The She-Wolf*, his mother's image had a definite impact on a number of Pollock's works. On the surface, he does not, however, seem to have extended this negative anima fixation onto the other most important woman in his life. In fact, with the exception of *Male and Female* and possibly a 1946 painting, *The Child Proceeds*,[13] before 1951 he does not seem to have wanted— or needed—to portray Lee Krasner at all. It is surely meaningful that now, with the advent of strain in their marriage, Krasner finally appeared in the bottom right corner of a large black pouring. She is easily identifiable as the woman in the lower portion of *Number 27, 1951* because Pollock emphasized her very distinctive pointed nose and rather unattractive full lips. To her left he placed a larger image that also appears human, but its sex and meaning are not clear, although a probable clue to its identity is provided by the horizontal crescent and the marginalia (conjunctions of backward C-shapes and crisscrossed lines), which can also be found in *The Moon-Woman* of 1942. Another more rapidly sketched face with dislocated lips and eyes is seen above Krasner's, but it is too jumbled to decipher any further. In a photograph of Pollock's studio taken by Namuth the year it was painted, *Number 27* can be seen as one of an assortment of paintings pinned on the barn wall for study. Next to it is a similar composition, but with a different, less specific head in the same position on the lower right. It is interesting to note that Pollock later cut up this second canvas, creating three totally separate works out of it. By contrast, and suggesting a definite thematic interrelationship, he kept intact the singular elements that constitute *Number 27*.

One more time, in 1953, Pollock would repeat a similar stream-of-consciousness grouping, once again featuring a face placed to the right of a more fluidly drawn narrative. In this larger painting he effectively reprised the imagery and style of *Number 27*, but with a few very important changes. The first change is technical: this work, *Portrait and a Dream* (the only one of this series he titled) was painted in oil, not enamel, and it included color. The second difference is formal: the size of the head has been magnified, eliminating the need for a third element above. The third change is psychological. The face is not Krasner's, but there is no uncertainty as to its identification. When asked who it was, Pollock told Elizabeth Wright

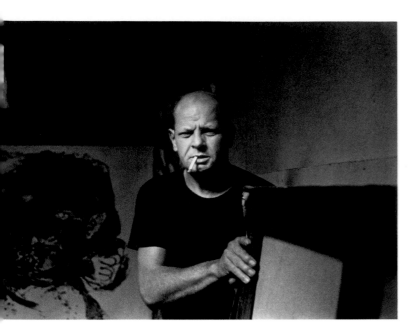

*Pollock with* Portrait and a Dream, *August 1953*

Hubbard's husband, "That's a portrait of me, can't you see it?" Hubbard recalled that Jackson described it even more specifically to her as a representation of himself when he was "not sober."[14]

To create this, his last self-portrait, Pollock obviously drew the outlines of the face in black first, applying at a second stage the thickly brushed areas of dark gray, as well as the more thinly painted sections of orange, gold, and pink. Although Pollock's features are partially obscured by the overlaid color, it is obvious that his ostensibly calm expression masks an inner malaise. In fact, his vaguely demented stoicism is strongly reminiscent of the expression of the large face in the drawing where Pollock portrayed his head being choked by a snake (page 79).

The tense feeling of containment on the "portrait" side of the 1953 canvas contrasts with his more expressionistically conceived "dream." To the left side of the face, Pollock now depicted several figures engaged in a savage and distinctly erotic confrontation, explaining to Krasner that this part of the picture was meant to reprise the dark side of the moon. Obvious proof of another transferral from *Number 27* is the upturned crescent that reappears grafted onto the moon woman's blackened face. In light of the formal and thematic connections to his earlier paintings and drawings of the moon woman, as well as to the 1951 image of Krasner, Pollock's newest conjunction of his most persistent obsession with the current state of his ego is quite suggestive. It raises the possibility that the narrative side of *Portrait and a Dream* may have been an outlet for Pollock to express his increasing resentment toward his wife's continued control. It also posits the likelihood that, all along, it was she who was the moon woman, both his crony and his nemesis.

At the same time as he was executing his semirealistic large-scale hybrid drawing/paintings, Pollock continued to practice a totally abstract form of notation in a more modest format (see pages 220–21). Paralleling his conversion to raw, unprimed canvas, by 1951 he was also looking for smaller, more absorbent supports to draw on. Introduced to pads of Japanese rice paper by Tony Smith, he found his answer: an adaptation of their blotter-like surfaces to his staining effects. Typically Pollock worked on the top sheet of the pad without separating it from the rest. Quickly spreading and spotting either India ink or enamel, he created marks that stained not only the sheet he was working on, but also soaked through onto numerous sheets below. At other times he detached several pages, placing one on top of another to create a more limited set. Following in the same vein as the Surrealists, who had invented or utilized decalcomania and *frottage*, Pollock obviously intended to allow the unexpected forms that appeared on the papers below to stimulate his imagination. He played with these "shadow" images to help him create entirely new compositions, often reorienting the pages or turning them over to the back before retouching or adding new marks.[15]

During the fall of 1951, at her husband's request, Lee Krasner was given an exhibition of her own at Betty Parsons. Actually she participated in a two-person presentation shared with another woman artist, Anne Ryan. Krasner showed rather atypical color-field works, and Ryan showed collages made on special backings fabricated for her by a man named Douglass Howell. Neither Pollock nor Krasner had previously been aware of Howell, although he too had a studio on Long Island, where he made his original "papers" with no glue, sizing, chemicals, or drying agents. Employing only table damask, huck towels, and other linens, and using special molds, Howell wove these fine materials into thick slubbed sheets. When they

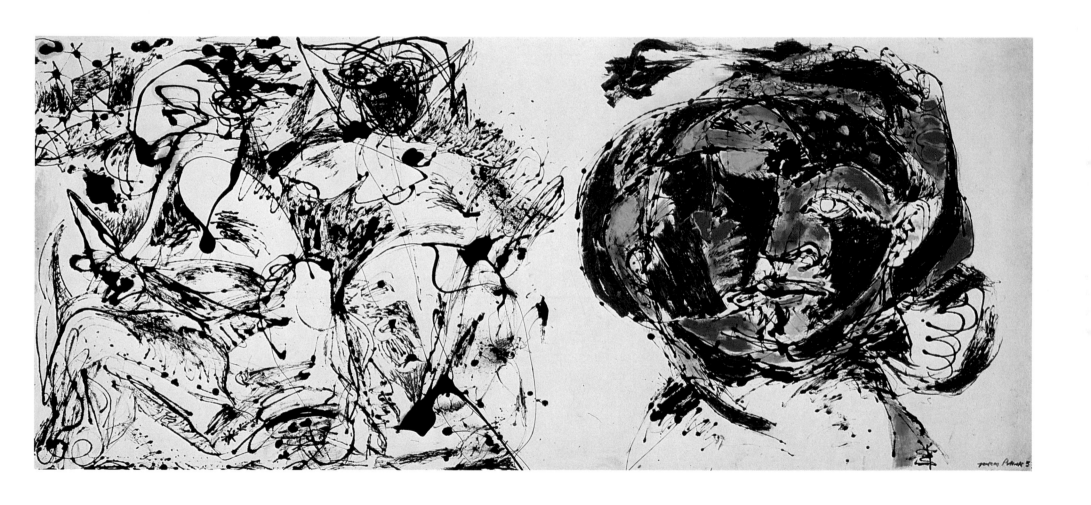

Portrait and a Dream. *1953*

Number 3, 1951. *1951*

Untitled *(on Howell paper). c. 1952–56*

first saw Ryan's works, Pollock and Krasner were so impressed with these unusual surfaces that they paid an impromptu visit to Howell in Westbury to purchase hand-made sheets for their own use.[16] On his Howell papers, Pollock used brush, pen, and pouring techniques, sometimes combining several at one time. Most of Pollock's Howell-backed compositions are considerably more complicated and suggestive than his rice-pad works. Perhaps inspired by the irregularities of the paper, he was able to recreate on a smaller scale more of the agitated, compulsive quality of the black poured paintings. Although faces and reclining figures can be discerned in some, he did not, however, always duplicate the imagistic focus of the larger works.

By mid-1952, when he left Parsons for the Janis Gallery (just across the hall) Pollock was once again a desperate man due to his inability to arrest the resurgence of his earlier self-destructive patterns. A physical and emotional heaviness had begun to alter his appearance as well as his personality, undoing what was left of his former charisma. Tense, confused, and in despair over his steadily encroaching loss of both purpose and efficiency, Pollock was willing to try any prospect of a cure at this time—he even drank "total well-being" protein emulsions formulated by a trendy Manhattan biochemist—but nothing made any difference.[17] In a frightening regression to the loose moorings of his youth, at home on Long Island he was often sighted driving around aimlessly in search of not even he knew what.[18]

It had been less than two years before, when Pollock had still been on a more even keel, that he and Krasner were featured in *The New Yorker*'s "Talk of the Town" column. It was at that time, in the late summer of 1950, that Pollock explained to Berton Roueché that they had moved out to Long Island because he had had "some wonderful notices," and this had developed in him "an underneath confidence" that he and his wife would finally be able to live on the sales of his work. Krasner had chimed in that more collectors *were* beginning to "nibble" at his paintings. "Be nice if it lasts," was Pollock's typically laconic reply.

However, during the entire period he was with Betty Parsons, if they had not been receiving regular handouts from wealthier friends, Pollock and Krasner would have been worse off financially than they had been during the depression. As late as 1954, in the midst of a national economic boom, their situation was still so bad that Pollock unsuccessfully begged Ossorio, who had already given them free access to his city pied-à-terre, to let them live also at his East Hampton estate. Once Pollock made the switch to Janis, sales did begin to pick up, but it is certainly ironic that he never really made any serious money until the last, most unproductive and unstable year of his life.[19] It is fascinating that the severity of his final descent into alcoholism and depression did not stop him from flaunting his new prosperity.

When Pollock moved to Janis, it was agreed that he should continue his recent practice of presenting new work every November. His first show there—mostly black pourings—was voted by *Art News* magazine the second best one-man exhibition of 1952; some critics were becoming more used to his change of focus. But, even after Greenberg crowned him "the best painter of a whole generation,"[20] Pollock was not sufficiently sure of his current abilities to produce enough for another show until February of 1954, and then he only had ten exhibitable works. His output was so sparse by the following year that his wife and dealer talked him into a retrospective. Since Pollock hated the definitiveness implied in the act of signing and dating his pictures (which he always put off as long as possible), the finality suggested by a retrospective must have been absolutely terrifying in his psychological state of near paralysis.

Untitled. *c. 1951*

*Pollock with* Color Totem *by Lee Krasner, 1955*

*Abner Dean.* An "action" critic confronts "Action Painting." New York Times Magazine, *October 28, 1962*

Dangerously low in self-esteem by the winter of 1955, with most of his former fans (including Greenberg) now considering his work passé, Pollock was actually light years away from the "champ" *Time*'s review portrayed.

His indecisiveness about the direction he wanted to pursue was certainly Pollock's major problem. Working mostly in the stained black semifigurative mode, before moving to Janis in 1952, he had also turned back in a halfhearted way to larger-scale abstraction. Described by one reviewer as "heaped high and churned up,"[21] several medium-sized paintings completed late the previous year had featured an allover organization with the reintroduction of color, but they had an obviously tentative, unorganized air, and Pollock could not move beyond this tortured surface even when he tried a larger format. On the 7′9½″-x-13′ surface of *Number 10, 1952*, also known as *Convergence* (see pages 225–26), he started out to do a big black poured composition, but then added on top of the mess he had made a swirl of thick and thin trickles of white, bright yellow, red, and blue. Dripped with a heavy, rather unsteady hand, these colored trails were carelessly allowed to fuse, smear, and spread. There is almost no visual coherence between the various layers of pigment, and the gaiety of the colors seems forced, a last resort to rescue an unsatisfactory painting.

In another oversized canvas done soon after, Pollock was able to save himself from the mistakes of *Convergence*. His old teacher Thomas Hart Benton was later to remark that only someone who had studied in his classes could have come up with Jack's solution for salvaging *Number 11, 1952*: eight monumental verticals which energize the field with their presence, creating dynamic order out of chaos.[22] Retitled *Blue Poles* (see pages 227–28) after the color and shape of these accents, *Number 11*, has since become one of Pollock's most famous works, in large part due to the price of two million dollars paid for it by the Australian government in 1972. (Since that time, this record has been topped many times over.) But its cost is not the only reason for the prominence of *Blue Poles*. For all intents and purposes, this work has to be considered his last masterpiece. By the addition of a brilliantly conceived and executed overstructure, Pollock managed to create one more electrifying composition. Dominating the less coherent underlayers of the painting and weaving what some have described as a totemic spell, the eight angled rods of *Blue Poles* triumphantly exert their author's briefly revived authority.

Although in numerous statements beginning soon after he met Krasner in 1942, Pollock disparaged his experience with Benton, it is well-known that he maintained a long-distance relationship with his first mentor throughout his entire life. Of course, Benton never could totally reconcile himself to Pollock's adaptation of (and success with) an approach so completely opposed to Regionalism. (In Abner Dean's lampoon of "Action Painting," he gives the critic Benton's features.) But Benton was apparently astute enough to realize that, even with Jack's more abstract orientation, throughout every phase of his career his former pupil had kept in mind many of his own precepts. For his own personal purposes Pollock modified not only Benton's accentuated linearity and centrifugal construction, but also his teacher's focus on light and dark as the primary basis of pictorial organization, his stratification of forms to create a feeling of deep space, and his accent on rhythm. We have already seen that, during his exploratory years, Pollock had frequently followed Benton's advice on ordering a composition by imagining that it revolves around one or more implied uprights, and that he had adopted this pattern in paintings whose styles ranged from *Birth* to *Gothic*.[23] We have

already noted that, more than fifteen years before *Blue Poles*, Pollock had actually employed its identical solution—the frank acknowledgment of this vertical structural device—as a way to add visual coherence to the smaller, but equally swirling *Composition with Figures and Banners*.

Benton's assessment of his own indirect contribution to *Blue Poles* was prompted by reports in the popular press in 1973 that this work was the result of a drunken painting spree by Pollock and Tony Smith.[24] These accounts further stated that the uprights were added later by another friend, Barnett Newman. Although there seems to be some truth to the contention that *Blue Poles* started out in this unserious, haphazard fashion, Pollock explained to Greenberg that he subsequently took "full possession" of the canvas, completely covering over the mishmash he and Smith had made.[25] For both economic and aesthetic reasons, Pollock never abandoned any canvas if he could avoid it. As we have seen numerous times, when he did not like what he saw, he either kept scraping it down or repainting it until it "worked." That the tilted poles with their cruciform extensions, created by imprinting the surface with two by fours dipped into wet blue paint, were the idea and/or handiwork of Newman is unlikely given the many earlier instances when Pollock had used a similar expedient. Taking a cue from her husband, even Krasner had played around with this solution, employing it with great success in a "Little Image" painting of 1946.[26]

It was about the same time as he was reworking *Blue Poles* that Pollock painted *Portrait and a Dream*, undeniably another late masterpiece; but, unfortunately, he could not sustain this brief return to works with presence and power. In fact, if any theme can be said to emerge from Pollock's increasingly spotty production between 1953 and 1955, it might be the thwarted effort of any kind of meaning to break through the impervious barrier his painting surface had become. The trapped hues of the spectrum at the bottom of *Greyed Rainbow* or the severed eyes and body parts glimpsed as they swirl around *Ocean Greyness* are two good examples of this. It is not difficult to imagine what cataclysm he imagined to be waiting beyond the ragged white edge in the dark center of *The Deep*. A major exception to these instances of unremitting obstruction is the anomalous late canvas *Easter and the Totem*, in which Pollock capriciously resumed for just a moment his quirky and sporadic engagement with Matisse. The organic forms and luxuriant colors used by Matisse in such works as his 1916 *Bathers by a River* Pollock seem to have filtered in *Easter and the Totem* through his wife's increasingly decorative sensuosity.[27] (As Pollock's work deteriorated and their relationship crumbled, Krasner's art somehow managed to gain in originality and expressiveness.)

By 1956, Jackson Pollock was producing nothing at all, as he was almost constantly inebriated. He was well aware that, with the few exceptions mentioned, the paintings of his last three years had been sadly undistinguished; compared to the extraordinary accomplishments of his prior decade, they constituted little more than a catalogue of desperate efforts to revive his own heroic past. In his very last works, Pollock turned back almost exclusively to the more indecisive, transitional style of the paintings he created just after moving to Long Island.[28] On an ineluctable downward spiral, he could duplicate neither the instances of furious passion, nor the intermittent periods of tranquillity that had made possible his former greatness.

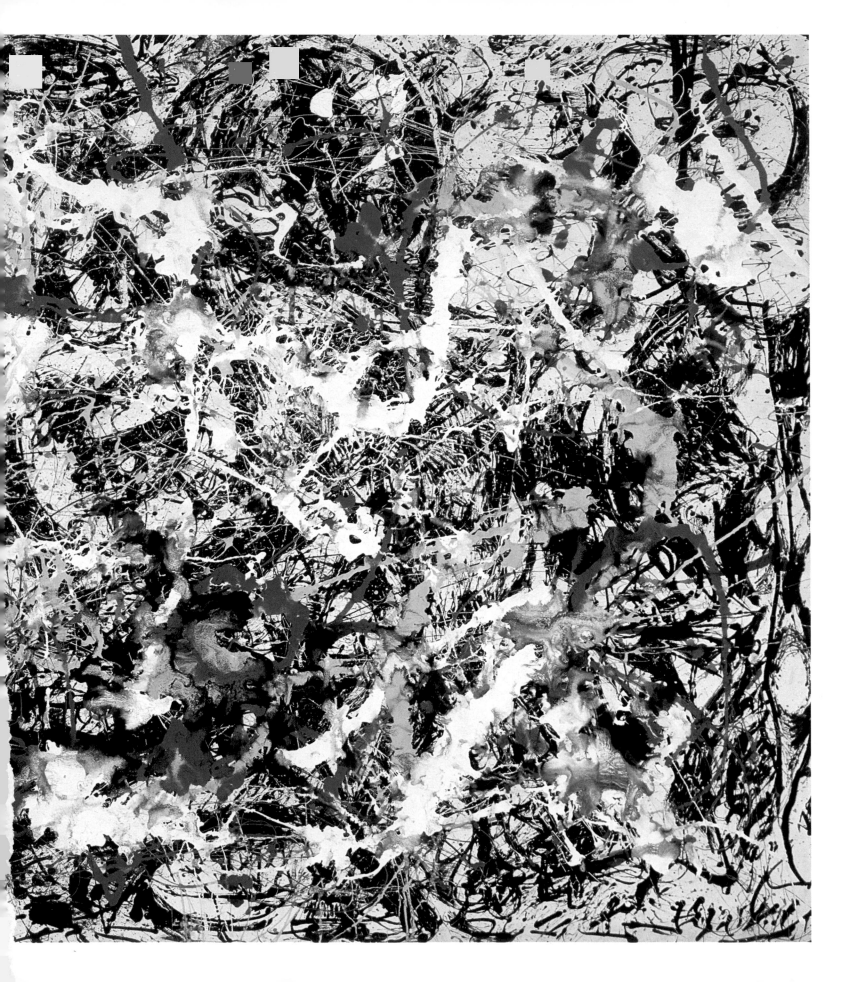

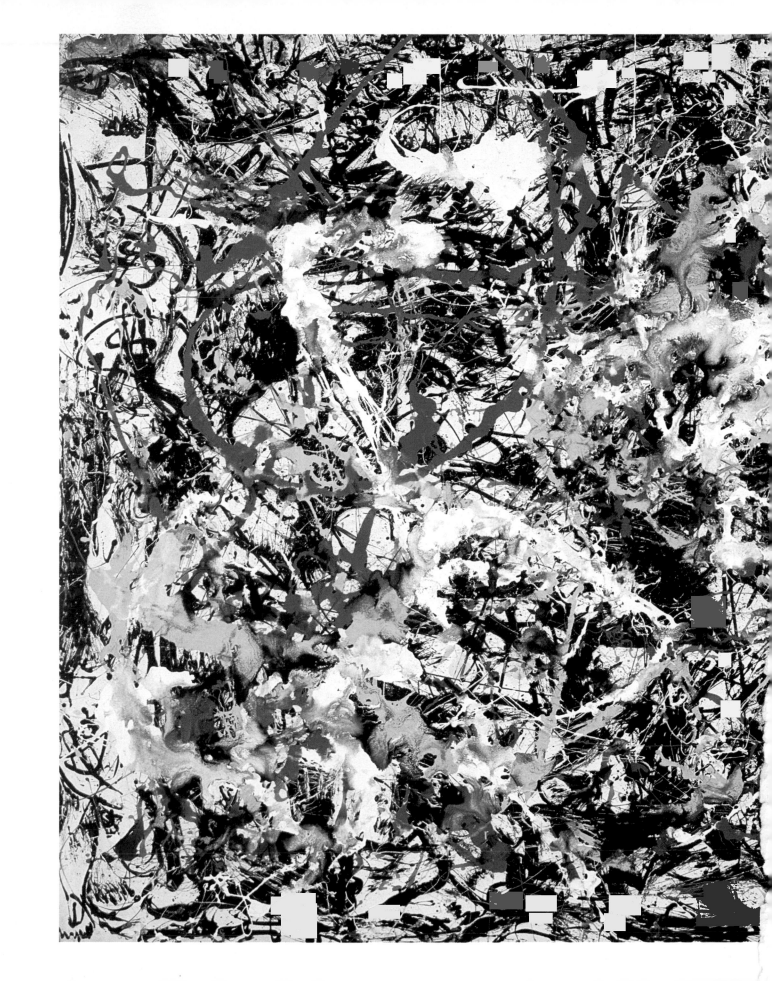

Blue Poles: Number 11, 1952. *1952*

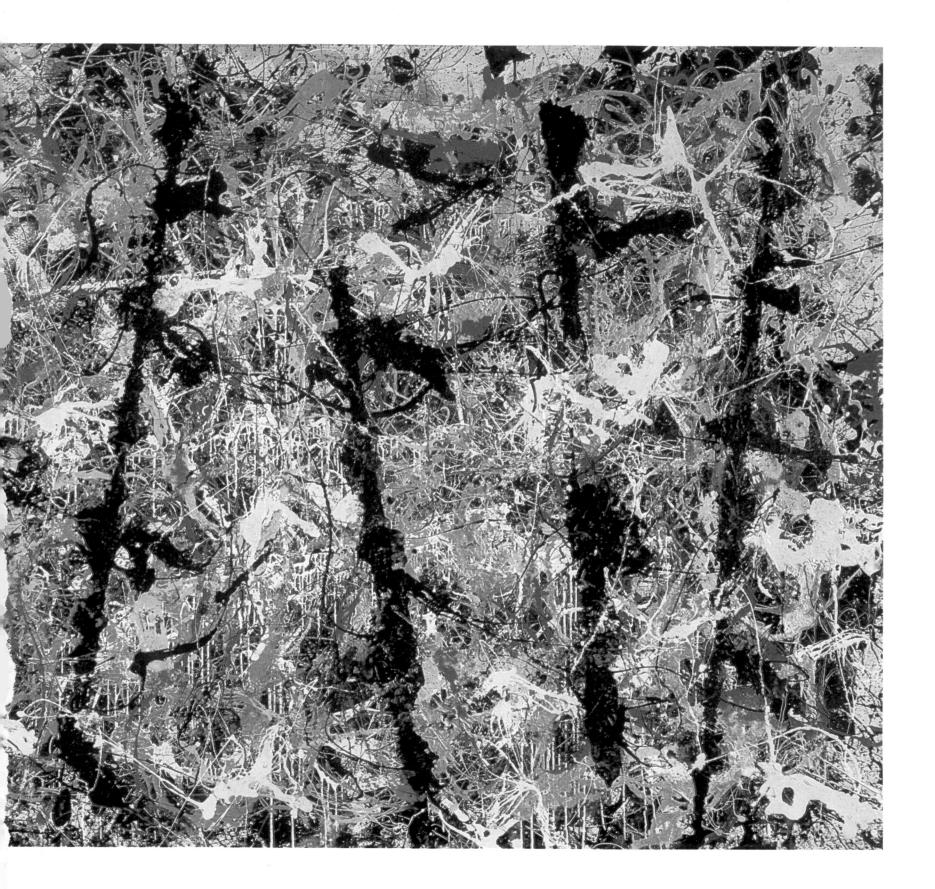

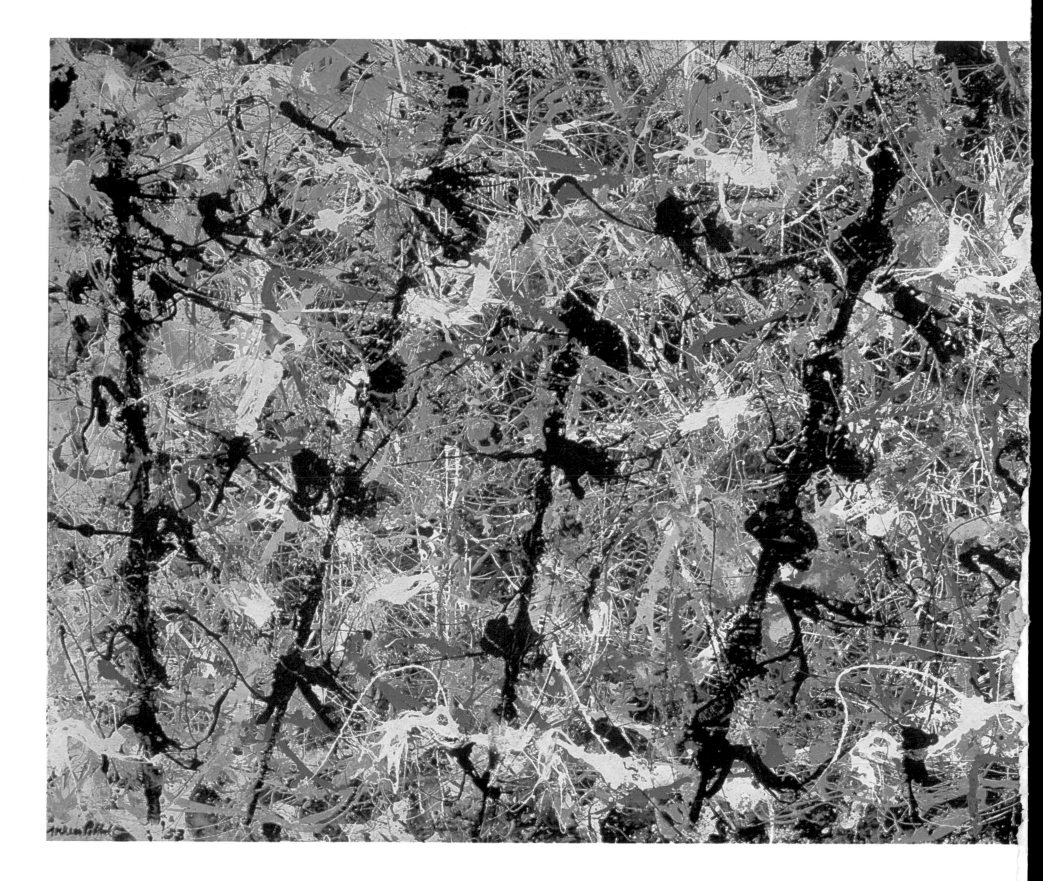

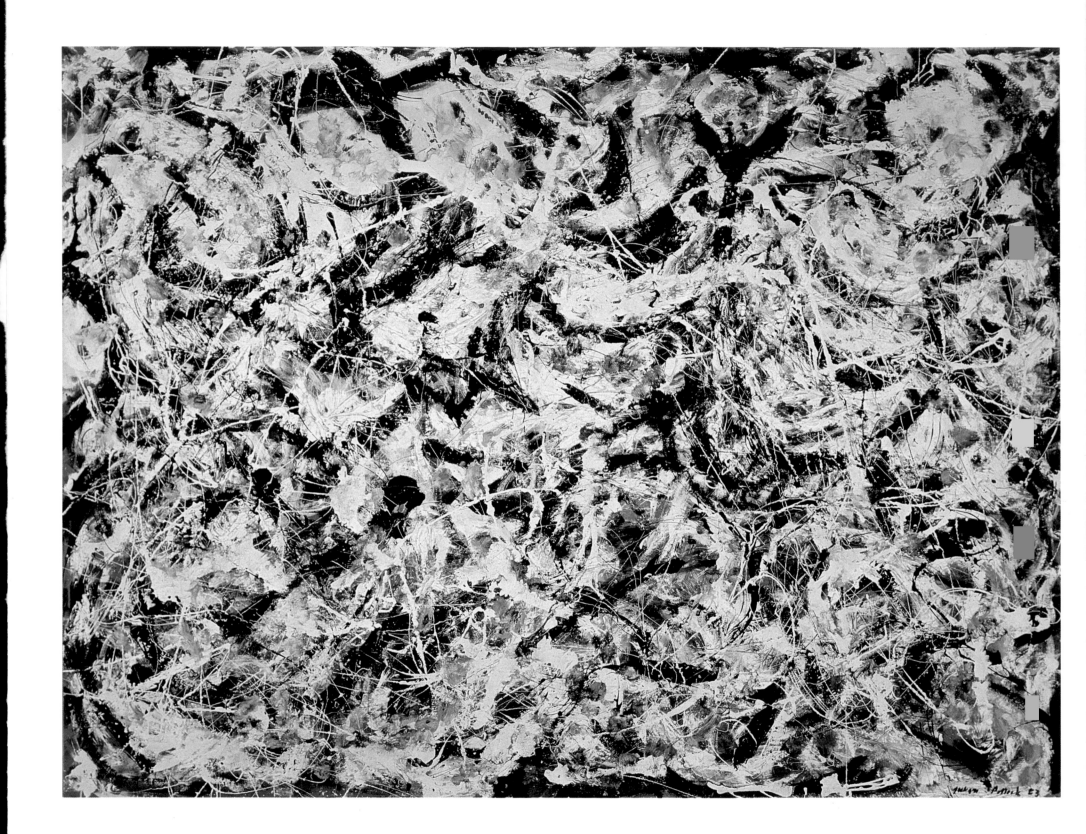

Greyed Rainbow. *1953*

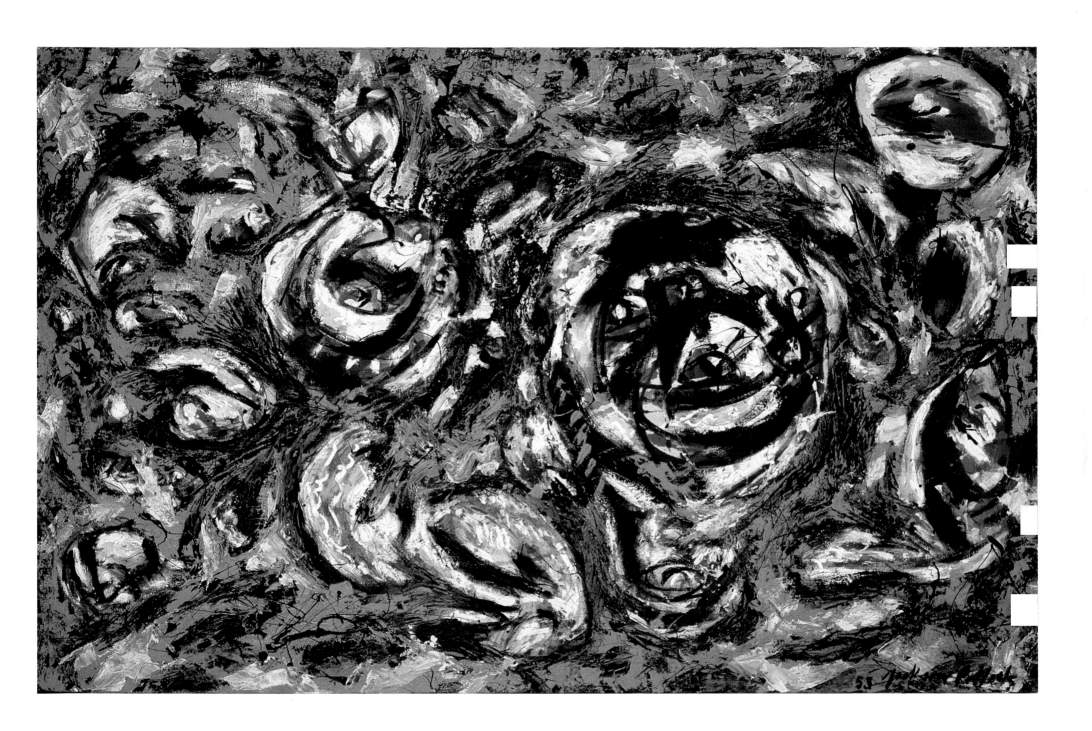

Ocean Greyness. *1953*

The Deep. *1953*

Easter and the Totem. *1953*

White Light. *1954*

Scent. *c. 1955*

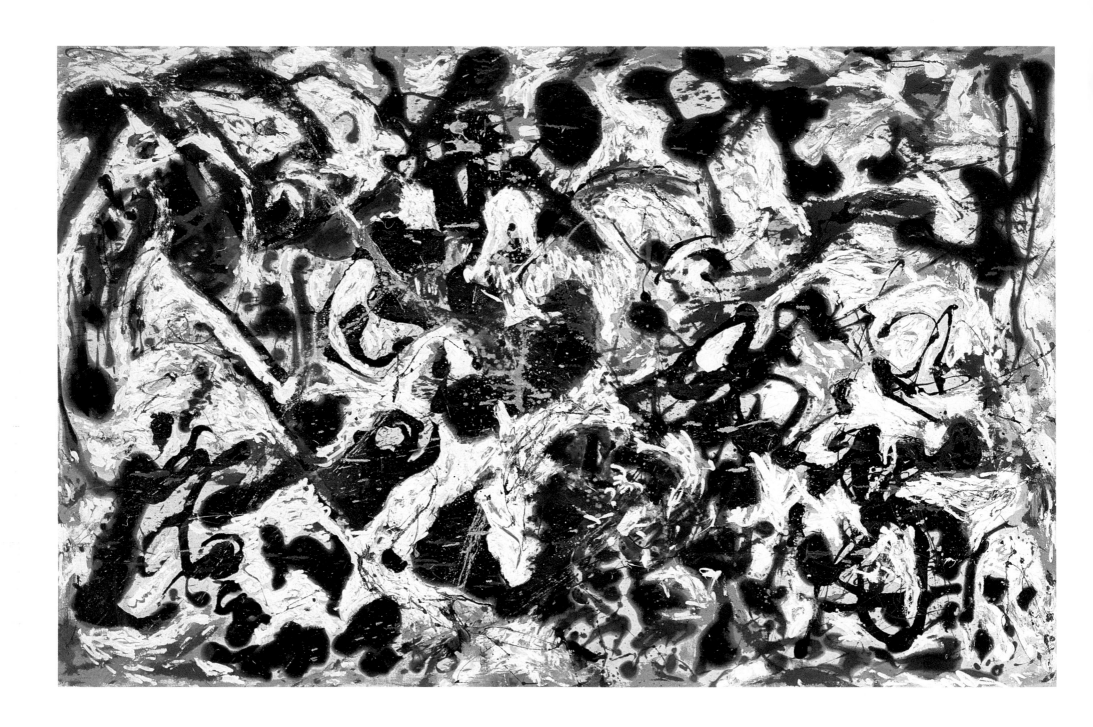

Search. *1955*

# TWELVE

# The American Prometheus

The only people for me are the mad ones, the ones who are mad to live, mad to talk, mad to be saved, desirous of everything at the same time, the ones who never yawn or say a commonplace thing, but burn, burn, burn like fabulous roman candles exploding like spiders across the stars and in the middle you see the blue centerlight pop and everybody goes "Awww!"
—Jack Kerouac, *On the Road*, 1957

It's never quite clear if Pollock's story is about what he did to New York—or about what New York did to him.
—Jed Perl, *The New Criterion*, 1987

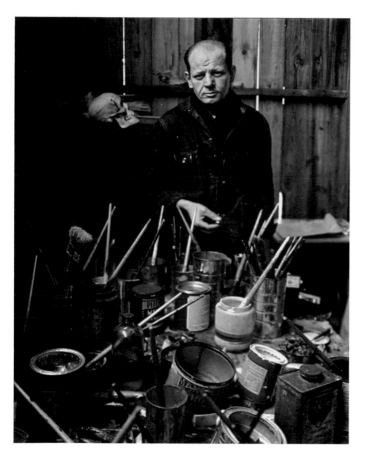

*Pollock, 1949.*
*Photograph © Arnold Newman*

Ten years after *Life* reframed Greenberg's assessment of Pollock into a question for the nation, his work was featured again in the first installment of a two-part series on the Abstract Expressionists, now described by *Life* editor Dorothy Sieberling as "the world's dominant artists today." Part one of "Baffling U.S. Art: What It Is About" appeared in the November 9, 1959, issue of the magazine with a preface explaining that its readers would learn how Americans like Pollock, de Kooning, Clyfford Still, Mark Rothko and Franz Kline had managed to become "the most talked-about painters on the globe." Between these two major articles there had been another brief story devoted to Pollock in *Life*. On August 27, 1956, two photos and one page of copy had appeared under the headline "Rebel Artist's Tragic Ending," a boiled-down version of which *Time* had printed in its "Milestones" column the week before:

> Died. Jackson Pollock, 44, bearded shock trooper of modern painting, who spread his canvases on the floor, dribbled paint, sand and broken glass on them, smeared and scratched them, named them with numbers, and became one of the art world's hottest sellers by 1949; at the wheel of his convertible in a side-road crack-up near East Hampton, N.Y.

(Not mentioned by either magazine was the fact that two women were in the car, one of whom was also killed.)[1]

To begin her retrospective assessment of Pollock in 1959, Sieberling, still in charge of *Life*'s art pages, printed a striking color photograph of the artist taken by Arnold Newman at the time of "Is he the greatest living painter in the United States?" but not previously used. "His face deeply furrowed, his eyes shadowed and searching," Sieberling wrote in her now more flattering text, "Jackson Pollock wore the look of a man seldom at peace." She continued, "In his studio on Long Island, amid a clutter of paint tins, driftwood, a human skull and large rolls of canvas, he brooded and wrestled with an art that surged restlessly into uncharted territory." Newman's portrait presents the still young Pollock, ubiquitous cigarette

*Théodore Géricault*. Self-Portrait (?). c. 1819–20

in hand, standing in one corner of his studio. Before him is an assortment of half-empty bottles and paint cans from which extrude a dozen or so assorted sticks and brushes. To the left of his face is a human skull sitting on an upper shelf, unmistakable in its *vanitas* implications as well as in its resonance with numerous images of moody artistic geniuses of the past. One of the secrets of Arnold Newman's success as a portraitist has been his uncanny ability to reveal aspects of his subject that go deeper than the facts. Although this is probably best illustrated in a later photo, the brilliantly demonic view of German industrialist Alfred Krupp, Newman's talent for psychic penetration was already operative in his portrait of Pollock, which manages to convey both its subject's absolute modernity as well as his roots in previous art.

What Newman's image (which he insists was not planned)[2] divulges with great clarity is that, although Pollock's story is a very personal one, in many ways it also epitomizes a pattern that reaches far back into the centuries. In 1963, Rudolf and Margot Wittkower published an illuminating study of the stereotypical creative personality in their book *Born Under Saturn: The Character and Conduct of Artists*. The Wittkowers explain that some twenty-five hundred years ago, Plato first described the typology of "divine mania," and that its complexion has remained virtually unchanged since its particulars became more widely known in the Renaissance. Throughout the ages, the most notable characteristics of the artistic genius have been his unreliability, rebelliousness, extravagance, alienation, anxiety, and melancholia. More often than not he has been doomed to a solitary and tormented life as a result of his debilitating alternations between periods of manic productivity and deep despair. In a 1970 article in *Art Journal*, Johannes A. Gaertner likewise explored the phenomenon of myth and pattern in the lives of famous artists, discerning a recurrent scenario that should also sound familiar: the arrogant and passionate, but flawed genius (frequently addicted to alcohol or drugs) who requires his madness as a precondition to creativity, but eventually succumbs prematurely to its self-destructive effects. Gaertner cited Raphael, Modigliani, Watteau, and of course, Vincent van Gogh as prime exemplars of this archetypal *artiste-maudit*. Pollock is distinctive as the first American victim.

Although their study does not go up to the twentieth century, the Wittkowers raised an issue relevant to Pollock when they questioned whether absolute reciprocity ever exists between an artist's identity and what he creates. They point out that once the details of his personality are known, it is difficult to view an artist's work without preconceptions based on his character,[3] and many who have discussed Pollock's paintings have certainly fallen into this trap. A *New York Times* description of his canvases as "angry and seething" is one small example of the almost universal tendency of reviewers and art historians to treat Pollock's life and art as if they were totally indivisible. It is interesting that those closer to Jackson Pollock the man—Motherwell and Greenberg have been the most vocal—have maintained to the contrary that Pollock's mature work, which was often lyrical and quite beautiful, often had only a marginal relationship to his immature personality, which could often be quite ugly. Theirs, however, has not been the typical view, especially in the popular press, whose attentions, as we have seen, played a large role in creating Pollock's name and fame. For example, soon after deploring in *Commentary* magazine the fact that Brando's Stanley Kowalski had become a role model of the fifties, Robert Brustein cited "the frenzied arabesques" of Jackson Pollock's paintings as another example of what he called the "cult of

238

unthink." In a second article, in the September 1958 issue of *Horizon*, Brustein described the Kowalskian antihero in more detail, now incorporating explicit references to Abstract Expressionism. Whether he "throws words on a page" or "pigment on a canvas," Brustein wrote, whether he "mumbles through a movie" or "shimmies in the frenetic gyrations of rock-'n-roll," the Kowalskian type is belligerent in his self-indulgence. His most characteristic sound is "a stammer or a saxophone wail"; his most characteristic symbol "a blotch and a glob of paint."[4] Pollock's own aggression was all that Brustein could find reflected in his work, and although she softened her statements somewhat, the following year Sieberling also described Pollock's art as the outgrowth of "focused fury."[5]

Whatever his reservations were about Namuth's films and photographs, to an important degree it is their existence that vindicates Jackson Pollock as an artist by visibly repudiating the notion that he was as mindless and uncouth a painter as he was an alcoholic. Unfortunately, the most unsavory aspects of Pollock's personality were predominant when he was best known. During his last year, when he was very much a celebrity but no longer really an artist, Pollock is said to have swung irrationally between churlishness and self-flagellation. In public (especially "on stage" at the Cedar Bar), Pollock was adulated but easily provoked into explosive behavior[6]—hence the comparisons with Billy Budd. In private, with his marriage in a shambles, he was desperate and alone.

The level of this desperation is perhaps most poignantly revealed in stories surrounding Pollock's two aborted attempts to sit through Samuel Beckett's famous play *Waiting for Godot*, a quintessential example of the postwar Theater of the Absurd. In this essentially plotless drama, even its author admitted that "nothing happens, nobody goes, it's awful."[7] Although it would be difficult to assess Pollock's awareness of this fact, the structure of *Godot* is not unlike one of his own allover paintings: no story is told and there is no definable beginning, climax, or end.[8] Whether or not he understood this affinity, it is clear from eyewitness accounts that Pollock identified emotionally with Beckett's presentation of man's powerlessness to control his own destiny. Ruth Kligman (Pollock's girlfriend during the last months of his life) went with him the second time he tried to see *Godot*, and she has recounted in her memoir of their liaison that Jackson cringed throughout the play, becoming highly distraught as the main characters, Vladimir and Estragon, each attempted suicide. By the time Lucky appeared on the stage, according to Kligman, Pollock began to sob so loudly that they had to get up and leave.[9]

Jackson Pollock may have been America's first true *artiste-maudit*, but as we know, Kenneth Rexroth pointed out that he had counterparts in James Dean and Charlie "Bird" Parker. Not an American, but enormously popular in the United States in the 1950s was an even more similar figure, also noted by Rexroth, the Welsh poet Dylan Thomas. Just as he was drawn intuitively to Joyce, Melville, and Beckett, Pollock also admired the works of Dylan Thomas, taking particular delight in his rhythmically repetitive sound structures. Pollock acquired a 1953 volume of Thomas's collected poems as well as recordings of the author reciting. Once again, the points of intersection between Pollock and Thomas were numerous.[10] Most notably, as artists both were engrossed with themes of birth and death; Thomas in fact invoked the same rhyming opposites Pollock had used in his quip to Jeffrey Potter when he identified "womb to tomb" as his early poetic obsessions.[11] Also similar was the passion and intensity Thomas brought to his creativity, as well as the excesses which

239

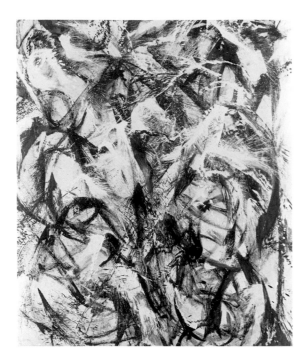

*Lee Krasner.* White Rage. *1961*

*Frank Stella.* The Marriage of Reason and Squalor.
*1959*

marked his inebriation; both painter and poet were praised for these polar examples of extravagance by John Clellon Holmes. Although this penchant for extremes ultimately destroyed both of them, at least, Holmes wrote, Pollock and Thomas "went out" without making accommodations to a hostile society.

Key spokesmen for the "Beat Generation," Holmes and Rexroth interpreted Pollock's demise as an embodiment of the Beat protest against the mediocrity of American life.[12] Encouraged, no doubt, by Harold Rosenberg's vision of Jackson Pollock as the self-definitive Action Painter pitted against the ambiguities of modern existence,[13] both willingly claimed him as a martyred hero, but neither took a closer look at the real Pollock. If they had, Holmes and Rexroth likely would have realized that Jackson Pollock was actually more typical of the 1950s than their diagnoses suggest. Shaped, as was the rest of his generation, by events over which he had no control—economic depression, global holocaust, Cold War—Pollock was prey to a lack of focus that mirrored the larger tensions between the individual and society that came to a head during the conformist fifties. What Holmes and Rexroth also did not perceive was that, having been an outsider all his life, with middle age approaching, Jackson Pollock yearned like everyone else to belong.

Although touted by *Life* in 1959 as "a reckless restless rebel to the end," actually Pollock's goals by the beginning of his last decade were absolutely conventional. Tired of critical acclaim that brought no remunerative rewards, he longed for the material trappings of success.[14] Despite Pollock's obnoxious behavior when intoxicated, those who knew Pollock well are virtually united in agreement with his East Hampton buddies Dan Miller and Donald Braider that, down deep, Jackson was basically a conservative man. Even frequent drinking partner Tony Smith has described Pollock's general outlook on life as "stern" and "puritanical."[15] As interested in status as everyone else, Pollock was thrilled to replace his picturesque but decrepit Model A with a Cadillac and then with Martha Jackson's Oldsmobile coupe, although he became famous in his tee shirt (á la Marlon Brando), paint-spattered loafers, and jeans, Pollock always dressed in tweeds, expensive shoes, and a buttondown shirt when he went into New York City. As Greenberg explained, "He didn't want to look like a damned artist when he went to Fifty-seventh Street."[16]

The charge that Pollock intended to subvert for subversion's sake—that he was a rebel without a cause—is, like so many aspects of Pollock's myth that fed neatly into the needs of others, largely a distortion of fact. By the time he grew a beard to cover his bloated face, Pollock probably was as raw and "emptied out" as the Beats; however, the financial security and respectability he craved would have been anathema to them with their rejection (Norman Mailer has described it as a "vomiting up") of the American dream. And when Pollock finally did become prosperous, it was too late. Tragically, according to those friends he still had left, Pollock had to face the fact that material success was meaningless if he could no longer create. From the very start of their relationship, a crucial aspect of Krasner's importance for Pollock was her recognition of the true value of his work. Fellow painter Nicholas Carone later told Jeffrey Potter that thinking "everything had to do with monetary value" was a crucial flaw in Jackson's personality; whereas Lee knew all along that money "had nothing to do with it."[17]

One of the most difficult aspects of attempting to assess Jackson Pollock's staggering importance to modern art is the necessity of placing his oeuvre not only into a meaningful context in relation to his own confused psychohistory, but also of fitting it into the matrix of

*Roy Lichtenstein.* Big Painting No. 6. *1965*

*Andy Warhol.* Marilyn Monroe's Lips. *1962*

*Helen Frankenthaler.* Mountains and Sea. *1952*

his times. Pollock's reputation (very much like that of Edouard Manet in the previous century) is based on his embodiment of more than just the aesthetic concerns of his era,[18] and as is true of his celebrated cowboy affinities, Pollock's own comments have contributed to the proliferation of this wider view. We have already remarked his handwritten notation that begins, "Experience of our age in terms of painting—not an illustration of—(but *the equivalent*)." It is not known exactly when this was written, but in 1950 Pollock made a similar statement when he told William Wright's radio audience that "Modern art to me is nothing more than the expression of contemporary aims of the age we're living in." "It seems to me," he elaborated, "that the modern painter cannot express this age, the airplane, the atom bomb, the radio in the old forms of the Renaissance or any other past culture."[19] In 1956, not long before Pollock's untimely death, Selden Rodman (the last to interview him) again asked what he intended to express in his work. Pollock's unhesitating answer—"My times and my relation to them"—reaffirmed his social ambitions.[20]

Without resorting to fanciful comparisons of Pollock's forms with atomic fission, intergalactic space, and the other wonders of fifties science that have been invoked as metaphors for Pollock's timeliness, in 1958, an unidentified writer for the *London Times* percipiently analyzed Pollock's role as an agent of culture by describing his radical transformation of painting as "almost an act of spiritual brinkmanship." This British commentator was right on, for—like the foreign policymakers of his era—one of the ways in which Jackson Pollock advanced the course of art was through his willingness to teeter on the edge of disaster.[21] To many it seemed shocking that Pollock let his body dictate what his mind should do, but as mythographer Joseph Campbell pointed out in another context, that is exactly what has always been involved in ritual behavior. Pollock's ritual, one admirer noted, "just happened to use paint."[22]

In a stunning reprise of the role earlier played by Picasso, during the past three decades most ambitious artists have been united in their perception that in order to make their own mark, Jackson Pollock is the major figure whose achievements they must either extend or defy. Ironically, in the years since his death, Pollock has often been most admired for characteristics that all during his life he tried to overcome.[23] Seeing him as both an embodiment and a vindication of their own desire for technical and stylistic freedom, many American and European artists of all types (including not only painters, but sculptors, poets, dancers,[24] and musicians) have invoked Jackson Pollock as symbol and progenitor of their own energies and actions.

Although de Kooning's disciples dominated the fifties, from the coolly detached holistic fields of Post-Painterly Abstraction (his own version of which Frank Stella defined as "negative Pollockism")[25] to the iconic drips, "allover compositions," and other witty sight gags of the contemporaneous Pop movement, by the following decade Pollock had become the more consistent inspiration. Bringing his name and legacy once again to the forefront during the sixties, Helen Frankenthaler readily acknowledged Pollock's black pourings as the major inspiration for her own highly influential stained acrylics.[26]

An even more radical offshoot of Pollock during this period related not to any of his individual works, but rather to what many perceived as his complete redefinition of the artist's role as maker. Greatly extending Pollock's notion of the canvas as an arena, which had become such an inextricable component of his legend, in the late fifties and early sixties a

group of artists including Allan Kaprow, Red Grooms, Jim Dine and Claes Oldenburg developed the Happening, a completely new art form that deified Pollock's emphasis on experience. According to Rosenberg, the major innovation of Action Painting was Pollock's dispensing with the *representation* of a state in favor of its *enaction* in physical movement; now these younger artists extended the situational implications of Pollock's aesthetic by transforming his private process into a public event.[27] Following suit, in the seventies, conceptual and performance artists began to probe their bodies as Pollock had probed his psyche.

The confrontational power of Jackson Pollock's paintings—he himself had used this term to describe his large-scale abstractions[28]—not only affected the development of Hard Edge modernism, but it was also responsible in large measure for stimulating one of the more controversial directions of the sixties, the literalist or Minimal trend. Both Robert Morris and Donald Judd, two of the key exponents of Minimalism, have written about the influence of Pollock's paintings on their own work, although the pieces they chose to create were three-dimensional. The inevitable reaction in the early 1970s against the repetitive and standardized "specific objects" of Minimal Art also took on a Pollockian cast in the guise of antiform or distributional sculpture. In 1970, when *Life* highlighted young artists such as Richard Serra and Lynda Benglis, whose work consisted of impermanent or malleable materials dropped, spilled, or scattered on the gallery floor, a photo of Pollock at work inset into the upper left-hand corner of the first page of the article, "Fling, Dribble and Drip," made it clear who these up-and-coming sculptors had been inspired by.

In most recent years, numerous Post-Modern appropriations of Jackson Pollock have surfaced. The broken crockery, antlers, and frankly borrowed drips of Julian Schnabel, the wildly Baroque gestural painting/reliefs created by Frank Stella in the eighties, and Mike Bidlo's line-for-line copies of Pollock's poured paintings are just a few examples out of many. Bidlo has probably been the most assiduous in his veneration, even assuming Pollock's identity for a while (he did the same thing with Picasso). In a sardonic send-up of Beaton's *Vogue* photographs, Bidlo transferred Pollock's pourings onto an actual suit, dress, and tie.[29]

*Claes Oldenburg in his happening* Injun I *at the Ray Gun Mfg. Co., New York. 1962*

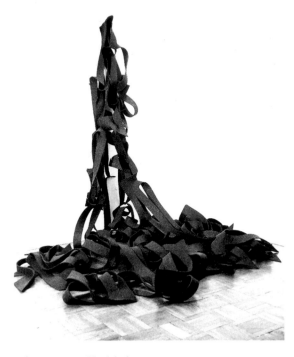

*Robert Morris.* Untitled. *1967–68*

*Lynda Benglis.* Bounce. *1969*

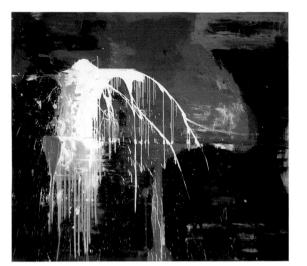

*Julian Schnabel.* Maria Callas # 2. *1982*

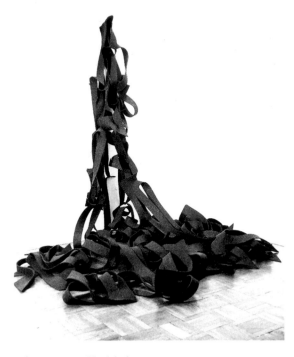

*Frank Stella.* Steller's Albatross. *1976*

*Mike Bidlo.* Jackson Pollock Dress. *1982*

As the reverent title of irreverent California sculptor Robert Arneson's 1987 monumental bust of Jackson Pollock makes explicit, it seems that few artists today can afford to create without taking into account some aspect of "the myth of the Western man."

There seems to be little doubt, as so many critics and art historians in both Europe and America have had to admit, that Jackson Pollock's most far-reaching achievement is his major role in the dramatic shift of the locus of the avant-garde from Paris to New York after World War II.[30] Although actively engaged throughout his life in a serious dialogue with the history of world art—we have examined in depth his catholic interests, which ranged from Paleolithic and Indian art to Rubens, El Greco, Tintoretto, and Ryder; from Regionalism to the Mexican muralists, the Surrealists, Picasso, Miró, and Matisse—Pollock's aspirations always remained courageously and (like Benton's) even chauvinistically of this continent.[31] He expressed this with typical bluntness in a 1946 letter to Bunce, where he wrote that, now that the war was over, "Everyone is going or gone to Paris. With the old shit (that you can't paint in America) have an idea they will all be back."[32]

Practically every artistic decision he ever made proves that Jackson Pollock actually believed in the "American" strengths Europeans thought he embodied: brashness, persistence, an outward lack of sophistication combined with a true inner primitivism, and an unbridled sense of daring and discovery. Pollock's defiant refusal to stay within traditional bounds, even (as Greenberg once put it) his "violence, exasperation and stridency,"[33] all were paradigmatically New World. At a time—and in a guise that absolutely nobody expected—these were the unlikely characteristics that finally came together to produce an American Prometheus.[34]

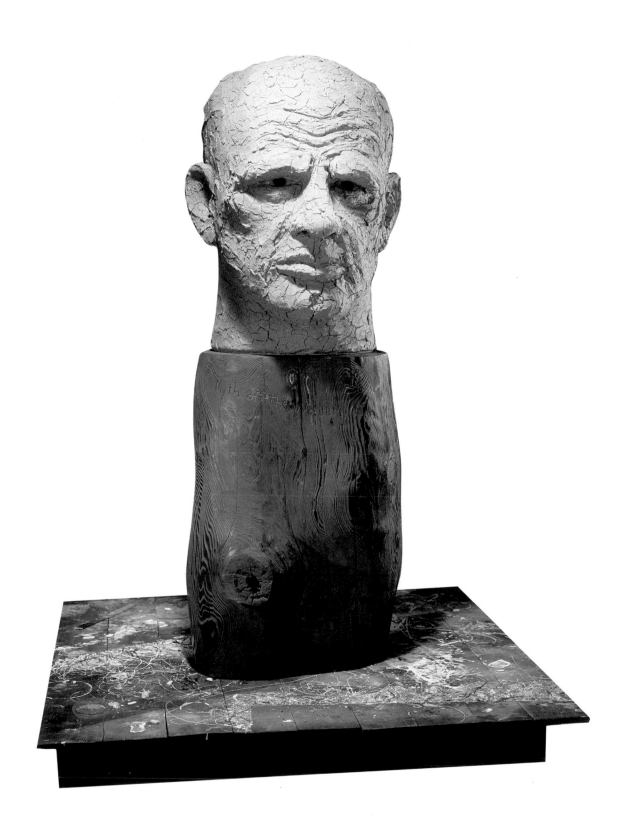

*Robert Arneson.* Myth of the Western Man. *1986*

# Chronology

**1912**

Paul Jackson Pollock (known as Jack) born in Cody, Wyoming, January 28, the last of five sons of Stella May McClure and LeRoy Pollock. At ten months moves with family to San Diego, California.

**1913–24**

Family moves back and forth between Phoenix, Arizona, and various locations in California, finally settling in Riverside, near Los Angeles.

**1927**

Works as surveyor along north rim of Grand Canyon with brother Sanford (Sande). Begins Riverside High School.

**1928**

Expelled from Riverside High. Moves to LA and studies at Manual Arts High School with Frederick Schwankovsky. Expelled there also.

**1929**

Works on surveying and road construction gang with father at Santa Ynez, California, during summer.

**1930**

Moves to NYC with brothers Charles and Frank. Drops unused first name Paul. Enrolls at ASL (Art Students League) to study with Thomas Hart Benton. Studies sculpture with Ahron Ben-Schmuel at Greenwich House.

**1931–32**

Continues study with Benton. Returns to California each summer.

**1933**

Enrolls in classes at ASL with John Sloan and Robert Laurent. Leaves after father's death in March. Lives with Charles and wife.

**1934**

Returns to LA for last time. Visits Bentons on Martha's Vineyard (also next three summers). Shares custodial job at City and Country School with Sande. Meets Helen Marot. Paints china for Rita Benton to sell at Ferargil Gallery.

**1935**

Cleans outdoor statues for NYC Emergency Relief Bureau. Joins mural division of WPA/FAP. Begins living with Sande.

**1936**

Switches to WPA easel division (stays off and on until 1943). Takes part in Siqueiros Workshop. Briefly meets Lee Krasner.

**1937**

Undergoes first psychiatric treatment. Probably meets John Graham.

**1938**

Treated for acute alcoholism at Westchester Division of New York Hospital for several months.

**1939**

Commences eighteen-month Jungian analysis with Dr. Joseph L. Henderson.

**1941**

Begins treatment with Dr. Violet Staub de Laszlo (until 1942) after Henderson's departure from NYC. Begins relationship with Krasner as a result of mutual inclusion in Graham's McMillen show.

**1942**

Works on War Services projects for WPA. Participates with Motherwell, Matta, and others in automatist experiments. Krasner moves in with Pollock at 46 East 8th Street.

**1943**

Does odd jobs after demise of WPA. Works at Museum of Non-Objective Painting. Exhibits in collage invitational and first Spring Salon at AOTC (Art of This Century). Offered contract by Peggy Guggenheim. First one-man show November 9–27. Begins homeopathic treatment with Elizabeth Wright Hubbard.

**1944**

First interview published in *Arts & Architecture*. Summers in Provincetown. Works at Hayter's Atelier 17. Sells first painting, *The She-Wolf*, to Museum of Modern Art.

**1945**

Marries Krasner October 25 and moves with her to 830 Springs Fireplace Road near East Hampton, Long Island. Second solo at AOTC March 19–April 14.

**1946**

Converts barn to studio. Third solo at AOTC April 2–20. Begins Accabonac Creek and Sounds in the Grass series.

**1947**

Applies unsuccessfully for Guggenheim Fellowship. Last solo at AOTC January 14–February 1. Transfers to Parsons Gallery when AOTC closes. Advanced experimentation in allover poured style.

**1948**

Six works in XXIV Venice Biennale. Begins successful treatment for alcoholism with Dr. Edwin Heller. First solo at Parsons January 5–23.

**1949**

Begins to number paintings. Meets Alfonso Ossorio. First feature story in *Life*. Solos at Parsons January 24–February 12 and November 21–December 10.

**1950**

Lives in Ossorio's NYC townhouse for several months. Signs "Irascibles" protest. Interviewed in *The New Yorker*. Tapes WERI radio interview with William Wright. Photographed by Hans Namuth and others. Resumes heavy drinking. Exhibits in Venice and Milan. Solo at Parsons November 28–December 16.

**1951**

Biochemical treatment with Dr. Grant Mark. Solo at Parsons November 26–December 15. Returns to more figurative style.

**1952**

Switches to Sidney Janis Gallery in May. First solo exhibition in Paris, Studio Paul Facchetti. First retrospective organized by Clement Greenberg for Bennington College.

**1953**

Vacillates between figuration and return to brushed and poured abstract style. No one-man show for first year since 1943.

**1954**

Paints very little. Solo at Janis February 1–27.

**1955**

Continues not to paint. Reenters analysis with Sullivanian therapist Ralph Klein. Meets Ruth Kligman at Cedar Bar. Retrospective at Janis November 28–December 31.

**1956**

Krasner goes to Europe in July. Pollock killed August 11 at 10:15 P.M. in car accident on Fireplace Road. Memorial retrospective at the Museum of Modern Art, December 19–February 3, 1957.

# Notes

## ABBREVIATIONS

*AAA*, SI = Archives of American Art, Smithsonian Institution
*AF* = *Artforum*
*AI* = *Art International*
*AIA* = *Art in America*
*AJ* = *Art Journal*
*AM* = *Arts Magazine*
*AN* = *Art News*
AOTC = Art of This Century gallery
*CR* = Francis Valentine O'Connor and Eugene Victor Thaw, eds., *Jackson Pollock: A Catalogue Raisonné of Paintings, Drawings and Other Works*
*NYT* = *The New York Times*
*NYTM* = *The New York Times Magazine*
*PR* = *Partisan Review*
*SDA* = John Graham, *System and Dialectics of Art*
*TVG* = Jeffrey Potter, *To a Violent Grave: An Oral Biography of Jackson Pollock*

## ONE: *The Wild One*

1. See Dorothy Sieberling, "Jackson Pollock: Is he the greatest living painter in the United States?," *Life*, vol. 27, August 8, 1949, p. 42, and "The Wild Ones," *Time*, vol. 67, February 20, 1956, p. 73. Greenberg's remark appeared in "Art," *The Nation*, vol. 166, January 24, 1948, pp. 107–8.

2. For the references in this paragraph, see Clement Greenberg, "The Jackson Pollock Market Soars," *NYTM*, April 16, 1961, pp. 42ff.; B. H. Friedman, *Jackson Pollock: Energy Made Visible*, New York: McGraw-Hill, 1972, p. xix; and for Smith's comment, Francine du Plessix and Cleve Gray, "Who was Jackson Pollock?," *AIA*, vol. 55, May–June 1967, p. 54.

3. Sam Hunter, "Among the New Shows," *NYT*, January 30, 1949, pp. 2 and 9.

4. Mark Stevens, "Quests in Paint," *Newsweek*, vol. 92, October 23, 1978, p. 138. This letter, written in February 1932, can be found in *CR*, vol. 4, doc. 12, pp. 211–12.

5. Jimmy Ernst quoted by Jeffrey Potter, *TVG*, p. 71. For descriptions of Pollock as a youth, see passim.

6. *CR*, vol. 4, doc. 40, p. 226; letter from Sanford McCoy, July 1941.

7. Krasner, quoted by Jack Kroll in "A Magic Life," *Newsweek*, vol. 69, April 17, 1967, p. 96.

8. In "America's New Culture Hero: Feelings Without Words," *Commentary*, vol. 25, February 1958, p. 126, Brustein compared Stanley Kowalski to Billy Budd, pointing out that "the struggle within an incoherent individual trying to express his feelings can be extremely powerful, for one often has the sense that the character's stammers, mumbles, and grunts will, like those of Billy Budd, erupt into violence if they continue to frustrate speech." In *TVG*, p. 136, Paul Jenkins states, "Meeting Jackson was an assault on the moral senses because in a frontal attack he would question your very being. I think of him somewhat like Melville's Billy Budd. The only way he could find expression was by some violent gesture, but underneath he had a very fine sense of decency and was a very moral man."

9. *CR*, vol. 4, doc. 6, p. 208; letter from Jackson to Charles and Frank Pollock, October 22, 1929. In a letter to O'Connor, November 17, 1963, Charles stated, "My father was the 'neurotic.' I use this term only in the comparative sense." (Quoted in O'Connor's Ph.D. dissertation, "The Genesis of Jackson Pollock: 1912–1943," The Johns Hopkins University, 1965, p. 5.) Arloie McCoy, the wife of Jackson's brother Sande (their father's real name was McCoy, and Sanford changed his back), discussed her father-in-law with James Valliere, August 2, 1962. She noted that "he was a man who knew that life had more to offer than he had experienced and was anxious that his sons should find it." She added that he held up the ideal of the artist as truly important, a position few could ever attain. (All interviews with Valliere are in *AAA*, SI.)

10. James Johnson Sweeney, "Five American Painters," *Harper's Bazaar*, April 1944, p. 126.

11. Jackson Pollock, [Answers to a Questionnaire], *Arts & Architecture*, vol. 61, February 1944, p. 14.

12. In interviews with Valliere, James Brooks and Tony Smith spoke about Pollock's cowboy affinities. Brooks remarked that it seemed as if Jackson "got a little more like a cowboy as time went on," and that de Kooning once dreamed that Pollock flung open the doors of the Cedar Bar exclaiming, "I can paint better than anybody." Smith stated that Pollock's feelings about the West affected his general behavior: "It showed in the way he would walk around—well, he walked like a cowboy. And it showed especially in the way he would relax. He would let his body sag in a chair much in the way you would imagine a cowboy." Smith elaborated these comments in du Plessix, "Who was ?," p. 52; similar remarks by others can be found in *TVG*.

13. Rita Parks, *The Western Hero in Film and TV: Mass Media Mythology*, Ann Arbor: UMI Research Press, 1982.

14. *TVG*, p. 168, and du Plessix, "Who was ?," p. 51.

15. [Berton Roueché], "Unframed Space," *The New Yorker*, vol. 25, August 5, 1950, p. 16.

16. Ibid.

17. See Harold Rosenberg, "The Search for Jackson Pollock," *AN*, vol. 59, February 1961, pp. 35, 58–59; William Rubin, "Jackson Pollock Was No Accident," *NYTM*, January 27, 1974, pp. 35ff.; Thomas B. Hess, "Pollock: The Art of a Myth," *AN*, vol. 62, January 1964, pp. 39–40, 62; and Brian O'Doherty, "Jackson Pollock's Myth," *American Masters: The Voice and the Myth*, New York: Random House, 1973, pp. 80–111, for general discussions of this issue. Representative examples of the use of the cowboy analogy in the popular press include John J. O'Connor, "The Pollock Line," *Wall Street Journal*, September 13, 1957, and Jean-Paul Crespelle, "Pollock, peintre-cowboy," *Le Journal du Dimanche*, Paris, October 17, 1979.

18. Quoted by Sam Hunter, "Pollock catalogue raisonné," *AN*, vol. 77, November 1978, pp. 24 and 27.

19. Roland Marchand, "Visions of Classlessness, Quests for Dominion: American Popular Culture, 1945–1960," in R. H. Bremner and Gary W. Richards, eds., *Reshaping America: Society and Institutions 1945–1960*, Columbus: Ohio State University Press, 1982, pp. 163–90, points out the popularity in the fifties of Mike Hammer and the Marlboro Man, both of whom evoke masculine adventure and rebelliousness. In addition to James Dean, Elvis Presley was an example of defiance in this era, and indeed, the Italian critic Giovanni Galtieri termed Pollock "Il Presley della Pittura," *Avanti*, Rome, March 22, 1958.

20. See Mary Lee Corlett, "Jackson Pollock: American Culture, The Media and the Myth," *The Rutgers Art Review*, vol. 8, 1987, pp. 71–108.

21. "Beyond the Pasteboard Mask," *Time*, vol. 83, January 17, 1964, p. 67.

22. For Pollock's comment to de Kooning, see James T. Valliere, "De Kooning on Pollock: An Interview," *PR*, vol. 34, Fall 1967, p. 604. Selden Rodman's *Conversations with Artists*, New York: Devin-Adair, 1957; Capricorn Books, 1961, pp. 76–87, includes Pollock's definition of painting. It is interesting to compare these statements with those of Lee Strasberg in his memoir, *A Dream of Passion: The Development of the Method*, Boston: Little, Brown, 1987. There, p. 103, Strasberg wrote: "the extent to which unconscious habits of thought, feeling and behavior influence the actor during the actual process of acting still demands greater clarification." He also pointed out, p. 105, that "while all art is for the creator a means of self-expression, it is only the extent to which it reveals what is experienced that it becomes art." Especially applicable to Pollock is Strasberg's statement that "Part of the therapeutic value of art generally . . . resides in the ability to share experiences and emotions that are otherwise locked and blocked, incapable of being expressed, except under artistic and controlled conditions" (p. 140).

23. Quoted in *Energy*, p. 72. See also Tennessee Williams, *Memoirs*, Garden City, New York: Doubleday, 1975, p. 56. In a letter dated June 21, 1944, Williams described the scene at Provincetown: "Here I am, back on Captain John's Wharf—shades of 1940. All a bit nostalgic, or perhaps ghoulish is the right word. The whole lunatic fringe of Manhattan is already here, Valesch, Joe Hazen, Robert Duncan, Lee Krasner and

Pollock, the Bultmans and myself. Such a collection could not be found outside of Bellevue or the old English Bedlam. . . ." See Williams's *Letters to Donald Windham, 1940-1965*, New York: Holt, Rinehart and Winston, 1976, p. 134.

24. Tony Smith in du Plessix, "Who was ?," p. 53, describes Pollock in the forties: "His brow was heavy and deeply ridged. He was so sullen and intense, so miserable."

25. Williams, *Memoirs*, p. 56.

26. Interviewed by Valliere, Tony Smith disagreed:

All the talk about his being non-verbal is false. When he had something to say—he said it. He didn't waste words, in that sense he was laconic—he came directly to the point. Also in the strict sense of the term you didn't have a conversation with Jackson. You would ask him a direct question and he would give you an answer. Although he wasn't a talker, he wasn't evasive either. Occasionally when he didn't want to answer a question he would just smile.

Many who knew Jackson (Brooks, Bultman, Kadish, et al.) recall that he became less self-conscious and a more trenchant talker after a few drinks. According to de Kooning, "when he was half-loaded . . . he was good, very good, very provocative." (See Valliere, "De Kooning on Pollock," p. 604.)

27. In *TVG*, p. 137, Penny Potter notes that Pollock "was interested in what it was to be an actor. We found a lot to talk about in terms of what you go through creating a painting and creating a character role—long, complicated conversations." Brooks mentioned to Valliere the "touch of theatricalism" in Jackson's behavior.

28. Regarding Pollock as Rosenberg's model, see *Energy*, p. 197; Rosenberg, "Search," pp. 59-60; William Rubin, "Pollock as Jungian Illustrator: The Limits of Psychological Criticism, Part Two," *AIA*, vol. 67, December 1979, pp. 89 and 91; and letters to the editor from Rosenberg and Rubin, *AF*, vol. 5, April 1967, pp. 6-7, and May 1967, p. 4. Rosenberg's original article was "The American Action Painters," *AN*, vol. 51, December 1952, pp. 22-23, 48ff.

29. Letter to this author from Jeanne Bultman, New York City, March 24, 1987. See Donald Spoto, *The Kindness of Strangers: The Life of Tennessee Williams*, Boston: Little, Brown, 1985, for Williams's relationship with Rodriguez, whom he met in 1946 at La Fonda de Taos, a hotel in New Mexico.

30. This key section of Gosling's review, "Jack the Dripper," *The Observer*, London, February 11, 1973, p. 36, reads as follows:

His career was a sort of a success story of a peculiarly American kind. . . . For while [artists like Picasso or van Gogh] stand and fall as individuals, Pollock seems to represent a whole generation, even a nation. He was, even in his lifetime, that favourite mass-media figure, the folk hero. The big, hard-swearing, hard-drinking, lovable, handsome and magnetic young man slowly going down into middle-age like a warship with all guns firing, has the tragic familiarity of a character by O'Neill or Tennessee Williams. The "famous photograph" of Pollock sitting on the running board of his Ford (of what European artist could there be a "famous photograph"?) seems clipped from an epic Hollywood movie. His career and his character wonderfully incorporate the great transatlantic dream—the rugged pioneer matching his integrity against a wily world, the eternally boyish rebel without a cause, the wild one stampeding through a sophisticated jungle, shot down by some slim, treacherous bullet. If Pollock had not existed, surely *Time-Life* would have invented him.

31. See Williams, "In the Bar of a Tokyo Hotel," *Dragon Country: A Book of Plays*, New York: New Directions, 1969. For Williams's intentions in devising Mark Conley, see Charles Ruas, "Tennessee Williams," in *Conversations with Tennessee Williams*, ed. by Albert J. Devlin, Jackson and London: University Press of Mississippi, 1986, p. 294. There Williams remarks about "Bar," "But do you know who I thought I was writing about? Jackson Pollock, not myself." According to Fritz Bultman, *TVG*, p. 214, Williams saw Pollock as like Hart Crane, "with all those elements of self-destruction."

Another literary usage of Pollock may be found in Donald Braider's *The Palace Guard*, New York: Viking Press, 1958, where the author thinly disguised Pollock as a writer named Payson Hughes (a fact confirmed by both Braider and his wife). One character in the book, p. 305, describes "Pays": "The world put him in a pigeonhole; it called him 'great,' and went on to adore an image of Hughes that the man himself bore only the most casual resemblance to." Another comments about Hughes/Pollock's last few years and all of the hangers-on he had attracted by then: "The joke if that's the word, is that he came to need the damn coterie just as badly in the end as we needed him" (p. 291).

32. Williams, *Memoirs*, p. 250.

33. For Motherwell's comments see *TVG*, p. 70, and Jeffrey Schaire, ed., "Was Jackson Pollock Any Good?," *Art & Antiques*, October 1984, p. 87. For Segal's, see "Jackson Pollock: An Artists' Symposium, Part Two," *AN*, vol. 66, May 1967, p. 29. Motherwell told Potter that "Brando was much more controlled than Pollock."

34. Late in his life, Pollock discussed Brando's film with B. H. Friedman. In *Energy*, p. 228, Friedman relates that Pollock said, "'What do they know about being wild? I'm wild. There's wildness in me. There's wildness in my hands.' He paused, picked up some sand, let it trickle through his heavy fingers. 'There was,' he finished softly."

35. See Joe Morella and Edward Z. Epstein, *Brando: The Unauthorized Biography*, New York: Crown Publishers, 1973, as well as Pauline Kael, "Brando: A View," in Tony Thomas, ed., *The Films of Marlon Brando*, Secaucus, NJ: The Citadel Press, 1973. Morella and Epstein quote Maurice Zolotow on Brando's mother: "She made it almost impossible for him to develop a sense of security about being a man."

36. Numerous comments in this vein are in *TVG*. For Motherwell's, see Vivien Raynor, "Jackson Pollock in Retrospect—He Broke the Ice," *NYTM*, April 2, 1967, pp. 50ff. Also, Barbara Rose, reviewing Friedman's biography, wrote in "The Jackson Pollock Story," *New York Magazine*, September 18, 1972, that Pollock had "a Jekyll and Hyde personality. . . . when he was good, he was very, very good, and when he was bad, he was violent."

37. See Gosling, "Dripper," p. 36, and Barbara Rose, "Jackson Pollock: The Artist as Culture Hero," *Pollock Painting*, New York: Agrinde Publications, 1978, p. 5. For interesting comparisons of Pollock and Dean, see Corlett; John Berger, "The White Cell," *New Statesman*, vol. 56, November 22, 1958; and Robert Hughes, "An American Legend in Paris," *Time*, vol. 119, February 1, 1982, pp. 70-71. Berger decided that both Dean and Pollock were "unhappy geniuses in an age out of joint."

38. *CR*, vol. 4, doc. 7, p. 209; letter from Jackson to Charles, January 31, 1930. See also docs. 4 and 5, which describe Pollock's rebellious activities in high school, as well as Deborah Solomon, *Jackson Pollock: A Biography*, New York: Simon and Schuster, 1987, pp. 37-47.

39. Brando made many comments that are similar to those attributed to Pollock. For instance, he once remarked, "I don't like people. I don't love my neighbor. Every time I put any faith in love or friendship I only come through with deep wounds. Today I am truly a person not open to relationships; this isn't a lie, but a very true fact. I am deeply lonely: alone. . . ." Quoted in Charles Higham, *Brando: The Unauthorized Biography*, New York and Scarborough, Ontario: New American Library, 1987, p. 5. Higham, p. 82, relates that, despite his brilliant performances, Brando was tortured by doubts about his adequacy to play the role of Stanley Kowalski and began seeing psychiatrist Bela Mittleman for help in finding the confidence to do it.

Brando's volatile personality was once characterized by fellow Method actor Paul Newman: "Marlon's basic quality . . . was just the extraordinary threat of eruptibility." See Robin Bean, "Dean—Ten Years After," *Films and Filming*, vol. 12, October 1965. Dean had similar characteristics. In Ezra Goodman, "Delirium over Dead Star," *Life*, vol. 41, September 24, 1956, p. 76, the actor is quoted as saying, "I'm a serious-minded and intense little devil, terribly gauche and so tense I don't see how people stay in the same room with me. I know I wouldn't tolerate myself."

A strikingly similar description of their contemporary, writer Jack Kerouac, can be found in John Clellon Holmes, *Nothing More to Declare*, New York: E. P. Dutton, 1967, p. 85: "I saw a man, often quarrelsome . . . as defensive as a coyote on the scent, and as intractable as a horse that will not take a saddle, a man who sometimes seemed positively crazed by the upheavals in his own psyche, whose life was painfully wrenched between the desire to know, for once and all, just who he was, and the equally powerful desire to become immolated in a Reality beyond himself. . . ."

40. John Clellon Holmes, "The Philosophy of the Beat Generation," *Esquire*, vol. 35, February 1958, p. 38. Quoted by Corlett, p. 101.

41. For a more extensive discussion of the relationship of the Beat poets and Pollock, see Irving Sandler, *The New York School: The Painters and Sculptors of the Fifties*, New York:

Harper and Row, 1978, chapter 1, "The Milieu of the New York School in the Early Fifties," pp. 1–28, and Neil Chassman, ed., *Poets of the Cities: New York and San Francisco 1950–1965*, New York: E. P. Dutton, 1974. For Creeley's first meeting with Pollock, see *Energy*, p. 216. In Chassman, p. 60, Creeley describes how he and the other Beat poets wanted a "way of thinking of the process of writing that made both the thing said and the way of saying it an integral event."

42. Mike McClure, "Ode to Jackson Pollock," *Evergreen Review*, vol. 2, Autumn 1958, p. 125. In Chassman, pp. 58–59, McClure states that Pollock became "so integral that his work began immersing my way of thinking in such a subtle way so early I can't tell you when. . . ." McClure notes that he "totally bought Abstract Expressionism as spiritual autobiography."

43. Allan Kaprow, in "Should the Artist Become a Man of the World?," *AN*, vol. 63, October 1964, p. 35, invoked Antonin Artaud's essay "Van Gogh: The Man Suicided by Society," *Tiger's Eye*, no. 7, 1949, when he wrote, "According to the myth, the modern artist is the archetypal victim who is 'suicided by society.' . . . Rembrandt, Van Gogh and Pollock died on the cross. . . ."

44. Elaine de Kooning, in "Jackson Pollock: An Artists' Symposium, Part One," *AN*, vol. 66, April 1967, pp. 63–64.

## TWO: *Birth*

1. Quoted in du Plessix, "Who was ?," p. 49. In John Gruen, *The Party's Over Now: Reminiscences of the '50s—New York's Artists, Writers, Musicians and Their Friends*, New York: Viking Press, 1967, pp. 229–30, Krasner related that after finding out where Pollock lived from Lou Bunce, a mutual WPA friend,

> Being an impulsive creature . . . then and there I marched myself over to 8th Street, climbed five flights of stairs and, once on the landing asked a man standing there to direct me to Pollock's studio. This man, it turned out, was Jackson's brother Sande, who lived in the opposite loft. He pointed to a door. I knocked, and a tall, lanky fellow opened it. I blithely walked in. . . . We talked about [his] paintings and the conversation was totally easy and marvelous. He seemed happy that I liked his work so much. It was later I learned people don't just walk into Pollock's studio. . . . and it was only later I learned how guarded and tortured he was about his work, his person, his life.

Krasner also told the story of this first meeting in Cindy Nemser, *Art Talk: Conversations with 12 Women Artists*, New York: Scribner's, 1975, p. 86, and Eleanor Munro, *Originals: American Women Artists*, New York: Simon and Schuster, 1979, p. 112.

2. After studying at the Otis Art Institute and doing various art-related jobs in California, Charles Pollock decided to study with Benton, whom he learned about from a newspaperman in Los Angeles (interview, October 25, 1987). Jackson Pollock's early admiration for Benton was expressed

in a letter to his dad dated February 3, 1933 (*CR*, vol. 4, doc. 16, p. 214), where he wrote: "After a life time struggle with the elements of every day experience, [Benton] is beginning to be recognized as the fore most American painter today. He has lifted art from the stuffy studio into the world and happenings about him, which has a common meaning to the masses."

3. *CR*, vol. 4, doc. 12, p. 211, quoting a letter from Pollock to his father dated February 1932.

4. On January 31, 1930, Jackson wrote to Charles, "i [*sic*] am still interested in philosophy and am stud[y]ing a book light on the path [by Mabel Collins, 1885] every thing it has to say seems to be contrary to the essence of modern life but after it is under stood and lived up to i think it is a very helpful guide. i wish you would get one and tell me what you think of it." See *CR*, vol., 4, doc. 7, p. 209. For descriptions of Schwankovsky as a teacher, see O'Connor's dissertation and article "The Genesis of Jackson Pollock 1912–1943," *AF*, vol. 57, May 1964, pp. 16–23; the biographies of Pollock by Solomon and Friedman; Potter's *TVG* and Dore Ashton, *Yes, but . . . A Critical Study of Philip Guston*, New York: Viking Press, 1976, pp. 13–14.

5. Accounts by Tolegian, Langsner, and Kadish confirm Pollock's attempts to appear "arty" in high school. He affected long hair like Oscar Wilde's, renamed himself after Victor Hugo to impress his English teacher, and tried to read *transition*, *The Dial*, and "metaphysical" works. Closer at first to Guston, Kadish (who did not really become friendly with Pollock until the summer of 1930, upon his return from New York) recalled, "We were living a European fantasy"; "Jack didn't want to be mistaken for anything but an artist." See Solomon, p. 48.

6. Both quotations in this paragraph are from a letter to Charles dated January 31, 1930 (*CR*, vol. 4, doc. 7, p. 209). Proof of Pollock's interest in art magazines can be found in an October 22, 1929, letter from Los Angeles written to Charles and Frank in New York. (Charles was at the League, Frank at Columbia University.) Jackson wrote, "Altho [*sic*] I am some better this year I am far from knowing the meaning of real work. I have subscribed for the 'Creative Art', and 'The Arts'. From the Creative Art I am able to under stand you better and it gives me a new outlook on life." See *CR*, vol. 4, doc. 6, p. 207. Earlier that same year, during summer vacation, LeRoy Pollock had written to Charles and Frank from Santa Ynez: "Jack is working with me and is getting along fine. He reads quite a lot of good magazines and so doesent [*sic*] seem to get lonesome for the city." (Pollock was working with his father on a surveying and road construction crew at Santa Ynez.) This letter, dated July 20, 1929, was kindly provided to me by Charles and Sylvia Pollock.

7. Jackson Pollock entered the Art Students League on September 29, 1930, enrolling in Benton's life-drawing and painting classes. In October 1931 and 1932 he enrolled in Benton's mural class. In January of 1933, after Benton left New York, he tried John Sloan's painting class, which he did not like. The following month he enrolled in Robert Laurent's sculpture class; but after his father's death in March, Pollock left the League, ending his formal art training for

good. Pollock did become a member of the Art Students League in December 1932, enabling him to work in the graphics studio for free. He was dropped from membership in September of 1935 for nonpayment of dues.

8. Pollock was extremely close to Rita Piacenza Benton from about 1933 to 1937. He was invited every summer as a houseguest to the Bentons' place at Martha's Vineyard, and he frequently acted as babysitter to the Benton children. Also, Rita sold Pollock's painted ceramics, which he created at her suggestion. Rumors have frequently surfaced that Pollock's relationship with Rita was also sexual. (See *TVG*, p. 48.)

9. These ideas were articulated by Benton's friend and promoter the critic Thomas Craven. During the period of his study with Benton, Pollock greatly admired Craven. Almost singlehandedly Craven had defined the Regionalist movement with Benton, Wood, and Curry as its major exponents. He completely debunked European art in his 1931 book, *Men of Art*, which Pollock owned. There Craven discussed the major European artists from Giotto to Cézanne and concluded that they had nothing of value to offer the American people. Elsewhere he called modern art "colored litter." Pollock's opinion of Craven was expressed in a letter to his mother, May 1932 (*CR*, vol. 4, doc. 13, p. 213), in which he wrote, "Sande didn't say in his letter if he heard Thomas Craven lecture or not—he should have. I meant to write him about it, he is one critic who has intelligence and a thorough knowledge of the history of art. I heard that he was made quite a joke there which is not unlikely for the element of painters found out there."

Philip Pavia recalled to John Gruen that "Jackson believed in the kind of big thing that Thomas Craven was building up when he wrote those books. You know. Thomas Craven was building up this kind of pro-American anti-French thing. . . . Jackson always walked around wearing his cowboy hat, and had complete contempt for all of us 'foreigners' as he called us. He loved the west and the midwest and he was a regional painter at the time." See Gruen, *Party's Over*, p. 262.

10. See Benton's *An Artist in America*, Columbia: University of Missouri Press, 1968, 255–56, n. 143. In "The Mechanics of Form Organization in Painting, Part III," *The Arts*, vol. 10, January 1927, Benton described painting as "preeminently a motor activity."

11. Axel Horn, "Jackson Pollock: The Hollow and the Bump," *Carleton Miscellany*, vol. 7, Summer 1966, p. 81.

12. Thomas Hart Benton, "The Mechanics of Form Organization, Part IV," *The Arts*, vol. 10, February 1927, pp. 95–96.

13. Pollock attended Benton's country musicales, for which he attempted to learn to play the Jew's harp. This experience is reflected in *CR* 8, an early sketch (c. 1933–34), done in oil on wrapping paper, for two murals for Greenwich House, a settlement house in the Village. The bottom section depicts five musicians playing a banjo (or guitar), an accordion, a clarinet, and either harmonicas or Jew's harps.

14. Whitney Darrow, Jr., another classmate, recalled that "Jackson drew with a real Bentonesque hollow-and-bump muscularity—always with frenzy, concentration, wild direct

energy. His work was rough—but direct, again—never polished or graceful." Quoted in Friedman, *Energy*, p. 25.

15. For these and subsequent comments by Benton about Pollock as a student, see Benton's two autobiographies and Dorothy Sieberling, "Baffling U.S. Art: What It Is About, Part One," *Life*, vol. 47, November 9, 1959, p. 79.

16. Horn, in "Hollow," p. 83, recalled that "Jack fought paint and brushes all the way. They fought back and the canvas was testimony to the struggle. His early paintings were tortuous with painfully disturbed surfaces."

17. Horn, in "Hollow," p. 83, also noted that many Benton students affected a "distinctive hairy scribble-scrabble drawing style" by building forms with layer on layer of pencil strokes. Pollock's drawings, Horn wrote, were "easily the hairiest."

18. See Ana M. Berry, "The Appreciation of Art," *Creative Art*, vol. 4, February 1929, p. 123.

19. Solomon, p. 89.

20. See Barbara Rose, "Painters of a Flaming Vision: El Greco and Jackson Pollock," *Vogue*, vol. 171, December 1981, p. 334.

21. Solomon, p. 67, writes that Pollock used to tell Benton's son, T. P., stories of Jack Sass, a make-believe hero from the West. She reports that Tom Benton described these as "big tales in compensation for [Pollock's] own poor and frustrated condition," pointing out that "Jack Sass was Jackson Pollock without the frustrations." See Benton, *Artist in America*, p. 339.

22. *CR*, vol. 4, doc. 10, p. 210, quoting an undated 1931 letter from Jackson to his brothers in New York.

23. In a catalogue put out by the Whitney Museum of American Art in 1932 concerning Benton's mural series *The Arts of Life in America*, the artist points out that "In the interest of representational inclusiveness the flow of a line is frequently broken, twisted and bent back on itself. As a consequence of this, some other line must needs be treated violently as an offset or counter."

24. In "The Faces That Haunt Van Gogh's Landscapes," *NYT*, January 4, 1987, scc. 2, p. 27, Michael Brenson discusses "secondary imagery," which he defines as "images that are rarely noticed at first glance, that refuse to get lost once they are found, and whose meaning, importance, or role is hard to define," pointing out that van Gogh's landscapes are "inhabited" with faces and heads in the trees and clouds. Brenson describes these as an indication that van Gogh personified and projected himself into the natural world. In a subsequent article, *NYT*, July 24, 1988, sec. 2, p. 1, "Faces in the Shadows: What Do They Mean?," Brenson extended this discussion to Renoir, Jasper Johns, and other artists, pointing out that faces seem to be "laced into the 'drip' paintings of Jackson Pollock." Clearly, this tendency was already present in *Going West* and such seascapes as *CR 26*. In Potter, *TVG*, p. 99, Mervin Jules, a Benton classmate, relates:

> Pollock would work at our studio occasionally—no one worked that way—and we all watched him. To prepare a canvas, he would put it on the floor and spatter it—that

was the underpainting, spatter and drip—then let it lie there. Images began to appear for him. It was a stimulation, and he believed Michelangelo who said he saw forms in clouds and such. Everything an artist sees becomes part of his visceral bank—exists in the subconscious. When the need arises, it comes forward. The underpainting would be dry when Pollock began to work on it, so it didn't show.

25. *CR*, vol. 4, doc. 38, p. 225.

26. *CR*, vol. 4, doc. 40, pp. 225–26.

## THREE: *Gods of the Modern World*

1. Letters to Valliere (both dated September 1963) from two of Pollock's doctors at Bloomingdale's, James H. Wall and Edward B. Allen, are in the Jackson Pollock Papers, *AAA*, SI. Wall is also quoted in *TVG*, pp. 57–58.

2. In his unpublished 1968 lecture, "Jackson Pollock: A Psychological Commentary," Dr. Joseph Henderson related that Pollock relied on the seventy-year-old Marot "for his need to give and receive feeling" and that the death of this surrogate mother figure pushed him back into his old troubles. Portions of this text are quoted in Friedman, *Energy*, pp. 41–44.

3. Benton's friendship with Pratt led to his including her in a panel of the *America Today* murals, painted in 1930 for the New School for Social Research, where she is shown teaching a child in "City Activities with Dance Hall." For more biographical information on Pratt, see Emily Braun, "Thomas Hart Benton and Progressive Liberalism: An Interpretation of the New School Murals," in *Thomas Hart Benton: The America Today Murals* by Emily Braun and Thomas Branchick, Williamstown, MA: Williams College Museum of Art, 1985, pp. 21 and 35 (nn. 84 and 85).

4. Rodman, *Conversations*, p. 87.

5. See Friedman, *Energy*, pp. 41–44; *TVG*, pp. 58–59, 62; C. L. Wysuph, *Jackson Pollock: Psychoanalytic Drawings*, New York: Horizon Press, 1970; and [Joseph L. Henderson], "How a Disturbed Genius Talked to His Analyst with Art," *Medical World News*, vol. 12, February 5, 1971, pp. 18–28.

6. *CR*, vol. 4, doc. 40, p. 226.

7. Henderson did note that Picasso and Orozco were reflected in some of these works. See Friedman, *Energy*, p. 41.

8. For Busa's comment see Friedman, *Energy*, p. 29.

9. Jackson wrote the following in a letter to Charles and Frank dated October 22, 1929: "I became accquainted [*sic*] with Rivera's work through a number of Communist meetings I attended after being ousted from school last year. He has a painting in the Museum now. Perhaps you have seen it, Dia de Flores. I found the Creative Art January 1929 on Rivera. I certainly admire his work. The other magizines [*sic*] I could not find." See *CR*, vol. 4, doc. 6, p. 208.

10. Letter to this author from Reuben Kadish, Vernon, N.J., March 22, 1987, p. 1. Shifra Goldman in "Siqueiros and Three Early Murals in Los Angeles," *AJ*, vol. 33, Summer 1974, p. 327, n. 26, states that in several conversations with her Siqueiros mentioned Jackson Pollock in connection with the summer of 1932 in Los Angeles.

11. As a gift to Henderson before he left for San Francisco, Pollock made a small gouache crucifixion (*CR* 940) possibly related to memories of Siqueiros's tropical version. This theme would reemerge in Pollock's oeuvre in 1951 in a serigraph poster designed for the Betty Parsons Gallery (*CR* 1090 [P 26]) and possibly in a black-and-white painting of the same year (*CR* 332).

12. See *TVG*, p. 49.

13. The Los Angeles critic Arthur Millier's comments were quoted in "Orozco and Pijoan Dream of Giants," *Art Digest*, vol. 4, August 1930, p. 1. The architect Sumner Spaulding was quoted in *Time*, vol. 16, October 13, 1930, p. 30.

14. See Reed's "Orozco and Mexican Painting," *Creative Art*, vol. 9, September 1931, pp. 199–207. In the notes to an unpublished lecture, "The Influence of Jose Clemente Orozco on Jackson Pollock," given at Dartmouth College on October 13, 1984 (typescript, p. 20, n. 10), Francis V. O'Connor points out that Alma Reed maintained a permanent Orozco room in her gallery, Delphic Studios, with an ongoing display of Orozco's current work, including sketches for murals. Unfortunately, the records for this gallery are now lost, so it is impossible to ascertain precisely what Pollock could have seen.

15. Benton, *American in Art*, p. 61.

16. Kadish letter, p. 2.

17. There are probably enough indications in his private fantasies, bolstered by the subsequent disposition of this work (discussed below), to suggest that *Naked Man with Knife* was meant as a self-portrait. (I am indebted to O'Connor for suggesting this in a telephone conversation on December 30, 1987.) In *Jackson Pollock*, New York: Harry N. Abrams, 1960, p. 17, Bryan Robertson commented that Pollock "was absorbed all his life by the structure of violence."

18. We also know that Pollock went to this show with art dealer Peggy Guggenheim. Many authors have discussed Pollock's interest in Indian art. Probably the most comprehensive treatment (although some of the specific comparisons in it are a bit far-fetched) can be found in W. Jackson Rushing, "Ritual and Myth: Native American Culture and Abstract Expressionism," in Maurice Tuchman, ed., *The Spiritual in Art: Abstract Painting 1880–1985*, Los Angeles: Los Angeles County Museum of Art, in conjunction with Abbeville Press, New York, 1987, pp. 273–394.

19. Kadish letter, p. 3.

20. Pollock, *Arts & Architecture*, p. 14.

21. Solomon, p. 146, states that Motherwell collaborated with Pollock in preparing the interview for *Arts & Architecture*. Her account is probably based on Motherwell's own statement in "Artists' Symposium, Part I," pp. 64–65. In an

interview with this author, July 18, 1979, Krasner maintained that it was Putzel who helped Pollock with this. See also Gail Levin, "Jackson Pollock (1912–1956)," in *Abstract Expressionism: The Formative Years* by Robert Carleton Hobbs and Gail Levin, Ithaca, NY: Herbert F. Johnson Museum of Art, Cornell University, and New York: Whitney Museum of American Art, 1978, p. 102, n. 4, for Putzel's role.

22. In his unpublished Dartmouth lecture, O'Connor relates *Composition with Woman* to Orozco's *Allegory of Mexico*, painted for the Gabino Ortiz Library at Jiquilpan in 1940. (See p. 10 of O'Connor's unpublished text.)

23. Fritz Bultman and Reuben Kadish, interviews with this author, New York City, February 27, 1979, and January 22, 1979, respectively. See also Rushing, p. 282, for a more complete discussion of this.

24. See the comments of Dr. Wayne Barker, *TVG*, p. 177.

25. Friedman, *Energy*, p. 42, quotes Henderson's comment that

> Following a prolonged period of representing human figures and animals in an anguished, dismembered or lamed condition, there came a new development in the drawings Pollock made during therapy. This was not merely the dissociation of schizophrenia, though he was frequently close to it. It has seemed to me a parallel with similar states of mind ritually induced among tribal societies or in shamanistic trance states. In this light the patient appears to have been in a state similar to the novice in a tribal initiation rite during which he is ritually dismembered at the onset of an ordeal whose goal is to change him from a boy into a man.

Similar remarks about Pollock's shamanism, made by his second Jungian psychiatrist, Violet Staub de Laszlo, are discussed below.

26. Related drawings of c. 1942 include *CR* 650, 653, 656, and 661, as well as 685 of c. 1943 and 741 of c. 1945. (Pollock's use of the central eye will be discussed in the next chapter.) It has been suggested by Elizabeth Langhorne that *Naked Man* relates to Pollock's fascination with Surrealist Max Ernst's bird-headed men. Pollock owned *Une Semaine de Bonté*, Ernst's 1934 collage novel devoted to the bird/man Oedipus. However, it is not known when he acquired this book, and a date of purchase (or gift) later in the forties, after his association with Peggy Guggenheim, seems more likely. See Langhorne's dissertation, "A Jungian Interpretation of Jackson Pollock's Art Through 1946," Ph.D., University of Pennsylvania, 1977.

27. Langhorne Ph.D., p. 140, n. 139.

28. In "Pollock's 'Bird' or How Jung Did Not Offer Much Help in Mythmaking," *AIA*, vol. 68, October 1980, p. 43, Donald Gordon discusses the enantiodromal nature of this feature, defining it as an archetypal image which contains its opposite because it is both vaginal and phallic. The possible relation of the lower portion of *Birth* to Picasso's *Demoiselles* and to a drawing reproduced in C. G. Jung's *Collected Works*, ed. by Sir Herbert Read, et al., New York: Pantheon Books, 1957, vol. 5, p. 125, is discussed at length by Judith Wolfe in "Jungian Aspects of Jackson Pollock's Imagery," *AF*, vol. 11,

November 1972, pp. 65–73. Wolfe points out that Jung discussed the psychological relevance of this drawing of the birth-giving orifice from a Mexican *lienzo*.

29. J[ames] W. L[ane], "Mélange," *AN*, vol. 40, January 15–31, 1942, p. 29. Some writers have noted that the circular structure of the main forms in *Birth* resembles a series of plaques or medallions. Beginning around 1934, and again around 1939, Pollock created painted designs on circular chinaware. Some of these Rita Benton sold at Ferargil; others remain in her estate (*CR* 916, 917, 919, 920). A few were given by Mrs. Benton to the William Rockhill Nelson Gallery of Art and Mary Atkins Museum of Fine Arts, Kansas City, Missouri (*CR* 918 and 922); a few are in other private collections (*CR* 923, 924, 925). *CR* 924 clearly derives from Orozco's murals in the Hospicio at Guadalajara, especially his *Man of Fire* dome. This direct quotation was discussed by O'Connor in his Dartmouth lecture, unpublished text, p. 10.

30. De Kooning, quoted by Dore Ashton in *The New York School: A Cultural Reckoning*, New York: Viking Press, 1973, p. 49.

31. John Graham, "Primitive Art and Picasso," *Magazine of Art*, vol. 30, April 1937, p. 236.

32. Perhaps the lower portion of *Birth* may be equated, as Picasso's *Demoiselles* has been, to the primitive female deities with legs spread apart (often in the act of childbirth) frequently found above the door to men's lodges. Carol Duncan in "Virility and Domination in Early Twentieth Century Vanguard Painting," included in *Feminism and Art History: Questioning the Litany*, ed. by Norma Broude and Mary P. Garrard, New York: Harper and Row, 1982, pp. 305 and 313, n. 8, points out that Picasso intuitively grasped the ideological meaning of these forms as a reinforcement of the view of woman as "other." Duncan cites Douglas Fraser's essay "The Heraldic Woman: A Study in Diffusion," in *The Many Faces of Primitive Art*, Englewood Cliffs, NJ: Prentice-Hall, 1966, pp. 36–99.

## FOUR: *The Magic Mirror*

1. *TVG*, p. 63.

2. See Gordon, "Bird," pp. 48–49. The drawing for Henderson is *CR* 537r.

3. Elizabeth L. Langhorne, "Jackson Pollock's 'The Moon Woman Cuts the Circle,'" *AM*, vol. 53, March 1979, pp. 133 and 137.

4. See Rushing, "Ritual and Myth," p. 282.

5. In a letter to O'Connor, Siqueiros noted that Pollock "worked with me in all the practices made in modern technics and with new plastics" (quoted in O'Connor's dissertation, pp. 62–63). Dubbed "Il Duco" in the thirties because of his espousal of that brand of commercial enamel, Siqueiros believed that Duco, "being a product of the auto industry fits the twentieth century idea" (Mervin Jules, quoted in *TVG*, pp. 98–99). For an extensive description of the kind of experimentation that went on at the workshop, see Horn, "Hollow and Bump," p. 86, and Laurance P. Hurlburt, "The Siqueiros Experimental Workshop: New York, 1936," *AJ*, vol. 35, Spring 1976, pp. 237–46.

6. See Gordon, "Bird," p. 48.

7. With reference to the main images of *Bird*, it could be pointed out that an eagle was supposedly the father of the first shaman. Also, ritual death followed by rebirth is a part of all shamanistic initiations. (The writings of Mircea Eliade discuss these aspects of primitive mythology.) In her dissertation, "Theory Undeclared: Avant-Garde Magazines as a Guide to Abstract Expressionist Images and Ideas," Ph.D., University of Delaware, 1984, p. 288, Ann Eden Gibson points out that a bird is commonly a metaphor for a Promethean hero.

8. See Wolfe, "Jungian Aspects," pp. 67–68.

9. See *CR* 580r.

10. In "Theory Undeclared," Gibson discusses the various meanings of the third eye as the seat of wisdom, enlightenment, and true vision, as well as its identification with the ability to control nature. Langhorne and Wolfe have both discussed this painting in terms of Pollock's desire for, or achievement of, psychic integration. Comparisons can be made between Pollock's *Bird* and Max Ernst's *Origin of the Pendulum* of 1925. See Evan Maurer, "Dada and Surrealism," in *"Primitivism" in 20th Century Art: Affinity of the Tribal and Modern*, ed. by William Rubin, New York: Museum of Modern Art, 1984, vol. 2, p. 560.

11. Rushing, "Ritual and Myth," p. 284, discusses *The Magic Mirror* in relation to reproductions of the pictographs at Barrier Canyon. When *The Magic Mirror* was sold to the Menil Collection, Houston, Texas, it underwent extensive conservation. Some of the findings of the conservators have been published by Walter Hopps in "*The Magic Mirror* by Jackson Pollock," *The Menil Collection: A Selection from the Paleolithic to the Modern Era*, New York: Harry N. Abrams, 1987, p. 259. Hopps notes that the canvas was cut from a prior painting and then remounted on another stretched and painted canvas of slightly larger dimensions. It is covered with a skin of variously thick and crusty paint mixed with a granular filler, possibly fine gravel. There are three distinct strata of painting activity effectively masking the original composition. As Hopps points out, the final composition is "extraordinary as much for what it conceals as for what it reveals." He sees the work as a self-portrait undergoing "subjective, psychic transformation" (p. 261).

12. See Wolfe, "Jungian Aspects," p. 66.

13. In "Guernica—Its Creation: Artistic and Political Implications, and Later History," the introduction to *Picasso's Guernica*, New York and London: W. W. Norton, 1988, pp. 84–85, Ellen C. Oppler illustrates other possible prototypes for the shrieking face, including Guido Reni's *Massacre of the Innocents*, c. 1611; Nicolas Poussin's *Massacre of the Innocents*, c. 1628–29; and François Rude's *La Marseillaise (Departure of the Volunteers of 1792)*, 1833–36.

14. See Oppler, "Guernica," pp. 106–10.

15. O'Connor has pointed out that the snake or ropelike shape on or about the head recurs in Pollock's oeuvre in fourteen different guises: *CR* 63, 71, 489, 525, 531, 533v, 557, 580r, 588, 592, 602, 615, 620, and 636.

16. *TVG*, p. 63.

17. The following papers are included on this list: C. G. Jung, *The Concept of the Collective Unconscious*; M. Esther Harding, *Redemption of Ideas in Alchemy*; Eleanor Bertine, *The Individual and the Group*; Hildegard Zozel, *The Eranos Conference*; M. Esther Harding, *The Mother Archetype and its Functioning in Life*; Jane Abbott Pratt, *Early Concepts of Jahweh*; Joseph Henderson, *Initiation Rites*; E. Bertine, *The Psychological Aspects of War*; C. G. Hung, *Picasso*; and two papers by Kristine Mann: "The Shadow of Death" and "The Self-Analysis of Emanuel Swedenborg." This list can be found in the Jackson Pollock Papers, *AAA*, *SI*.

18. Emily Wasserman, unpublished interview with Lee Krasner, January 9, 1968, p. 1 of typescript. In the Krasner papers, *AAA*, SI.

19. For these comments on Picasso by Graham, see Marcia Epstein Allentuck, *John Graham's System and Dialectics of Art*, Baltimore and London: The Johns Hopkins Press, 1971, section 96, "What is the real influence of Cézanne on modern painting? And of Picasso?," pp. 169–73. For Graham's turn away from Picasso, see Eleanor Green, *John Graham: Artist and Avatar*, Washington, DC: The Phillips Collection, 1987, pp. 66–68, and Eila Kokkinen, "John Graham During the 1940's," *AM*, vol. 51, November 1976, pp. 88–103. Krasner once remarked, "When I met Graham he was very pro-Picasso. This was a common denominator we had. After he turned, then you couldn't mention the name Picasso in front of him." She pointed out that in addition to inscribing a copy of *SDA* to Pollock, Graham later gave the two of them "The Case of Mr. Picasso," a four-page mimeographed broadside he issued in 1945, inscribed "To Jackson & Lenore Very Affectionately GRAHAM."

20. Information on Graham comes primarily from Allentuck; Green; Kokkinen; Hayden Herrera, "John Graham: Modernist Turns Magus," *AM*, vol. 51, October 1976, pp. 100–5; Barbara Rose, "Arshile Gorky and John Graham: Eastern Exiles in a Western World," *AM*, vol. 50, March 1976, pp. 62–69; Irving Sandler, "John D. Graham: The Painter as Esthetician and Connoisseur," *AF*, vol. 7, October 1968, pp. 50–53; and this author's interviews with Fritz Bultman, New York City, May 1, 1979, and Ilya Bolotowsky, New York City, October 30, 1979.

21. Taken from an interview with Krasner conducted by Barbara Rose, July 31, 1966, p. 14 of typescript. ( I am indebted to Barbara Rose for allowing me access to personal material.)

22. All quotes are from Allentuck, *Graham's SDA*.

23. About their visits to Graham's studio Krasner also recalled that "it was quite a striking image you walked in on. Then if he asked you for tea, he did it in his best Russian manner. He'd have the finest linen tablecloth, the best tea you can imagine brewed in a samovar, and then you looked at the objects which were Oceanic pieces, just magnificent." (Taken from the typescript of an unpublished interview with Krasner by Barbara Rose, n.d., pp. 4–5.) In an interview with this author, February 25, 1980, Krasner remembered that Graham "always did the talking. You didn't talk, you listened. There were so many marvelous things for the eye to absorb. Between that and the elegant tea and listening to what he had to say, it was quite enough."

24. Reuben Kadish, interview with this author, New York City, May 2, 1979.

25. See "Primitive Art and Picasso," p. 237. This statement by Graham seems to be closely related to Jung's ideas in *Modern Man in Search of a Soul*, New York: Harcourt, Brace, 1933, p. 165. There Jung states:

> We mean by the collective unconscious, a certain psychic disposition shaped by the faces of heredity; from it consciousness has developed. In the physical structure of the body we find traces of earlier stages of evolution, and we may expect the human psyche also to conform in its make-up to the law of phylogeny. It is a fact that in eclipses of consciousness—in dreams, narcotic states and cases of insanity—there come to the surface psychic products or contents that show all the traits of primitive levels of psychic development.

26. Allentuck, *Graham's SDA*, p. 97.

27. Pollock was once asked by Nicholas Carone if Clement Greenberg really knew what his painting was about. Pollock reportedly replied, "No. He doesn't know what it is about. There's only one man who really knows what it's about, John Graham." See *TVG*, p. 183.

## FIVE: *Male and Female*

1. In a number of interviews, Krasner spoke about the meaning these lines had for her (she had copied them from Fritz Bultman's copy of the Schwartz translation). For example, see B. H. Friedman, *Lee Krasner: Paintings, Drawings and Collages*, London: Whitechapel Gallery, 1965, p. 8, and Munro, *Originals*, p. 111, where Krasner is quoted: "They express an honesty which is blinding. I believe those lines. I experienced it. I identified with it. I knew what he was talking about. . . . Those lines have to do with reality, not lies." She told Friedman that Pollock did not like them, and that she once kicked Tennessee Williams out of her studio for criticizing them (*Energy*, p. 71).

2. Myers, speaking in Barbara Rose's film, *Lee Krasner: The Long View*. Myers also told Rose in an undated interview, *AAA*, SI, p. 26; "Just look at Lee Pollock. There would never have been a Jackson Pollock without Lee Pollock and I put this on *every* level. I mean she was in there." According to Alfonso Ossorio (interview with this author, East Hampton, July 17, 1979), Krasner did most of the talking because "someone had to speak." May Rosenberg remembers that Krasner would actually say, "Pollock thinks this. Pollock thinks that . . ." (Interview, February 22, 1980). Motherwell stated in "Artists' Symposium, Part One," p. 30: "His wife often spoke up for him, in a protective but not always feeling way; one sometimes wondered if Pollock himself would have replied in the same words; and beneath his depression you could often sense his potential rage."

3. Krasner made this comment in Gruen, *Party's Over*, p. 230. Kadish's remarks are from this author's interview, New York City, May 2, 1979. Bultman's comment is found in *TVG*, p. 65.

4. B. H. Friedman, *Energy*, pp. 92–93, notes that although *On Growth and Form* is always listed as one of Pollock's favorite books, it is probable that he looked at the pictures only and never read past the introduction. The text is full of notations and mathematical equations that would have gone over Pollock's head.

5. Included in these three issues of *View* were the following articles: Benjamin Péret, "Magic: The Flesh and Blood of Poetry" (Series 3, no. 2); and Kurt Seligmann, "Microcosmological Chart of Man" (Series 4, no. 4) and "Magic and the Arts" (Series 6, no. 5).

6. See Ellen G. Landau, "Lee Krasner's Early Career: Part One: Pushing in Different Directions," *AM*, vol. 56, October 1981, pp. 110–22; "Part Two: The 1940s," November 1981, pp. 80–89, and Barbara Rose, *Lee Krasner: A Retrospective*, Houston: Museum of Fine Arts, and New York: Museum of Modern Art, 1983, for Krasner's background.

7. Krasner told Gruen, *Party's Over*, pp. 229–30: "I blithely walked in, introduced myself, and taking a good look at him realized that I had met this man some four years earlier at a party. I remembered him because he turned out to be a lousy dancer. Of course, I had no idea what his work was like at that time, nor did I ever give him another thought."

8. In his *Arts & Architecture* statement, p. 14, Pollock noted, "My work with Benton was important as something against which to react very strongly, later on; in this, it was better to have worked with him than with a less resistant personality who would have provided a much less strong opposition." Later, in 1950, in "Unframed Space," p. 16, Pollock told Roueché; "I'm damn grateful to Tom. He drove his kind of realism at me so hard I bounced right into non-objective painting."

9. For Greenberg's acknowledgment of his debt to Hofmann's lectures, see "Art," *The Nation*, vol. 160, April 21, 1945, p. 649.

10. In a letter to this author from Norwich, NY, January 28, 1980, Greenberg observed: "People who knew Pollock personally were, I think, misled by his indifference to phrases and 'ideas.' He was beautifully right in that: in my opinion he saw more in art and knew more of it than did almost anybody (with the exception of his wife, the painter Leonore Krasner) who talked to him about it." See also Greenberg's "Jackson Pollock: Inspiration, Vision, Intuitive Decision," *Vogue*, vol. 149, April 1967, p. 161. The critic wrote of Krasner in "Jackson Pollock," *Evergreen Review*, no. 1, 1957, pp. 95–96: "Even before their marriage her eye and judgment had become important in [Pollock's] art and continued to remain so." In a lecture delivered on May 22, 1980, at the Hirshhorn Museum and Sculpture Garden, Washington, DC (held in conjunction with the exhibition "Aspects of the Fifties"), Greenberg stated that the "greatest influence" on Jackson Pollock was his wife.

It was Krasner's contention, however, that complexity existed because they did not usually talk formally about art: they discussed it "only in a shop sense." See Dorothy Seckler, interview with Krasner, November 2, 1964, *AAA*, SI, p. 10: "We really didn't do art talk . . . in the sense of talking about Matisse, his influence, etc. This simply never existed in our life. . . . He would . . . speak specifically of the painting in

front of him . . . it never went into a so-called formal talk in painting." "When he did talk," Krasner said, "it was extremely pointed and meaningful and I understood what [Pollock] meant." Krasner noted that she and Pollock often went to shows together, and one might say to the other in front of a particular work, "Great painting!" and the other nod affirmation. John Bernard Myers recalled Krasner and Pollock's conversations as often consisting of "the kind of shorthand people who are very close develop" (Interview, January 18, 1979). See also Wasserman's interview with Krasner, p. 3.

11. *TVG*, p. 75, quoting de Laszlo.

12. A copy of this letter, dated May 3, 1941, sent to the Examining Medical Officer of Selective Service Local Board No. 77, 412 Sixth Avenue, reads as follows:

Dear Sir,
Mr. Jackson Pollock has been referred to me by Dr. J. L. Henderson. Pollock has been coming to me for a number of psychoanalytical interviews during the past six months in connection with his difficulty of adaptation to a social environment. I have found him to be a shut-in and inarticulate personality of good intelligence [*sic*], but with a great deal of emotional instability, who finds it difficult to form or maintain any kind of relationship. I would say that the problem is fairly deep-seated and not due to any superficial tendencies toward evasion, or to immaturity of outlook. Although he has not during these months shown any manifest symptoms of schizophrenia, yet in the course of the interviews, it has become evident that there is a certain schizoid disposition underlying the instability. It is for this reason that I venture to suggest that Pollock be referred for a psychiatric examination.
Very truly yours,
Violet Staub de Laszlo

(This letter can be found in the Jackson Pollock Papers, *AAA*, SI.) Pollock went through an extensive psychiatric interview at Beth Israel Hospital on May 22, 1941, and received a 4-F rating.

13. Both Krasner and Pollock signed a petition to Franklin Roosevelt protesting the deterioration of creativity caused by the new war orientation. They asked the President to "do whatever possible to remedy the present conditions which do not permit us to contribute either to the war effort or to the culture of this country." (O'Connor's Ph.D. dissertation, p. 81, contains the complete text of this petition.) In general, Jackson Pollock had a rather checkered history with the WPA, which is fully chronicled in O'Connor and Thaw, *CR*, vol. 4, pp. 219–27. The role of Burgoyne Diller, director of the New York City WPA/FAP Mural Division from 1935 to 1942, in keeping Pollock from quitting is discussed in O'Connor's dissertation, pp. 78 and 94, n. 49. In an interview with O'Connor on April 17, 1964, Jack Tworkov explained that Diller considered Pollock one of the most talented on the project, looking upon him "as a great hope for American painting."

14. When Valliere asked him about Pollock's political leanings, Kadish replied that he was "definitely left-wing, a liberal." Other than a general feeling for the rights of individuals, however, Kadish remarked, "I don't think he had a keen political consciousness." In her interview with Valliere, Arloie McCoy (Sande's wife) commented, "Jack and Sande helped Siqueiros but I don't think that made them Communists. You must look at the actions within the circumstances of the times. It was virtually impossible not to be concerned with the problems of the day, but a concern doesn't make one active politically." She also noted that the Pollock brothers were "criticized by some who counted how many meetings you attended and the amount of time you spent carrying a poster."

In his dissertation, p. 89, n. 2, O'Connor states that, despite letters which indicate that Pollock attended some Communist meetings in California, his association with the Party was quite tenuous and there is no indication that he was ever a member, although he exhibited one work, *Abandoned Factory* (*CR* 13), at a show at the Communist-sponsored John Reed Clubs.

Letters from Sande to Charles indicate that the two of them also signed Communist Party petitions in the late thirties. For instance, on October 22, 1939 (*CR*, vol. 4, doc. 39, p. 225), Sande wrote about the WPA:

They are dropping people like flies on the pretense that they are Reds, for having signed a petition about a year ago to have the C.P. put on the ballot. We remember signing it so we are nervously awaiting the axe. They got 20 in my department in one day last week. There is no redress. The irony of it is that the real Party People I know didn't sign the damn thing and it is suckers like us who are getting it. I could kick myself in the ass for being a damn fool—but who would of thought they could ever pull one as raw as that. Further more, when they get us in the Army with the notion that we are Reds you can bet they will burn our hides. Needless to say we are rigid with fright.

15. In his unpublished Dartmouth lecture, O'Connor stated that he believes that Pollock's *War* reflects Orozco's mural *After the Battle*, painted for the Gabino Ortiz Library at Jiquilpan in 1940.

16. In Kermit Champa, et al., *Flying Tigers: Painting and Sculpture in New York 1939-1946*, Providence, RI: Bell Gallery, Brown University, 1985, p. 83, John Sawyer made the following comments (which I believe to be much too specific) about *Burning Landscape*:

Besides allusions to Miro's elided portrayal of body and landscape [in *Le Renversement*, 1942], there is a specific reference to Allied aerial warfare in Pollock's painting. This reference is found in the red traces on the left. The flame-like tail terminated in a circle is Miro's motif for fire, for instance, the volcano. But Pollock clarifies his reference in using this shape by making the circle concentrically red, white, and blue, as is the Allied Air Force insignia. If Pollock's red, white, and blue circle is read as a falling aircraft, then the parabolic red curve which starts beside it must refer to the parabolic trajectory of either an aerial bomb or another disabled aircraft.

In this catalogue the forms in *Burning Landscape* are also compared to "the engulfment in fire of huts on small Pacific atolls" (p. 8). Henry McBride, in the *New York Sun*,

December 23, 1949, was to compare the effect of a later Pollock work, *Number 7, 1949*, to "that of a flat, war-shattered city, possibly Hiroshima, as seen from a great height in moonlight."

17. Adolph Gottlieb, "The Ides of Art," *Tiger's Eye*, no. 2, December 1947.

18. Interview with Peter Busa, Charlottesville, VA, October 13, 1979.

19. Robert Motherwell, "The Modern Painter's World," *Dyn*, November 1944, p. 13.

20. After Motherwell implied this in a number of publications, Krasner wrote a letter to the editor of *Art News* on December 13, 1967, to refute him. In the first edition of *American Art Since 1900*, New York: Praeger, 1967, Barbara Rose perpetuated Motherwell's version. The American Surrealist David Hare wrote to Rose on November 22, 1967, to correct this mistake. Copies of these letters are in the Lee Krasner Papers, *AAA*, SI.

21. All quotes by Graham are taken from Allentuck, *Graham's SDA*.

22. These drawings and their relationship to the automatic games Pollock played are discussed at length in Langhorne's "Moon Woman," p. 133 and her dissertation, as well as in Bernice Rose, *Jackson Pollock: Drawing into Painting*, Oxford: Museum of Modern Art, 1979, p. 19.

23. Motherwell's most complete description of these sessions was given in Bryan Robertson, "Interview with Motherwell." Addenda, 1964, The Motherwell Papers, Greenwich, CT. Quoted by Barbara Cavaliere and Robert Hobbs in "Against a Newer Laocöon," *AM*, vol. 51, April 1977, p. 111.

24. Lee Krasner, interview with Wasserman, p. 8, and this author's interview with Ethel Baziotes, New York City, February 21, 1980. Further discussion of these sessions can be found in David Rubin, "A Case for Content: Jackson Pollock's Subject Was the Automatic Gesture," *AM*, vol. 53, March 1979, pp. 103–9.

25. Anecdotes concerning these sessions and Pollock's participation in them can be found in Sidney Simon's "Concerning the Beginnings of the New York School, 1939–1943: An interview with Peter Busa and Matta conducted in Minneapolis in December 1966," *AI*, vol. 11, Summer 1967, pp. 17–20. Busa's remark was made to Melvin P. Lader in an interview, Minneapolis, MN, May 26, 1976. For more information see Nancy Miller, *Matta: The First Decade*, Waltham, MA: Rose Art Museum, Brandeis University, 1982, pp. 18–33.

26. Max Kozloff, "An Interview with Matta," *AF*, vol. 4, September 1965, pp. 25–26.

27. Pollock, *Arts & Architecture*, p. 14.

28. Kozloff, "Interview," p. 25.

29. André Breton, *Manifeste du Surréalisme*, Paris 1924, p. 42. English translation in William S. Rubin, *Dada, Surrealism and Their Heritage*, New York: Museum of Modern Art, 1968, p. 64.

30. See Ashton, *New York School*, p. 115.

31. Horn, "Hollow and Bump," p. 85.

32. O'Connor and Thaw, in *CR*, vol. 4, p. 35, note that "Clement Greenberg states concerning this work: 'Pollock himself dated this painting 1939; I myself would date it a year or two later.... He had split it in two in order to smuggle it out of the premises of the WPA, where he painted it'" (Greenberg to F. V. O'Connor, April 13, 1966).

33. In an interview with Martica Sawin, fall 1985, Busa recalled, "Matta would look at our work and make comments as to what dimension we were reflecting. He also had organic attitudes and was interested in whether you were reflecting a rhythm that would be associated with water or with fire or with rock forms. The things that Pollock did were really outstanding because he had a very natural exuberance about this point of view." Quoted in Sawin, "The Cycloptic Eye, Pataphysics, and the Possible: Transformations of Surrealism," in *The Interpretive Link: Abstract Surrealism into Abstract Expressionism. Works on Paper 1938–1948*, Newport Beach, CA: Newport Harbor Museum, 1986, p. 39.

34. For a complete discussion of this event, see Jeffrey Wechsler, "Surrealism's Automatic Painting Lesson," *AN*, vol. 76, April 1977, pp. 44–47.

35. By 1944, Motherwell summed up his attitude—which was clearly incompatible with Matta's point of view—when he wrote: "The fundamental criticism of automatism is that the unconscious cannot be *directed*, that it presents none of the possible choices, which, when taken, constitute any expression's form." See "Modern Painter's World," p. 13.

36. See Melvin P. Lader, "Peggy Guggenheim's Art of This Century: The Surrealist Milieu and the American Avant-Garde, 1942–1947," Ph.D. dissertation, University of Delaware, 1981, p. 296, n. 4, quoting an interview with Guggenheim, Venice, April 3, 1978.

## SIX: *The Circle Is Broken*

1. Henry McBride's comments were made in a review in the *New York Sun*, clipping from November 1943 in the Pollock Papers, *AAA*, SI. Jewell's remarks appeared in the *NYT*, November 14, 1943. Pollock wrote to Sweeney about his essay: "I have read your forward [*sic*] to the catalogue, and I am excited. I am happy—The self-discipline you speak of—will come, I think, as a natural growth of a deeper, more integrated, experience, Many thanks——We will fulfill that promise—/Sincerely/Pollock." See *CR*, vol. 4, doc. 50, p. 230.

2. See *Time*, "Surrealists in Exile," vol. 39, April 20, 1942, p. 50. Klaus Mann, in "Surrealist Circus," *American Mercury*, vol. 56, February 1943, pp. 174–81, called Peggy "Surrealism's benevolent angel." See Lader, "Guggenheim's Art of This Century," for these and subsequent quotes to the media from Guggenheim about her gallery.

3. See Lader, "Guggenheim's Art of This Century," pp. 163–70. Lader quotes Guggenheim's comment to Hermine Benhaim, made in an interview, March 7, 1966. In this interview, which is part of the Howard Putzel Papers, *AAA*, SI, Guggenheim said:

> I would like to say that Putzel had much more influence over me than I over him. . . . I think he had a great influence in discovering, encouraging, and exhibiting the artists of the abstract American school. As far as I remember he specially admired Pollock . . . Rothko, Gottlieb, Pousette D'Arte [*sic*], Motherwell and Baziotes. . . . He was in a way my master: surely not my pupil.

See also Lader's "Howard Putzel: Proponent of Surrealism and Early Abstract Expressionism in America," *AM*, vol. 56, March 1982, pp. 85–96. In the latter, Lader relates that Putzel told Ronnie Rose Elliott, "I want to show you someone who I think is a very great artist. I found him, and we're [Art of This Century] going to exhibit him: To me, he's one of the best. . . . This is going to be the major artist in this country."

4. In an interview with Lader, Venice, Italy, April 3–6, 1978, Guggenheim stated that in her search for new protégés she listened attentively to both Matta and Putzel on Pollock. Guggenheim noted that "Matta particularly liked Pollock's art and supported no other artist as strongly." See Lader's dissertation, p. 296.

5. After the termination of his WPA position, Pollock heard about Hilla Rebay's program of aid to indigent artists at the Museum of Non-Objective Painting. On April 15, 1943, he wrote to her:

> Dear Baroness ReBay—
> I want to thank you [for interviewing him] and tell you how stimulating and vitally alive I found your criticism yesterday. I have been very interested in the work you have been doing, and the Museum of Non-objective Art, for some time; so I was more than happy to meet you and have you see some of my work. I would like to continue working in this direction, but find it impossible at this time as I am working at night with little energy left for painting and drawing during the day light. It is my wish that you saw, in my work, possibilities of development in the direction of which you spoke; and that through your assistance I may be allowed to continue developing in this direction. I am sincerely yours, Jackson Pollock

As a result of this letter (probably ghostwritten by someone else), Pollock received a check for supplies and was hired to begin work May 8. He resigned July 21 after Peggy Guggenheim offered him a contract. See Joan M. Lukach, *Hilla Rebay: In Search of the Spirit in Art*, New York: George Braziller, 1983, pp. 154–56. John Bernard Myers has noted Pollock's complaints about "the canned music and the craziness of the director" at MNOP. (See Myers, *Tracking the Marvelous: A Life in the New York Art World*, New York: Random House, 1981, p. 81.) Lukach indicates that Rebay was not fond of Pollock or his work.

6. See letter from Pearl Bernstein, Administrator of the Board of Higher Education of the City of New York, to Audrey McMahon, General Supervisor of the War Services Program, dated October 1, 1942, Krasner Papers, *AAA*, SI. A more complete description of this project can be found in Landau, "Krasner's Early Career, Part Two," pp. 80–89.

7. This description by Motherwell, which is found in Sidney Simon, "Concerning the Beginnings of the New York School 1939-1943: An Interview with Robert Motherwell in New York in January 1967," *AI*, vol. 11, Summer 1967, pp. 20–23, is strikingly similar to Whitney Darrow, Jr.'s, description to O'Connor (December 11, 1964) of Pollock working in the desert during the 1930s. Darrow noted, about a trip to California they took together, that in the desert Jackson wanted to use colored crayons which were meant to be moistened: "water being scarce, he spit on them liberally and applied them in a frenzied un-Benton manner." (See O'Connor's dissertation, pp. 42–43.) Motherwell wrote to Valliere about Pollock's collage on August 31, 1964, letter in the Pollock Papers, *AAA*, SI.

8. The psychological implications of this backward writing are discussed in Langhorne's dissertation and in Charles F. Stuckey, "Another Side of Jackson Pollock," *AIA*, vol. 65, November–December 1977, pp. 80–91. It has been suggested that Pollock may have been stimulated by Picasso's 1937 print *Dream and Lie of Franco*.

9. Connelly's review on p. 786. Further information on the first Spring Salon, which included thirty-three artists, can be found in Lader's dissertation, pp. 210 and 378–80.

10. *CR*, vol. 4, doc. 44, p. 228.

11. Robert M. Coates. [Review], *The New Yorker*, May 29, 1943; quoted in O'Connor, *Pollock*, p. 29.

12. In some ways it is surprising that Guggenheim objected so vehemently to *Stenographic Figure* since she owned this equally repulsive figure by Miró. *Seated Woman II* of 1938–39 was shown in the opening exhibition at AOTC, but there is no way of proving that Pollock saw this show. This painting represents a monster-like female with (as described by Barbara Rose) a Ubangi-like neck, tiny pawlike hands, uneven pendulous breasts pointing in different directions, flipper-like appendages and wearing a necklace with a hairy vulva fetish. See Rose, *Miró in America*, Houston: Museum of Fine Arts, 1982, p. 22.

13. Pollock's interest in Miró was undoubtedly further stimulated by his friendship with Putzel, who had begun proselytizing for the Catalan's work in California in the 1930s. In February of 1941 Putzel arranged for a show of works by Ernst and Miró to accompany Gordon Onslow-Ford's lecture series on Surrealism at the New School for Social Research. One wonders if Pollock knew that Miró was also interested in shamanistic practice. The latter's *Harlequin's Carnival* of 1924-25 was supposedly painted under self-induced starvation to approximate a shamanistic state.

14. *CR*, vol. 4, doc. 45–46, pp. 228–29. For Pollock's apprehensions, see the comments of Leland Bell, *TVG*, p. 73.

15. Margery G. Blackie, in *The Patient, Not the Cure: The Challenge of Homeopathy*, Santa Barbara, CA: Woodbridge Press, 1948, pp. 164–65, described Elizabeth Wright Hubbard, who died in 1967, as a famous American homeopath who advised English doctors to note particularly mental and general symptoms first before the strange, rare, and peculiar. Under the beliefs of homeopathy (*similia similibus curentur*), an ill patient would be given the very drug that would give

rise to his symptoms in a well person with the aim of stimulating the diseased organ to heal itself. Homeopaths are particularly interested in a holistic approach, believing that any evaluation of a person's state of health must take into account his mental, emotional, and physical states.

16. David Rubin, "Case for Content," pp. 106–7, notes that a number of Pollock's drawings seem to involve questions about sexual gender. Just like rumors of Pollock's affair with Rita Benton, there have also been periodic rumors that he was a latent homosexual. Stories have surfaced of his having a male affair in Provincetown the summer he was "friendly" with the Tennessee Williams crowd, although he was staying there with Krasner. O'Connor has expressed the opinion (telephone conversation, July 26, 1988) that as a young handsome boy Pollock may have been introduced to male sex when he worked in lumber camps and on surveying gangs with his father. Alfonso Ossorio presents a similar hypothesis in *TVG*, p. 213. See also the comments by Manuel Tolegian on the summer in Santa Ynez, *TVG*, pp. 39–40. Potter, p. 212, notes that talk of Pollock's possible homosexual tendency was popular right after his death. This idea is then discussed by others, pp. 212–14. Fritz Bultman conjectures, p. 214, that "there was such a confusion in Jackson, I think it's probably true that he came close to being asexual."

17. According to Betty Parsons, Pollock's second woman dealer, he needed aggressive women to break through his shyness. She states that he thought most women were terrible bores and that he associated the female with the negative principle. See du Plessix, "Who was ?," p. 55.

18. *CR*, vol. 4, doc. 40, p. 226. Elizabeth Pollock, Charles's first wife, recalls believing that Jackson had been tainted by Stella's "smothering affection for her baby," with the result that he remained frightened of sexual relationships and incapable of tenderness and commitment. (Her rather vehemently negative comments are scattered throughout *TVG*.) As discussed in the text below, at one point in 1942 when he knew his mother was coming to New York to visit, Pollock ended up in the drunk tank at Bellevue Hospital. (See du Plessix, "Who was ?," p. 49.)

19. Descriptions of Stella Pollock by those who knew her, or met her when she visited Jackson, include such adjectives as monolithic, domineering, straitlaced (although it was revealed, in Solomon, p. 17, that Charles was born before her marriage), awesome, purposeful, smothering, dignified, silent, strong-willed, unemotional, and matriarchal. In her biography of Pollock, Solomon writes of Stella (p. 24): "A rigid woman to begin with, she pulled deeper into herself in her husband's absence, internalizing her unhappiness and becoming a remote presence to her children." Solomon conjectures that these deprivations gave Jackson "a weak uncertain image of himself and an unfathomable sense of loneliness." See n. 35 in chapter one, *The Wild One*, for a similar situation in the life of Marlon Brando.

20. Frank Pollock in *TVG*, pp. 21 and 25–26.

21. A typical example of a matriarchal statuette is the limestone *Great Mother Goddess*, made in Cyprus c. 3000–2500 B.C., which is in the collection of the J. Paul Getty Museum, Malibu, CA. O'Connor has suggested the analogy with Orozco's prostitute drawings.

22. *TVG*, pp. 22 and 203. Potter notes that Pollock also said: "Mothers are just the agents, the giants that better turn us loose—or watch out!," ibid., p. 190.

23. In an interview with this author, East Hampton, July 14, 1979, Alfonso Ossorio remarked that when he first met Krasner and Pollock—and for many years after—there was "certainly a sexual thing there . . . certainly an attraction there." Later, after their marriage soured, Pollock could be very cruel to Krasner, making many disparaging remarks in public about her looks.

24. Frank O'Hara, *Jackson Pollock*, New York: George Braziller, 1959, p. 17. See also the writings of Langhorne and David Freke.

25. Proof that Pollock attended the 1941 Miró show at the Modern is found in Paul J. Karlstrom, "Jackson Pollock and Louis Bunce," *Archives of American Art Journal*, vol. 24, no. 2, 1984, p. 27. Karlstrom cites a December 1982 interview between Bunce and Rachel Rosenfeld Lafo, where the former stated, "I remember we [Jackson and I] went to see a big beautiful Miro show at the Modern Museum in '41. It was a dinger. . . ." The "little miracle" quotation was related to this author by George Mercer in a telephone conversation from Boston, MA, October 1, 1979. Works by Krasner, such as her c. 1935–36 painting, *Gansevoort II*, can be compared with such Miró paintings as *Dog Barking at the Moon* of 1926.

26. In *TVG*, p. 56, Reggie Wilson recalls an incident which took place during the 1930s in Bucks County, PA:

As a lot of us were, [Jackson] was very moved by the work of Ryder, and he had a thing about the moon. One night we'd had a couple of beers at that Frenchtown hotel and there was a bright moon. After we'd gone to our rooms we heard a great noise on the roof, so Bernie Schardt and I went out and saw Jackson up there. He was running back and forth along the ridge pole, waving his fists at the moon and shouting, "You goddam moon, you goddam moon!" We talked him down after a while, but we were really scared!

Tony Smith told Valliere in August 1965 that he once saw Pollock pick up a bamboo rod, raise his face to the moon, and using an Indian-sounding tone and meter, begin to utter poetry to it.

27. With regard to Pollock's "Moon-Woman" pictures, Philip Leider has written that he must have seen M. Esther Harding's *Woman's Mysteries: A Psychological Interpretation of the Feminine Principle as Portrayed in Myth, Story and Dreams*, first published in 1935, since its subject—the moon and its bond with women—as well as many of the motifs illustrated in it (the moon swastika, moonstones, etc.) appear in Pollock's work. Leider identifies the following as based on imagery illustrated in the Harding book: *CR* 516 r/v, 518 v, 519 r/v, 521 v, 533 v, 534 v, 571, 581 v, 583 r, 585 r, 588, 615, 616, 722. See Leider's "Surrealist and Not Surrealist in the Art of Jackson Pollock and His Contemporaries," *The Interpretive Link*, pp. 43–44. Also, *Cahiers d'Art*, vol. 12, 1937, pp. 177–80, included several illustrations of *cailloux gravés* by Picasso. These were stones onto which Picasso engraved female faces with half-moon ornamentations.

28. Langhorne, "Moon Woman," pp. 128–37.

29. For instance, see Miró's *Portrait of Mistress Mills in 1750*, 1929, in the collection of the Museum of Modern Art, New York.

30. See David Freke, "Jackson Pollock: A Symbolic Self-Portrait," *Studio International*, vol. 184, December 1972, pp. 217–24. Wolfe, in "Jungian Aspects," rejects a specific reference to the Hiawatha story, stating that it is wiser to remain more general in interpreting this work. See Langhorne, "Moon Woman," and Rubin, "Jungian Illustrator, Part One," pp. 115–16, for further discussion of this issue.

31. Langhorne has interpreted the "Chinese American/ Indian" girl as the moon woman piercing herself with a dagger. She states that the tail-biting snake above the girl's face represents the negative anima, i.e., the Uroboros, which contains both male and female principles as yet undifferentiated. Langhorne relates that in Jungian theory, the great mother must break or cut the uroboric circle of her nature to achieve a higher union of opposites, and interprets the message which runs along the side of this drawing as an attempt to deal with opposites and synthesis. See "Moon-Woman," p. 133.

32. In his interview with Lader, typescript p. 30, Busa described Pollock's attitude toward explaining his art, using *Moon-Woman Cuts the Circle* as an example:

it's underestimated the clarity and the meaning quality of the work. For instance, when Jack did his composition *Moon-Woman Cuts the Circle*, if he had two or three people there, then he could describe his experiences in painting it and the qualities of the many overtones of a painting not being fixed or static, but in the state of becoming. Very much like one thing leads to another. And he used those elements, metaphorically speaking, to represent a whole chain of events in his unconscious. Which is very much like believing in something as a primitive might. In terms of totemism or the symbols that you might make. Not that he made specific symbols, it sort of came out of this.

## SEVEN: *A Whiff of Primal Hordes*

1. Elizabeth Pollock recalled about Jack and his mother that "he used her for years and as his debt to her became greater— a debt she never presented—he despised her. He had a tremendous load of guilt where she was concerned." See *TVG*, p. 61.

2. See Freke, "Symbolic Self-Portrait," p. 217, and Wolfe, "Jungian Aspects," p. 69.

3. Trying to establish exactly when Pollock met Rothko and Gottlieb has not been easy. It is probable that they became acquainted within the context of Art of This Century. Putzel reportedly admired Rothko's work and tricked Guggenheim into giving him a show, which was held January 9–February 4, 1945. Krasner related that she and Pollock helped Putzel plan a party where the walls were all hung with Rothkos so that the reaction of the guests would persuade Peggy he was

worthy of an exhibition. In a letter to this author dated June 21, 1987, Joseph Solman, an early and close friend of Rothko and Gottlieb, confirmed that they did not know Pollock in WPA days (Rothko and Gottlieb were on the Project for a very short time); nor were they acquainted at the time of the 1943 letter to *The New York Times*, which was cowritten by Barnett Newman, although his name was not on it. (See Ashton, *New York School*, p. 127.)

4. Their carefully worded text protested a negative review by critic Edward Alden Jewell of paintings Rothko and Gottlieb had submitted to a recent group exhibition. This letter has come to be regarded as constituting the first and only "manifesto" for those who would soon be grouped together as the Abstract Expressionists. Although Pollock and Krasner traveled in different circles from Rothko, Gottlieb, and Newman, it is remarkable how closely their ideas agree. The letter is reprinted in ibid., p. 128.

5. Allentuck, *Graham's SDA*, p. 171.

6. Greenberg, "Art," *The Nation*, vol. 157, November 27, 1943, p. 621.

7. The two drawings related to *Pasiphaë* are *CR* 670 and *CR* 677.

8. See William Rubin, "Notes on Masson and Pollock," *AM*, vol. 34, November 1959, pp. 38–43, and Rubin, "Jungian Illustrator, Part Two," pp. 73–74.

9. Extensive discussion of this is found in Evan R. Firestone, "Herman Melville's *Moby-Dick* and the Abstract Expressionists," *AM*, vol. 54, March 1980, pp. 120–24. Firestone points out how frequently connections have been made between Ahab and Prometheus.

10. Jung, *Modern Man in Search of a Soul*, pp. 154–55. Jung rhapsodizes over the fact that Melville was unconscious of the "groundwork of implicit psychological assumptions" of his tale.

11. Ishmael's complete quotation reads, "Whenever I find myself growing grim about the mouth; whenever it is a damp, drizzly November in my soul; whenever I find myself involuntarily pausing before coffin warehouses, and bringing up the rear of every funeral I meet; . . . then, I account it high time to get to sea as soon as I can. This is my substitute for pistol and ball." See Firestone, "*Moby-Dick*," p. 124, n. 29. Information on this was provided to Mona Hadler by Ethel Baziotes. Additional artists interested in Moby Dick in the forties include Seymour Lipton, Theodore Roszak, Paul Jenkins, and Theodoros Stamos.

12. Tennessee Williams wrote to Donald Windham in July 1944 that "Joe Hazen is very wild and sexlessly beautiful in the lamp-light reading 'Moby Dick' and passages from his novel aloud in that voice which is almost like the language of apes." See Williams, *Letters*, p. 144. B. H. Friedman's assessment is found in *TVG*, p. 224.

13. Greenberg, *The Nation*, November 27, 1943, p. 621. It is not surprising that Pollock was attracted to Melville's prose. As Lewis Mumford has pointed out, "It is in the very rhythm of his language that Ahab's mood, and all the devious symbols

of Moby-Dick are sustained and made credible: by no other method could the deeper half of the tale have been written." See *Twentieth Century Interpretations of Moby-Dick*, ed. by Michael T. Gilmore, Englewood Cliffs, NJ: Prentice-Hall, 1977, p. 77. (I am indebted to Malinda Smyth for pointing this passage out to me.) It is also not surprising that Pollock sensed a kinship with Melville similar to his feelings for Ryder. Melville also suffered acute psychic distress and his works were similarly labeled careless, disordered, and in bad taste. See Edward I. Edinger, *Melville's Moby-Dick: A Jungian Commentary*, New York: New Directions, 1978, p. 13.

14. Wolfe, "Jungian Aspects," p. 68, suggests that Pollock derived its structure from the ground plan and post-and-lintel elevation of a Greek temple. Freke, in "Symbolic Self-Portrait," p. 220, invokes Jung's description of the sacred cave in the temple at Cos: "a rectangular pit covered by a stone slab with a square hole in it."

15. See Jeannette Low, "Lo, the Rich Indian: Art of the American Aboriginals," *AN*, vol. 39, February 1, 1941, p. 7, for this prehistoric New Mexican bowl. Extensive discussion of the American Indian contribution to *Guardians* is found in Rushing, "Ritual and Myth," p. 286. Rushing's suggestion that the composition of *Guardians* is a conflation of two illustrations accompanying an article on the Indians of Zia Pueblo found in one of Pollock's Smithsonian Bureau of Ethnology Reports (#11, 1894) is not visually convincing, and it minimizes the truly archetypal and symbolic nature of Pollock's painting.

16. Francis V. O'Connor, in *The Black Pourings: 1951–1953*, Boston, MA: Institute of Contemporary Art, 1980, p. 9, postulates the importance of the color black in Pollock's oeuvre as based on facts gleaned in a statement made to him by Mrs. Marvin Jay Pollock, June 27, 1973, that Jack was born choked by his cord, and according to his mother was "as black as a stove" (*CR*, vol. 4, p. 203). Other members of the family have discounted both Pollock's own knowledge of this fact and its potential importance for his work (interview with Charles Pollock, October 26, 1987).

17. Pollock's passport, issued July 2, 1955, but never used, indicates that his right index finger was partly missing. Frank Pollock told the story of its loss in *TVG*, p. 24. See also Horn, "Hollow and Bump," p. 82. Charles Pollock (interview, October 25, 1987) identified the Porter brothers, neighbors and distant relatives of their father, as the protagonists in this event. This family had come to Phoenix from New Orleans, and according to Charles, Jack and these boys liked to dare each other and test their skills. For other retellings of this story see Friedman, *Energy*, p. 6, and Solomon, p. 33. Its implications are discussed at length in Stuckey, "Another Side," p. 87.

18. In *TVG*, p. 24, Frank Pollock relates, "Slaughtering was a distasteful business. In Phoenix mother would wring a chicken's neck or tie the bird to a clothesline by the feet, then grab the head and cut the neck. I made a frightful job of chopping a chicken's head off—awful."

19. See Willard E. Misfeldt, "The Theme of the Cock in Picasso's Oeuvre," *AJ*, vol. 28, no. 2 (Winter 1968–69), pp. 146–54, 165.

20. During the 1930s and 1940s in the basement of the Metropolitan Museum of Art, in wing H, vignettes from the Book of the Dead were exhibited among the mummy cases and papyri on view. One, illustrated in the Met's publication *A Guide to the Collections, Part I, Ancient and Oriental Art*, 1934, p. 11, shows Anubis weighing the symbol of truth with the heart of Princess Entiu-ny. Since Pollock frequented the Metropolitan, it is highly likely that he knew this work. The Papyrus of Ani, owned by the British Museum and frequently reproduced, shows a more totally canine Anubis prone on top of a casket in a pose very similar to Pollock's dog in *Guardians*.

A similar dog appears in an oil and gouache with pen and ink drawing on paper of 1942 (*CR* 961). Although he loved them, Pollock had very specific and eccentric ideas about dogs. He told Jeffrey Potter that dogs have a high charge of psychic energy and that they shouldn't sleep on your bed or they might "drain your astral body" (*TVG*, p. 168). As we know, one of Pollock's dogs, a large poodle acquired from Alfonso Ossorio, was called Ahab. Another, a cross between a Newfoundland and a Labrador, was named Gyp—probably after a childhood pet. Gyp, Krasner once pointed out, was not short for gypsy but for gypsophila, a flower. Rubin, "Jungian Illustrator, Part Two," pp. 117–20, discusses all of the various interpretations given the dog in *Guardians* by other writers, as well as Pollock's attachment to his own dogs and one of his dreams about them, which he illustrated in a late drawing, *CR* 897.

21. A small (8¼ x 9¼") composition with collage elements (*CR* 100), which is in the collection of the Shoenberg Foundation, Saint Louis, Missouri, seems to be related to the central panel of *Guardians*.

22. A bit later, this chart also had an impact on Krasner's paintings. A narrow black and white Little Image series painting in the collection of Robert U. Ossorio is typical of the hieroglyph type of Little Image she created in the late 1940s. These works were covered with a persistent repetition of tiny proto-alphabetic forms resembling cuneiform or other ancient writing systems.

23. See Andrew Kagan, "Paul Klee's Influence on American Painting: New York School," *AM*, vol. 49, June 1975, p. 85, and Caroline Lanchner "Klee in America," *Paul Klee*, New York: Museum of Modern Art, 1987, pp. 83–108. Clement Greenberg has pointed out that, in the thirties, "almost everybody, whether aware of it or not, was learning from Klee, who provided perhaps the best key to Cubism as a flexible, general, 'all-purpose' canon of style." (See his "New York Painting Only Yesterday," *AN*, vol. 56, Summer 1957, p. 84.) Krasner, however, recalled that she and Pollock felt antagonistic toward the works in the Modern's 1941 Klee retrospective (interview, October 30, 1979).

24. In *TVG*, p. 72.

25. Complete discussion of this is found in Firestone, "*Moby-Dick*." The central panel in *Guardians* seems to illustrate Dr. de Laszlo's comment that, in Pollock's drawings and paintings of the forties, archetypal elements seem to "swim to the surface only to sink back again into the unconscious."

26. Carl Gustav Jung, *Psychology of the Unconscious: A Study of Transformations and Symbolisms of the Libido*, trans. by Beatrice M. Hinkle, New York: Moffat, Yard and Company, 1916, p. 5.

27. Hess, "Art of a Myth," p. 63.

28. *CR*, vol. 4, doc. 50, p. 230.

29. In *Modern Man*, pp. 69–70, Jung wrote that he encouraged a patient to draw or paint because "at first he puts on paper what has come to him in fantasy, and thereby gives it the status of a deliberate act. He not only talks about it, but he is actually doing something about it." "The discipline of drawing," Jung remarked, "endows the fantasy with an element of reality, thus lending it greater weight and greater drawing power." A patient "can give form to his own inner experience by painting it. For what he paints are active fantasies—it is that which activates him."

30. The Stroup clipping, "Time Out," from *Town & Country*, labeled "March/April 1945" in the scrapbook Pollock and Krasner kept, can be found in the Pollock Papers, *AAA, SI*.

31. Krasner confirmed that both she and Pollock were aware of Paalen's writings and *Dyn* magazine, in a letter to Robert Saltonstall Mattison, June 28, 1979. See Mattison, *Robert Motherwell: The Formative Years*, Ann Arbor: UMI Research Press, 1987, p. 225, n. 25. As we have seen, Pollock's *Moon-Woman Cuts the Circle* was illustrated in *Dyn* in November 1944.

32. Pollock apparently met one of his great heroes, Miró, at Atelier 17. However, as Miró told Barbara Rose in 1981, "Pollock and I would greet each other, but we could not have a conversation because he only spoke English and my English is very poor. I did not really know his work until I saw the black and white show at Facchetti in Paris in 1951. It was stunning—really bold and impressive." See "Interview with Miró," *Miró in America*, p. 120.

33. L[ane], "Mélange," p. 29.

34. Friedman, in *Energy*, p. 65, retells a story about Pollock's perversity that Krasner delighted in relating throughout her life. Mercedes and Herbert Matter brought the sculptor Alexander Calder to Pollock's studio in 1943. Calder studied Pollock's paintings, such as *The She-Wolf*, and said, "They're all so dense." Pollock replied, "Oh, you want to see one less dense, one with open space?" When Calder said yes, Pollock brought out "the densest painting he had." See also du Plessix, "Who was ?," p. 51.

35. Motherwell, in "Artists' Symposium, Part One," p. 66, recalls that it seemed to him that Pollock wanted to paint in the manner of Picasso, and then at a certain point started to become angry that "it came out too Picassoid." With "compulsive violence," Motherwell relates, Pollock then "splashed" this image out.

36. See Friedman, *Energy*, pp. 76–77, for critical reactions to Pollock's second one-man show.

37. Farber, "Jackson Pollock," *New Republic*, June 25, 1945, pp. 871–72.

38. Greenberg, "Art," *The Nation*, vol. 157, November 27, 1943, p. 621.

39. Greenberg, "Art," *The Nation*, vol. 160, April 7, 1945, p. 396. Gertrude Stein's similar comment, found in *What are Masterpieces?*, Los Angeles: Conference Press, 1940, p. 29, is cited by Ellen Johnson in "Jackson Pollock and Nature," *Studio International*, vol. 185, June 1973, pp. 259 and 261, n. 18.

## EIGHT: *Acceptance and Transition*

1. *CR*, vol. 4, doc. 44, p. 228.

2. See Greenberg, "Present Prospects of American Painting and Sculpture," *Horizon*, vol. 16, October 1947, p. 26.

3. See Matthew Rohn, "Visual Dynamics in Jackson Pollock's Abstractions," Ph.D. dissertation, University of Michigan, 1984, p. 133, n. 28, citing a November 1979 interview with Greenberg. For an interesting discussion of the heroic and intuitive ramifications of the term "Gothic," see Gibson, "Theory Undeclared," pp. 215–16.

4. Rushing, "Ritual and Myth," p. 285, suggests correctly that Pollock created *Mural* in a shamanistic manner. However, Rushing's firm statement that *Mural* was based on a prehistoric Hohokam pottery bowl in the Modern's 1941 Indian Show has no visual or documentary proof to back it up. His assertion that Pollock "no doubt recognized the painted figure on the Hohokam bowl as being the Kachina . . . Kokopelei, a humpbacked flute player associated with fertility" has no factual basis. Indeed, Pollock's knowledge of specific Indian myths does not seem to have been extensive; his appreciation of Indian culture was related to its general spirit. Thus, it seems highly unlikely that Pollock consciously created in *Mural* a rhythmic line of black humpbacked flute players who dance from left to right with female figures clinging to their backs. In fact, the visual similarity of the wavy stick figures in *Mural* is much closer to Miró's *personnage* paintings of the mid-1930s, with which we know Pollock was familiar.

5. For discussion of Pollock's debt to Benton in *Mural*, see Stephen Polcari, "Jackson Pollock and Thomas Hart Benton," *AM*, vol. 53, March 1979, pp. 120–24.

6. Allentuck, *Graham's SDA*, p. 165.

7. Ibid., p. 115. There Graham wrote that "*Minimalism* is the reducing of painting to the minimum ingredients for the sake of discovering the ultimate, logical destination of painting in the process of abstracting."

8. See Barbara Rose, "Jackson Pollock at Work: An Interview with Lee Krasner," *PR*, vol. 47, no. 1, 1980, p. 90.

9. Ernst described his method of *coulage* this way:

   It's a children's game. Attach an empty tin can to a thread a meter or two long, punch a small hole in the bottom, fill the can with paint liquid enough to flow freely. Let the can swing from the end of the thread over a piece of canvas resting on a flat surface, then change the direction of the can by movements of the hands, arms, shoulder and entire body. Surprising lines thus drip upon the canvas. The play of association then begins.

   See William S. Lieberman, ed., *Max Ernst*, New York: Museum of Modern Art, 1961, p. 20.
   Ernst was apparently not the only one to do this. A letter dated December 13, 1978, from Mrs. Seymour Fogel to Francis V. O'Connor described how Charles Chapman, an instructor at the National Academy of Design in the early thirties, "punctured small cans of commercial enamels and dripped colors on a small board already coated with white. After each dripping—yellow, red, blue—he tilted the board this way and that so colors formed graceful linear patterns." Mrs. Fogel said that her husband, Sy, who attended these classes, felt that Chapman ruined the work by trying to form these accidental effects into representational images. She also pointed out that Lee Krasner was at the Academy when Chapman taught there. ( I am indebted to O'Connor for providing me with a copy of this letter.)

10. In *TVG*, p. 98, Hayter told Potter:

    There must have been hundreds of drip works at Atelier 17, and I wrote about unconscious drawing and how it can be developed. Jack and I talked about this sort of thing. . . . Among our tricks was a well-known one, the compound pendulum. A paint can is hung on two strings tied together, which is a classic example of discontinuous cyclic motion (it winds up and down again). The machine is childishly simple—just a can with a drip—and if you let it go, it makes an amusing pattern. Left long enough, it winds up making a disc or doughnut; but interrupt it and you get extraordinary and beautiful shapes.

11. See Ann Hoene, "The Origins of Jackson Pollock's Style," M.A. thesis, New York University, 1967, pp. 58–60. Although Hofmann's dripped painting *Spring* has typically been dated 1940 and two others are also supposed to be early—*Wind*, 1942, and *Fantasia*, 1943—Cynthia Goodman recently pointed out that probably none of these was done before 1944. They were most likely dated after the fact, and may reflect knowledge of Pollock's early drip paintings shown in his first exhibition at AOTC. See Cynthia Goodman, *Hans Hofmann*, New York: Abbeville Press, 1986, pp. 45, 49–52, and 106, n. 52.

12. See B. H. Friedman, "An Interview with Lee Krasner Pollock," *Jackson Pollock: Black and White*, New York: Marlborough-Gerson Gallery, 1969. For a complete discussion of the argument surrounding this remark, see David Rubin, "Case for Content," p. 103, and William Rubin, "Jungian Illustrator, Part Two," pp. 83–86.

13. See Rodman, p. 82.

14. See Maude Riley, "Review," *Art Digest*, vol. 19, April 1, 1945, p. 59. In February 1932, Pollock wrote to his father: "I've got a long way to go toward my development—much that needs working on—doing every thing with a definite purpose—without a purpose for each move—thers [*sic*] chaos. . . . [I'm] in such a turmoil" (*CR*, vol. 4, doc. 12, p. 212). Thus, even at this early point Pollock abhorred the thought of "chaos." Therefore, it is not surprising that he

objected strongly to *Time*'s picking up selected bits of Italian critic Bruno Alfieri's commentary from *L'Arte Moderna*. There Alfieri wrote:

> It is easy to detect the following things in all of [Pollock's] paintings:
> Chaos.
> Absolute lack of harmony.
> Complete lack of structural organization.
> Total absence of technique, however rudimentary.
> Once again, chaos.

See "Chaos, Damn It!," *Time*, vol. 56, November 20, 1950, pp. 70–71, and Pollock's response in "Letters to the Editor," ibid., December 11, 1950, p. 10.

15. O'Hara, *Pollock*, p. 19.

16. A network of string is frequently a metaphor for the connection between the conscious and unconscious mind. Since the Minotaur, who lived in a labyrinth, symbolizes the unconscious, Ariadne's thread—the means by which Theseus made his way out of the labyrinth—has taken on the opposite connotation in psychological literature.

17. See Rose, *Drawing into Painting*, pp. 21–22.

18. That Pollock may have been drawn to Kandinsky because of their similar Theosophist beliefs (Kandinsky's thoughts along these lines were highlighted in an article in the *Art News* issue of April 1, 1945) is not impossible to imagine. Fritz Bultman and John Little have both confirmed Krasner's awareness of Kandinsky's interest in Theosophy. All four were appalled by the "spiritualist diagrams" of Rudolph Bauer, favored in the Solomon R. Guggenheim collection because of the Baroness von Rebay's personal relationship with this artist. For a complete discussion of the possible influence of Kandinsky on Pollock see (Sandra) Gail Levin, "Wassily Kandinsky and the American Avant-Garde, 1912–1950," Ph.D. dissertation, Rutgers University, 1976, and her "Miró, Kandinsky and the Genesis of Abstract Expressionism," *Formative Years*, pp. 27–40.

19. "The Passing Shows," *AN*, vol. 44, April 1–14, 1945, p. 6.

20. Pollock to Bunce, postmark June 2, 1946. See Karlstrom, "Pollock and Bunce," p. 26.

21. Friedman, *Energy*, p. 82. Krasner has retold this story many times.

22. Interview with May Rosenberg, February 22, 1980. Pollock's father had been against organized religion because his own stepmother had been such a religious fanatic. He did write to Jack on September 19, 1928: "I think your philosophy on religion is O.K. I think every person should think, act & believe according to the dictates of his own conscience without to [*sic*] much pressure from the outside. I too think there is a higher power a supreme force, a Govener [*sic*], a something that controls the universe. What it is & in what form I do not know." (See *CR*, vol. 4, doc. 3, p. 206.) In du Plessix, "Who was ?," p. 50, Krasner said, "When we were married Jackson wanted a church wedding; *not me. He* wanted it and we had it. Jackson's mother, in fact all the family, was anti-religious—that's a fact. Violently anti-religious. I felt that

Jackson, from many things he did and said, felt a great loss there. He was tending more and more to religion. I felt that went back to his family's lack of it." (Rumors have circulated that Pollock, in the last years of his life, was considering converting to Catholicism.)

23. Rose interview with Krasner, March 1972, typescript, p. 8.

24. *CR*, vol. 4, doc. 61, p. 236.

25. [Roueché], "Unframed Space," p. 16.

26. *CR*, vol. 4, doc. 62, p. 237.

27. Interview with Carol Braider, Southampton, New York, July 18, 1979.

28. Pollock to Bunce, June 2, 1946, in Karlstrom, "Pollock and Bunce," p. 24. Daniel Miller's remarks were made to James Valliere.

NINE: *Sounds in the Grass*

1. Parsons, quoted in du Plessix, "Who was ?," p. 55.

2. Pollock was living next door to Hans Hofmann on Eighth Street, but as we have noted, the two had not become acquainted on their own. In a number of interviews and articles Krasner described the meeting, which she arranged, relating that, to her dismay, Hofmann said to Pollock, "You are very talented. You should join my class." Hofmann looked at Pollock's palette, and tried to pick up a brush; the whole can came up with it, causing the older artist to comment, "With this you could kill a man." He then said to Pollock, "You do not work from nature. This is no good, you will repeat yourself. You work by heart, not from nature," whereupon Pollock replied defensively, "I *am* nature." (The exact words of this anecdote were taken from an undated interview between Krasner and Barbara Rose, p. 10 of typescript.)
  Hofmann seems to have been affected by Pollock's attitude. Some years later, he remarked to Elizabeth Pollett about the 1930s, "Then I was still under nature: I too am a part of nature: my memory comes from nature, too." See *AM*, vol. 31, May 1957, p. 30. In the 1960s, Hofmann wrote in the preface to an unpublished painters' manual (a typescript of which is in the library of the Museum of Modern Art), "Nature—we ourselves are nature—how can we ever deny it?"

3. Ossorio, quoted in du Plessix, "Who was ?," p. 58.

4. In 1944 in *Arts & Achitecture* Pollock noted that, on the East Coast, only the Atlantic Ocean gives a sense of horizontality like the plains of the West. See *CR*, vol. 4, doc. 52, p. 232. Jeffrey Potter's remarks about Pollock "feeling as right as he could" are found in *TVG*, p. 175. In du Plessix, "Who was ?," p. 52, Tony Smith describes how Jackson felt possessed by his feelings for his land, his sense of identity with it, and his desire to "establish himself upon it." Smith commented of Pollock, "When he walked in the fields, it was as if he had his head in the weeds. He used to find things in them. When he looked up, it would be with a sweep of his head and eyes. He was conscious of looking up at the sky;

looking down, he was relaxed and could be quite passive." It was Smith's opinion that Pollock's working on the floor had a great deal to do with the strong bond he felt with the elements.

5. See Ellen Johnson, "Pollock and Nature," p. 259, where Johnson quotes a conversation with Krasner that took place on October 22, 1971, in which she said that Pollock gave these paintings their titles.

6. Gail Levin has expressed the opinion that works like *The Key* are closer to Kandinsky's paintings of the 1920s, such as *Deep Brown* of 1924 in the collection of the Solomon R. Guggenheim Museum. For her discussion, see *Formative Years*, pp. 100–101.

7. Greenberg discussed the impact of Matisse's "aerated" surfaces on American artists in "Influences of Matisse," *AI*, vol. 17, November 1973, p. 28. There Greenberg noted that "What should be noticed is how Matisse laid on and stroked varying thinnesses of paint so that the white ground breathed as well as showed through. But even when he laid his paint on evenly or more densely, or when he used a palette knife—which was seldom—the paint surface would still manage to breathe." Krasner had adapted this aspect of Matisse to her own purposes when she painted in front of the still lifes set up at the Hofmann School in the late 1930s. See Landau, "Pushing in Different Directions," pp. 110–22. The only influence Krasner would ever admit she had on Pollock was to introduce him to the art of Matisse.

8. In her dissertation, pp. 339–40 and 346, Langhorne interprets the implied circle "after-image" in *Shimmering Substance* as a Jungian mandala superimposing order on the chaos of the libido; i.e., it represents the state of individuated selfhood toward which Pollock had been striving since the late thirties. In "Jungian Illustrator, Part One," pp. 113–15, Rubin counters Langhorne's interpretation of this work as a psychological conclusion with his own theory that it represents an artistic transition.

9. *CR*, vol. 4, doc. 102c, p. 264.

10. Peggy Guggenheim was to describe in her memoirs that she felt that Pollock later minimized her role in making him a star. A letter in the Greenberg Papers, *AAA*, SI, written to Clement Greenberg on February 12, 1958, expresses her bitterness and resentment. Guggenheim wrote:

> Thank God Lee Pollock was not with me as you thought when Pollock died. I should have felt terrible to have had to break the news to her as you intended me to do. At that time i [*sic*] did not want her to come here. I felt that she and Pollock minimized what i had done for him. This fact is perpetually cropping up and i am more & more convinced of it. hence this letter.

There was even more bitterness between Guggenheim and Krasner when Guggenheim unsuccessfully sued Pollock's estate for the return of works she thought were due her under the terms of his contract.

11. Letter to Bunce postmarked August 29, 1947, in the collection of the *AAA*, SI. See Karlstrom, "Pollock and Bunce," p. 24.

12. Greenberg, "Art," *The Nation*, vol. 164, February 1, 1947, pp. 136–38, 139.

13. *CR*, vol. 4, doc. 67, p. 238.

14. *CR*, vol. 4, doc. 71, p. 241.

15. Aline Louchheim, "ABC (or XYZ) of Abstract Art," *NYTM*, July 11, 1948, p. 16. Coates's review appeared in the January 17, 1948, issue.

16. A[lonzo] L[ansford], "Automatic Pollock," *Art Digest*, vol. 22, January 15, 1948, p. 17.

17. Greenberg, "Art," *The Nation*, vol. 164, May 3, p. 525.

18. In two telephone conversations, December 20, 1987, and July 3, 1988, O'Connor discussed with me how *Galaxy*, as well as *Number 5, 1950* (now in the collection of the Cleveland Museum of Art) and *Sea Change*, 1947, may have been painted over three of the eight unlocated works from 1945 described in *CR*, vol. 1, p. 132. All are known only from AOTC catalogue citations in 1945, 1946, or 1947. With the help of William Robinson of the Department of Modern Art and Bruce Miller of the Conservation Department of the Cleveland Museum of Art, on July 6, 1988, I examined X rays of *Number 5, 1950*, and looked at the painting under a raking light. It does seem likely that the currently visible marks were dripped and poured over a previously brushed composition. The impasto patterns revealed by the raking light are consistent with the forms Pollock created in the works made just prior to and including the Accabonac Creeks.

19. See *CR*, vol. 4, doc. 72, p. 241; doc. 89, p. 253; and doc. 87, p. 251.

20. Busa quoted in *TVG*, p. 101.

21. *CR*, vol. 4, doc. 100, p. 262.

22. See [Roueché], "Unframed Space," p. 16. For a description of Siqueiros's approach to the mural as an architectural environment, see Hurlburt, "Experimental Workshop," p. 238.

23. See Evan R. Firestone, "James Joyce and the New York School," *AM*, vol. 56, June 1982, p. 117.

24. Quoted from James Joyce, *Ulysses*, New York: Random House, 1934, p. 50.

25. "Ariel Sings," *Tiger's Eye*, No. 2, 1947.

26. This is the only Joyce record currently in the house, but according to Parsons, Pollock frequently talked about Joyce. See du Plessix, "Who was ?," p. 55. Putzel is said to have listened for hours to rare recordings he had acquired in Paris of Joyce reading *Ulysses*. This information was relayed by Mrs. Darrel Austin to Melvin P. Lader. (See Lader, "Putzel," p. 95, n. 10.) Ossorio also mentions Pollock's love for Joyce's recordings in "Who was ?," p. 58.

27. See Firestone, "Joyce and the New York School," p. 117, quoting a discussion of Claude Lévi-Strauss in Margot Norris, *The Decentered Universe of Finnegans Wake*, Baltimore and London: Johns Hopkins University Press, 1974, p. 130. Lévi-Strauss describes the primitive *bricoleur*. *Bricolage* in art refers both to the combination of fragments of quotation from other works in a new piece, and to the use of found objects and fragments of literal material in a work of art. See Michael Newman, "Revising Modernism, Representing Postmodernism," *ICA Document 4: Postmodernism*, ed. by Lisa Appignanesi, London: Institute of Contemporary Art, 1986, pp. 45–46, for a more complete discussion of this artistic technique and its updated usages. Firestone, in "Joyce and the New York School," p. 117, fully analyzes its effect on Pollock.

28. Greenberg, "Avant-Garde and Kitsch," *PR*, vol. 6, Fall 1939, pp. 34–49. Reprinted in John O'Brian, ed., *Clement Greenberg: The Collected Essays and Criticism*, vol. 1, Chicago and London: University of Chicago Press, 1986, p. 10.

29. With reference to Pollock's incorporation of found materials in *Full Fathom Five*, it is interesting to read Horn's description of Pollock working in the Benton class ("Hollow and Bump," p. 83). Horn points out that Jack's early paintings were "tortuous with painfully disturbed surfaces. In his efforts to win these contests [with his paint], he would often shift media in mid-painting. . . . In his frantic efforts at realization, he would use anything within reach."

30. Peggy Guggenheim owned and exhibited several of Schwitters's *Merz* pieces in her apartment and gallery. The one illustrated in *Art of This Century, Objects, Drawings, Photographs, Paintings, Sculpture, Collages 1910 to 1942*, New York: Art of This Century, 1942, pp. 108–9, is typical. Pollock and Krasner also knew Guggenheim's first husband, Laurence Vail, and were acquainted with his works: ordinary bottles covered with montaged photographs and closed with bizarre stoppers encrusted with found objects such as bits of plaster, cork, plastic, celluloid, rubber, etc. These were exhibited at AOTC in 1942 and 1945.

31. See Landau, "Krasner's Early Career, Part Two," pp. 83–87, and Cindy Nemser, "Lee Krasner's Paintings, 1946–49," *AF*, vol. 12, December 1943, pp. 61–65.

32. See Robertson, *Pollock*, p. 96. In the winter of 1949/50, Pollock and Krasner experimented with making clay pots and molding clay with their friends Rosanne and Lawrence Larkin. (See *CR*, vol. 4, p. 120.) In 1949, Pollock exhibited a painted terra-cotta sculpture (*CR* 1053) in "Sculpture by Painters," at the Museum of Modern Art, and two years later he showed *CR* 1054 in a similar exhibition at the Peridot Gallery. These were his only real forays into three-dimensional work after his move to The Springs. For descriptions by Krasner and Ossorio of Pollock's desire to sculpt, and his collection of materials for this purpose, see du Plessix, "Who was ?," pp. 51 and 58.

Ossorio later made his own artistic reputation by fabricating "paintings" out of a large variety of unexpected materials and disparate objects, and the influence of Pollock on these has been frequently remarked. Ossorio, however, also admitted to being impressed by Krasner's mosaic tables (interview, July 17, 1975). See B. H. Friedman, *Alfonso Ossorio*, New York: Harry N. Abrams, 1972.

33. *CR*, vol. 4, doc. 12, p. 212.

34. Seligmann, "Magic Circles," *View*, No. 1, February–March 1942, p. 3.

35. This "weird-looking device" Krasner described as based on a series of glass jars and retorts connected by rubber tubes used to test the amount of hydrogen in an explosive. She observed its form and function on Tuesday, May 26, 1942, when visiting the laboratory of a class in the study of explosives. Her window display entitled "Chemistry of Explosives" features a photograph of this device in the center. See Krasner Papers, *AAA*, SI.

36. See Jonathan Welch, "Jackson Pollock's 'The White Angel' and the Origins of Alchemy," *AM*, vol. 53, March 1979, pp. 138–41. In addition to Welch, David Rubin, Langhorne, and Wolfe have also discussed alchemical associations in Pollock's work.

37. See Eugene Jolas, "Homage to the Mythmaker," *transition*, vol. 27, April–May 1938, p. 169. (This was cited by Elizabeth Langhorne in her dissertation.)

38. It is interesting that, in Jung's *Man and His Symbols*, London: Aldus Books Ltd., 1964, p. 264, parallels were noted between Pollock's poured paintings and alchemy: "In their lack of structure they are almost chaotic, a glowing lava stream of colors, lines, planes and points. They may be regarded as a parallel to what the alchemists called the massa confusa, the prime material. . . . Pollock's pictures *represent* the nothing that is everything—that is the unconscious self."

39. In *CR*, vol. 1, p. xiv, Thaw notes that the fact that Pollock may have associated different colors with different types of expression is borne out by a small annotated pencil sketch of c. 1939–40. In this notation concerning a crucifixion (possibly *CR* 940, given to Dr. Henderson) Pollock quoted Jung's four functions, associating each with a color: red for emotion or feeling; black (crossed out) or green with sensation; yellow with intuition; and blue with thinking. Whether he made the alchemical associations Manheim must have noticed cannot be determined.

40. The *Life* Round Table on Modern Art and the comments made about Pollock are discussed in more detail in Corlett, "Media and the Myth," pp. 79–84.

41. Russell W. Davenport and Winthrop Sargeant, "A Life Round Table on Modern Art," *Life*, vol. 25, October 11, 1948, p. 78.

42. Ibid., p. 62.

43. Robert Rosenblum, "The Abstract Sublime," *AN*, vol. 59, February 1961, p. 56.

44. See Harold Rosenberg, "The Art World—The Mythic Act," *The New Yorker*, vol. 43, May 6, 1967, p. 169.

## TEN: *States of Order*

1. Robert W. Elson, *The World of Time Inc.: The Intimate History of a Publishing Enterprise*, ed. by Duncan Norton-Taylor, vol. 2, New York: Atheneum, 1973, p. 422, n. 8.

2. According to Krasner, Pollock saw Dr. Heller—who was a general practitioner, not a psychiatrist—every week at the East Hampton Medical Clinic, where they mostly just talked.

Pollock told Krasner that he listened to Heller because Heller was "an honest man." See du Plessix, "Who was ?," p. 48. Solomon, *Pollock*, p. 190, disputes Jackson's having been put on tranquilizers by Dr. Heller.

3. *CR*, vol. 4, doc. 90, p. 253.

4. Interviews with Arnold Newman and Rudolph Burckhardt, both in New York City, March 8, 1988. Burckhardt confirmed that Pollock was later upset that he agreed to actually paint for Namuth's camera. In Rose, "Pollock at Work," pp. 91–92, Krasner noted that Pollock said being photographed made him uncomfortable, and she commented that his allowing it was "entirely contrary to his nature."

5. Ossorio, quoted in *TVG*, p. 209, and Potter, recalling Pollock's words, *TVG*, p. 129.

6. It is interesting to compare Pollock's method with Miró's comments about his own way of approaching art. See Rose, ed., *Miró in America*, p. 12.

7. Namuth shot his photos with two Rolleiflexes with 80-mm lenses. That some are blurred is the result of a defect in one of the two cameras and the relatively slow shutter speeds he used (1/25 and 1/50 of a second). See Namuth, "Photographing Pollock," in *Pollock Painting*, New York: Agrinde, 1978, for further description of these sessions.

8. See Friedman, *Energy*, p. 162, quoting Hans Namuth, "Jackson Pollock," *Portfolio, The Annual of the Graphic Arts*, Cincinnati, 1951.

9. Taped interview with William Wright for radio station WERI, Westerly, RI, 1951. (See *CR*, vol. 4, doc. 87, p. 251.) It is likely that Pollock was influenced in this technique by his experience with Matta. Busa told Lader (interview, May 26, 1976) that Matta very clearly articulated to the group of Americans he befriended "what it meant not to touch the canvas": "It meant that you were working with the element [a term that Breton used in those days], it was called the element of the free agent, where you didn't have contact, you just threw it on." "We were all aware of this," Busa noted.

10. Alfred Frankenstein, [Review], *San Francisco Chronicle*, August 12, 1945. See also Chad Mandeles, "Jackson Pollock and Jazz: Structural Parallels," *AM*, vol. 56, October 1981, pp. 139–41.

11. Most of Pollock's records were acquired through exchange with Norman and Carol Braider, owners of a shop/gallery called Books and Music, in East Hampton (interview with Carol Braider, Southampton, NY, July 18, 1979). Although the actual 78 rpm disks have warped and melted, the discovery of Pollock's collection in the attic of the house at The Springs in 1987 will allow for a complete inventory of Pollock's taste. Among the records found are not only Parker and Armstrong, but also Red and His Big Ten, Chick Webb and His Orchestra, and Eddie Condon.

12. Krasner, quoted in du Plessix, "Who was ?," p. 51.

13. Krasner never went out to Pollock's studio in the barn without an invitation from him. As she told Barbara Rose:

The pattern was that if he went out to work, I did not ever just come into the studio. But he might come back from the studio and I might say something like, "How did it go?," although I could tell before I asked the question. And he would say on occasion, "Not bad, would you like to see what I did?" I would go out with him and see what he did. Sometimes on these occasions he might pick up and start to work while I was there.

See Rose, "Pollock at Work," p. 89. Krasner also remarked to newspaper reporter Lon Tuck, "We were both playing double roles, painters and spouses at the same time. . . . We visited each others' [studios] only by invitation, and then we watched what we said. We could say just about anything to each other we wanted over the breakfast table or in bed, but the studios were off limits." See "Lee Krasner—Living with a Legacy," *The Washington Post*, December 23, 1978, p. C 7.

14. For the influence of *Number 1A, 1948*, on the classic works of 1950, see E. A. Carmean, Jr., "Jackson Pollock: Classic Paintings of 1950," *American Art at Mid-Century: The Subjects of the Artist*, Washington, DC: National Gallery of Art, 1978, pp. 129–31.
    Frank O'Hara, in *Pollock*, p. 24, was the first to define the period 1947–50 as the artist's "classical" period because of his "comprehensive, masterful and pristine use of his own passions" and the paintings' "cool, ultimate beauty . . . 'characterized especially by attention to form with the general effect of regularity, simplicity, balance, proportion, and controlled emotion,' to quote the dictionary." "In the sense of this definition," O'Hara noted, "Pollock is the Ingres, and de Kooning the Delacroix of action painting. Their greatness is equal, but antithetical."

15. Charles Stuckey has pointed out that a handprint also appears in the enigmatically signed "Jack-son" collage of around the same time; this makes sense in a work where attention was being focused on the expression of his ego. It should be noted that Pollock was not, however, the only twentieth-century artist to appropriate this proprietary device. As Stuckey points out, *Minotaure* had published the handprints of famous people in the mid 1930s, and soon after, Joan Miró had used the mark of his palm to adorn the catalogue to his current New York show. Also, during the same year as *The She-Wolf*, Adolph Gottlieb had twice featured this same motif. Gottlieb's two paintings were *The Black Hand* and *Hands of Oedipus*, both pictographs of 1943. In 1947 Hans Hofmann painted a similar work, *The Third Hand*. See Stuckey, "Another Side," p. 83.
    Although Pollock's awareness of these particular works by Miró, Gottlieb, and Hofmann cannot be determined with any certainty, Pollock certainly must have remembered a float made while he was part of the Siqueiros workshop: the sides of this float, intended for an anti-Fascist demonstration, were covered symbolically with a chorus of bloody handprints. See Hurlburt, "Experimental Workshop," p. 240.

16. Matter, speaking in "Strokes of Genius: Jackson Pollock," Cort Productions, Inc., film, written and directed by Amanda C. Pope, produced by Karen Lindsay, 1984.

17. Alfred H. Barr, Jr., "Gorky, de Kooning, Pollock," *AN*, vol. 49, Summer 1950, pp. 22–23.

18. For a complete discussion of this, see Carmean, "Classic Paintings," pp. 133–40.

19. In "Pollock Paints a Picture," *AN*, vol. 50, May 1951, pp. 39–40, Robert Goodnough relates:

About the rest of the studio, on the floors and walls, are paintings in various stages of completion, many of enormous proportions. Here Pollock often sits for hours in deep contemplation of work in progress, his face forming rigid lines and often settling into a heavy frown. A Pollock painting is not born easily, but comes into being after weeks, often months of work and thought. At times he paints with feverish activity, or again with slow deliberation.

Once again, Miró's process can be seen as prototypical, although in this case it is not so easy to prove that Pollock was aware of this fact, although he could have read the issue of *Partisan Review* in 1948 (vol. 15, no. 21, pp. 206–12), where James Johnson Sweeney quoted the Catalan artist as saying:

I start a canvas or a drawing, without a thought of what it may eventually become. I put it aside after the first fire has abated. I may not look at it again for months. Then I take it out and work at it coldly like an artisan, guided strictly by rules of composition after the first shock of suggestion has cooled.

The Sweeney article in which this quotation appeared was later reprinted in *Art News Annual*, no. 23, 1954, p. 187.

20. As we have seen with Manheim and Sweeney, Pollock frequently allowed others (including his wife) to suggest titles for his works. Thus, most titles seem to have been given after a painting was already completed. Often Pollock would allow a group of friends to indulge in verbal free association with a selection of his paintings stacked around them. During his most abstract period, 1948–50, Pollock decided that he preferred numbers to words as titles. In [Roueché], "Unframed Space," p. 16, Krasner explained, "Jackson used to give his pictures conventional titles . . . but now he simply numbers them. Numbers are neutral. They make people look at a painting for what it is—pure painting." Pollock added, "I decided to stop adding to the confusion. . . . Abstract painting is abstract. It confronts you." Those works (such as *Number 1A, 1948*) that also include the letter A were so designated by Betty Parsons for gallery purposes to distinguish paintings in her inventory left over from an earlier show.

21. See William Rubin, "Jackson Pollock and the Modern Tradition, Part Two: Impressionism and the Classic Pollock," *AF*, vol. 5, March 1967, pp. 28–37. As many art historians and critics have noted, Pollock's work actually had an important impact on the rehabilitation of Monet's reputation in the early fifties. See also Irving Sandler, "The Influence of Impressionism on Jackson Pollock and His Contemporaries," *AM*, vol. 53, March 1979, pp. 110–11.

22. Pollock, *Arts & Architecture* statement, p. 14.

23. See Putzel's statement in Edward Alden Jewell, "Toward Abstract or Away," *NYT*, July 1, 1945, sec. 2, p. 2. Putzel's exhibition, "A Problem for Critics," was held May 14–July 7,

1945, at his 67 Gallery, located at 67 West Fifty-seventh Street. Putzel cited Arp and Miró as forerunners of such Americans as Pollock, Krasner, Gorky, Hofmann, Gottlieb, Rothko, Richard Pousette-Dart, and Charles Seliger. His show also included Masson, Picasso, and Tamayo. In Jewell's column, Putzel challenged the art world to name this new movement.

24. Bernice Rose, *Drawing into Painting*, p. 22.

25. Pollock's knowledge of Tobey is indicated in a June 2, 1946, letter to Bunce: "New York seems to be the only place in America where painting (in the real sense) can come thru [*sic*]. Tobey and Graves seem to be an exception—are they around your part of Oregon?" In another letter postmarked a few months earlier, January 5, 1946, Pollock had written similarly: "Do you ever see Tobey or Graves? I still like their work a lot." See Karlstrom, "Pollock and Bunce," p. 26.

26. Busa told this to Lader, May 26, 1976. In "'American-Type' Painting," which appeared in *PR*, vol. 22, Spring 1959, pp. 179–96, reprinted in Greenberg, *Art and Culture*, Boston: Beacon Press, 1961, the critic noted of Sobel's work:

Pollock (and I myself) admired these pictures rather furtively: they showed schematic little drawings of faces almost lost in a dense tracery of thin black lines lying over and under a mottled field of predominantly warm and translucent color. The effect—and it was the first really "all-over" one that I had ever seen, since Tobey's show came months later—was strangely pleasing. Later on, Pollock admitted that these pictures had made an impression on him.

For Sobel's work, see also Sidney Janis, *Abstract and Surrealist Art in America*, New York: Reynal and Hitchcock, 1944, pp. 96–97.

27. See Rubin, "Modern Tradition, Part Three," pp. 18–31, for a complete discussion of this. See Greenberg, "'American-Type' Painting," *Art and Culture*, p. 218:

By means of his interlaced trickles and spatter, Pollock created an oscillation between an emphatic surface further specified by highlights of aluminum paint—and an illusion of indeterminate but somehow definitely shallow depth that reminds me of what Picasso and Braque arrived at thirty-odd years before, with the facet-planes of their Analytical Cubism. I do not think it exaggerated to say that Pollock's 1946–1950 manner really took up Analytical Cubism from the point at which Picasso and Braque had left it when, in their collages of 1912 and 1913, they drew back from the utter abstractness for which Analytical Cubism seemed headed. There is a curious logic in the fact that it was only at this same point in his own stylistic evolution that Pollock himself became consistently and utterly abstract.

28. Pollock and Krasner became aware of Mondrian's earlier work (pre-Neo-Plasticism) only after the latter's Valentine Gallery exhibition in 1942. Two paintings of Mondrian's "Pier and Ocean Series" were included in that show, and there was further opportunity to see this type of work in the Museum of Modern Art's 1945 Mondrian retrospective. Also,

Peggy Guggenheim owned a "Plus and Minus" or "Pier and Ocean" drawing—*The Sea*, of 1914—which was included in the 1942 catalogue of her collection, and Janis included a 1915 "Plus and Minus" oil composition in *Abstract and Surrealist Art in America*. Pollock, in a conversation with Tony Smith, which took place in the 1950s at the Sidney Janis Gallery, specifically referred to the connection of his poured paintings with this series by Mondrian. See Rubin, "Modern Tradition, Part Three," p. 23, and Carmean, "Classic Paintings," p. 153, n. 73. Tony Smith confirmed this conversation to Carmean on February 12, 1978.

29. Clement Greenberg, "How Art Writing Earns Its Bad Name," *Encounter*, No. 111, December 1962, p. 70.

30. In "The Jackson Pollock Market Soars," *NYTM*, April 16, 1961, p. 132, Greenberg noted:

The interstitial spots and areas left by Pollock's webs of paint answer Picasso's and Braque's original facet-planes, and create an analogously ambiguous illusion of shallow depth. This is played off, however, against a far more emphatic surface, and Pollock can open and close his webs with much greater freedom because they do not have to follow a model in nature.

31. In "Magic Circles," p. 3, Seligmann noted that an artist can create only in a state of trance. Busa told Lader, May 26, 1976, that Pollock marveled at the idea that Indians worked in a trance: "He was attracted to that. The honesty of it, the directness, and the idea of art being a ritual. He even speaks about that himself in one of his interviews, about his work doesn't come from the easel and so forth; he has to be in it . . . he was very aware of that aspect of being in a trance when you're working."

32. Namuth, in "Photographing Pollock," p. 17, discusses this scene in the film, which begins with the artist standing on the glass, pouring paint out of a can. Namuth notes that he was surprised to see that "when white paint hits the glass it turns black. It becomes silhouetted because the rays of the sun cannot bend around the glass, an unexpected visual effect."

33. *CR*, vol. 4, doc. 87, p. 251.

34. Blake to O'Connor, December 11, 1963. See *CR*, vol. 4, pp. 126–27. The model museum was written up in *Interiors* magazine, vol. 109, January 1950, pp. 90–91. In this article, entitled "Unframed Space: A Museum for Jackson Pollock's Paintings," Arthur Drexler wrote that the continuous rhythms of Pollock's pictures often appear to end only because there was no canvas left: "The paintings seem as though they might very well be extended indefinitely, and it is precisely this quality that has been emphasized in the central unit of the plan." He goes on to describe how in the model "a painting 17′ long constitutes an entire wall. It is terminated on both ends not by a frame or a solid partition, but by mirrors. The painting is thus extended into miles of reflected space, and leaves no doubt in the observer's mind as to this particular aspect of Pollock's work."

35. Potter recalls Pollock saying, "the movie, the way Hans works, was no worse than a still camera, and it wouldn't have happened maybe, either, if Lee hadn't kept at me. A camera

whirring away is easy compared to that. Maybe those natives who figure they're being robbed of their souls by having their images taken have something." See *TVG*, p. 129.

36. See Namuth, "Photographing Pollock," p. 18; Friedman, *Energy*, p. 165; and *TVG*, pp. 130–33, for accounts of this event.

37. Brooks to Valliere, interview, November 1965. Many who knew Pollock well—including Bultman and Parsons—have confirmed Brooks's observations about Pollock's inability to handle fame; Jackson is said to have told his wife that unwanted recognition after the *Life* article was making him feel like "a clam without a shell." (See Friedman, *Energy*, p. 140.) To Jeffrey Potter, Pollock remarked that notoriety is okay for performers, "But that shit isn't for a *man*. People don't look at you the same, and they're right. You're not your own you anymore—maybe more, maybe less. But whatever the hell you are after that, you're not your you." (See *TVG*, p. 114.) However, Pollock had a large stack of copies of the August 8, 1949, issue of *Life*, and he usually showed them to anyone who came to visit.

An excellent analysis of the attitude of *Time* and *Life* to Pollock's work can be found in Piri Halasz, *Directions, Concerns and Critical Perceptions of Paintings Exhibited in New York, 1940-1949: Abraham Rattner and His Contemporaries*, Ann Arbor: UMI Research Press, 1984. Halasz points out that while Sieberling wrote most of the *Life* articles, the unsigned reviews in *Time* were by Alexander Eliot, previously a sportswriter, and that Eliot wrote about Pollock with obvious distaste. "Is he . . . ?," the feature on Pollock by Sieberling, was apparently suggested by Daniel Longwell, an executive editor of the magazine. In a telephone interview with Halasz, Sieberling confessed that she later apologized to Pollock for the "flip tone" she had used.

### ELEVEN: *"The Dying of the Light"*

1. See "Jackson Pollock's Abstractions," *Vogue*, vol. 117, March 1951, pp. 158ff., and Richard Martin, "The New Soft Look: Jackson Pollock, Cecil Beaton and American Fashion in 1951," *Dress*, 1981, pp. 1–8. The latter characterizes Beaton's photographs as presenting Pollock's classic paintings in the guise of "icons of the new in American cultural life." Martin's question as to why/how Beaton decided to use Pollock's Parsons show for his fashion spread is answered in John Bernard Myers's *Tracking the Marvelous*, p. 86, where the author notes that his own apartment mate, Waldemar Hansen, was Beaton's secretary. "I used to talk to Cecil about Jackson Pollock," Myers wrote, "and the world of fashion was stunned when he photographed *Vogue* models against the whirling expanses of Pollock's 'poured paintings' at the Parsons Gallery. Cecil was a barometer of changes of taste and seemed instantly aware of what was 'now.'"

2. See *CR*, vol. 4, doc. 94, p. 257, for the first letter, and doc. 99, p. 261, for the letter of June 7, 1951.

3. Evelyn Segal, "From My Journal—September 25, 1949—A Weekend in East Hampton," p. 2, of an unpublished three-

page manuscript in the library of the Museum of Modern Art. Segal notes that Greenberg, Motherwell, the Peter Scotts, and a Miss Blumberg were also present.

4. See *Tracking the Marvelous*, p. 105, where Myers wrote:

> One day [Jackson] called me into the studio and said, "Look! I've made a puppet for you!" It was a figure about eighteen inches high, cut out of wood, on each side of which canvas was glued. Both sides were gaily painted and the figure seemed to dance as it hung from a string and turned. I don't think any other gift ever made me so happy. Unfortunately, a few years later the puppet was accidentally destroyed by Larry Rivers' children. Some time after Jackson had died, I was at a retrospective showing of his work and came upon a good-sized canvas from the middle of which was cut the figure that Jackson had pasted onto the wooden puppet. I suppose anyone looking at me must have wondered why I was so melancholy.

5. Greenberg to Valliere, interview dated May 11, 1972, Pollock papers, *AAA*, SI. This comment may have been meant more generally with reference to his entire output.

6. Krasner went into explicit technical detail concerning the materials and methods Pollock used in creating these black poured works in her interview with Friedman in *Black and White*, 1969. This is reprinted in *CR*, vol. 4, doc. 102d, p. 264.

7. *TVG*, p. 204, as recounted by Cile Downs.

8. Bruno Alfieri, "A Short Talk on the Pictures of Jackson Pollock," *L'Arte Moderna*, Venice, June 8, 1950; complete English transcript in the Betty Parsons Papers, *AAA*, SI. The most negative portion of this article is the text that was reprinted as "Chaos, Damn It!," in *Time*, pp. 70–71, causing Pollock's angry telegram, which was published December 11. (See *CR*, vol. 4, doc. 91, p. 253.) In his response Pollock suggested that *Time* had purposely left out the "most exciting part" of Alfieri's commentary, the last sentence which read, "Compared to Pollock, Picasso, poor Pablo Picasso, the little gentleman who, for a few decades now, troubles the sleep of his colleagues with the everlasting nightmare of his destructive undertakings, becomes a quiet conformist, a painter of the past."

It is possible, however, that Pollock's own belief that he had triumphed over Picasso was never total. According to Robert Welch, who met Pollock at a party given by textile designer Dorothy Liebes in the early 1950s, Pollock was still telling everyone there, "I've got to get Picasso off my back." (Interview with Welch, Shaker Heights, Ohio, July 29, 1987.) Jonathan Weinberg deals with this issue in "Pollock and Picasso: The Rivalry and the 'Escape,'" *AM*, vol. 61, Summer 1987, pp. 42–48. According to Weinberg, the dripped/poured paintings were Pollock's attempt, by denying the inevitability of figuration, to "prove Picasso wrong."

9. Leo Castelli, *TVG*, p. 161, summed up the situation between these two men when he said, "Jackson's relationship with de Kooning was rather strange: there was competition between the two, so it was friendship with enmity. As at the Cedar Tavern, where there were fights occasionally, one

could feel a tension in their company." On p. 162, fellow artist Nicholas Carone confirms that "Jackson always talked about de Kooning," and Elaine de Kooning, Bill's wife, commented:

> Jackson was hostile to Bill's utilizing the figure, the *Woman* series, and would use some of his pejorative terms [to describe these].... But figures had begun to appear in his own work in an extremely facile way—not worked on but as a kind of decision like, 'Well, now we'll have a figure,' and then a figure would appear in those great sweeps like Masson. It wasn't out of . . . study of the figure that went on for years and years and years like Bill did.

Pollock explained his return to the figure to Patsy Southgate: "it was almost sacred to break down the image and re-form it out of your own image. It was a *very* creative act." (See *TVG*, p. 188.)

10. One of the most controversial theories about Pollock to have surfaced in the past decade is E. A. Carmean, Jr.'s notion that the black pourings were intended as drawings for stained-glass windows to be incorporated into a hexagonal church design by Tony Smith. For Carmean's argument, see his "Les peintures noires de Jackson Pollock et le projet d'église de Tony Smith," *Jackson Pollock*, Paris: Centre Georges Pompidou, 1982, pp. 54–77; "The Church Project: Pollock's Passion Themes," *AIA*, vol. 70, Summer 1982, pp. 110–22; and Jo Ann Lewis, "The Pollock Dispute," *The Washington Post*, April 13, 1982, p. D 6. Rosalind Krauss refuted this possibility in "Contra-Carmean: The Abstract Pollock," *AIA*, vol. 70, Summer 1982, pp. 123–31. O'Connor agreed with her in his unpublished Dartmouth lecture, pp. 12–15. No one disputes that Pollock and Smith considered collaborating on the design of a Catholic church, a project that never went beyond the planning stages (see *CR*, vol. 4, p. 257); however, Carmean's identification of the forms in the black pourings as representations of specifically Christian iconography (the crucifixion, the lamentation over the body of Christ, etc.), and his identification of Picasso's 1930 *Crucifixion* as the prototype for this imagery, cannot be backed up visually or with any documentary evidence. Furthermore, no letters or statements made by Pollock link these paintings to the aborted church project.

11. O'Connor, *Black Pourings*, pp. 10–25, identifies the following configurations in the works of 1951–52 that recapitulate conformations of the past: the frontal figure (*CR* 335, 343, 344), the seated figure (*CR* 320, 334, 337, 338, 340), the figure joined to the complex (*CR* 319, 323, 333, 350), the figure freed of the complex (*CR* 324, 328, 329, 368), the figure alone (*CR* 316, 321, 322, 352, 353, 354), and the recumbent figure (*CR* 325, 336, 339, 341, 351, 355).

12. It has been suggested that, in addition to de Kooning, the work of the French *art brut* painter Jean Dubuffet may have been an inspiration for Pollock's coarse imagery in the black pourings. Pollock was introduced to Dubuffet's work by Ossorio, who was friendly with both of them. (See *CR*, vol. 4, doc. 95, p. 258, where Pollock thanks Ossorio for sending him a book about Dubuffet.) In *TVG*, pp. 155–56, Ossorio recalls:

In addition to liking the work of Dubuffet, Jackson liked the fact that people *didn't* like it, that here was someone trying to do something different. As to how far the liking went—well, there's no doubt they looked at each other's work with extreme attention and understanding, but with Jackson thinking that Dubuffet didn't go far enough and Dubuffet thinking that Jackson was too easy, perhaps.

I took pains to have them meet, and we brought the Dubuffets to East Hampton. The idea was that we would have dinner at the Pollocks'; but Jackson decided that life would be simpler if he and Dubuffet didn't meet. With the host missing, it was just the four of us and it was rather embarrassing. Lee talked, Dubuffet talked, we all did like mad, but there was a big gap. So the plan for a meeting didn't work and I have no recollection of seeing them together.

13. It is tempting to conjecture that Krasner may have been briefly pregnant when Pollock painted this work (*CR* 145), sometimes also called *Development of the Foetus*. Numerous statements by Krasner make it very clear, however, that she did not want a child, believing that two painters would not have time to be parents, and that dealing with Pollock's alcoholism took up all of her emotional resources. According to many accounts by friends, Jackson, on the other hand, was apparently fascinated with the notion of being a father. For example, Tony Smith notes in du Plessix, "Who was ?," p. 54, that "Pollock was very curious about children. He couldn't imagine our having them. He was always asking what it was like. Did they seem part of you, an extension of you? All sorts of things like that." (See *TVG*, pp. 81, 190 for similar comments by others.) In her dissertation, Langhorne points out that Pollock owned an illustrated text, *Gynecology* by William Graves, Philadelphia: W. B. Saunders, 1919, which may have influenced *CR* 145. O'Connor has postulated that the childless Pollock considered his paintings the progeny he would bequeath to the future.

14. O'Connor, *Black Pourings*, p. 20, quoting an interview with Dr. Hubbard, February 22, 1964, and a letter from her, May 14, 1964.

15. See Rose, *Drawing into Painting*, pp. 28–29, and *CR*, vol. 3, p. 283, as well as comments for *CR* 814, 816, 818, 819, 822, and 824. Krasner told Barbara Rose ("Pollock at Work," p. 87) that her husband had "indulged in materials very heavily. That is to say for drawings, he had the most fantastic collection of pens I had ever seen. He would go into Rosenthal's art supply store before we moved out to Springs and would pick out every new form of pen that would come out." She also noted that, "at one point [Pollock] got Du Pont to make up very special paints for him, and special thinners that were not turpentine. I don't know what it was."

16. See *CR*, vol. 3, p. 308, for the circumstances of Pollock's acquaintance with Howell and a description of the latter's technical processes. In *TVG*, p. 179, Howell recalled that Pollock acquired about fifty sheets of his paper and described their meeting: "He left silent as he came. It was phenomenal, that silence and all his drinking in—and you could feel the force of his telepathy. He stopped outside with his back to

me, thinking deeply, and I could feel the sense of reflection. Then he turned around; it was a telling moment as in Greek drama. He said, 'Do you know many men would be pleased to send their sons to work with you?'" There are, however, only nine extant drawings on Howell paper: CR 829–31 and 833–38.

17. See TVG, pp. 145, 156, and 169; CR, vol. 4, pp. 264 and 267; Solomon, Pollock, pp. 226–27; and Friedman, Energy, p. 192, for Pollock's hideous experience in 1952–53 with Dr. Grant Mark, who ran Psychological Biochemics Inc. Pharmaceuticals. Mark's emulsion treatments were recommended by Dr. Hubbard. The previous year Pollock had briefly tried Antabuse under the direction of therapist Ruth Fox, and in 1953 he reentered analysis with Ralph Klein, a clinical psychologist at the Sullivan Institute. See TVG, pp. 231–32, for comments on Pollock's attitude toward Klein.

18. See TVG, pp. 104–5, for observations by Blake and Potter on Pollock's constant driving around. Krasner (in du Plessix, "Who was ?," p. 51) said that Pollock would often remark, "Painting is no problem; the problem is what to do when you're not painting."

19. Dierdre Robson, in "The Market for Abstract Expressionism: The Time Lag Between Critical and Commercial Acceptance," Archives of American Art Journal, vol. 24, no. 3, 1985, p. 20, points out that, of all the Abstract Expressionists, Pollock was the only one who sold a painting in the fifties for more than $5,000 (One sold for $6,000 in 1954 and Blue Poles for $8,000 in 1955). During Pollock's lifetime the Metropolitan Museum of Art was unwilling to pay $8,000 for Autumn Rhythm, but paid $30,000 for it the year after his death. In 1955, Pollock was listed as a speculative (growth) investment by Fortune magazine. However, around 1950, according to Tony Smith, Pollock's total income for the year had been only $2,600. (See du Plessix, "Who was ?," p. 54.)

20. Greenberg, "Art Chronicle: 'Feeling Is All,'" PR, vol. 19, January–February 1952, p. 102. As pointed out by Nicole Dubreuil-Blondin, the adjectives Greenberg used to describe Pollock between 1943 and 1947 soared from "first" to "best" to "greatest" to "most powerful" to "strongest" to "most original" to "most important." Dubreuil-Blondin noted that "The object of the comparison can be represented by a succession of ever-widening concentric circles which point out Pollock's excellence in relation to the six or seven most significant young American painters [The Nation, November 11, 1944], then to a whole generation of easel painters under forty years of age [The Nation, April 13, 1946], and finally to the most powerful painters of contemporary America [Horizon, October 1947] and even of our era [The Nation, February 19, 1949]." See her "Number One: Towards the Construction of a Model," in Jackson Pollock: Questions, Montreal: Musée d'Art Contemporain, 1979, p. 48.

21. Stuart Preston, [Review], NYT, December 4, 1955.

22. See CR, vol. 2, p. 196, where Benton's words to O'Connor, December 26, 1973, are quoted:

I think it highly improbable that anybody but Jack would have thought of them (the poles)—anybody, I mean who had not studied composition with me. (Note articles in

"The Arts" 1926–27.) In one of these, poles are shown in a diagram and explained in the text. In an actual composition I always erased the poles or most times simply imagined them. I never made them parts of a composition as did Jack in the "Blue Poles" painting. But it was probably some vague memory of my theory demonstrations that caused him to "inject" the poles in that painting. Their use however is a purely Pollock concept. . . . The only possible precedent, that I know of, is shown in "The Arts" diagrams of '26–'27 and that is a minor one.

23. In "The Mechanics of Form Organization, Part II," The Arts, vol. 1, December 1926, pp. 340–42, Benton described one way in which murals can be composed by using "different units of form . . . set up about separate poles, tipped backward and forward and at different angles in a three-dimensionally conceived space, but so arranged that the lines of these forms are connected on their peripheries." See Polcari, "Pollock and Benton," pp. 123–24, for a discussion of Pollock's use of Bentonian poles in works of various periods. The effect of Blue Poles has frequently been compared with the majestic beauty of Monet's 1891 series of paintings depicting poplar trees near the Epte River.

24. See Stanley P. Friedman, "Loopholes in 'Blue Poles,'" New York Magazine, October 29, 1973, pp. 48–50; CR, vol. 2, p. 196; TVG, pp. 163–64; and Solomon, Pollock, p. 234. Krasner confirmed that Pollock got "hung up" on Blue Poles, causing him to "re-enter" the painting many times. She claimed to have watched Pollock put in the poles himself (CR, vol. 2, p. 193).

25. See also Krasner's remarks in Rose, "Pollock at Work," p. 89.

26. See Rose, Krasner, p. 56, fig. 50, for an illustration of this untitled Little Image painting of 1946 whose whereabouts are currently unknown.

27. In Krasner, p. 89, Rose notes that Pollock seemed the artist most excited by his wife's decorative Matissean collages shown at the Stable Gallery in the fall of 1955. Rose implies that it was Krasner, not Pollock, who realized how to extend the implications of his negation of imagery in Out of the Web. She notes that in works like Bird Talk and Shooting Gold, Krasner "solved the problem of the reserved shapes—which can no longer be read as negative or left-over shapes in the background—locking them into the complex interplay of pasted paper petal-like shapes by filling in around both applied and reserved freeform shapes with brushed paint, applied in several carefully considered layers."

28. Pollock's final painting, the aptly titled Search, was signed and dated 1955. White Light is dated 1954 and Scent, c. 1953–55. His last drawings are found in a sketchbook that contains his doodles from 1950 to 1956. At first this pad was on the telephone table in the house, but it was later (c. 1953–56) moved to his studio in the barn. The last pages comprise abstract ink and wash compositions. See CR, vol. 3, pp. 338–63, and William S. Lieberman, Jackson Pollock: The Last Sketchbook, New York: Johnson Reprint Corp., Harcourt Brace Jovanovich Pub., 1982.

## TWELVE: The American Prometheus

1. Time's obituary appeared in the issue of August 20, 1956, p. 90. For further details of Pollock's death, including the investigation report filed by the East Hampton police with the Suffolk County coroner, see CR, vol. 4, doc. 116, pp. 276–77. The immediate cause of Pollock's death was listed as "Compound fracture of skull. Laceration of brain. Laceration of both lungs. Hemothorax. Shock." Ruth Kligman, his girlfriend, who was also in the front seat of the car, was only injured, but a friend of hers whom Pollock had just met, Edith Metzger, was thrown out of the back seat and killed instantly. Kligman gives a rather sensational version of Pollock's last few moments in Love Affair: A Memoir of Jackson Pollock, New York: William Morrow, 1974. Pollock's will, written March 7, 1951, left everything to his wife. (See CR, vol. 4, doc. 96, p. 259.)

2. In The Mainliner, November 1980, p. 68, Newman notes about this photograph that, "The skull in the background was there, it was not something I did for effect or a premonition of death. I just left it there because I felt it fit, and it sure did."

3. Rudolf and Margot Wittkower, Born Under Saturn: The Character and Conduct of Artists: A Documented History from Antiquity to the French Revolution, New York: Random House, 1963, pp. 281–82.

4. Robert Brustein, "The Cult of Unthink," Horizon, vol. 1, September 1958, pp. 38 and 44.

5. Dorothy Sieberling, "Baffling U.S. Art," p. 74.

6. Barnett Newman is reported to have advised Pollock not to go to the Cedar Bar anymore. "They're laying for you," Newman told him. "You go in there a hero, and you come out a bum." Quoted in "Pasteboard Mask," p. 67.
In Love Affair, p. 29, Kligman recounted her first experience meeting Pollock at the Cedar:

Then I laid eyes on Jackson Pollock for the first time. He looked tired out, sad, and his body seemed as though it couldn't stand up on its own. He was leaning against the bar as if for support. He was huge. His head massive. His torso very developed, a full beard covered half his face. Some fantastic energy emanated from his presence. He was like a magnet, his giant form compelling. His passivity was aggressive and solid. The bar changed within seconds. Everyone changed. There was so much excitement from his presence it was staggering. An electric current seemed to float through the dingy bar. It came alive in a new way. He was monumental, magical, a genius walked in, and we all knew it, felt it, each and every one of us. The trumpet had sounded, the greatest of the matadors had arrived and we all came alive, to attention, we became super alive, super tuned into him. Waiting for him to make the first move. "Jackson, Jackson," his name sounding and resounding in the atmosphere.

Accounts of Pollock fighting with de Kooning and Kline abound. Asked by Valliere if he had wrestled with Pollock at the Cedar Bar, de Kooning replied, "Oh yes. It was a joke, very friendly. He'd go berserk—like a child—a small boy.

We'd run, fight, jump on each other. Such joy, such desperate joy." (See Valliere, "de Kooning on Pollock," p. 605.) For Pollock's behavior with Kline, see Fielding Dawson, *An Emotional Memoir of Franz Kline*, New York: Pantheon Books, 1967. Excerpts from this book are found in Friedman, *Energy*, pp. 229–32.

7. Beckett was notoriously adamant about rejecting any discussion of theories or meanings in relation to his work. His comment, when asked to identify Godot, "If I knew, I would have said so in the play," projects a roughly comparable point of view to the one expressed in Pollock's comment about *The She-Wolf*, that any attempt on his part to say something about it, "to attempt explanation of the inexplicable," could "only destroy it." For Beckett's attitude, see Martin Esslin, "Samuel Beckett: The Search for Self," *The Theater of the Absurd*, Woodstock, NY: The Overlook Press, 1973, pp. 11–65. (I am indebted to Malinda Smyth for this source.)

8. For extensive comparison of Pollock's work with Beckett's, see Christa Erika Johannes, "Relationships Between Some Abstract Expressionist Paintings and Samuel Beckett's Writing," Ph.D. dissertation, University of Georgia, 1974. Johannes chose to elaborate an extensive comparison between *Autumn Rhythm* of 1950 and Beckett's novel *Molloy* of 1947, pointing out that both have an "overall cyclical structure and a single continuous flow of text without climax that progresses toward dissolution."

Richard Ellmann's descriptions of both Samuel Beckett and James Joyce exhibit a strong resonance with what we know about Pollock's personality. In *James Joyce*, New York and London: Oxford University Press, 1959, p. 661, Ellmann wrote that "Beckett was addicted to silences, and so was Joyce; they engaged in conversations which consisted often of silences directed towards each other, both suffused with sadness, Beckett mostly for the world, Joyce mostly for himself." Compare this vignette with the anecdote related in Friedman, *Energy*, p. 65, concerning Pollock's first meeting in the early forties with photographer Herbert Matter, the husband of Krasner's friend Mercedes Carles. Friedman relates that "Jackson and Herbert went to the lower floor and were so silent that the women became worried about their not having hit it off. Actually the two men were very comfortable with each other's shyness." According to Herbert Matter, he and Jackson "never had to talk much."

9. In *Love Affair*, pp. 68–69, Kligman relates: "I didn't get the point of the play but Jackson did. Every line made him cringe, he got more and more into the play, and by the time Alvin Epstein came out as Lucky, in the most thrilling performance, Jackson was beside himself. He started to cry.... [His] crying turned to sobs and then it went into heartbreaking moans. He was out of control. He was lost, not realizing we were in the theater."

*TVG*, pp. 229–30, contains other recollections of Pollock's experience with *Waiting for Godot* by Nicholas Carone and Patsy Southgate. Southgate observed that Pollock "thought 'Godot' expressed his despair, and that it was the most brilliant play of our time." He "identified very closely with being the bum with bum's clothes—no money, nothing to eat but a carrot and a turnip, always waiting for Godot and Godot never shows up." John Bernard Myers (interview,

January 18, 1979) described Pollock in his later years as affected with a "profound malaise," and George McNeil commented that, "There was always an emptiness about Jackson, like living in an abyss. You could feel it in the way he talked, in the way he looked" (*TVG*, p. 34). In 1956, Pollock told Dr. Hubbard that music should have been his field and that the tips of his fingers were so sensitive that he could hardly bear to touch anything. He said to her, "I just can't stand reality." (See *CR*, vol. 4, p. 275.)

10. John Malcolm Brinnin, in *Dylan Thomas in America*, Boston: Atlantic–Little, Brown, 1955, p. 126, notes that Thomas "began every poem merely with some phrase he had carried about in his head. If this phrase was right . . . it would suggest another phrase. In this way a poem would 'accumulate.'" Other aspects of Thomas's poetry that relate closely to Pollock's methodology are discussed in William T. Moynihan, *The Craft and Art of Dylan Thomas*, Ithaca, NY: Cornell University Press, 1966. In "Artists' Symposium, Part One," p. 56, Motherwell describes Pollock's lyricism, surge of feeling, formal complexity, and nakedness of impulse as essentially Celtic, and the parallels between Thomas and Pollock are elaborated by Greenberg in "Pollock Market Soars," pp. 42, 135. Robertson, in his 1960 monograph on Pollock, used Thomas's poem "Do Not Go Gentle" as an epigraph for the text. It is also the source of the title of chapter 11 of this book.

11. Thomas, quoted by William York Tindall in *The Literary Symbol*, New York: Columbia University Press, 1960, p. 183.

12. See Holmes, "Philosophy," p. 38, and Kenneth Rexroth, "Disengagement: The Art of the Beat Generation," *New World Writing No. 11*, New York: The New American Library, 1957, pp. 28–41.

13. A copy of Rosenberg's 1952 article, "The American Action Painters," exists in Krasner's Papers (*AAA*, SI) with marginal notations in her handwriting indicating many areas of disagreement. It is impossible to tell if these objections reflect her own point of view only, or that of Pollock as well, although it is likely that the latter is true given their general agreement in matters of art. It is interesting to note that her marginalia indicates that Krasner considered the title Action Painter to be "insidious." She noted that "original work exists; it does *not* demonstrate what it is about to *become*" [her emphasis].

14. In *TVG*, p. 91, Greenberg told Potter, "My beating the drum for Jackson had some effect, only the work didn't sell. After Peggy had gone to Europe, Jackson would get drunk and he'd call up at one in the morning, saying, 'We don't have a penny! What the hell good is your praise!' Then I'd feel guilty that he'd become *notorious* without becoming *famous*."

In his last years, Pollock's attitude toward his growing fame was clearly unresolved. Potter (*TVG*, p. 192) recalled that in the winter of 1954/55 he asked Jackson how it felt "to have really made it." The answer was, "Lousy.... When you've done it, turns out you're done for—in yourself you're nowhere and no one...." Cile Downs's assessment in the same text of Pollock's ambivalent need to succeed is very interesting and provocative. On p. 275, Downs states:

I think Jackson felt fame was for the birds. He really hated all that stuff; he wanted to be loved, understood, and appreciated by people who could look at paintings. He so hated fame he would do the most vicious things to admiring people; he hated the whole apparatus—critics, dealers, all those schemes. Yet he wanted to be *numero uno* with everybody loving him, only as though he were nobody. He never got over the fact that people don't love you as much when you're big and successful as they did when you were poor and a nonentity.

15. For Miller's comments, see Valliere's interview with him in the Pollock Papers, *AAA*, SI. Braider's are found in a letter to Norman Kotker dated March 8, 1971, pp. 7–8, where the author points out that Pollock's personality has been "egregiously misrepresented in print" and that there were "important residues of his nearly Spartan antecedents and upbringing" in him, that he had "a very strong sense of 'propriety.'" (This letter is found in the Krasner Papers, *AAA*, SI.) As we have seen, Paul Jenkins, *TVG*, p. 136, also confirmed that underneath Pollock's violence he was a very decent and moral man. For Smith's comment, see du Plessix, "Who was ?," p. 53.

16. *TVG*, p. 93.

17. *TVG*, p. 236. Motherwell has recalled that, during his last few years, Pollock did not want to talk about art any longer, only money.

18. We could easily substitute Pollock's name for Manet's when reading George Heard Hamilton's assessment of the social importance of the latter in *Manet and His Critics*, New Haven: Yale University Press, 1954, p. 280. There Hamilton wrote, "If Manet's genius could be reduced to a formula, it might be stated as his gift for extracting from the undifferentiated visual whole of everyday life just those aspects which we see and feel as qualitatively 'modern' rather than chronologically 'contemporary.'"

19. *CR*, vol. 4, doc. 87, p. 249. Pollock had obviously been fascinated with the airplane as a symbol of the new age as far back as the late 1920s, and his father felt this way also. LeRoy, in a letter to Charles on July 20, 1929, points out that when he and Jack were in the desert near Santa Ynez, they saw a great many planes: "We are on the route from Los Angeles to San Francisco and some days there is [*sic*] a dozen or more big liners go over" (text supplied by Charles and Sylvia Pollock). Late in his life, Pollock ran into Raphael Soyer on the street. The more traditional painter recalled that "Without greeting me [Pollock] rudely said, 'Soyer, why do you paint like you do?' He pointed to an airplane. 'There are planes flying, and you still paint realistically. You don't belong to our time.'" Quoted in "Raphael Soyer, Social Realist Artist, is Dead at 87," obituary by Douglas C. McGill, *NYT*, November 25, 1987. Pollock took his first trip on an airplane to judge a show in Chicago in 1951. See *CR*, vol. 4, doc. 95, p. 258, for his reaction.

20. Rodman, *Conversations*, p. 84.

21. See "The Hero-Figure of Action-Painting," *The Times* (London), November 11, 1958. In *Look* magazine, January

1956, Eisenhower's secretary of state, John Foster Dulles, described the United States Cold War policy of brinkmanship as being willing to go to the brink of war without getting into it in order to achieve democratic goals and keep world peace. A number of recent writers, including Max Kozloff, Eva Cockcroft, Serge Guilbaut, and David and Cecile Shapiro, have investigated the use of Abstract Expressionism as "a weapon of the Cold War." Their essays are collected in Francis Frascina, ed., *Pollock and After: The Critical Debate*, New York: Harper and Row, 1985, pp. 107–66.

22. Allan Kaprow, "The Legacy of Jackson Pollock," *AN*, vol. 57, October 1958, p. 26.

23. As his friend David Hare so aptly put it, "What was for Pollock the only way in which he could function, became for others a goal in itself." See Hare's "The Myth of Originality in Contemporary Art," *AJ*, vol. 24, Winter 1964–65, p. 140.

24. Pollock's ideas had a particularly important impact on avant-garde dance. It has frequently been noted that the work of dancer and choreographer Merce Cunningham is closely related to Pollock's painting. In "Theory Undeclared," pp. 377–78, Gibson discusses the resonance of a comment by Cunningham, made in the magazine *trans/formation* in 1952, with Pollock's allover configurations: "A prevalent feeling among many painters that lets them make a space in which anything can happen is a feeling dancers may have, too: imitating the way nature makes a space and puts lots of things in it, heavy and light, little and big, all unrelated, yet affecting all the others." For a complete description of Cunningham's aesthetic, which makes his relationship to Pollock even clearer, see Calvin Tomkins, "Merce Cunningham," in *The Bride and the Bachelors: Five Masters of the Avant-Garde*, New York: Viking Compass, 1965, pp. 239–96. Cunningham essentially fused the ideas of Pollock with those of Duchamp, as understood and practiced by his collaborating composer, John Cage.

25. See William S. Rubin, *Frank Stella*, New York: Museum of Modern Art, 1970, pp. 26, 28–29. On p. 29 the artist states: "I tried for something which, if it is like Pollock, is a kind of negative Pollockism. . . . I tried for an evenness, a kind of all-overness, where the intensity, saturation, and density remained regular over the entire surface."

26. According to Frankenthaler, "You could become a de Kooning disciple or satellite or mirror but you could *depart* from Pollock." For an extensive discussion of the influence of Pollock on Frankenthaler (the two were introduced by Clement Greenberg), see Barbara Rose, *Frankenthaler*, New York: Harry N. Abrams, 1971, pp. 30–40, 80.

27. In "Artists' Symposium, Part One," p. 60, Kaprow explains Pollock's role as progenitor of the Happening:

When his all-over canvases were shown at Betty Parsons' gallery around 1950, with four windowless walls nearly covered, the effect was that of an overwhelming

*environment*, the paintings' skin rising toward the middle of the room, drenching and assaulting the visitor in waves of attacking and retreating pulsations. . . . A film of the artist at work indicated the close bond between his body movements and the track left by them on the surface of the canvas. Then Harold Rosenberg's article . . . completed the growing idea: why not separate the *action* from the *painting*? First make a *real* environment, then encourage appropriate action. The expanding scale of Pollock's works, their iterative configurations prompting the marvelous thought that they could go on forever in any direction including out, soon made the gallery as useless as the canvas, and choices of wider and wider fields of environmental reference followed. In the process, the Happening was developed.

In "Hans Namuth's Photographs and the Jackson Pollock Myth: Part One: Media Impact and the Failure of Criticism," *AM*, vol. 53, March 1979, pp. 114–15, Barbara Rose explains her idea that Namuth's photos—rather than Pollock's actual paintings—are responsible not only for the development of the Happening, but for antiform, distributional, conceptual, performance, and body art.

28. [Roueché], "Unframed Space," p. 16.

29. Bidlo also makes witty reference to several of the comments made at the *Life* Round Table on Modern Art, October 11, 1949. As noted earlier, Sir Leigh Ashton of the Victoria and Albert Museum postulated that Pollock's *Cathedral* "would make a most enchanting printed silk," and Dr. Theodore Green of Yale University said it seemed "a pleasant design for a necktie." Bidlo even carried his Pollock veneration to the point of developing a close relationship with Ruth Kligman. (See Robert Pincus-Witten, "Entries: Ruth Kligman, A Commodity in Art History," *Flashart*, no. 141, Summer 1988, pp. 122–23.)

30. As early as 1948, Clement Greenberg set up the parameters of the Pollock versus Paris dichotomy. See his "Art Chronicle: The Decline of Cubism," *PR*, vol. 15, March 1948, pp. 356–69.

31. In an undated brochure put out by the Associated American Artists Gallery, Chicago, Benton is described as having been seen in his day as representative of "energy" and "modes of action," and as being "unmistakably American in temper, spirit, roughness"; Benton was not just a painter, but "an American phenomenon," an "explosive mixture of social history, anthropology, cultural irritant and vivid exponent of American civilization." Thus Pollock seems to have been his teacher's true heir, despite their radically differing stylistic characteristics. Pollock's own comments about expressing the modern age were probably also stimulated—at least in part—by his recollection of Benton's ideas. For instance, Benton is quoted in the *New York American*, March 24, 1927, as saying, "An artist must be alive to what is going on. Ours is a mechanical age and we live in an atmosphere of machines and vast building activity." This point of view would have been underscored for Pollock by his association with Siqueiros.

That Pollock did not believe, like Benton, in ignoring European innovations, is evident in his answer to one of the questions posed in the *Arts & Architecture* interview of 1944. To the query, "Do you think there can be a purely American art?" Pollock replied:

The idea of an isolated American painting, so popular in this country during the 'thirties, seems absurd to me, just as the idea of creating a purely American mathematics or physics would seem absurd. . . . And in another sense, the problem doesn't exist at all; or, if it did, would solve itself: An American is an American and his painting would naturally be qualified by that fact, whether he wills it or not. But the basic problems of contemporary painting are independent of any one country.

(See *CR*, vol. 4, doc. 52, p. 232.) Nevertheless, when asked in later years if he wanted to go to Europe to see the newest works, Pollock reportedly replied, "Hell no. Those Europeans can come look at us." (Brooks interview with Valliere.)

32. Quoted in Karlstrom, "Pollock and Bunce," p. 26. Krasner's assessment of Pollock's "Americanness" was particularly astute. In "Pollock at Work," p. 85, Rose records that she stated:

Of course he was very aware of European art, but what he identified with was about as American as apple pie. His stories about the Indians—and he made many trips to the West—were not European in any sense. In finding this flow of paint, this thrust of paint, this aerial form which then landed—his so-called breakthrough—he could merge many traditions of art. You recall he had said in a '44 interview that here in the East, only the Atlantic gave him a sense of space that he was accustomed to. He did work with his father, who was a surveyor, in the Grand Canyon, so he really had a sense of physical space. In finding this technique of expressing what he expressed, he merged many things out of his American background—which does not disconnect him from tradition and his knowledge of European painting. His art was a synthesis.

Greenberg discusses the Europeans' attitude toward Pollock in "Pollock Market Soars," p. 43.

33. Greenberg, "Present Prospects," p. 26.

34. Peter Schjeldahl, in his review, "'Les Drippings' in Paris: The Jackson Pollock Retrospective," *The Village Voice*, February 10–16, 1982, pp. 94–95, termed Pollock an "American Prometheus who stole the School of Paris's fire," neatly encapsulating the assessment of a number of previous critics and art historians, as well as Pollock's own aspirations. That from the very beginning of his career his favorite painting was Orozco's *Prometheus* adds to the mythic truth of the ultimate fulfillment of Pollock's destiny.

# Acknowledgments

Many people and institutions helped make this book a reality, and I would like to take this opportunity to thank them. First of all, I wish to thank the American Council of Learned Societies, whose substantial grant in 1985–86 allowed me to take an eight-month leave from my teaching position at Case Western Reserve University to work on this text. Second, I would like to thank Francis V. O'Connor, who first encouraged me to do a book on Pollock, based on the knowledge and insights gleaned during the period I was researching and writing my Ph.D. dissertation for the University of Delaware on the early career of Pollock's wife, Lee Krasner. O'Connor has been generous with his ideas and suggestions, his unpublished material, and his knowledge about sources related to Krasner and Pollock.

Between 1978 and 1981, while working on my dissertation, I spent much time with Krasner, staying in her Manhattan apartment and at The Springs, with complete access to her personal files as well as her memory of events in her life. During that period, I also interviewed numerous friends and associates of Krasner and Pollock, all of whom are detailed in the bibliography; I would like to acknowledge with gratitude the help and insights of each of those interviewed. I consider myself especially lucky to have spent the better part of two days in Paris, talking with Charles Pollock and his wife, Sylvia, just months before his death.

In the spring of 1985, I taught a graduate seminar on Jackson Pollock at Case Western Reserve, and I would like to recognize the students who took this course and the stimulation I received from them. They are Geraldine Wojno Kiefer, Mary Lee Corlett, Lloyd Ellis, Jr., Paul Bock, Holly Rarick, Malinda Smyth, Nancy McAfee, Diane Kortan, Pamela Runyon, and Diane Kelling. Where specific ideas or sources were suggested by a seminar participant, I indicate this in the endnotes. With my assistance, and under my supervision, Mary Lee Corlett published an article in a graduate-student magazine, *The Rutgers Art Review*, on Pollock's reception in the media. Corlett's examination of the negative attitude toward modern art in American magazines prior to Pollock, and her general treatment of Pollock in the context of media heroes of the fifties, provide excellent background for my own more specific discussion and the conclusions I draw about Pollock's popular image in chapter one of this book.

I first presented my thoughts on this subject in a paper at the 1987 Annual Meeting of the College Art Association, in Boston, where they were heard by Yves Michaud, editor-in-chief of the *Cahiers du Musée National d'Art Moderne*, published by the Centre Georges Pompidou in Paris. I am very grateful to Michaud for his enthusiastic response to my talk and his perseverance in presenting my ideas to a French audience. The French translation of an early version of chapter one appeared as "Jackson Pollock—L'équipée sauvage," in no. 23 of the *Cahiers* in spring 1988.

I would also like to acknowledge Eugene Victor Thaw, executor of the Pollock-Krasner estate, for granting me permission to read and use materials from the Pollock Papers in the Archives of American Art at the Smithsonian Institution; Garnett McCoy and his staff at the Washington, D.C., headquarters of the Archives for their cooperation; the Interlibrary Loan staff of Freiberger Library at Case Western Reserve; Clive Phillpot at the Museum of Modern Art Library; Ann Abid and her staff at the library of the Cleveland Museum of Art; and Henrietta Silberger, who verified my bibliography, for their assistance in facilitating my research. The encouragement I received from Dr. Harvey Buchanan and Dr. Jenifer Neils, both chairs of my department during the preparation of this book, has been greatly appreciated. I have bounced ideas off a number of my colleagues in the Abstract Expressionist field, including Elizabeth L. Langhorne and Ann Gibson, and I very much appreciate Melvin P. Lader's loan of unpublished materials related to his pioneering study of Peggy Guggenheim, as well as Barbara Rose's allowing me access to her own unpublished interviews during my dissertation research. These also turned out to be helpful to me in the preparation of this book.

I also wish to give particular thanks to the following who were extremely helpful in obtaining photographs for this book: Jason McCoy, who supervised the photography of the Pollock-Krasner Foundation works in

storage; Nina Nielsen and Allison Albert of the Nielsen Gallery in Boston, who provided locations and transparencies for several drawings whose whereabouts would have otherwise remained unknown; William Acquavella of Acquavella Gallery, Inc., and Mrs. Dorothea Elkon of Elkon Galleries, who likewise provided invaluable assistance in retrieving inaccessible material.

I have supplemented my own and these other published and unpublished interviews with those conducted by Jeffrey Potter, in *To a Violent Grave*; and I am especially indebted to Potter's conversations with friends and acquaintances of Pollock no longer living. All material from *To a Violent Grave* is acknowledged in the notes.

Finally, I would like to thank the wonderful people at Harry N. Abrams who have been so encouraging and helpful to me: Phyllis Freeman (whose idea it was to expand what had originally been intended as a more limited study of Pollock into a full-scale monograph) for her thoughtful editing suggestions and her perseverance in making sure that all the facts and quotations in this book are exactly right; Paul Gottlieb for his endorsement of the enlarged scope of my project; Jennifer Bright, my photo editor, for expediting (sometimes with the skill of Sherlock Holmes) my often unusual and seemingly ever-changing illustration requests; Mark La Riviere for his elegant and sensitive design of the book; and Rebecca Tucker for her careful attention to the captions and myriad other details. I am very appreciative of the willingness of Hans Namuth, Rudolph Burckhardt, Arnold Newman, and Tony Vaccaro to allow me access and rights of reproduction to their incomparable images of Pollock.

Last, but certainly not least, I want to thank my husband, Howard Landau, and my two children, Jay and Julie, for cheerfully enduring my long hours at the word processor and every other aspect of my intense dedication to the volume in your hands. Sometimes I find it hard to believe that when I began working on Krasner and Pollock, my nine-year-old had not been born, but Barbara Rose's documentary film on art in New York in the 1930s, in which I am seen—very pregnant with my daughter—interviewing Krasner about her WPA days, provides amusing visual proof of the longevity of my interest in these two artists. I certainly could never have accomplished this book without my family's love and support.

*Shaker Heights*
*March 1989*

# Selected Bibliography

(Additional sources consulted not cited in notes)

## Books and Articles on Jackson Pollock

Alloway, Lawrence. *Jackson Pollock: Paintings, drawings, and watercolours from the collection of Lee Krasner Pollock*. London: Marlborough Fine Art Ltd., 1961.

_____. "Jackson Pollock's Black Paintings." *AM*, vol. 43 (May 1969), pp. 40–43.

Bozo, Dominique, et al. *Jackson Pollock*. Paris: Centre Georges Pompidou, Musée Nationale d'Art Moderne, 1982.

Brenson, Michael. "The Legacy of Jackson Pollock." *NYT*, December 13, 1987, sec. 2, p. 1.

Farber, Manny. "Jackson Pollock." *The New Republic*, vol. 112 (June 25, 1945), pp. 871–72.

Fichner-Rathus, Lois. "Pollock at Atelier 17." *The Print Collectors Newsletter*, vol. 13 (February 1982), pp. 162–65.

Foster, Stephen C. "Turning Points in Pollock's Early Imagery." *University of Iowa Museum Bulletin*, vol. 1 (Spring 1976), pp. 25–38.

Fried, Michael. "Jackson Pollock." *AF*, vol. 4 (September 1965), pp. 14–17.

Glaser, Bruce. "Jackson Pollock: An Interview with Lee Krasner." *AM*, vol. 41 (April 1967), pp. 36–38.

Glueck, Grace. "Scenes from a Marriage: Lee Krasner on Pollock." *AN*, vol. 80 (December 1981), pp. 57–61.

Hunter, Sam. "Jackson Pollock." *The Museum of Modern Art Bulletin*, vol. 24, no. 2 (1956–57).

Karp, Ivan. "In Memoriam: The Ecstasy and Tragedy of Jackson Pollock, Artist." *The Village Voice* (September 26, 1956), p. 8.

Kramer, Hilton. "Jackson Pollock and Nicolas de Staël: Two Painters and Their Myths." *Arts Yearbook* 3 (1959), pp. 53–60.

_____. "Social Art and the Pollock/Krasner Connection." *NYT* (November 15, 1981), sec. 2, p. 37.

Krauss, Rosalind. "Jackson Pollock's Drawings." *AF*, vol. 9 (January 1971), pp. 58–61.

Kroll, Jack. "A Magic Life." *Newsweek*, vol. 69 (April 17, 1967), p. 96.

Levine, Edward Z. "Mythic Overtones in the Work of Jackson Pollock." *AJ*, vol. 26 (Summer 1967), pp. 366–74.

Lieberman, William S. *Jackson Pollock: The Last Sketchbook*. New York: Johnson Reprint Corp., Harcourt Brace Jovanovich Publishers, 1982.

*Life*. "Rebel Artist's Tragic Ending: Critical Storm Brought Pollock Fame." vol. 41 (August 27, 1967), p. 58.

Martin, Richard. "New Look and Newer Look: The Commutation of Jackson Pollock by Cecil Beaton and Mike Bidlo." *AM*, vol. 62 (March 1988), pp. 20–21.

Meier, Anthony P., Jr. "Jackson Pollock's Prints, 1944–1945." *AM*, vol. 58 (Summer 1984), pp. 136–37.

Millard, Charles W. "Jackson Pollock: Characteristics of Early Pictures and Their Similarities with Later Works." *Hudson Review*, vol. 36 (Summer 1983), pp. 338–44.

O'Connor, Francis V. "The Genesis of Jackson Pollock: 1912–1943," *AF*, vol. 57 (May 1967), pp. 16–23.

_____. "Hans Namuth's Photographs of Jackson Pollock as Art Historical Documentation." *AJ*, vol. 39 (Fall 1979), pp. 48–49.

_____. *Jackson Pollock*. New York: Museum of Modern Art, 1967.

_____, Eugene Victor Thaw, and Andrea Spaulding Norris. *Jackson Pollock: New-Found Works*. New Haven: Yale University Art Gallery, 1978.

Perl, Jed. "Pollock and Company." *The New Criterion*, vol. 6 (November 1987), pp. 27–33.

Rose, Barbara. "Hans Namuth's Photographs and the Jackson Pollock Myth, Part Two: # 29, 1950." *AM*, vol. 53 (March 1979), pp. 117–19.

_____. "Life on the Project: Lee Krasner, Jackson Pollock and the Federal Art Projects of the Works Progress Administration." *PR*, vol. 52, No. 2 (1985), pp. 74–86.

Rubin, William. "Jackson Pollock and the Modern Tradition." *AF*, vol. 5 (February 1967), pp. 14–22; (March 1967), pp. 28–37; (April 1967), pp. 18–31; (May 1967), pp. 28–33.

Sandler, Irving, David Rubin and Elizabeth L. Langhorne. "More on Rubin on Pollock." *AIA*, vol. 68 (October 1980), pp. 57–67.

*Time*. "The Champ." vol. 66 (December 19, 1955), pp. 64, 66.

Valliere, James T. "The El Greco Influence on Jackson Pollock's Early Works." *AJ*, vol. 24 (Fall 1964), pp. 6–9.

## Other Books and Articles

Auping, Michael, et al. *Abstract Expressionism: The Critical Developments*. New York: Harry N. Abrams, Inc. and the Albright-Knox Art Gallery, 1987.

Barker, Virgil. "Albert Pinkham Ryder." *Creative Art*, vol. 5 (December 1929), pp. 839–42.

Barr, Alfred H., Jr. *Picasso: Forty Years of His Art*. New York: Museum of Modern Art, 1939.

Brown, G. Baldwin. *The Art of the Cave Dweller: A Study of the Earliest Artistic Activities of Man*. New York: R. V. Coleman, 1927.

Douglas, Frederick H. and René d'Harnoncourt. *Indian Art of the United States*. New York: Museum of Modern Art, 1941.

Gaertner, Johannes A. "Myth and Pattern in the Lives of Artists." *AJ*, vol. 30 (Fall 1970), pp. 27–30.

Greene, Theodore P. *America's Heroes: The Changing Models of Success in American Magazines*. New York: Oxford University Press, 1970.

Guggenheim, Peggy. *Confessions of an Art Addict*. New York: Macmillan, 1960.

Guilbaut, Serge. *How New York Stole the Idea of Modern Art: Abstract Expressionism, Freedom and the Cold War*. Translated by Arthur Goldhammer. Chicago and London: The University of Chicago Press, 1983.

Halasz, Piri. "Stanley William Hayter: Pollock's Other Master." *AM*, vol. 59 (November 1985), pp. 73–75.

Holmes, John Clellon. "This is the Beat Generation." *NYTM* (November 16, 1952), p. 10.

Hurlburt, Laurance P. "Notes on Orozco's North American Murals: 1930–1934." *¡Orozco! 1883–1949*. Oxford: Museum of Modern Art, 1980, pp. 51–59, 127.

Kozloff, Max. "An Interview with Matta." *AF*, vol. 4 (September 1965), pp. 24–26.

*Life*. "Fling, Dribble and Drip: young sculptors pour their art all over the floor." vol. 68 (February 27, 1970), pp. 62–66.

_____. "Moody New Star: Hoosier James Dean Excites Hollywood." vol. 38 (March 7, 1955), pp. 125–28.

Mellen, Joan. *Big Bad Wolves: Masculinity in the American Film*. New York: Pantheon Books, 1977.

Morella, Joe and Edward Z. Epstein. *Rebels: The Rebel Hero in Film*. New York: Citadel Press, 1971.

Moser, Joann. "The Impact of Stanley William Hayter on Post-War American Art." *Archives of American Art Journal*, vols. 18–19, no. 1 (1978), pp. 2–11.

Paalen, Wolfgang. "Totem Art." *Dyn*, nos. 4–5 (December 1943), pp. 7–33.

Reed, Alma. *José Clemente Orozco*. New York: Delphic Studios, 1932.

Rubin, William. *Miró in the Collection of The Museum of Modern Art*. New York: Museum of Modern Art, 1973.

_____. *Picasso in the Collection of The Museum of Modern Art*. New York: Museum of Modern Art, 1974.

Scott, David W. "Orozco's *Prometheus*: Summation, Transition, Innovation." *College Art Journal*, vols. 17–18 (Fall 1957), pp. 2–18.

Seitz, William C. *Abstract Expressionist Painting in America*. Cambridge: Published for the National Gallery of Art, Washington, DC, by Harvard University Press, 1983.

Simon, Sidney. "Concerning the Beginnings of the New York School, 1939–1943: An Interview with Peter Busa and Matta, conducted by Sidney Simon in Minneapolis in December 1966." *AI*, vol. 11 (Summer 1967), pp. 17–20.

Wechsler, Jeffrey. "Surrealism's automatic painting lesson." *AN*, vol. 76 (April 1977), pp. 44–47.

## Interviews

### Conducted by the Author

Baziotes, Ethel. New York City, February 21, 1980.

Bolotowsky, Ilya. New York City, October 30, 1979.

Braider, Carol. Southampton, N.Y., July 18, 1979.

Brooks, James. The Springs, N.Y., July 19, 1979.

Bultman, Fritz. New York City, February 27, 1979; April 30, 1979.

Burckhardt, Rudolph. New York City, March 9, 1988.

Busa, Peter. Charlottesville, VA, October 13, 1979.

Janis, Sidney. New York City, May 1, 1979.

Kadish, Reuben. New York City, May 2, 1979.

Kiesler, Lillian. New York City, February 27, 1979.

Krasner, Lee. New York City, November 3, 1978; January 14, 1979; February 28, 1979; May 1, 1979; October 30, 1979; February 21, 1980; February 25, 1980.

Krasner, Lee. The Springs, N.Y., July 18, 1979.

Lassaw, Ibram. The Springs, N.Y., July 17, 1979.

Little, John. The Springs, N.Y., July 19, 1979.

McNeil, George. Brooklyn, N.Y., March 1, 1979.

Myers, John Bernard. New York City, January 18, 1979.

Newman, Arnold. New York City, March 9, 1988.

Ossorio, Alfonso. East Hampton, N.Y., July 17, 1979.

Parsons, Betty. New York City, May 2, 1979.

Pollock, Charles. Paris, France, October 25, 1987; October 26, 1987.

Rosenberg, May Natalie Tabak. New York City, February 22, 1980.

Southgate, Patsy. New York City, February 22, 1980.

### Conducted by Others

Bolotowsky, Ilya. Interview with Paul Cummings, March–April 1968, *AAA*, SI.

Brooks, James. Interview with James Valliere. The Springs, August 1963, Jackson Pollock Papers, *AAA*, SI.

Bultman, Fritz. Interview with Irving Sandler, January 1968, *AAA*, SI.

Busa, Peter. Interview with Melvin P. Lader, Minneapolis, Minn., May 26, 1976, collection of interviewer.

Greenberg, Clement. Interview with James Valliere, May 11, 1972, Jackson Pollock Papers, *AAA*, SI.

Kadish, Reuben. Interview with James Valliere, n.d., Jackson Pollock Papers, *AAA*, SI.

Krasner, Lee. Interview with Dolores Holmes, Summer 1971, *AAA*, SI.

Krasner, Lee. Interview with Gaby Rodgers, 1977, Lee Krasner Papers, *AAA*, SI.

Krasner, Lee. Interviews with Barbara Rose: undated, probably 1972; July 31, 1966; March 1972, collection of interviewer.

Krasner, Lee. Interviews with Dorothy G. Seckler: November 2, 1964; December 14, 1967; April 1968, *AAA*, SI.

Krasner, Lee. Interview with Judd Tully for *Horizon* magazine, July 31, 1980, Lee Krasner Papers, *AAA*, SI.

Krasner, Lee. Interview with Emily Wasserman, January 9, 1968, Lee Krasner Papers, *AAA*, SI.

McCoy, Arloie. Interview with James Valliere, August 2, 1962, Jackson Pollock Papers, *AAA*, SI.

McCoy, Sanford. Interview with James Valliere, The Springs, August 1963, Jackson Pollock Papers, *AAA*, SI.

Smith, Tony. Interview with James Valliere, August 1965, Jackson Pollock Papers, *AAA*, SI.

# List of Illustrations

The number preceding each entry refers to the page on which the picture is to be found.

## CHAPTER FOUR

275

# Index

Numerals in italics refer to illustrations.

280

# Photograph Credits

The author and publisher wish to thank the museums, galleries, libraries, and private collectors who permitted the reproduction of works of art in their possession and supplied the necessary photographs. Photographs from other sources (listed by page number) are gratefully acknowledged below.

Acquavella Galleries, Inc., NY: 143; Azon, NY: 243 bottom right; E. Irving Blomstrann, New Britain, CT: 24, 33; Camerarts, Inc., NY: 29, 30, 49, 50, 136; Geoffrey Clements, NY: 90, 91, 106 bottom, 216 top right; Lee Fatherree: 138, 208; Carmelo Guadagno, NY: 165; Carmelo Guadagno and David Heald, NY: 231; Hickey & Robertson, Houston: 68; Nicholas Hlobeczy: 94 top; Kate Keller, NY: 39, 64, 146, 167, 233; James O. Milmoe: 74; Mali Olatunji, NY: 234; Phillips/Schwabb: 243 bottom left; Steven Sloman, NY: 194–95; Joseph Szaszfai: 199–200; John Tennant: 148; John F. Thomson, Los Angeles: 178, 209; Malcolm Varon, NY: 123; Tim Volk, Basking Ridge, NJ: 60; John Webb: 22, 54, 61 right, 216 bottom left; Zindman/Fremont, NY: 27, 35, 40, 41, 47, 52, 53, 55 right, 69 bottom, 72, 78, 106 top, 112 top, 122.